UFOs, Psi, and Spiritual Evolution

UFOs, PSI and Spiritual Evolution;
A Journey Through the Evolution of
Interstellar Travel

Christopher C. Humphrey, Ph. D.

Adventures Unlimited

UFOs, Psi and Spiritual Evolution;
A Journey Through the Evolution of Interstellar Travel

©2004 Christopher C. Humphrey, Ph. D.

ISBN 1-931882-38-X

Printed in Canada

Published By
Adventures Unlimited Press
One Adventure Place
Kempton, Illinois 60946 USA
auphq@frontiernet.net

Acknowledgements: Cover from the Hubble Heritage Team –STSci –taken by the Hubble Space Telescope.

"I'm amazed by the magnitude, scope, depth, & richness of your writings. Your mind is phenomenal, & you probably are a genius, if not a guru. I also think you're probably also somewhat of a "crackpot", at least about certain things, at least to me, although much of what you say I agree with whole-heartedly & find extremely insightful & interesting." --- Prof. Howard Gillary, U. of Hawaii

"WOW! This is absolutely fascinating, and something inside me says that it is true. "-- Leslie Swan

"This book by mystic, philosopher and scientist Dr.H, is an intriguing metaphysical study of how interstellar travel might be possible not through contemporary physics (which currently seem to refute it), but rather through advanced powers of the mind and mystical experience. He refutes traditional concepts of religion as a means of expanding one's spirituality, but instead embraces the depths of the Self as a means of traversing the stars. This book is a thought-provoking, iconoclastic metaphysical study written by an author who has borne witness to a UFO at close range and is recommended reading for students of cutting edge metaphysical studies."
 --Midwest Book Review from Oregon, Wisconsin

Dedicated to Darmus and Milana

Contents

Contents

Introduction

UFOs ghost silently along overhead or race in a few seconds to outer space. That reminds me of levitation, a power of the mind. UFOs abruptly disappear in one place and instantly reappear someplace else, perhaps hundreds of light years away. That reminds me of teleportation, another power of the mind. If it weren't for levitation and teleportation, star travel would not be possible at all. Physics rules out any technology of star travel. Despite that, every UFO enthusiast I've ever met believes UFOs just have more advanced technology than we do. If we could go from first flight in 1904 to first landing on the moon in 1969, then surely in a few hundred years, we can go from space travel to star travel! I wish it were so simple. Present space technology can at best be extrapolated to about one-tenth light speed. If star travel were just a matter of technology, Earth would long ago have been colonized by evil ETs. That has not happened. This is known as Fermi's paradox. Either there are no ETs, or evil ETs cannot jump light years.

Lawrence Krauss, a respected physicist and cosmologist, is the author of *The Physics of Star Trek*. He takes the Starship Enterprise apart and does the calculations, and it just doesn't work. For instance, it would take all the energy the Sun has produced and ever will produce just to achieve Warp One.

In any case, FTL is too slow. Stars and planets capable of evolving intelligent humanoids are few and far apart. A star must be long lived and old enough (about 4.5 billion years) for intelligence to have evolved. That rules out all the type "A" blue-white giants, which will blow themselves up in just a few million years. A star must be warm enough to maintain liquid water on a planet like Earth. That rules out the type "M" red dwarfs, which is too bad, since they are the most common type of star. About 80 percent of the stars within 22 light years of us are type "M," even though we can't see them with the naked eye. A star must be a singlet, rather than a multiple star system, in order for planets to have stable orbits. Our own star is a high metal type "G2" yellow dwarf singlet. Astronomers have not yet found another like it, although they must be out there somewhere. Earth-Moon systems like ours may also be quite rare, being the accidental

consequence of just the right kind of collision with the right kind of planetoid. It gave the Earth a large metal core, one-half the radius, including a lot of radioactive metals. This has kept plate tectonics going on Earth, long after it has ceased on Venus or Mars. Our Earth-Moon system has a lot of angular momentum, so we have 24 hour days. By contrast, Venus rotates slowly backwards. Having a large moon keeps the Earth stable in its tilt. All this means that suitable Star-Planet-Moon combinations may be quite rare, hundreds of light-years apart. Despite that, we have been visited by at least 50 different species of star-traveling humanoids just since May, 1947. We know this from the "landed occupant" studies of Gordon Creighton and Charles Bowen. The only practical method of star travel is teleportation, instantaneous jumps over hundreds of light years.

I see I shall have quite a job, convincing UFO skeptics that they really exist, and convincing UFO enthusiasts that they couldn't get here by technology. Naturally, there are also quite a few skeptics out there about psychic powers. If the mind is capable of teleportation and levitation, it can't be the brain, can't be the activity of the brain, and cannot be made of ordinary matter. It must be made of Dark Matter, invisible and intangible, something discovered by the astronomers but still very mysterious.

None of this is speculation. I rely totally on scientific method, which is not the same thing as accepting whatever academic scientists believe. About half of what they believe is just the worldview of reduction, a dogma, a matter of faith. We could even call it the religion of the scientists. These are the articles of faith that cannot be challenged and still have a job as an academic scientist.

How do we convince the skeptics? They will have to change worldviews. People will do almost anything to avoid changing worldviews. We have rigorous scientific proof of the reality of space-traveling humanoids, and we have rigorous scientific proof of reincarnation and other proofs of the real and independent existence of the mind, with its own powers and laws of nature. So the difficulty is not in the quality of our evidence. The difficulty lies in persuading any academic scientist to look at the best evidence. Galileo had the same problem. He couldn't persuade any of his academic colleagues at the

University of Padua to look through his telescope. They wouldn't even come down and look at the telescope. Galileo and Kepler had a good laugh at the extraordinary stupidity of these academics, which is no greater than the extraordinary stupidity of our own academics. We shall have to go our own way, outside the universities, as did the physical sciences for two hundred years after Galileo's time.

There are and have been a few people such as D. D. Home and Uri Geller who could levitate and teleport objects, even themselves. These are inherent and potential powers of mind-stuff. And how do we as a species develop such powers to the interstellar level? Not easily. Not quickly. It is my thesis that we develop such powers by spiritual evolution. I base this idea in part on Fermi's Paradox.

In 1950, the talk turned to ETs, and the great Italian scientist, Enrico Fermi, said, "If ETs are at all common, where are they?" What he meant was this. For the past 1.5 billion years, Earth has had liquid water, oxygen, and dry land. If we came across a planet like that, we would colonize it. But this hasn't happened. That is the paradox. Fermi's mistake was to assume that ETs would be like present day humanity, greedy, violent, uncaring about the ecology, reproducing out of control, like a plague on the planet Earth. A spiritually advanced species would not be like that. That is why ET didn't colonize us. My thesis is that **only** spiritually evolved species can teleport light-years. Our humanoid brethren come in peace, carrying no weapons. They are not here to save us, or colonize us, or convert us. Like our own anthropologists, they wish only to leave untouched the primitive culture under study. That is why UFOs pose no threat to national security. It also explains why they make no official contact, and confine their landings to remote and lightly inhabited regions of Earth.

Take nothing on faith. Make no assumptions. Consider the evidence for UFOs, levitation and teleportation for yourself. It is every bit as good as the evidence for "dark energy. " Better, actually, since I have an alternative explanation for the temporary acceleration of the Hubble expansion, in the chapter on physics.

We stand at a branch point in history. Down one path lies the scientist's religion of reduction of everything to physics. As a religion, it provides little comfort. If we took that path people would

reject science and with it all of rationality. We would then fall prey to new superstitions, producing the collapse of civilization and a new Dark Age. It has all happened before.

Down the other path lies a renaissance of the spirit. It rejects all religions and articles of faith. It expands scientific method to all questions. For every question, there is a realm of reproducible experience that can provide the answer. If people only knew that Professor Stevenson has proof of reincarnation, and that Gordon Creighton has proof of star-traveling humanoids, we would be half way home to a glorious new age. That is our Journey, one that will change us. The Journey is as important as the destination, though it might not be to everyone's taste.

Physics is the key, and understanding it is the first step. Nonetheless, I have put that chapter last. If there is one subject where people are inclined to accept whatever the scientists say, no matter how paradoxical, it is physics. I have discovered the feet of clay. The physicists may think of themselves as above the restrictions of logic and mathematics, and it took me a long time to challenge that arrogant and absurd claim. I have shown that one can do physics without paradox, singularity or infinity. Physics is bound by the rules of logic and mathematics after all.

What About UFOs?

If UFOs exist, then surely the UFO pilots are the experts on star travel. Indeed, if we knew for sure that UFOs exist, we could just say, "let us do what the UFOs do."

There is general agreement that Kenneth Arnold's sighting near Mount Rainier on May 12, 1947 began the modern era of UFO sightings. He was piloting a small plane when he saw them, and he said they seemed to skip through the atmosphere like a saucer across water. From this came the term "flying saucer," which is strange, because his UFOs were not saucer shaped. They looked like a boomerang with 3 tails. There were many other UFO events in 1947, including Roswell in early July, and the Villa Santina case that happened on July 23, 1947. Since that time, there have been millions of ordinary sightings of UFOs and thousands of the "Landed Occupant" cases. From Bowen's book *The Humanoids*, we can distinguish at least 50 different species of alien humanoid.

Assuming you are willing to suspend disbelief in UFOs for a moment, we must ask why this sudden influx of 50-100 species of space-traveling humanoids? That is a lot of different civilizations considering that stars and planets capable of evolving intelligence are very rare. Why here (Earth), and why now? My hypothesis is that the "foo fighters" of World War 2 (small glowing spheres seen in all theatres of war) went back home after August 1945 and announced that Earth was getting interesting. We had gone nuclear, had built rockets, and had no strong world government. Maybe we would self-destruct. From August 1945 to May 1947 is a year and 8 months. Given the time for the "word" to spread along the UFO grapevine, to hold scientific conferences and plan expeditions, for several different species to arrive in sizable numbers in less than 2 years, the actual mode of travel must be instantaneous jumps across hundreds of light years. I call that "jumping light years," or "star jumps."

There is nothing in technology about "jumping light years," which means disappearing in one place and reappearing instantly in another place. Wormholes and star gates have no basis in physics though they are common in science fiction.

There is good scientific evidence of the reality of UFOs as space-traveling humanoids. Landed UFOs have been seen with their occupants standing outside and seen at close range by human witnesses. Not once, but thousands of times. Here, it is easy to rule out experimental military craft, Venus, the infamous "Swamp Gas," sprites, Earth Lights, Venus and fraud.

Fraud could not possibly account for the full data set, accumulated by several scholars over a long time period. The studies in Bowen's book cover the period between 1947 and 1969, long before major media took any serious interest in UFOs. The reports come from many parts of the world, though the best cases come from South America. The witnesses were ordinary people in rural and isolated locations, who never became famous, never had TV movies made about them, and never went to conventions of UFO enthusiasts. The reports of these witnesses remained local, in local papers in the local language, usually not English, and not on the wire services or BBC. If it was fraud, how could they have formed a giant conspiracy to claim that all our visitors are humanoid? That is a surprising but consistent result. This data satisfies all the requirements for scientific data. Why, then, do scientists remain skeptical about the reality of UFOs? This is a peculiar kind of skepticism, a resolute refusal even to look. We must stop and examine this strange phenomenon, as something extraordinary in the history of ideas.

Skeptics

Every age of every culture has a tribal mythology and every mythology has its High Priests. Our tribal mythology is reduction to physics, and our High Priests are scientists. Human beings automatically pick up the tribal mythology, just as they automatically pick up the language and slang of their time and place. Mental blinders produced by a tribal mythology are not a new problem. Galileo faced the same problem, not from the church, but from his fellow academics, as we see from this little known letter from Galileo to his fellow philosopher of nature, Kepler:

> "I think, my Kepler, we will laugh at the extraordinary stupidity of the multitude. What do you say of the leading philosophers here [U. of Padua] to whom I have offered a thousand times of my own accord to show my studies, but who...have never consented to look at the planets, or moon, or telescope?....How you would laugh if you heard what things the first philosopher of the faculty at Pisa brought against me in the presence of the Grand Duke. He tried hard with logical arguments, as if with magical incantations, to tear down and argue the new planets out of heaven!" ---Portions of a letter to Kepler, 19th August 1610, www.humanistictexts.org --

Our own leading philosophers (scientists) likewise refuse to look at the best evidence for UFOs, the landed occupant cases. They also refuse to look at the best evidence for the separation of mind and body, namely Professor Stevenson's lifelong study of reincarnation data. It is easy to debunk TV psychics who "channel messages from the dead" and it is easy to debunk "mysterious lights in the nighttime sky," which might have a dozen possible explanations. Psychical researchers and Ufologists have already done that. By ignoring the good sciences in each field, by lumping Professor Stevenson in with daily horoscopes, the skeptics refuse to "look through the telescope," showing the same kind of unusual or extraordinary stupidity Galileo

encountered. It is very hard to change the tribal mythology.

Another name for "tribal mythology" is "worldview," or *"Weltanschauung"*. Worldview strongly determines what people think is possible and what they think is impossible. Luther, Erasmus, Chaucer, Aquinas, Augustine, Augustus, Jesus Christ and Alexander the Great had all held the same worldview as the one in Galileo's time. Aristotle, the teacher of Alexander the Great (if a butcher can be called great), invented this worldview. Ptolemy added some astronomical details. It lasted nearly 2000 years.

The 17th Century faculty at Pisa and Padua believed that here on this planet, at rest in the middle of the universe, everything is made of Earth, Air, Fire and Water and is mutable. Here below, things change, decay, corrode and corrupt. The heavens are made of the fifth element (quintessence) which is incorruptible, eternal, immutable, and perfect. The professors of Galileo's time simply found it impossible to believe in a moving Earth, or spots on the sun or craters on the moon or new moons unknown to the ancients. "How ridiculous!" they said to one another. "If the Earth is spinning, we would all go flying off into space! And if Galileo is seeing spots, they must be in his telescope. Or in his head!"

Reduction is the religion of scientists. The Grand Inquisitors are the professional skeptics, members of CSICOP (Psi-cops), who publish in *The Skeptical Inquirer*. They are determined to stamp out Psi research and Ufology as heresy. The Psi-cops are not scientists, though a few have scientific degrees. None of them has ever made a scientific discovery, not even Carl Sagan, the most famous of the Psi-cops. Carl Sagan is an excellent example of a very smart and arrogant man totally lacking in intelligence, the ability to learn from experience.

The Psi-cops make no scientific discoveries because they do not use scientific method. Instead, they use Hume's rule: "The more extraordinary the claim, the more extraordinary must be the proof." That sounds plausible, doesn't it? Nevertheless, it is completely wrong. If we had applied that rule in the 17th Century, when the new physics was the extraordinary claim, science would not exist. We would still be burning witches and heretics at the stake. There is no stronger or better proof than scientific method. That is what we must require of

new sciences and old sciences as well, if they wander off the path over time.

The "Psi-cops" do use Hume's rule. I will give you an example. When Martin Gardner heard about the demonstrations of dermo-optical vision through a blind, before the Soviet Academy of Sciences, Gardner immediately "debunked" it on the grounds that this could be duplicated by a stage illusionist (Gardner, 1966). Of course, that is true, if the stage illusionist gets to "set the stage," and use her own blind. I'm sure the Soviet Academy thought of that. According to the Psi-cops, all famous psychics, like Uri Geller, are master illusionists, despite the total lack of evidence that they have any training in that art, or any of the equipment necessary. Stage "psychics" or "mentalists" **are** illusionists, but they would never submit to the controlled experiments inflicted on the Russian psychics or on Uri Geller. Remember, the **illusionist's apparatus and skill can duplicate the appearance of anything**. Every scientific discovery reported in *Nature* could be a fake. We don't make such charges without grounds.

I sometimes refer to the "evil" Psi-cops. It is evil to try to prevent investigation of things just because those things are contrary to the religion of science. It is evil to get people fired from academic jobs just because they do investigate the forbidden subjects. This happened to Dr. Thelma Moss, of the UCLA Neuro-Psychiatric Institute. She was doing good work on telepathy, psychometry, Kirlian photography and other subjects. She is the author of *The Probability of the Impossible* (1974), an excellent introduction to Psi phenomena. She never again found an academic position. It has happened to many others.

You may have heard (wrongly) that James Randi has debunked Uri Geller. James Randi is an illusionist, and in a stage setting can produce the appearance of spoon bending. Nevertheless, he cannot explain how thousands of people just watching Uri on TV can also bend spoons or start up old clocks. Nor has Randi ever duplicated Uri's abilities under tight scrutiny and close scientific control.

Read *The Geller Effect* (1986) by Uri Geller and Guy Lyon Playfair to get a debunking of the debunkers in part three, written by

Playfair, particularly in Chapter 14, "The Witch-Hunters." Playfair says, "It is ironic that while the humanists and CSICOP do their best to wipe the paranormal from the face of American society, the state of affairs in many communist countries is quite different." (Geller and Playfair, 1986, p. 216). True. See "The Chinese Studies."

Scientific Method

Scientists have written little about scientific method. The only book on the subject written by a scientist that I know about is *Strong Inference*, written by a biologist. He draws a distinction between hard science (physics, biochemistry, geology, astronomy) and soft science (psychology and sociology). The hard sciences use strong inference to set up decisive either-or experiments, while the soft sciences rely on weak statistical correlations.

Scientists will tell you there is nothing all that complicated about scientific method. For them, it is no more than common sense. They learn it by example, handed down from Nobel Prize winner to Postdocs to graduate students or medical students. It would help non-scientists if we also had it written down. For one thing, it would greatly clarify the disputes between the forbidden sciences and the Psi-cops. If we had a verbal statement that scientists could accept, the intellectual history of the West might be quite different. I am going to attempt it. I begin with one basic assertion: scientific method is pure logic. It makes no assumptions about reality. If it did, it would just be another religion.

Shade tree mechanics, mothers with crying babies, gardeners, and even the master detective himself, Sherlock Holmes all use Scientific method. If the baby is crying, we first see if it is wet. No. Hungry? No. Is a pin or other object sticking the baby? No. Needs to burp? No. Maybe the baby is bored. Get out the stroller; take the baby for a walk in the park. The crying stops. Problem solved. The key thing is to see scientific method as problem solving. The problems may be varied and abstract. Newton solved all sorts of problems, having to do with the tides, and the trade winds, the flight of cannon balls, the working of pendulum clocks, and indeed, the motion of everything in the heavens and on Earth.

The genius and humanity of science lives in a certain kind of curiosity. Thousands of people over thousands of generations must have walked past cliffs showing geological unconformities, without thinking about it, without wondering about it, without caring about it.

In the 18th Century, a Scotchman named James Hutton

wandered past just such a cliff, and stopped to wonder, to question, and to imagine what might have happened. The top formation showed horizontal layers of marine limestone and shale. Hutton and others before him thought the processes of sedimentation going on at the present time could produce these horizontal layers in some ancient ocean or shallow sea.

Below the first formation was one where the layers were nearly vertical. Such boundaries between clearly different formations are examples of what geologists call an unconformity. Hutton realized a huge gap in time must have been missing. The second formation must also have been laid down in horizontal layers by sedimentation, then uplifted in a mountain range that was then worn away by erosion and eventually found itself on the bottom of the ocean again, to receive the top formation that was once again raised up as mountains that must have in turn been worn down by erosion into the gentle hills of Scotland. It was Hutton who first gave us geological time. As he said about geological time, there was "no sign of a beginning, no prospect of an end."

Below the second formation was a third, with smooth arches and folds, and different minerals. Hutton thought (correctly) that both the folding and the transformation of sedimentary rocks into other kinds of rock could only have happened in great heat, deep within the Earth. These are the pictures conjured up in Hutton's imagination by looking at a cliff. Sometimes being a scientist is just being curious about things that other people see, but do not wonder about.

Scientific method does not require math, laboratories, or explanation. Nor does it require double blind experiments, reported in peer-reviewed journals. It is not limited to the visible and tangible. Those are just the "accidents" of 19th and 20th Century academic science. We have a problem. We try to solve it, whether it is the motion of the planets, unconformities in geological formations, or the spectrum of thermal radiation. Scientific method requires reproducibility, veridical details, and rigorous tests to rule out all the known alternatives. A well-established theory is one that survives alone amidst continued rigorous testing and expansion of its range of application. We call this "scientific proof," not to be confused with

"mathematical proof."

Veridicality is a concept that applies to facts. A fact is really an interpretation of experience and is something like a hypothesis in miniature, since it is necessary to rule out alternative interpretations. Veridicality has no yardstick, but it does have various degrees. Typically, a data set will have data of widely varying veridicality. To establish the existence of an improbable phenomenon, the data set as a whole must have perfect veridicality, capable of ruling out every possible alternative, including ones that are themselves hypothetical, improbable, rare or non-existent. That is what the landed occupant cases do for UFOs, and that is what Ian Stevenson's lifetime of work does for reincarnation.

The other thing scientific method requires is reproducibility. This does not mean it must be possible to do it in a laboratory. One cannot make rock flow like hot plastic in the laboratory, yet field studies show that it happens in nature. One cannot create a large quasar in the laboratory (be glad of that!), nor a supernova, nor a galaxy. Field observations show us many instances of plastic deformations in layered rock, and many examples of quasars, and many supernovae, though none in our own galaxy during the age of science. It is all too easy to make mistakes in scientific studies. It is reproducibility that allows us to catch hoaxes. The Piltdown man is one of the most famous. It was a cranium of a primitive man with a large brain and ape-like teeth, found *In Situ*, in the early years of the 20th Century. However, as fossils of early hominids began to appear in museums, they were not at all like Piltdown man. The real hominids had small brains, upright posture, and human teeth and hands. Finally, about mid-century, a closer look was taken of Piltdown man and it was shown to be a forgery, though who did it and why is unknown.

When Sherlock is examining a crime scene, he is not making deductions. He is making up hypotheses to account for this smudge of boot black on the mantel, the sailor's knots holding the damsel in distress, the bit of candle wax on the carpet, and the three glasses of port, one of which has no dregs. The police notice these things, but to them they mean nothing. Sherlock is dreaming up fantastic theories involving a sailor in collusion with the said damsel. He knows of

ways to check this hypothesis. That's where the deduction comes in. Sometimes more than one theory will fit the facts, and he has to rule out alternatives. Sometimes he fails to come up with the correct hypothesis until more crimes are committed or more facts emerge.

Eliminating the alternatives is purely deductive logic, applied first to the processing of experience into scientific fact, and secondly in the proof of theories. The alternatives considered must have testable consequences. That is why Creationism is not a scientific theory, and why "Creationist Science" is an oxymoron.

Ian Stevenson ruled out the alternatives, leaving reincarnation as the only explanation for the young children who spontaneously recall former lifetimes, in the concluding chapter of his book, *Twenty Cases Suggestive of Reincarnation*. That is improbable, perhaps, given our current worldview. If we call ourselves scientists, we must either redo the studies, or accept these improbable results and reject reductionism.

Scientific method requires reproducibility to catch fraud, incompetence and "gremlins." There have been many follow-up studies of reincarnation children, published in the *JSPR* over the years. Anyone can repeat the studies. By contrast, cold fusion never seemed able to produce results when visiting scholars were around. Similarly, Stephen Hawking discovered that the more rigorous the controls in Parapsychology, the less the Psi observed.

I am a little dubious about this last point. One is no longer doing science if the experiment is set up to prevent the phenomenon from happening. That is what dogmatic skeptics will do, if we allow them to set up the controls in a Psi experiment. In any case, the best studies of Psi are studies of spontaneous cases, not studies made in the sterile and forbidding confines of a laboratory.

Parapsychology (lab investigation) does seem to be a soft science, while psychical research (field investigation) is a hard science. The biggest difference is that parapsychologists come into the field from psychology, while the greatest psychical researchers are MDs. Medical diagnosis requires scientific method, with a combination of "field observations" and laboratory tests. Psi events depend on human psychology. People are not machines, and do not

respond well to being treated like machines. It is surely wrong to design a test in such a way as to make the phenomenon impossible. I will give you an example of the Psi-cops doing this.

In one of the Psi-cop's appearances on the Discovery Science channel, I saw a "test" of the well-known phenomenon of staring at someone until they notice and turn around. However, they put the two people in different rooms! How can that be a test of the phenomenon? Such an experiment only guarantees the phenomenon will not happen. Similarly, it always seemed to me that J. B. Rhine's ESP tests would inhibit ESP, since they consist in deadly dull and repetitious guesses, with no positive feedback, involving cards that have absolutely no symbolic or emotive significance. I am also leery of any science that depends on statistical wizardry to tease a weak and erratic signal out of a lot of noise. If the parapsychologist gets no positive correlation between targets and guesses, he may change his search to look for statistical correlations to cards displaced by one or two before or after the target. By contrast, Professor Stevenson's studies do not depend on statistics. That is universally true of Psychical Research, the field study of remarkable paranormal events.

Remember that our facts must be both reproducible and veridical. "Veridical" means "details that cannot be explained away that are found to be true." In the Chinese tests of apportation, girls known to have this talent were asked to "remove the cigarettes" from a sealed box. Every time one of the girls said she had done so, the investigators would open up the box and count the cigarettes. There would be one fewer. Cigarettes do not spontaneously disappear. The girls did not touch the box. It remained in plain sight of everybody throughout the test. What alternative could there be, other than an apport? Hallucination? That is Hume's rule again.

Mystical experiences are reproducible. This was William James's great discovery in *Varieties of Religious Experience.* Unlike other sorts of religious experience, mystical states are the same in all cultures, under all religions. Symbolic interpretation is reproducible, at least in the hands of experts like Carl Jung or Joseph Campbell. See *Man and His Symbols* by Carl Jung. Symbolists find the same lessons in folk-tales, mythology, dreams and religious ritual. The chief

discoveries of Psychical Research are also reproducible. Anyone with the time and money can reproduce any of these studies.

Science is universal and non-sectarian. Even at the height of the Cold War, Soviet and Western physicists were friends and went to the same conferences, even those scientists who had built the H-bombs for each side. Every truly scientific theory has testable consequences, and thus we can decide between competing ideas by rigorous experimentation. That is why scientists ignore Creationism. It is not out of any prejudice against Christianity. It is just that Creationism is untestable, and provides no help to the scientist in trying to figure out where to look for what.

Doctor Leakey went to Africa to look for our ancestors, because Darwin's theory shows us to be primates. Except for us and the Yeti, primates prefer tropical climates. Furthermore, he knew from geology that Pleistocene fossils were washing out of the soil in the Great Rift Valley in Africa. He and his wife did indeed immediately find plenty of Pleistocene fossils, everywhere they looked. It took almost 30 years to find a hominid fossil, because our distant ancestors were relatively rare. Neanderthal fossils are easier to find. It is much harder to find 3 million year old hominid fossils.

Scientists can be just as opinionated and hotheaded about their favorite theories as anyone else can. That is unfortunate but it may motivate them to challenge any new idea. That is good, because it forces its originator to go back and examine new possibilities. Sometimes the new result turns out to be just an artifact, something not reproducible. Further tests always resolve scientific disputes peaceably. This is what I love about science, that and the adventure of ideas.

On the other hand, the existing sciences are very narrow in their scope, and leave out most of the really interesting questions. The existing sciences restrict themselves to a narrow band on the spectrum of reproducible experience, namely, the visible and tangible.

The trouble is that mystical experience is not visible and tangible. It does not register on photographic equipment. Neither do most of the things investigated by Psi researchers. Poltergeist phenomena will register on photographs, and even haunts may show

up on infrared cameras, but apparitions (which are far more common) do not register on photographic equipment. Nor is the mind itself visible or tangible. We see the mind by powers inherent to the mind. These observations have testable consequences, and they are reproducible. To restrict science to the visible and tangible is to build assumptions about the nature of reality into Science. If we do that, how is Science any different from Religion?

The existing sciences also restrict themselves to a particular kind of problem, that of reductionist explanation and prediction. We do not always want explanations, particularly not those of a reductionist kind. One of many Utopian problems is to find ways to prevent thermonuclear war. What good would it do to be able to predict it, even assuming that this is possible?

Reductionist explanation plays no part in Toynbeean History. It is part of the genius of Arnold Toynbee to show us that the patterns of history are not those of cause-and-effect. Rather, they are the free-will patterns of challenge and response. So far, historians and philosophers have not understood Toynbee, and inexplicably accuse him of being an "historicist," a kind of determinist. I have to wonder if they aren't just repeating some idiot early critic and have not bothered to read Toynbee.

My goal is the Aristotelian task of separating the essence from the accidents. The essence of scientific method is problem solving, and for every kind of problem, there is a relevant realm of reproducible experience. That is even true of free will, the problem of evil, and questions about immortality and divinity. All we need to do is find the equivalent of a fact, an experiment, and a theory. The concept of "well-established" is the same for all sciences, those accepted, those forbidden, those newly created, and any future ones. Something becomes a "fact-equivalent" or a "theory-equivalent" if we can empirically rule out the alternatives.

Many Psi-cops claim that physical evidence is a requirement of scientific method. Not so. They interpret this to mean that they will believe in UFOs if we can show them one in the laboratory. But there are no quasars in the laboratory, no galaxies, and no quarks. In fact, there is a slightly amusing story about quarks. When first proposed,

experimentalists looked for them. It shouldn't be that hard to find something with fractional charges, of one-third or two-thirds the standard charge. When no such thing could be found, they changed the theory so that "naked" quarks could only exist in the first few fractions of a second of the Big Bang, effectively making it untestable.

The independent testimony of numerous witnesses becomes especially important in the study of Near Death Experiences (NDEs). The best evidence for NDEs comes from Raymond Moody's original book, *Life After Life*. It is only the first part of the experience that we can verify with our five senses. A physician would have to work fast to verify the details seen by the patient in an OOBE state, since they are just trivial details about who came in, who went out, what they did, what they said, things like that.

Some ER operating rooms have mounted a random sequence of numbers and letters high up by the ceiling, where only an OBE person could see it. This is not a good test. The mind, the body, and the soul all have their own distinctive powers and modes of evolution. The power to interpret an arbitrary sequence of shapes as letters and numbers is a brain function, one that is inaccessible during an NDE. A far better test would be to videotape the room (with sound) and then check it against the NDE memories.

When it comes to applying scientific method to Psi research, the only special rule is to treat these people with dignity and respect. Treat them as human beings, not machines. If you change the psychological atmosphere, behavior will change as well. Hostile and dogmatic skepticism is likely to prevent Psi, not test it.

Summary: Scientific evidence must be both reproducible and veridical. That essentially means that we can rule out alternative interpretations of the experiment. Theories must have testable consequences, so we can set up decisive experiments that will either refute them all, or all but one. If that one continues to hold up under the battering of tests, it eventually gains the status of being well established. It is the best solution we know. Centuries from now, someone may come along with a better alternative.

There is one more element required of science, and I will let Sir Isaac Newton provide the example. He provided a mathematical

formula for the force of gravity, but said nothing more about gravity. Some skeptics and critics said that this really wasn't an explanation of gravity at all, and what did he have to say about that? He drew himself up in his magisterial way, and said, "I make no untestable speculations." At least, that is how I translate his 17th Century English. 20th and 21st Century Physics violates Newton's rule, and is in danger of becoming nothing but untestable speculation.

Bowen's Studies

The classic must-have scientific work on UFOs is *The Humanoids*, (1969) edited by Charles Bowen, editor at the time of *The Flying Saucer Review*, (FSR). The *FSR* is the most important journal in the field, published since 1955. The contributors to Bowen's book *The Humanoids* include Aimee Michel, Jacques Vallee, Gordon Creighton, Coral Lorenzen, Antonio Ribera, and Charles Bowen, all important Ufologists of the time. Each present a collection of cases of landed UFOs, with the occupants visible or on the ground, some organized by place, and some by time. Such landed occupant observations comprise the bulk of the scientific evidence about UFOs and the humanoids that drive them. That is because in the landed occupant cases we can clearly rule out the alternatives, such as swamp gas, or Venus, or secret military aircraft. They are therefore veridical. Many of these observations have multiple observers. Many of them happened in the daytime. All of them involve close encounters between humans and humanoid visitors, sometimes very close encounters.

The Humanoids is currently out-of-print, but you can find copies on the Web.

There is no first case of UFOs, since we find them in the background of some Renaissance paintings, looking just like the flying saucers of today, and we also find drawings of them in Paleolithic cave paintings, from the last ice age, or in aboriginal rock drawings. There are many examples on www.worldofthestrange.com.

As mentioned before, Kenneth Arnold's sighting near Mount Rainier on May 12, 1947 began the modern era of UFO sightings. There were many other UFO events in 1947, including Roswell in early July, and the Villa Santina case that happened on July 23, 1947.

The Villa Santina is in Friuli, in the extreme northeastern province of Italy, north of Venice and bordering on Austria and Yugoslavia. The witness was Professor R. L. Johannis, and he saw a classic flying disk, stuck in the side of a mountain, as well as one of the few known examples of "little green men." They weren't that little, being about the size of the San of the Kalahari, and they weren't that

green, being a kind of earthy green (Bowen, p. 188 ff.). Gordon Creighton presented this case. Professor Johannis said he knew nothing about flying saucers, because the Italian press had not begun to mention them. This happened only a few months after the Kenneth Arnold sighting, and a few weeks after Roswell. These small earth green characters with bright colored clothing are clearly not the same species as the small grays of Roswell (see the book by Col. Corso in the Bibliography).

The Johannis humanoids were less than 90 centimeters tall, wearing dark blue overalls with vivid red collars and belts and cuffs on the legs. Their heads were bigger than human, their skin was an earthy green, and they had 8 fingers without joints, with 4 opposing 4, so their precision grip was essentially the same as their power grip. Their eyes had a vertical pupil, like terrestrial reptiles or cats. They were very interested in the professor's climbing stick since it had a glacier-climbing ice axe and pick on one end. In fact, they temporarily paralyzed the Professor and took his walking stick. The two figures that had approached Johannis returned to their disk. It shot straight out from the rock, with a shower of stones and earth and rose silently into the air. "The disc suddenly grew smaller, and vanished. Immediately afterwards, I was struck by a tremendous blast of wind (the air shock?) that rolled me over and over..." (Bowen, p. 193). Did the craft really grow smaller, or was this an optical illusion as it simply moved straight away from Professor Johannis at a tremendous speed? Disguise, misdirection and disinformation are all ways of obeying the Prime Directive.

Creighton's case #64 is a sighting by some Argentine children of short, greenish humanoids. Among the different kinds of humanoid, we can definitely include short greenish humanoids, "little green men," if you like. The following case shows us another unusual variation, that of humanoids with bright red skin, and just one eye.

Gordon Creighton's case #30 describes the encounter by 3 boys in Belo Horizonte, Brazil, with a humanoid described in the following way: "Upon his extremely round and totally bald head the man wore a large round transparent helmet surmounted by a circular object. He appeared to have no ears or nose, his mouth appeared to open in a

strange manner, *his complexion was a vivid red, and he had only one large brown eye, devoid of any eyebrow.*" Binocular vision does not seem to be a requirement for humanoids. Gordon Creighton lists 5 species with just one eye. If this seems impossible to believe, Frank Edwards tells us in **Strange People** (1961) that in a backwoods community in Mississippi, there is an African American who also has one solitary normal-sized eye in the middle of his forehead. This is apparently a natural variation in the evolution of humanoids. In *The Humanoids,* there are some species with 3 eyes, and one species with many eyes. Generally, though, a humanoid is bipedal, bilateral, binaural and binocular, with eyes above nose above mouth, 2 arms with fingers, and 2 legs. There can be minor exceptions to some of these features. One thing that is universal is the body arrangement of head, trunk, arms and legs. None of them resemble Steven Spielberg's ET.

In case #28 in Gordon Creighton's list, a citizen encounters "a very tall creature with a melon-shaped head, very long and almost white hair, and three eyes which stared fixedly, without blinking." In Creighton's case #56, from a "Lima newspaper *La Prensa* of August 31, 1965, two people had recently been driving along the Pan-American Highway when, at a place some 20 kilometers from Arequipa, they saw 'a strange being, a Martian,' who 'resembled a shrub, was only 80 centimeters high, and had only one eye.' The creature was of a blackish color. In addition to its single golden-colored eye in the head, it also had other small eyes located up and down the body." The humanoid body plan can accommodate many variations.

Alien humanoids come in many different colors. I know of landed occupant cases involving humanoids with the following colors: white, gray, yellow, brown, black, green and red. There may be blue humanoids, but I haven't run across them. Some have fur; others are hairless, with everything in between. There are many variations in fingers and eyes. There are wide variations in size.

Space-traveling humanoids can be quite tiny. This is Creighton's #55, from Cuzco, Peru: "Shortly before noon on August 20, 1965, numerous people, including an engineer, Senor Alberto

Ugarte, and his wife, and a Senor Elwin Voter, saw a tiny disc land on a terrace of the ancient Inca Stone fortress of Sacsahuaman, just outside Cuzco. The disc was about 1.5 meters wide, of a vivid silvery color, and from it there emerged two small beings of strange shape and dazzling brightness. Discovering that there were so many people about, the little creatures at once went back into the disc that took off rapidly and vanished westwards." (Bowen, pp. 119-120). This is a diameter of about 5 feet, and a height of 1 foot, if it follows the usual dimensions of flying disks. Even if we allow a height somewhat greater, these little creatures could not be taller than 12 inches.

Abductions and seductions seem to have begun in 1957, with the A.V. B. case, not published until 1965 in the *FSR*. The next was Betty and Barney Hill, on September 19, 1961. They told their story in ***The Interrupted Journey***, by John G. Fuller. A species of humanoid that might pass for human seduced Mr. A.V.B. She had white skin and freckles, almost white hair, red pubic hair and red hair under the armpits. Mr. A.V.B. had no difficulty getting an erection, and they made love inside the alien spacecraft. The aliens in the Hill case may have been the same species, since they reminded Barney Hill of a redheaded Irishman. In both cases, the eyes were slanted, but not like the Chinese. In the A.V.B. case, the woman indicated by gestures to AVB that their sexual union would result in a baby that she would raise on her home world. She could bear a child in the normal way only if she and her companions were just another variant of our own species, in other words, a branch of Homo Sapiens that somehow became space travelers in the past 50,000 years. I do not rule that out. We know practically nothing about our history as a species, except for the past 5000 years or so.

Another possibility is expert gene manipulation. A third possibility is that she would raise a clone of AVB in a distant star system. A. V. B. could remember all this consciously. The aliens had not erased his memory, since it was in no way frightening or traumatic. AVB's story is not the product of hypnosis. Hypnosis sometimes produces just what one expects or fears.

How do UFOs navigate? One of our humanoid visitors (I don't like to call them aliens) told Billy Meier, a Swiss farmer, that they

came from the Pleiades (Randolph Winters, 1994, *The Pleiadian Mission*). This is surely disinformation, all part of their unwillingness to have any effect on our civilization, since a young star nursery dominated by huge blue white stars would be a hell of violent x-rays and UV and quite inhospitable to life.

Still, it could be a clue, for those smart enough to understand it. The Pleiades (Seven Sisters) are 425 light-years from Earth, yet are easily visible with the naked eye, riding the ecliptic across our winter skies, in front of Orion. They are a gravitationally bound system that would look much the same from any distance. If they can be seen across 425 light-years with the naked eye, they can surely be seen many thousands of light-years with even small telescopes. I suspect that visitors to our corner of the galaxy first find the Pleiades, jump there, and use the orientation of the seven very bright stars to define a three-dimensional coordinate system. Orient yourself correctly, look up the tables for the distance to jump to the Solar System...and then jump.

A few human beings can teleport objects instantaneously into or out of sealed containers. Psi researchers often call it an apport, from the Latin *Apportare*, meaning to "take to a place." Uri Geller once accidentally apported himself 30 miles, from Manhattan to Osinning. (*Uri Geller: My Story*, 1975, p. 238). He suddenly became aware that he was going to be late for a dinner party, so he began to run, and the next thing he knew, he was crashing into the back porch of the house of Andrija Puharich, a well-known Psi researcher of the time. That is where the dinner party was. It was Friday, November 9, 1973. Small objects often levitated or apported in Uri's presence, spontaneously, without any intent on his part. This suggests to me that levitation and apports are closely related. There are excellent controlled studies of apports by the Chinese (see the chapter "The Chinese Studies"). While we don't fully understand them, apports appear to take a shortcut through a fifth spatial dimension. That could work if the geometry of the physical universe is as described by Stephen Hawking in *The Universe in a Nutshell.*

Therefore, there is reason to connect UFOs, Psi and physics. Star travel requires the ability to jump hundreds of light-years

instantaneously. The only thing we know which resembles this is teleportation. Physics provides no such capability, except in the tiny world of quantum mechanics. Levitation and apports could entirely explain the UFO modes of travel. Levitation is silent and effortless. The UFO humanoids levitate their huge space ships silently and effortlessly, whether low and slow, or racing out of the atmosphere at thousands of miles per hour. Jumping light years requires teleportation. There is no other known alternative.

Could "jumping light years" be some technology with a superficial resemblance to apports? Maybe...but even the details are the same. For instance, Hans Bender investigated a poltergeist case in which objects were apported out of a closed chest inside the house, and they would appear outside the house under the eaves. No matter how heavy, they would flutter to the ground in the classic "falling-leaf" pattern frequently seen with UFOs (Vaughan, A. (1970). *Poltergeist Investigations in Germany*. Psychic, April.). When I read this, many years ago, I realized this is the secret to UFO propulsion and interstellar travel. Hans Bender was a noted German parapsychologist who died in 1991. Look him up on the Web.

There are several falling-leaf patterns in Bowen: "Mr. E. A. Bryant was out walking in the country on April 14, [1965, Scoriton, England] and had reached Scoriton Down, a spot with beautiful views, at about 5.30 P.M. Without warning he was confronted by a large aerial object which moved pendulum-wise to the left and then to the right before coming to rest, hovering some three feet from the ground, about forty yards in front of him. The object had appeared 'out of thin air' and Mr. Bryant says he was frightened." (Bowen, p. 21).

Jacques Vallee's case 24, September 28, 1954. In Froncles, three witnesses observed a large bright object that oscillated, then landed and changed color." (Bowen, p. 33).

In the next case, the falling-leaf pattern preceded the apport. "The Two little men went aboard, inviting Villanueva to follow, but he turned and ran to a distance, and then watched the craft rise slowly, in a kind of pendulum movement, 'Or like a falling leaf in reverse,' until at a few hundred feet, when it began to glow intensely, and then shot up vertically at staggering speed, with a faint swishing sound, and was

at once out of sight." (Bowen, p. 91, Gordon Creighton's case #4 at Ciudad Valley, Mexico in mid-august of 1953).

Following is Creigton's case 6, Pontal, Brazil: "On November 4, 1954, Jose Alves of Pontal was fishing in the river Pardo near that place. It was a quiet night; the spot was deserted. Suddenly, he saw a strange craft approaching with a wobbling motion, and it landed so near to him that he could have touched it." (Bowen, p. 92).

There is another aspect of the UFO phenomenon that suggests Psi powers rather than technology. Frequently the occupants individually levitate or apport, and this is how they manage to get very quickly from down on the ground to inside the spacecraft. The Ufologists have noted this problem of ultra-fast ingress or egress.

Here is a case of an individual alien levitating. It is Creighton's case #41 from Argentina in 1963. The 3-man crew of a freight train saw a figure on the tracks, apparently carrying the body of a small child. "Suddenly, when the locomotive was not more than 5 meters from the entity, he "shot upwards as though in a whirlwind' and vanished." (Bowen, p. 105). "Vanished," means an apport. Humanoid aliens who don't even need spaceships might visit us.

Our humanoid visitors come in a great variety of colors and sizes. Their behavior is sometimes surprising or even funny. They don't look as we expect, and they don't behave as we expect. Some species speak fairly good Spanish or Portuguese. [Most of the good cases come from South America.] Many species communicate by telepathy, but there are many more that do not. Their speech is variously described (depending on the species) as grumbling or barking or cackling or just unintelligible. You would think they would know that we couldn't speak their language, but there are many cases where they make the attempt.

There is also the comical vaudeville act in Creighton's last case, #65. "Their complexions were brown, and their faces 'shriveled' and furrowed like those of old people. The hair was white, their heads rather large in proportion to their bodies...One of the little men [80 centimeters tall] had a sparse beard and wore a dark peaked cap....The man with the flashing lights, who was the nearer, now jumped to his feet also and grabbed this cylinder by a handle in the middle of it, and

began running off, staggering as he did so, and he collided with his companion so that both nearly fell to the ground." (Bowen pp. 124-125). We can see how visits by this species of humanoid could give rise to stories of leprechauns and other small magical folk.

We tend to think of UFO aliens as peaceful and hairless. There are many cases in Bowen of bellicose hairy dwarfs that attack human citizens and leave claw marks. They do no real harm. They don't allow humans to use weapons, and will paralyze anyone who tries it. However, they are not averse to a good knock-down-drag-out-no-holds-barred wrestling match, if that is the right term for it. Maybe that is a sport in their home world.

The more I study landed occupant aliens, the less alien they seem. They are like us, not gods, not supermen. What they have done, we can do as well. Victims of abductions might not consider our visitors so benign. That is just one species out of hundreds. It could be worse. At least, they don't dissect their subjects.

The authors in **Bowen** give sources for each case. Usually these are newspaper reports, but sometimes they are UFO journals, including the FSR.

The landed occupant cases have both veridicality and reproducibility. These cases are not "swamp gas," Venus, experimental military aircraft, hoaxes or Jungian archetypal visions. They are real flesh and blood, as sexual or belligerent contacts with them demonstrate. The best proof of reproducibility of landed occupant observations is that all of our visitors turn out to be humanoid. This is unexpected. Both scientists and science-fiction writers have given their imaginary aliens a wide variety of forms.

The observers in these cases were just ordinary citizens. They never became famous. No one ever made TV movies about him or her. The reports themselves stayed local, in the local newspapers, not on the wire services or BBC. These cases come from many parts of the world, always rural and isolated places, and range in date from 1947 to 1969, over 20 years. If it were some kind of hoax, how could these ordinary citizens have coordinated their stories so well? With the fascinating variety of eyes, fingers, and skin color?

Case closed.

We now have enough data to ask the following questions:

(1) Our visitors do not make official contact. Why not? This was a great puzzle to the early Ufologists, yet there is an easy explanation. They are anthropologists, with a little bit of the other sciences thrown in. Landed UFOs usually make off with soil samples and bits of vegetation.

Human anthropologists never want to interfere in the primitive cultures they are studying, because they know that contact between primitive and advanced cultures is often fatal to the primitive culture. Compared to our visiting humanoids, we are the primitives, and therefore official contact would be bad for us.

All our alien visitors take care to avoid interfering with our evolution. They do this in various ways. (a) UFOs only land in rural and uninhabited places. (b) Some UFOs disguise themselves as something else, an asteroid for instance (see the "Autobiography" chapter.) (c) Or if they look like spacecraft, they may give us a sound and light show, making electrical systems nearby quit and doing other amusing tricks. This is to convince us that they travel by technology. That is what the "average man" assumes anyway. As long as we believe that, we will never be able to duplicate their feats. If you study Bowen, you will find no consistent correlation between the sound and light show and the action of the UFO. Some glow when accelerating. Some glow after they have landed. And so forth. (d) When our humanoid visitors make contact with a human, Billy Meier, for instance, they always feed the human disinformation, ideas that fit into popular mythologies, yet are easily refuted by scientists (Winters, 1994).

(2) Our visitors are all humanoids, with wide variations in size, color, hairiness, and the details of the face, fingers and eyes. In height, they vary from 12 inches to an estimated 20 feet, and some are as hairy as a Wookie, the furry creature from Star Wars.

(3) They jump hundreds or thousands of light-years in an instant. Planetary systems with intelligent and civilized humanoids are quite rare, quite far apart, and we must plan on trips of thousands of light-years. My chief reason for thinking star travel takes place by jumping light years rather than FTL (Faster Than Light) travel is the

sudden appearance in 1947 of sizable numbers of UFOs, of several different types, and several different species. I suspect that the "foo fighters" of WW 2 went home, spread the word up and down the star traveling grapevine that humans had gone nuclear and had actually used these fearsome weapons. Perhaps we would self-destruct. Some species began to plan expeditions. For several different species to begin arriving a year and 8 months later means they must be able to jump across hundreds of light years in an instant, especially when we see that suitable star-planet combinations for intelligent life are quite rare, and probably separated by thousands of light years. Some of our early visitors in 1947 seem to be first timers, who did not expect violent thunderstorms or powerful radar or anti-aircraft fire (3 theories for the Roswell crashes).

(4) UFOs travel by levitation and teleportation. This is only a hypothesis of course, but we know nothing from human experience that resembles UFO behavior other than levitation and teleportation. Such phenomena in human life are rare, and often not under the control of the person doing it. Still, there are those Chinese girls who can consciously control apports over short distances in controlled tests. There have been a few famous humans who could control levitation, including the levitation of their own bodies, particularly D. D. Home, in the 19th Century. If you do a Google search, you will find many web sites devoted to D. D. Home. Since the phenomenon does exist in humans, on a small scale, these must be innate powers of the human mind that only need understanding and developing.

(5) Fermi's Paradox, widely known in the scientific community provides one clue to such development. If we found a planet like Earth, we would colonize it. That has not happened. Despite the disinformation given to some contactees, there is no evidence of any alien involvement in the evolution of life on Earth.

Let's think about this. Why not? The universe is three times as old as our Solar System, so surely there were star traveling humanoids 1500 million years ago (1.5 billion years). If star travel by technology were possible, we would expect both good and evil aliens. That is what we find in science fiction. That is not what we find in reality. Evil aliens would have colonized Earth long ago.

Our humanoid visitors are all anthropologists, a trade more spiritually evolved than missionaries, traders, diplomats, or conquistadors. Only spiritually evolved species are capable of star jumping. Undoubtedly, UFOs have visited Earth over the last 1.5 billion years, but they had no wish to alter the natural evolution of the planet. I am sure they had no need, having learned to control population growth, preserving the ecology of their home world. Greed is a primitive habit, as is conquest. Self-control is a more advanced trait.

In summary, UFOs have to travel by jumping light-years. There is no other way they could have appeared so suddenly in large numbers less than two years after the end of World War Two. Yet we know that physics presents no such possibility. Therefore, they must travel by the powers of the mind, such as levitation and teleportation. Are there controlled studies that prove the existence of teleportation? Indeed there are, in the Chinese studies, unfortunately not widely known in the West. See "The Chinese Studies."

Space Technology

A sizable percentage of the population believes that UFOs are not unidentified, but really are space craft from a distant star, or the future, or some other dimension. The trouble is, nearly all of this population of believers think the inhabitants of the UFOs merely have a more advanced technology than we do. This does nothing to make belief in UFOs respectable among scientists.

There is good reason to think that interstellar travel cannot use any known space technology. There is only interstellar exodus, by means of the solar-sailed Ark. Lawrence Krauss, a well respected neutrino physicist, has taken the Starship Enterprise apart, piece by piece, done the calculations and shown that there isn't one single thing that Star Trek got right, unless it is the Prime Directive. See his book *The Physics of Star Trek.* As one example, he has calculated that it would take all the energy the sun has produced and ever will produce just to achieve Warp One. Thus, FTL (Faster Than Light) travel is impractical. Teleportation is not FTL because it has no velocity.

Star systems capable of evolving complex life are not very common, though there may be a great many with bacteria. Only certain kinds of stars will do. Our own star is a metal rich, middle aged G2 singlet. We have the only such star within a radius of at least thirty light-years. The planets circling multiple star systems would not have stable orbits. Only a narrow range of K2 to G2 (orange dwarf to yellow dwarf) stars will live long enough for intelligence to evolve and at the same time be warm enough to produce a comfort zone for a planet, where some liquid water will always be present. The hotter the star, the shorter is its life. Somewhere in the middle, we find the possibility of intelligent life. Only stars older than 4.5 billion years are likely to harbor intelligent humanoids, since it takes 4 to 5 billion years for intelligence to evolve. A planet which remains as tectonically active as the Earth, after 4.5 billion years, is unlikely unless the system formed out of a dust cloud high in heavy metals, including radioactive metals,.

Tau Ceti and Epsilon Eridani are possible target stars. They are about 10 or 11 light-years away. However, they are too young, too

small, too low in metals, and both appear to be part of multiple star systems. See http://www.solstation.com/stars.htm for information about our immediate neighborhood. Links disappear, so if there is anyone or anything you want to know more about, just Google it. Chances are the information is on the Web somewhere.

Planets with our Earth-Moon combination are rare. Without a large single Moon, our Earth would not maintain its stable angle of tilt. It could wobble as much as 90 degrees, and could sometimes lie over on its side, like Uranus. Our Moon was created by a collision with a Mars sized object very much like Earth, in that it had a metal core. The first collision was a glancing blow that gave our Earth-Moon combination its present angular momentum. Some of Earth's mantle splashed out to form the Moon, while the Earth got the metal core of the smaller planet on the second collision that captured the errant planetoid. Without this event, we would neither have such a large metal core (half the radius), nor would we have 24-hour days. By contrast, Venus has no metal core, and hardly any angular momentum. It slowly rotates backwards. Plate tectonics ceased long ago on both Venus and Mars. They are dead planets, incapable of supporting complex life. Planets will suffer many collisions in the formative stage of planetary development. It is pure chance if there is a final big collision at just the right angle to produce something like the Earth-Moon combination. This is the thesis of a book called *Rare Earth*. Thus, planets suitable for humanoid development are rare and the combinations of perfect star and perfect planet-moon are likely to be few and far apart, probably thousands of light years.

There is no known technology that can traverse thousands of light-years in anything less than millions of years.

The fastest possible rocket would expel an ionized propellant. This rocket could conceivably reach 1/10th the speed of light. The limiting factor on this kind of rocket (impulse power to Trekkies) is a law of vanishing returns, not Einstein's speed limit. To go faster requires more propellant and that increases initial mass, making the spaceship accelerate more sluggishly. At about one-tenth the speed of light, simply adding more propellant does not increase the velocity one can reach. There is no known power source to reach 0.1 C. For one

thing, all known power sources have mass that must be subtracted from the propellant.

Existing interplanetary probes might some day travel one light day in about ten years. Our Solar System is one-half a light day in diameter. A light day per decade is two or three times faster than any existing probes. A light year in distance would thus take roughly 3650 years in time. Since the nearest star system is 4.3 light-years away, it would take 15695 years to get to the Alpha Centauri system, roughly 16,000 years. In this multiple star system, star A is a G2, about 1.5 times the mass of the Sun. It probably won't last 5 billion years. Another star is 40 AU (Astronomical Units) away from A. Planets around A might not have stable orbits. The unit of AU is the average distance from the Earth to the Sun. 40 AU is also the radius of the Solar system, not counting the Kuiper Belt or the Oort Cloud.

A solar sailed Ark would be a better alternative than rockets since it could provide acceleration to leave home and deceleration when it approached its target star. The G forces involved would be enormous, 14 to 17 G. A blastocyst is the only form of a human being which can withstand such forces. A blastocyst is just a fertilized egg that has formed a hollow ball with a little pile of stem cells inside. Unlike a fetus, a blastocyst can be made in a test tube, and it can be frozen and thawed out years later and still be viable. The first and last generation on an Ark journey would thus likely be blastocysts.

A solar-sailed Ark would not get there any faster. It would still take millions of years to reach other humanoid civilizations, if we assume they are thousands of light-years apart.

An "Ark" is a self-contained ecological system, capable of renewing itself generation after generation, each of which would be born on the Ark, reproduce, live to a ripe old age, and die. The inhabitants might all be blastocysts for long periods of time. A primitive culture like ours could build such an Ark within this millennium. By traveling at a lower speed, we wouldn't have to worry so much about interstellar dust grains exploding into the hull with the force of an H-bomb, although shields would still be necessary. It wouldn't really matter how long it took to cross interstellar space. It would eventually get there. It could carry nuclear generators to create

electricity. It would not have to carry much propellant, just enough for maneuvering. It has the virtue that the same method used to propel it also stops it at the other end of the journey. For interstellar takeoff, it would maneuver as close to the sun as possible, point itself in the right direction, and unfurl an enormous solar sail. After gaining escape velocity, furl the sail and spin up the ring shaped ark to provide artificial gravity. It would then coast. At the end of the trip the reverse process would be used for deceleration, many thousands or millions of years later. This is the only technology of space travel proposed so far that might actually work, but only as a form of exodus.

When I think of "travel", I think of trips that might take a few hours, days or possibly even a few years. Anything longer than that would be a one-way trip, where one is not likely to come back. Another way of saying the same thing is that interstellar travel by technology is impossible.

Some of the people who leave messages in the guest book on my interstellar web site (http://users.aol.com/thales97/index.htm) present an argument from analogy. They say, "Look how far we have progressed in technology in the last 200 years. Surely, in another 200 years we will have developed technology we can't even imagine." Maybe. On the other hand, technology may have run its course.

I have often thought it would be interesting to go back in time (something I believe to be impossible) and talk to Thomas Jefferson. In philosophy and science, history and art, we would be in the same mental world and that would not be true if I visited Luther or Augustine or Plato. As I looked around his palatial mansion, I am sure I would find it remarkable that every single item had been hand made by a craftsman, often designed by Jefferson himself. Every gadget or item of furniture would be unique, without any interchangeable parts. Technology goes for long periods of time with little or no change. Neither people nor ideas could travel any faster in Jefferson's time than in Ancient Roman times or in the times of the Sumerians and the pyramid building Egyptians. Both people and ideas could travel about 9 knots, or 10 mph. No more. That is the speed of a fast sailing sloop, or the average speed of a pony express, with remounts.

Any student of Toynbee must realize one can never extrapolate

the past into the future. The one thing we can be sure about the future is that it will have surprising and unpredictable changes in direction for our civilization. The areas that have seen the most active change in the past few changes might cease to change. Change might pass to metaphysics or the arts.

We can now communicate worldwide at the speed of light, and we can travel at the speed of sound. Will we be communicating any faster in 200 years? Of course not. That would violate a fundamental law of physics. Will we be traveling any faster than the speed of sound? Through the air? Not if we value the ozone layer. I propose a return to the bicycle and the train since this would provide much faster commuter times than we now have with cars (only 5 mph at rush hour in Boston or LA). In many ways, technology reached apogee in the last quarter of the 20^{th} Century, when we decided not to build an SSC (Superconducting Super Collider), decided not to build the SST (Super Sonic Transport) and decided not to send any more people to the moon. Computers and communications are reaching apogee now, with the World Wide Web. There are a lot of computer users (me for one) who think the capabilities of their present systems are quite sufficient and would prefer to avoid upgrade or change, though it may be impossible to avoid.

Is there any possibility that physics could discover some way of jumping light years? While it is impossible to predict future discoveries, we can at least look at the problem areas in physics and its remaining questions, puzzles and paradoxes. String theory turns out to be relevant to interstellar travel. So does dark matter. In the appendix, you will find my take on the current state of physics, in a chapter called "Physics Without Paradox." There is nothing there to make us change our minds about the impossibility of "The Star Ship Enterprise." I put it at the end because it presupposes some knowledge of science, and there are a few very simple equations and important numbers. Still, you will need to read parts of it to understand my theory of the mind in terms of dark matter, de Broglie waves, and the warping of geodesics.

It is because scientists know that space travel by technology is impossible that they are so skeptical of UFOs. This also explains

SETI (Search for Extra-Terrestrial Intelligence). SETI is really the search for very stupid ETs. Why would any intelligent species set up a powerful radio or laser beacon, saying to the universe, "Here I am, a nice, water-fat planet with lots of oxygen and dry land -- come and get me!" Such a beacon might draw species like us, brutal, greedy, violent and reductionist, with no knowledge of the sciences of civilization, or of the mind and spirit. Unevolved, in other words. Even a primitive and unevolved species could traverse the cosmic spaces slowly with a Solar-sailed Ark, even though it might take millions of years to arrive at the destination.

The Chinese Studies

In this chapter, I describe some of the writings of Zhu Yi Yi, of Shanghai, a biology graduate of the Shanghai Fu Dan University, and staff writer for **Ziran Zazhi** (Nature Journal). **Incredible Tales of the Paranormal** has a translation of an article by her, edited by Alexander Imich, Ph.D. Despite the sensational title of this book, this is a scholarly collection of Psi research outside the English speaking world. The studies come from Italy, Iceland, Brazil, Poland, Russia and China.

The Chinese cases especially appeal to me, because, (1) they are all done under normal lighting conditions, (2) there is no medium and no "spirits" involved, (3) the psychics are all amateurs, mostly young girls 12-19, who are able to do what they do with little or no practice, (4) the principal investigators are usually professors of physics or other sciences, and (5) these are contemporary studies, begun about 1980 and on-going. The Chinese seem quite open to the investigation of Psi phenomena, and place no mental limitations on what is possible or impossible. All sorts of Psi phenomena present themselves. Best of all, here are the only controlled and successful experiments of teleportation that I know about.

The first Psi phenomena to catch Zhu Yi Yi's attention were cases of HSP perception. HSP stands for Higher Sense Perception, and is an acronym coined by Shafica Karagulla. Unlike ESP, HSP really is a form of perception that we all have automatically when Out-Of-Body (OOB). HSP allows us to see both physical and psionic matter, in complete darkness, and in successive layers of focus. This is how we see ordinary objects without eyes during OBE.

Back to Zhu Yi Yi. Subjects could read pieces of paper put inside various objects. Some subjects had the same kind of "x-ray" vision exhibited by Karagulla's "Diane." In other words, they could look inside a person's body. On one occasion, Professors Xu Xinfang and Xia Xugan brought a 12-year old girl named Hu Lian to see Mr. Yao, a member of the Science Committee of Xuan Chen city. Mr. Yao had a piece of shrapnel left in his body from the war. The girl correctly pointed out the position of this piece of shrapnel and accurately drew

its shape, in accord with Mr. Yao's x-ray films. He kept them in his house. Few people knew about Mr. Yao's shrapnel, although it is always possible that this young girl had heard about it.

The next kind of HSP perception was reading with the ear. The experimenters wrote words or phrases, usually in Chinese characters, balled them up and placed them in the subject's ears. After a few minutes, they could read the phrases, or describe the shapes if unfamiliar. Beijing Professors trained 10 year olds, and found that 60 percent of them could read with their ears. Shanghai investigators were similarly able to train juveniles in this art. This is very reminiscent of the Russian success at training juveniles in dermo-optic vision (See Ostrander and Schroeder). Some psychic children could read with the ball under their foot or in their armpit, or by chewing it up.

Next, a boy exhibited HSP control over mechanical watches. He could make them run fast or slow. If there were several watches on him, some would run fast, and some would run slow. In the terms of my theory of the mind, this boy was unconsciously "pushing the probabilities" that affect surface friction between mechanical parts, such as the escapement. By reducing the friction, the watch would run fast. Increase the friction and the watch would run slow. He had no effect on electronic watches. All this was quite unconscious. The boy had these abilities with no training.

Professors Zheng Tianming, Luo Xing, and Zhu Mingling of the University of Yun Nan devised a test for simple psycho-kinesis. Levitation is just one kind of Psycho-Kinesis or PK. They took the watches apart, separating the face with its hands from the mechanism. They found several juveniles who could make the watch hands move rapidly without touching them. This might be a good screening test for children who have PK ability. The hands of the watch are very light, and it would take very little force to make them move.

Finally, we come to apports. The first case brought to Zhu Yi Yi's attention was that of a young girl named Yang Li who could "remove the cigarettes." Ms. Zhu herself counted the cigarettes that inside a cardboard box with a lid. After awhile, Yang Li said, "One had been removed." Ms. Zhu opened the box and counted the cigarettes, and sure enough, one was missing. Where it went to is

unknown. This continued until they were all gone.

There were also children who could apport something into a closed container. In this case, the containers were teacups with lids on them and the objects apported into the cups were flowers and flower buds. Mr. Yang found the source of one of the Jasmine buds. It came from a Jasmine plant growing in a pot on Mr. Yang's balcony. This incident took place at the home of Yang Li, mentioned above (in Chinese the Surname comes first) in the town of Kun Ming, famous for its flowers. Zhu Yi Yi invited two 12 year old girls trained for two years under Professors Luo Xinfun and Zheng Tianming, who also came along for the test. There were four young girls in all, and all were able to apport flowers and buds into the teacups, although none of them had tried this particular experiment before.

The Chinese studies suggest that young children, about 10 or 12, are more likely than adults to exhibit Psi abilities spontaneously are. They are also more trainable, and their abilities improve with practice. They were rewarded only with the delight and amazement their successes evoked from the adults. This is the way Psi research should be done, quite the opposite from the boring card guessing or dice rolling of J.B. Rhine and the Parapsychologists. Psi is, after all, a mental ability, not something that can be done by machines. Social and psychological factors have to be relevant.

Today, China may be in the forefront of Psi research, largely because of the chilling effect of CSICOP (the Psi-cops) on the West. The Chinese investigators have no pre-set notions of what is possible or impossible. Instead of treating their subjects like frauds when they exhibit Psi abilities, they treat them like the special and advanced human beings they are. A psychic is treated like a criminal in the West, and meets widespread approval and delight in China.

Zhu Yi Yi does not expect anyone to believe in Psi abilities just from reading about it. What we need is to make use of "the second Geller effect." When Uri Geller did spoon bending and watch starting on TV, he always asked his TV audience to try it along with him. Thousands did, flooding the switchboards of the TV station. It is as if the greatest secret is just that something is possible, and once the viewers see that it is possible, many also find that they too can do it.

Michael Shermer, who writes a column in *Scientific American,* has this to say about the evidence for Psi.

"Until Psi finds its Darwin, it will continue to drift on the fringes of Science." - Michael Shermer, *Scientific American*, "Psychic Drift," Feb. 2003.

"The deeper reason scientists remain unconvinced of Psi is that there is no theory for how Psi works. Until Psi proponents can elucidate how thoughts generated by neurons in the sender's brain can pass through the skull and into the brain of the receiver, skepticism is the appropriate response, as it was for continental drift sans plate tectonics." - Michael Shermer, *Scientific American,* "Psychic Drift," Feb. 2003.

He may be right. I do have a detailed and testable theory of the mind that is capable of explaining Psi. I shall introduce it in stages, beginning in the following chapter.

Uri Geller and de Broglie Waves

Uri Geller is the world's greatest living paranormalist. "Paranormalist" is the term he prefers, not one I would have chosen. He is most famous for bending spoons or keys, usually by lightly stroking them, or starting old clocks or watches. Sometimes he only has to hold his hand over them. Sometimes keys and spoons nearby will spontaneously bend and curl. Sometimes they will keep on bending and curling after he has left the room. Bending metal and starting watches are examples of the "Geller Effect." When he does this on the radio or TV he asks that people at home get out old cutlery and make them bend in the same way. He also encourages them to get out old watches and start them by the Geller effect. Thousands are able to do so. Some of them are still able to do it months or years later. I shall dub this the "second Geller effect."

No one has ever been able to explain the Geller effect, but I intend to do so, mostly in terms of 20^{th} Century physics. The mind-brain information and control interaction takes place because of de Broglie waves. All physical and chemical phenomena on the atomic and molecular scale are also due to the de Broglie wave of every particle, including those particles like photons that behave like waves. All wave-like effects of particles are due to the de Broglie wave because it has positive and negative interference, resonances, radiation, reflection and all other wave phenomena. The de Broglie wave is an information wave, determining the possible behavior of its associated particle, and the probability of each possibility. The greater the intensity of the de Broglie wave at some point, the more likely the particle will be there.

The ability to make clocks run relates to spoon bending. Both are de Broglie effects, produced by the human aura, especially the aura around the hands. An old-fashioned wind up clock (which was the usual thing in the 1970s) will quit running if the internal friction is greater than the force produced by the spring. Stick and slip friction is in turn a de Broglie phenomenon on the two surfaces that are sliding past each other. There is a certain probability that they will stick and a certain probability that they will slip. Uri Geller and all the people who

can do the "Geller effect" can push the probabilities towards slip and away from stick. It will sometimes happen that a watch or clock that was running will cease to run. Indeed, Uri Geller has twice stopped the Big Ben clock in London (Big Ben is the name of the bell). Therefore, we can push the probabilities either way, towards slip or towards stick.

This is very similar to what happens in spoon bending. If we look at the structure of an alloy under high magnification, we see that it is a collection of small domains of different kinds of atoms, held in place by stick and slip friction. In metals that allow the domains to slip, bending is possible, as in a springy kind of steel. If stick dominates, bending is not possible, except with great force that may break the spoon or key instead of bending it. The aura around Uri Geller's hands can push the probabilities towards stick or slip. If we make one side of the key or spoon slip (where the tiny domains can slip past each other), they tend to flow together into a more orderly state. This contraction of one side of the key or spoon causes it to curl up. Uri can hold a spoon and allow the slip to go right through the spoon or key and this will allow gravity alone to make it bend or break.

It may seem odd that the aura knows how to produce exactly the right quantum state for the phenomenon wished for by the conscious mind. The mind does this all the time. We control our brains in an entirely unconscious fashion. The mind consciously wishes something to happen and unconscious levels of the mind produce the right quantum state for it to happen.

Sports provide examples of the second Geller effect. There are many things we could do, if we only knew that they were possible. How do we know that it is possible? By seeing someone do it.

Here's an analogy. I was a track "star" at the small college I attended in the late 1950s and early 1960s. This was also the time when people were trying to break the 4 minute mile. However, no one could do it. Athletes were afraid it was beyond the physiological capabilities of the human body. It seemed an insuperable barrier for decades, until Roger Bannister (if memory serves) did it. Immediately, the other world class mile runners also broke the barrier. They merely needed to know that it was possible. The only thing that was keeping

them from doing it was a mental block, thinking that it was beyond the physiological capabilities of mankind.

Some of Uri Geller's books are on-line at www.uri-geller.com or you can search with Google. I cannot quote page after page of it here because of copyright restrictions. At least his first book, *Uri Geller: My Story* is available on-line and you can buy it on-line. This book is only the first part of his biography, written when he was 25 and published in 1975. I shall make references to it this way: (Geller, 1975, p. 29), as I do with all references. The name refers you to the bibliography. If that author has more than one book in the bibliography, I also include the publication date. One of the beautiful things about the Web is that it is now easy to find books and ideas and letters that were once inaccessible. Just use your browser to Google for it.

The Stanford Research Institute and Professor John Taylor, a mathematician at King's College at the University of London thoroughly checked and verified Uri Geller's abilities. Very little of this was ever published. The SRI published nothing about the "Geller Effect" and so far as I can determine, neither did John Taylor. This reminds me of the reception of D. D. Home in the 19th Century. He demonstrated levitation, including levitating himself, before all the crowned Heads of Europe, as well as all the famous scientists of the time. Yet, this had no lasting effect on the reductionist materialism that is the chief article of faith in the religion of the scientists.

There is another very interesting Geller Effect (Geller, 1975, p. 29). He can take pictures of himself through a solid black lens cover without removing or touching the lens cap. This was during his first visit to the US. An English reporter from one of the London papers named Roy Stockdill went with him. At the Eden Roc Hotel in Miami Beach, Uri shot three rolls of film, holding the camera at arm's length, pointing it at his face. When they got back to London the films were developed. Two of the rolls were blank, but in the middle of the third roll, there were two pictures of Uri, perfectly clear, and reproduced in his first auto-biography. (Geller, 1975, before p. 161). This is due to a quantum effect called tunneling. If the de Broglie wave for a particle exists on both sides of a barrier, that particle will sometimes be on one

side and sometimes on the other, without ever passing through the barrier. This may be hard to believe, but it is a well-known quantum effect. Suppose that there is clear sailing for the photons bouncing off Uri and the background to the film, except for the lens cap. Uri's aura succeeded in making the probability of those photons continuing on the other side of the lens cap non-zero. Indeed, he was able to push the probability high enough so that some photons actually did get through on two pictures, enough to show on this high-speed black and white film. It would be interesting to know if the other pictures on the three rolls were genuinely blank or merely very faint.

After 1975, Uri Geller seemed to vanish from the American scene, and I always wondered what he was up to. The answer, at least up to 1986, is in *The Geller Effect*, by Geller and Playfair. *Time Magazine* and *The New Scientist* had published lying, scathing and scurrilous attacks on Geller by quoting illusionists and ignoring the things that millions of people had seen. After that, Geller learned to be wary about the media. He also learned to quit being a guinea pig for the scientists, especially after Prof. John Taylor became a turncoat traitor and lied about what he had seen. *Nature* and *The New York Times* had favorable things to say, based on the little that the SRI published. That is the trouble. They published only Uri's most trivial of talents, and ones shared by many psychics. That was just the tip of the Uri Geller iceberg.

Although Uri lived part of each year in New York City, he avoided the limelight. He spent much of each year in Mexico, where he became friendly with the ruling class. He also spent time in Europe and Israel. Mostly, he moved up several notches in the social ladder, so he was now working with the Presidents of countries and of companies. He was making himself rich, not through any illegitimate use of his powers, but by helping people who were prepared to pay. He found that he was good at finding things, whether it was a kidnapped person or gold and oil deposits. He and a friend in Israel invented and marketed a number of useful devices, such as an electrical pen that distinguished diamonds from any fake. He spent some time working with the CIA and some time working with the FBI. Uri was very busy. His powers are undiminished, but he uses them more selectively. Like

many celebrities, he discovered that fame itself is unpleasant. Unlike show business celebrities or politicians, Uri does not need fame to make a good living or to help people.

Seven Psi Phenomena

What is the greatest scientific discovery of the 20th Century? Reincarnation! While there have been many other great discoveries in the past Century, this is the one that is most important to mankind. Read all about it at http://www.childpastlives.org/stevenson.htm -- It follows that the greatest scientist of the 20th Century was Professor Ian Stevenson. There have always been many cultures where reincarnation was part of the tribal mythology. However, there is a great difference between believing something and knowing it.

What does Psi phenomena have to do with star travel? Star travel is Psi phenomena, specifically levitation and apports. Some scientists are skeptical about Psi unless we can produce a testable theory of Psi. For that we must consider all Psi phenomena.

Founded in 1882, the Society for Psychical Research (SPR) has found interesting evidence for seven different kinds of phenomena. Psi research has a wider boundary than the various SPRs. Many Psi researchers (Shafica Karagulla and Raymond Moody come to mind) were MDs first and generally published their articles in medical journals, or in books that are unknown to most of the members of the SPRs. After we look at the reincarnation data, we can define Psi research in a different way. My theory of psionics may give a further twist to the definition of "Psi research," and distinguishes it somewhat from "Psychical Research" and "Parapsychology" as they are today. And how are they today? They have no theory. To be scientific, you must have testable theories.

The seven known Psi phenomena are reincarnation, HSP, NDEs, OOBEs, psychometry, apparitions, and PK.

1. Reincarnation is the only Psi phenomenon we can call scientifically well established, although it is not yet widely accepted outside Psi research circles. It means there is a reproducible phenomenon having veridical details that rule out all other alternatives. Professor Stevenson and his colleagues in the SPR have given us a wealth of reproducible and veridical studies. Investigators either study young children who spontaneously recall a former lifetime, or they hypnotically regress adults to former lifetimes to produce responsive

xenoglossy. It has been more than thirty years since Professor Ian Stevenson published his epochal *Twenty Cases Suggestive of Reincarnation* (1967). This was the first lengthy, hands-on investigation of young children who spontaneously recall a former lifetime. There had been a few prior scattered reports in PR literature of the same phenomenon, referenced in Stevenson's book. He selected twenty examples that rule out alternate interpretations of the phenomena, such as ESP-Personation. I want to go through these alternatives one by one. This book is a technical monograph, including all details, whether favorable or unfavorable to the reincarnation hypothesis. He did not write it for the general public.

The study of Imad Elawar rules out normal channels of communication, since Stevenson found out about him before the family had tried to make any verification, and before his past life memories had begun to fade. Imad was five in 1964, when Stevenson made his investigation, and Imad had been talking about his past life since age two. Stevenson made copious notes before he and the family visited Imad's former family, where Imad made spontaneous recognitions of people and pictures, also recorded by Stevenson. Imad Elawar's family was Druse, a sect of Islam believing in reincarnation. Imad Elawar, a five-year-old child, could remember more than seventy details about a quite obscure man, living in another mountain village with little direct traffic to Imad's village, a man who had died nine years before Imad's birth. Both Imad's village and Ibrahim's village have good direct connections to Beirut, but connect to one another only by a narrow, winding forty-mile mountain road.

It is impossible for a two year old child to find out anything on his own about an obscure individual in a distant village who died nine years before his own birth. Were his parents coaching him? Not by Imad's family. The Druse believe that one incarnation follows immediately after another, without time in between, and Imad's family were also under the mistaken belief that he was claiming to be Said Bouhamzy.

I have never read about a spontaneous past-life recall where the former personality was well known, much less famous, contrary to the lies of the Psi-cops. Certainly there was nothing about Ibrahim's life or

death on the radio or in the newspapers. If there had been any news, it was "news" nine years before Imad's birth.

The only contact Imad had with a person from Ibrahim's village turns out to be a strong point of confirmation. When Imad was about two, he was out on the street with his grandmother when Salim el Aschkar of Ibrahim's village came along. Imad ran up to him and threw his arms around Salim. "Do you know me?" asked Salim. "Yes, you were my neighbor." Salim had lived close to Ibrahim Bouhamzy's place, but had since moved away.

Imad had never mentioned the first name of the previous personality (Ibrahim), only the last name (Bouhamzy) as well as a member of the family named Said. Therefore, Imad's family mistakenly thought he was claiming to be Said Bouhamzy. If they were coaching, they were coaching for the wrong person.

As a general comment about all twenty investigations, coaching does not explain the identity of personality and character traits, much less the persistence of physical traits or reincarnation birthmarks from one life to the next.

Past life memories of the present personality often cause problems in the village, or were unsavory and nothing to brag about. (1) Wijeratne recalled being an executed murderer in the same village, named Ratran Hami. (2) Jasbir refused to eat the cooking of his mother because she was not of the Brahmin caste. Fortunately a neighbor Brahmin woman cooked for him. (3) Ravi Shankar had his throat slit in his former lifetime as Munna, and named his murderers, who still lived in the village. There was even a trial, but the court decided past life memories were not legally admissible evidence. Ravi had a reincarnation birthmark. Ian Stevenson examined it. It looked like the scar left from having his throat slit.

Therefore, past life memories bring nothing but trouble. The children were told to keep quiet about their past life memories, and even beaten, though all of Stevenson's twenty children come from cultures where belief in reincarnation is universal. When reincarnation was back into the same family, or into the same small village, family and neighbors always noticed the identity of personality. Even if one had a book listing every fact about the former person, there is no way

personality could be the same. Complex interactive skills rule out cryptomnesia, itself an obscure and rare phenomenon. Cryptomnesia, a favorite theory of the debunkers, is like a recording of a forgotten incident. It always plays back the same.

Only the combination of ESP plus personation has some hope of providing an alternative to reincarnation. Mediums can produce ESP plus personation, at least in trance states. These children are not in a trance state. Nothing but reincarnation can account for the physical marks related to the previous lifetime that Professor Stevenson called "reincarnation birthmarks." William George, Jr. had several. William George, Sr. had injured his right ankle severely as a youth, and walked with a slight limp. So did William George, Jr. The dying William George, Sr. had told his daughter-in-law that he would be reborn to her, and she would recognize him by two prominent moles. William George, Jr. had the moles, in the same locations, about half size.

Charles Porter had been killed in a spear fight in his former lifetime, and had a birthmark in the shape of a spear wound on his right flank. Stevenson observed the birthmarks of both Charles Porter and William George.

Reincarnation birthmarks not only rule out all alternatives to reincarnation for these cases; they also imply that the mind forms the body, rather than vice versa. Young children who spontaneously recall former lifetimes may be rare, but I have encountered two myself and I wasn't looking for them. What is rare is for Psi investigators to hear about such children, especially when the child is still young and still able to recall the past life. These memories usually fade between ages seven and twelve.

Hypnotic regression is the other route to reincarnation evidence. One of the most famous books about past life regression is *The Search for Bridey Murphy*, by Morey Bernstein, published in 1957. This book became an international best seller. Debunkers attributed it all to cryptomnesia, on the grounds that a Bridget Kathleen Murphy lived on the same block when the present personality was a small child. The families were not acquainted, and there is no evidence they ever met.

Cryptomnesia cannot account for the veridical details (names

of merchants, streets, buildings) that Bridey knew about mid 19th century Cork because these had never been published and were unknown even to scholars until after the publication of *The Search for Bridey Murphy*. After that book became an international bestseller, old diaries and letters were brought out to verify those details. So be sure to look up the second or later edition of this book.

Nor can cryptomnesia account for the interactive abilities of Bridey Murphy. Bridey could dance Irish Jigs and speak in the lilt and slang of mid-19th Century Irish county Cork, and much of this slang and many of these jigs had never been published and had been forgotten, like much of the ephemeral popular culture of any age.

Stevenson has published many studies of "responsive xenoglossy." This refers to the ability of a hypnotically regressed individual to carry on a conversation in a language unknown to the present personality. My friend and mentor, Bill Coates, collaborated with Stevenson in the investigation of a woman who spoke Old Norse under hypnosis. Bill (now deceased) was one of the few linguists who specialized in dead European languages.

It appears that all we need are more reincarnation studies of the same kind, to guarantee reproducibility, and we need to allow time to see if any new alternative explanations are proposed. Reincarnation studies have met these two conditions over the past thirty plus years.

By all the rules of scientific method, reincarnation is a well-established scientific fact. If you don't believe it, go do your own studies of the phenomenon. That is what scientific method requires of genuine skeptics.

The discovery of reincarnation proves that mind and body are separate and different. There is one question people always ask when they first hear about reincarnation. How do we account for population growth? Where all the 6 billion minds do now incarnated come from? If we had research grants and professors of Psychical Research, we could answer that question. It is possible they come from other planets that have humanoid inhabitants. It is possible that minds and souls can split, and sometimes do with identical twins. It is possible that the pool of available spirits in the astral planes attached to Earth is larger than we think. After all, about 106 billion distinct individuals have so far

lived on Earth. It is also possible that minds and souls (spirits) can work their way up from lower life forms. Scientific research can answer those questions but that requires time and money. It also requires research grants, Ph.D. candidates and Postdocs to do it, and journals to publish in.

2. Higher Sense Perception or HSP: The pioneer of these studies was Shafica Karagulla, whose poorly titled book *Breakthrough to Creativity* is one of the great classics of Psychical Research. An unknown classic! Although her work was definitely Psychical Research by my definition, she published in medical journals, not in PR journals, and the editors of PR and Parapsychology journals usually know nothing of her work (Karagulla, 1967). Shafica Karagulla was a noted neuroscientist about thirty years ago, and a practicing MD.

Karagulla often worked with "Diane," who was a successful businesswoman, who kept her powers a secret. First Diane examined a patient by her methods, then Karagulla did the standard analysis of an MD, and they compared notes. Karagulla found Diane to be at least her equal at medical diagnosis. Diane once spotted an obstructed bowel, missed by Karagulla's own exam. They called the patient back, X-rayed him, and operated on him, saving his life. HSP is a mode of perception, like ordinary vision.

"Diane" was really Dora Van Gelder Kunz, President of the Theosophical society for years. Theosophy is a religion based on the idea that we have a physical body, an energy body, an astral body, and a primary body, if I remember correctly. I know of no evidence for that. Moreover, it seems inconsistent with Stevenson's reincarnation birthmarks. Therefore, I don't believe it.

I could define the "mind" as "the non-physical component of a living creature, as seen by HSP." Diane describes the human mind as a glowing structure with nine major vortices and numerous smaller ones, each having a characteristic number of sub-cones, and a characteristic place in the body. We could also define mind as that which reincarnates, carrying with it the same consciousness. It will take further investigation to see if these two different definitions refer to the same thing.

Five vortices are on the spine, one at the tailbone, one at L5 on the lumbar, one each at the levels of navel, heart and throat. The sixth chakra is at the eyebrows, the seventh at the crown of the head, and the eighth at the back of the head. A smaller ninth chakra is at the pancreas.

It was the Yogis who labeled these things "chakras," meaning "wheels," revealing an ancient science. A web of light beams connects the chakras, or at least that is how they appear to HSP. The Yogis call these lines "nadi," while the Chinese call them "meridians" in Chinese acupuncture. There is considerable evidence that these meridians really exist. Analgesic acupuncture does increase the endorphins in the brain. Acupuncture on a meridian connected to a particular organ will "light up" that part of the brain responsible for that organ, on fMRI. For instance, the meridian for the eyes surfaces alongside the outside of the foot. Stimulating these "eye" points will "light up" the same parts of the brain used for seeing, on an fMRI scan. (***Discover Magazine***, September 1998, p. 61).

Outside the boundaries of the body, there is the multi-hued aura. This structure of chakras, nadi and aura is what I call "mind." Since the mind is a stable object, always visible when looked at by people with HSP, it must be made of some kind of "stuff." I call it "Mind stuff," or "psionic matter." I also use the term "nouonic" for the apparitional signals sent from one mind to another, from the Greek "Nous." With HSP, Diane can see internal organs, as we saw in the obstructed bowel case. However, she usually found it more informative to observe the internal workings of the chakras. Serious pathology is associated with breaks in these structures. Minor pathology produces a jerky rhythm in the chakras.

Where the nadi enter or leave the surface of the physical body, there we find the acupuncture points. The physical needles focus the aura to restore the flow of energy in that nadi to its normal flow and rhythm. Thus, it requires "healing hands" to be a chiropractor or acupuncturist. Merely knowing the physical part is insufficient.

People who can do HSP in-the-body are rare. Everyone automatically has HSP Out-Of-Body. It is by HSP that an OOB person can see ordinary objects without eyes, and without light. One can see

in a 360-degree arc, and one can focus on successive internal layers, either by sight or by touch. One can see psionic matter as well as physical matter with HSP.

The chief shortcoming of the study of HSP is just the paucity of data. We have Karagulla's work, but an accident cut short her life and career. Fortunately, we also have the Chinese studies, although they do not use the term "HSP." Robert Monroe's *Journeys Out of the Body* provides a partial confirmation. On page 184, he writes "...when one begins to 'see' in this unfamiliar shape, the impression is that this 'seeing' is much the same as optical reception by the physical eyes. Only later do you discover empirically that this is not the case...You learn that you can 'see' in all directions at once, without turning the head...and that when examined objectively, it is more an impression of radiation rather than a reflection of light waves." (Monroe, 1971, p. 184) Monroe does not see auras, chakras, etc. Instead, his apparitional sense is always used, and he sees himself and other OOB persons as they see themselves. Self-body image is something that all people have, and always broadcast to others. It is also something one can deliberately or unconsciously change. Many OBEs do include the observation of auras around people.

From my own informal investigations, I know that it is possible for OBE persons to see the aura, because my then-wife did. I was conducting a group-hypnotic experiment in Manhattan, Kansas in 1970 or 1971, and my little experiment caused her to pop out of her body into a kind of bilocated experience. One point of view was up in the corner of the room, the other was in her body. From her OBE point of view, she saw a brilliant aura of gold and orange around me, but not around anyone else. The explanation is the suggestion I had made to "draw yourself into the middle of your head." Only later did I discover that this is one way of inducing the OBE. Of course, the instruction would also result in drawing in the aura. My then-wife was and still is an excellent hypnotic subject.

There are two powers that everyone automatically has when they go out of body. The first is HSP, but not usually the highly developed HSP of "Diane." No one knows why "Diane" had the power and no one else did. My working hypothesis is that this entity had

spiritually evolved through a series of past lives to a level to handle such talents safely.

The second automatic power in the OBE state is the apparitional power. In the OBE, one sees other people as they see themselves, not as a blob of psionic matter. In an NDE, beyond the earth plane everything is an apparitional experience, whether it is steps, corridors, or tunnels, heavens and hells, or other people. With the apparitional power, one can create apparitional realities as well as observe them.

What is it that radiates constantly from both physical and psionic matter, even in the dark? It is Prince Louis de Broglie's vibrations. HSP is only the first of many phenomena explained by the de Broglie vibes. It also accounts for the mind-brain interaction. It accounts for dermo-optic vision, and for thoughtography, the ability of a few (see Jules Eisenbud's accounts of Ted Serios) to imprint images on unexposed film, or at least "expose" the film. The mind can emit or receive de Broglie vibes. In the emit mode, the mind can "push the probabilities" on any macro-state where the probability of two different outcomes is about equally balanced. The waves of de Broglie are described in detail in the appendix on modern physics.

In addition to these seven paranormal phenomena well established by Western investigators, there is the work of the East Europeans, done during the Cold War, between 1930 and 1970. The Eastern investigators took a completely different tack from the West, and discovered things of great importance for my theory.

One of these discoveries is dermo-optic vision. This is the ability of people to "see" colors or read print with their fingertips (Ostrander & Schroeder, 1970, p. 158 ff.). Some of the subjects were physically blind, and the others had to read by putting their arms through a blind that prevented visual observation of the target. This phenomenon became something of a fad in Russia in the 1960s. I put this in the same category with HSP, since both are de Broglie phenomena.

3. Near Death Experiences (NDEs). This term is a bit misleading. In the George Rodonaia case, and in many so-called NDEs, the EEG is flat line, the heart monitor is flat line, the breathing

monitor is flat line, pupils are fixed and dilated, and there are no reflexes. In other words, they meet every clinical requirement for death. The doctors pronounced him dead; they filled out the death certificate, put the body on a gurney, covered it with a sheet, sent it to the morgue, and put in one of those drawers. All this happened to George Rodonaia. In the meantime, he was having a wonderful time in a very lengthy and interesting NDE. No two of these are exactly alike. He only came back to his body when someone started cutting on his stomach! The coroner was beginning an autopsy. George opened his eyelids, moved his eyes and began shivering. He spent 9 months on a respirator, but recovered completely, with no brain damage. I would say this is not "near" death; this is as dead as a doornail, as dead as you can get, or as the munchkins said about the wicked witch of the East, he was really most sincerely dead. So, like many NDEs, like that of Dannion Brinckley, where he too was put on a gurney and sent to the morgue, one might better call it death and miraculous coming back to life, like Lazarus in the Bible. In fact, I propose we call them "Lazarus" cases. Of course, these people would not stay alive without all the modern resuscitation equipment like respirators.

There are many excellent books on NDEs, but you might prefer to begin with http://www.near-death.com and click on "evidence." Scroll down until you see a line about being dead for several days. Click on that. It will take you to the Rodonaia case. The whole web site is fascinating to explore, and I encourage you to do so. I am going to quote some from the Rodonaia case. This is the story from his point of view. This was what was happening to his spirit while his body lay for three days in a refrigerated cabinet in the morgue.

"Slowly I got a grip on myself and began to think about what had happened, what was going on. Nothing refreshing or relaxing came to me. Why am I in this darkness? What am I to do? Then I remembered Descartes' famous line: "I think, therefore I am." That took a huge burden off me; for it was then I knew for certain I was still alive, although obviously in a very different dimension. Then I thought, "If I am, why I shouldn't be positive? That is what came to me. I am George and I'm in darkness, but I know I am. I am what I am. I must not be negative."

"Then I thought, How can I define what is positive in darkness? Well, positive is light. Then, suddenly, I was in light; bright white, shiny and strong; a very bright light. I was like the flash of a camera, but not flickering - that bright. Constant brightness. At first I found the brilliance of the light painful, I couldn't look directly at it. However, little by little I began to relax. I began to feel warm, comforted, and everything suddenly seemed fine.

"The next thing that happened was that I saw all these molecules flying around, atoms, protons, neutrons, just flying everywhere. On the one hand, it was totally chaotic, yet what brought me such great joy was that this chaos also had its own symmetry. This symmetry was beautiful and unified and whole, and it flooded me with tremendous joy. I saw the universal form of life and nature laid out before my eyes. It was at this point that any concern I had for my body just slipped away, because it was clear to me that I didn't need it anymore, that it was actually a limitation.

"Everything in this experience merged together, so it is difficult for me to put an exact sequence to events. Time as I had known it came to a halt; past, present, and future were somehow fused together for me in the timeless unity of life.

"At some point I underwent what has been called the life-review process, for I saw my life from beginning to end all at once. I participated in the real life dramas of my life, almost like a holographic image of my life going on before me - no sense of past, present, or future, just now and the reality of my life. It wasn't as though it started with birth and ran along to my life at the University of Moscow. It all appeared at once. There I was. This was my life. I didn't experience any sense of guilt or remorse for things I'd done. I didn't feel one way or another about my failures, faults, or achievements. All I felt was my life for what it is. And I was content with that. I accepted my life for what it is.

"During this time the light just radiated a sense of peace and joy to me. It was very positive. I was so happy to be in the light. And I understood what the light meant. I learned that all the physical rules for human life were nothing when compared to this unitive reality. I also came to see that a black hole is only another part of that infinity

which is light.

"I came to see that reality is everywhere. That it is not simply the earthly life but the infinite life. Everything is not only connected together, everything is also one. So I felt a wholeness with the light, a sense that all is right with me and the universe.

"I could be anywhere instantly, really there. I tried to communicate with the people I saw. Some sensed my presence, but no one did anything about it. I felt it necessary to learn about the Bible and philosophy. You want, you receive. Think and it comes to you. So I participated, I went back and lived in the minds of Jesus and his disciples. I heard their conversations, experienced eating, passing wine, smells, tastes - yet I had no body. I was pure consciousness. If I didn't understand what was happening, an explanation would come. But no teacher spoke. I explored the Roman Empire, Babylon, the times of Noah and Abraham. Any era you can name, I went there.

"So there I was, flooded with all these good things and this wonderful experience, when someone begins to cut into my stomach. Can you imagine? What had happened was that I was taken to the morgue. I was pronounced dead and left there for three days. An investigation into the cause of my death was set up, so they sent someone out to do an autopsy on me. As they began to cut into my stomach, I felt as though some great power took hold of my neck and pushed me down. And it was so powerful that I opened my eyes and had this huge sense of pain. My body was cold and I began to shiver. They immediately stopped the autopsy and took me to the hospital, where I remained for the following nine months, most of which I spent under a respirator."

Before this experience, George Rodonaia was the typical scientific materialist, convinced that consciousness is like a candle that goes out when one dies. Afterwards he got a second Ph.D. in the psychology of religion, immigrated to the United States (from Russia), and is currently a minister, though he thinks none of the religions have a sufficiently inclusive concept of divinity. Divinity is everything. That is pretty much what the mystics have always been saying.

One other thing about this case. It really gives meaning to the famous statement by Descartes, "Cogito ergo Sum." Don't ever forget

that. It might come in handy.

Let us look for NDEs with "veridical" detail, the kind of fact that would rule out "brain hallucinations." Sabom presents the case of a retired air force pilot who had suffered a cardiac arrest 5 years earlier. The pilot described the defibrillator. He said it had a meter on the face that was square and had two needles, one fixed, and one moving. The moving needle came up rather slowly. His description of a 1973 defibrillator is perfect. Later defibrillators are different, so he could not have gotten the information by going into an ER and studying one in 1978.

Or consider the detailed description of the equipment and personnel in the NDE of an elderly woman blind since childhood. Fred Schoonmaker, a cardiologist in Denver, Colorado, who claims to have three such cases among his former patients, including one congenitally blind person, recorded this case. He described these cases in detail to Kenneth Ring (Blackmore, 1993, p. 133). It is such veridical details that we should track down and check. Debunkers cannot explain away veridical detail.

Professor Blackmore challenges all verifications of veridical details. She rejects the Sabom case for lack of details. She wants proof of a defibrillator. She throws out Schoonmaker's work simply because he never published it; he only conveyed it by phone to a well-known NDE researcher, Kenneth Ring. There are a number of NDE cases with veridical details. Professor Blackmore publishes most of the best ones. For instance, there is the "shoe on the roof case," reported by a social worker named Kimberly Clark. A woman named Maria came into a hospital in Seattle after a severe heart attack and then she had a cardiac arrest. She later told Clark that she had been Out-Of-Body and noticed a tennis shoe on the third floor ledge at the north end of the building. It was a tennis shoe with a worn patch by the little toe and the lace stuck under the heel. Kimberly Clark looked out of various patients' windows until she found the shoe and retrieved it. It was exactly as Maria described. (Blackmore, 1993, p. 128).

Yet Blackmore rejects the shoe story, because she was unable to get any further information. Well, what more does she need to know? How likely is something like this to happen by chance? Does

she think both Kimberly and Maria are liars?

I don't believe Blackmore is willing to accept any case, no matter how good, because she has an alternative theory to explain NDEs and OOBEs. Blackmore has a theory of reality and self which is bizarre in the extreme, yet common among psychologists.

She thinks nothing is real but brain models (analogous to computer simulations), including one brain model that calls itself Professor Susan Blackmore. The world does not exist. You and I do not exist. None of the things discovered by science exist.

There is only the world of the brain model. Moreover, she has an ingenious theory to explain the feelings of well being (endorphins in the temporal lobe), the black tunnel with the light at the end (hypoxia) and even a way of explaining the Out of Body experience. Her book, *Dying To Live* is well-worth reading, by believers and skeptics alike. The main thing wrong with her theory is that she explains too much. According to her theory, everyone who has a cardiac arrest and nearly dies should have a NDE. The latest research shows that half do. According to her debunking, all those having NDEs should go through a black and featureless tunnel to the light, but that isn't true either. Some climb stairs, some are wafted away by angels, some get in a boat and cross a river, some walk up a corridor richly paved and paneled, and some just fall through a void to a distant point of light. There is another difficulty with her theory. It is self-contradictory! If reality doesn't exist, then neither does the brain, endorphins or temporal lobes of brains. All that exist are brain models, and the only one of those Blackmore can be sure exists is the one arbitrarily labeled "Susan Blackmore." She has fallen into the classic trap of solipsism.

However, I would say that the chief problem with her theory is that the brain does not continue functioning when a person dies. The EEG goes flat-line at the same time as the EKG. There is no brain activity in a dead person. There is no flood of endorphins, no activity in the temporal lobe. Before pronouncing someone dead, doctors make several tests for brain activity of any kind. The fact that experience continues, and that some of it can be verified as details impossible for the physical body to perceive, constitutes one more proof of the

independence of mind and brain, one more proof of the survival of the spirit and of consciousness.

4. Out-of-Body-Experiences: A web site about Out of Body Experiences (OBEs, or "astral projection,") is www.out-of-body.com -- This is William Buhlman's site, or one of them. It exists primarily to sell his books, videos and CDs, but it does have a FAQ, a list of Frequently Asked Questions, with short and accurate answers. Visitors to this web site describe their own OBEs, and most of them do not sound like pleasant experiences. Robert Monroe's OBEs (*Journeys Out Of Body*) are also often scary or unpleasant. I don't think I would recommend OBEs, except to people who are really fearless, and still want to do it after reading a lot of examples. What might be useful, however, is to consciously get out of the body just enough to work on the development of HSP and the apparitional power.

Robert Monroe describes a variety of techniques for getting out of the body, especially in the glossary. His first OBE was partial and accidental. He was born with a natural talent for it. That seems to be true of all psychic talents. He refers to this world as the First World and the OBE world as the Second World. He describes his ordinary body as the First Body and the OBE body as the Second Body that looks exactly like the First Body, but seems to be very elastic. It is evident that he is seeing himself and other beings via the apparitional sense, not HSP. Both Buhlman and Monroe agree that the First Body attaches to the Second Body with an infinitely elastic cord, however, not all OBErs or NDErs see this. Not all see themselves in any kind of body. They also both agree that vision is a 360-degree arc that makes it rather unlike ordinary vision.

5. Psychometry: Our next subject is "blue sense," often called psychometry. People with this skill are rare. Those who can do it can always do it. It is a mode of perception, not a once-in-a-lifetime event. Blue sense is an instance of conscious apparitional perception. It is called "blue sense" because of the use of such sensitives by "the men in blue," i.e. policemen. When a "blue sense" sensitive holds objects found at a murder scene belonging to the victim, she receives apparitional visions of the victim's experience, not only the murder, but events leading up to it, as well as the victim's own body-image.

These images may or may not be of any use to the police.

Of course, the owner of an object doesn't have to be dead. In the 1960s I saw a contest (broadcast over local TV in Los Angeles), run by Dr. Thelma Moss of the UCLA Neuropsychiatric Institute. It pitted a "blue sense" sensitive against a psychologist. Before the contestants came out to the stage, a few strikingly different audience members contributed various items. This was in the mid 60s, when men sometimes wore necklaces and other jewelry. I especially recall the readings given for a necklace of gaudy plastic beads. The psychologist said it belonged to a lower class woman with little education (wrong as usual) while the sensitive said it belonged to a man, a highly educated lawyer that the sensitive proceeded to describe (right as usual). Alas, she does not describe her work in psychometry in her 1974 book *The Probability of the Impossible.*

6. Apparitions: The first successful project of the infant SPR back in 1882 was the study of apparitions. G.N.M. Tyrrell's book *Apparitions*, first published in 1942, is the classic summary and theory of the primary phenomenon of apparitions. This is a volume to go on the shelf of history's great books, along with *Twenty Cases, The Principia,* and *The Origin of Species*.

Tyrrell first shows us that the collective unconscious of the recipients create apparitions, because no physical change in the environment occurs. Yet, we cannot call them hallucinations. There is no such thing as a collective hallucination. Any experience shared by a number of people is reality, although not our ordinary physical reality.

I have had apparitions. Once as a freshman in college, in a dormitory, I woke up to see 3 nicely dressed middle aged ladies sitting and standing around my desk. They looked completely real, completely solid. I blinked my eyes and they were gone.

I had another apparitional experience when I was in a Los Angeles hospital. These apparitions I could hear and feel, when they sat down on my bed, but I could not see them. It is quite common for apparitions to exist in some of our five senses, but not all. Sometimes apparitions are in a mirror, but not in real space, or vice versa. These apparitions were young girls, at least two, of an age somewhere around fifteen. One of them giggled and said, "Let's kill him," but not at all in

a threatening tone of voice. It is as if killing people in the hospital were some sort of joke, a lark. However, I decided to open my eyes and stay awake for awhile. These apparitions shade over into the category of "haunt." Haunts attach to a place, not to people.

My department chairman, Herr Werkmeister, at the USC School of Philosophy, had a similar apparitional haunt. The piano would appear to play, and it would always play the same tune. Similarly, the radio would appear to come on and play that tune. The librarian house-sat one summer and hardly knew how to tell Herr Professor Werkmeister (raised in Germany) that his fairly new and modern house in Baldwin hills had a ghost. The Professor just laughed and said; "I should have told you about that. I wasn't sure it would manifest for you. The ghost comes with the house."

By the way, are there really ghosts? Maybe not. There are apparitions, there are haunts, and there are poltergeists, but none of them act with the intelligence and animacy of the spirit of a person. They are more like a recording that is stimulated to play for the right sort of person. Psi researchers do not agree on this point, and it is hard to think of a critical test.

Apparitions have several common though not universal characteristics: (a) several people can see them at once, and all will see it (or feel it or hear it) from their own appropriate point of view, (b) there may be a feeling of cold, (c) the physical world is not changed. (d) Apparitions sometimes appear as the result of a crisis, such as the death of the person seen; wearing the clothes that person was wearing at the time. Yet the apparition never says "I have been killed," but instead does whatever the percipients would expect him to do.

From this Tyrrell draws some conclusions: (1) Percipients create apparitions on some unconscious level. (2) Yet, they may convey some information, for instance, the self-image of a person at the moment of death.

Apparitions are the most common spontaneous forms of ESP (Extra Sensory Perception), a term I don't like to use. ESP in the body works sporadically, unlike sensory perception. When we are Out-of-Body, both HSP and apparitional perception work a hundred percent of the time, and what we perceive with the latter consists in

apparitional reality. We see other people and ourselves according to self body-image. The stage setting of places and objects is apparitional. We use HSP only on the physical plane, since it allows us to see physical objects without having physical eyes or any EM interaction with light. The mind has no EM interactions and that is why it is invisible and intangible, and explains why a spirit can easily walk through physical objects.

Skeptics reject the huge volume of ESP research in parapsychology as a combination of faulty experimental design and coincidence. Dr. Thelma Moss has shown that this debunking is wrong, in the book previously cited. Skeptics cannot debunk the apparitional perception and transmission of information during NDEs and OBEs. Here is where we find the best proof of "ESP". I quote from an NDE reported by Moody:

> I could see people all around and I could understand what they were saying. I didn't hear them, audibly, like I'm hearing you. It was more like knowing what they were thinking, exactly what they were thinking, but only in my mind, not in their actual vocabulary. I would catch it the second before they opened their mouths to speak." (Moody, 1975, p. 52 of the Bantam edition)

There seems general agreement among NDE and OBE participants that they do not actually hear physical sound. Notice that it is not mind reading. Apparitional listening receives the intent and whole content of a sentence, just before speech. The apparitional sense is not serial bit communication like that of a telegraph, telephone or television. That is why I do not use the term "telepathy" and think it is misleading.

7. Poltergeists: "Poltergeist" is German for "prankster spirit," and one of the most noted poltergeist investigators, Hans Bender, also happens to be German. Poltergeists exhibit real PK effects, both levitation and apports.

Poltergeists are much less common than apparitions, children

who recall former lifetimes, or people who have had OOBEs. Poltergeists are so dramatic, however, that the world is much more likely to hear about it. Some member of the household unconsciously produces poltergeists, since they follow the household from place to place. German investigators believe adolescents are unconsciously responsible, since families "grow out of" poltergeists.

What do poltergeists do? One is levitation and movement of small objects such as cups and saucers (psycho-kinesis) that sail across the room and smash, and the other is teleportation, the disappearance of an object from one point in space-time and its reappearance at another point in space-time. Hans Bender has witnessed both. An apported object floats to the ground with a falling leaf motion, as if nearly weightless. UFOs exhibit the same behavior.

Poltergeists are only one source of information about PK. We also have the experiments of Kenneth Batcheldor, and the personal experiences by Guy Playfair in a Batcheldor sitters group, described in chapter 10, "Turning the Tables," in *If This Be Magic* (Playfair, 1985, p. 184 ff.). Kenneth Batcheldor has developed a technique for accomplishing the same kind of wild PK phenomena produced by 19th Century mediums, without using any mediums, or invoking any spirits. This includes table-tipping that I witnessed in high school at Monica's birthday party, (see my "Brief Autobiography"), but it goes way beyond tipping to outright levitation, sometimes of quite heavy tables, sometimes of heavy tables with all the participants sitting on it. Batcheldor says that any group of experimenters can do the same, as long as they believe it is possible. He thinks one should wait until the PK phenomenon is freely working before introducing any scientific controls, such as lights. A Batcheldor group works at night, into the wee hours, going until dawn, and they start in complete darkness. Once the PK is flowing, then Batcheldor will briefly turn on a flashlight or take photographs. He records the entire session on audiotape.

If you wish to test the reality of PK, it is not always possible to find a good poltergeist case, since they are rare. Any group of willing participants can create what Batcheldor calls a "sitter group." I imagine most people will call it a "Batcheldor group."

Mind as a Dark Matter Object

This chapter contains a radical new theory of the mind, which is that the mind is a natural object, made of dark matter, having size, shape, internal structure and regular functions in such everyday events as perception and sleep. It has mass, conservation of energy and powers. It weighs about 21 grams.

I define "the mind" as "the non-physical part of a person seen by someone with really good HSP." The mind is a structure of chakras, nadi and auras, more or less as taught for thousands of years by Yogis. We could also reasonably define "the mind" as that which reincarnates in Dr. Stevenson's studies. Only further research can tell us if these two definitions refer to the same thing. It is possible that only part of the "energy body" seen by HSP reincarnates. It is also possible that the spirit that reincarnates is not visible by HSP at all.

My first hypothesis about the mind is that it is made of dark matter and that is why it is invisible and intangible. We know that astronomical dark matter has mass; therefore, it is reasonable to suppose that the dark matter of the mind also has mass. Duncan MacDougall, M.D. of Haverhill, Mass., made the only test of this idea, published in the April 1907 issue of *American Medicine*. This was a small study, of 6 subjects. The best for his purposes were dying of tuberculosis, since they did not struggle or move around on his delicate scales. He found a sudden mass change at death of about 21 grams, origin of the title of the 2003 movie "21 Grams." The MacDougall experiment shows that this hypothesis is testable, but we cannot draw any conclusions from such a limited study. See the text of his article at http://www.wizardofeyez.com/soul.html.

Whatever the non-physical part of a person is, whether we call it mind or energy body, it has size, shape, internal structure, conservation of energy, and mass. It has two ways of interacting with matter, and one way of interacting with other minds. I call these powers, since all three can receive or transmit, observe or create. To summarize:

[1] Information interactions with matter take place via de Broglie waves. This is how the OBE person sees. The radiation they

see consists in the de Broglie vibes constantly generated by both ordinary and dark matter. The aura around the hands and the aura that stretches out from the eyes can absorb or emit de Broglie waves, absorbing information or pushing the probabilities for one physical event over another. We acquire this psychic power by mere practice.

[2] The mind can generate physical force by effortlessly twisting or bending the geodesics of space-time. The sleep-dynamo does this every night in sleep. Every dynamo or generator requires a resistant force to convert kinetic energy into another form such as nouonic energy. That force is a rhythmic distortion of the space-time geodesics in sync with the slow labored breathing of sleep, where the diaphragm and abdomen are pushing against this resistant force. Thus, we all have PK, but only in an unconscious form. Twisting the higher dimensional geodesics of Hawking's "Universe in a Nut Shell" accounts for teleportation.

[3] Minds interact with one another primarily via the apparitional power. We see people as they see themselves, since everyone constantly emits their self body-image. By changing ones body image, one can change the way one looks, even in the body. The apparitional power can create apparitional reality of varying degrees. It can faithfully reproduce the physical senses of taste and smell, as well as touch and feel, sight and sound, but most apparitions studied by the various SPRs lack such a full degree of reality. The heavens and hells experienced in NDEs are apparitional realities. What one experiences upon death depends in part on expectation, and in part, on what friends and family who have gone before have prepared.

Where are heavens and hells located? Right here, but on different astral planes. There is not a continuous astral dimension. Astral planes are more like discrete quantum states; each having a well developed astral past and future as well as a present, nicely decorated with apparitional creations in 3 spatial dimensions. This is not part of physics, not even the 21st Century variety.

Two of the strangest phenomena in PR are precognition and teleportation. Precognition is learning about something before it happens, and teleportation is the disappearance of an object at one place, and its instantaneous reappearance at another place, without

traveling the intermediate space-time.

Is there good evidence that precognition occurs? I don't know. This is another one I know from personal experience. I have only known a very few legitimate psychics, and none of them had any control over their powers. One was a philosophy student of mine, an undergraduate at USC in the 1960s. Precognitive flashes came to her spontaneously. Here is a typical one. It was the USC homecoming, in the Coliseum. The Queen and her court were sitting on the back of convertibles that drove along the runner's track that surrounded the football field. They came pretty fast around the curve. Suddenly, my student stood up and began screaming. Thirty seconds later, the whole crowd was standing up and screaming, because the Queen fell out of the car and hit her head on the concrete ring which surrounds the track. She wasn't seriously hurt, fortunately, but one can imagine that pandemonium reigned. For me personally, this is proof of precognition. It suggests that precognition does not usually reach very far into the future. In the apparition studies by the SPR, crisis apparitions often came before or after the event, by as much as 12 hours. The mind seems to exist in a four dimensional astral reality.

One possible explanation of apports involves a fifth dimension. Imagining five dimensions is not easy, so consider this analogy. Suppose we reduce the physical world to a sheet of paper, with width representing space, and length representing time. Physics gives us the laws of this sheet of paper, and everything known to physics is on that sheet of paper. Thus, to get from one point in space-time to another, one must traverse all the points in between on the sheet of paper, and we cannot exceed the Einsteinian speed limit that is the speed of light. Suppose we bend the sheet of paper in 3-dimensional space (which represents 5-dimensional space) so that two points separated on the sheet of paper come in contact in 3-dimensions. At that contact point, an object could levitate across, producing teleportation. This is the mode of interstellar travel in *Dune*, by Frank Herbert.

Unfortunately, this theory of apportation does not work. If there were only one humanoid in the universe doing apports at any given time, it might work. That is pretty much true in *Dune.* In the real world, there are dozens of species of humanoids visiting us from

distant stars and they can all apport at once. In the Chinese studies, there are four girls doing apports at the same time, in the same place. With all of them bending space-time at once, there is no telling where anything would go. All we really know is that levitation and apports are associated. People who can do one can often do the other. Uri Geller, for instance. Poltergeists produce both levitation and apports.

My theory of apports uses some ideas from String Theory. In his book *The Universe in a Nutshell,* Stephen Hawking draws a picture of the history of the universe as a somewhat lumpy and wrinkled nutshell. As I understand it, imaginary time is on the vertical axis. The surface of the nutshell represents the 3 spatial dimensions, and they could be P-branes or M-branes. Such ideas are part of string theory and its successors that attribute 10 or 11 dimensions to space, all but 3 coiled up so they are not even as big as a proton. In the latest theories, one or more of these extra dimensions is infinite, and becomes our higher dimensionality of space. In Hawking's nutshell, the shell is a "brane" of space-time, while the interior of the nutshell represents a fifth spatial dimension. Apports could take a shortcut through this fifth dimension. The mind can effortlessly distort the geodesics, and is aware of the higher dimensionality, invisible to the physical senses. One kind of distortion causes levitation. A distortion in a higher dimensionality opens the portal to the otherwise hidden fifth dimension.

From the Chinese studies, we know that the unconscious mind knows how to do a controlled apport from here to there. In the remove-the-cigarettes performance, the Chinese girls were able to target specific items on the "here" side. In the flower-bud-into-teacups performance, the Chinese girls were able to acquire the right objects, without knowing where they were consciously, and put them in the right place, on the "there" side.

Time-Travel: This idea about apports and precognition suggests the possibility of time-travel. Why not apport an object, even a person, to a different time as well as a different place? This leads to the paradoxes of an endless series of "Terminator" movies. I have never heard of a single instance of a physical object arriving from the future or the past. As Stephen Hawking says, if time-travel were

possible, tourists from the future would be everywhere. Allowing time travel is a fatal flaw for any theory, such as General Relativity which does have time travel solutions, as shown by Kurt Gödel. The rest of this chapter is devoted to the proposition that time is not a real dimension; though as an imaginary dimension it is very useful in physics.

Relativity is compatible with the concept of a universal, simultaneous "now." Relativistic effects may slow down or speed up clocks but people never vanish into the past or future as a result. They always remain here in the "now." Relativity only shows that we cannot always determine what time it is from any one clock.

What about those rare reports of people suddenly being in the past for a few moments? This is an apparitional experience. They have witnessed an apparition of the past, which might turn out to be the real nature of the so-called Akashic Records. What about the future seen by Seers or Prophets? This too is an apparitional experience. Prophets are witnessing an apparitional reality. The apparitional future is the probable future, the expected future, given what has already happened. The student driver's intent to drive fast around the curve had consequences. Thus, it already existed in the astral plane where a Seer could see it. It is the probable, not inevitable future, since the driver could have realized he was going too fast and slowed down.

Some of what a Seer sees may have a symbolic rather than a literal meaning, and the meaning may be personal rather than objective. Such visions may be warnings, or visions of possibilities, not inevitabilities. The future is never fixed, and is always subject to change, until it actually occurs in physical reality.

A Seer like Nostradamus looking into the "future" is not looking at the physical future, because that does not exist. He is looking at one possible future in the astral planes. There are many other possible futures in the astral planes, such as the one found in the book *Spiritwalker*, by Henry Wesselman. Henry is apparently a Seer...or a novelist. In either case, he has given us a very convincing and detailed world 5000 years into the future, aftermath of a great catastrophe, in which the climate of the Earth switched to global tropical, melting all the ice, flooding all the coastal cities and low-

lying states and countries, and releasing the creatures from the zoos. There seem to be only two small bands of humans that survived. One is a combination of Inuit and Norse fisherman, and the other consists in Hawaiian natives who had not forgotten how to live off the land. Everyone else has perished. The ancient cities still exist under water. The surviving humans have returned to a hunter-gatherer way of life. Civilization has vanished.

This is a convincing piece of science fiction, but the reality is that human life takes place in the midst of a seemingly endless series of Ice Ages, each one separated by 10,000 years of warm interglacial climate. Time's up! We have had our 10,000 year interglacial, and it is time to prepare for the next ice age. The glacial part of an ice age ends abruptly, but starts slowly, with oscillations of the climate that steadily grow in amplitude. We have already seen the first cycle, or most of it, with a warm period in the Viking age, a "little Ice Age" between 1350 and 1850 (really it remained colder than normal up to 1940) and since 1940, we see the beginnings of the warm part of this oscillation.

Humans and greenhouse gases are just the icing on the cake. After all, carbon dioxide is a rare trace gas, only 345 parts per million of the atmosphere. We shouldn't think of it as a reservoir that just fills up with greenhouse gases. Plant tissue builds itself mainly from carbon dioxide, despite its rarity. What counts is the speed of the cycling of this rare gas through the biosphere. During glacial periods, there is a correlation between temperature and greenhouse gases, but which is the cause and which the effect? Geologists believe plate tectonics and the Milancovitch cycles of the suns orbit cause ice ages. The slow oscillation of eccentricity between circular and elliptical paces the ice ages, since it has a period of 100,000 years. There is also the precession of the equinoxes, and the nutation (or nodding) of the angle made by the spin vector. Mankind can do nothing about plate tectonics or the Milancovitch cycles, so we had better prepare for the next ice age, and indeed, a whole series of them stretching for millions of years into the future.

The problems associated with man-made global warming are nothing compared to living in a fully glacial climate. That is why our

population explosion is the number one challenge for humanity today. Even a warm interglacial may not be able to support 6 billion humans indefinitely, and it is doubtful that a glacial period could support more than a few million. The next ice age may have already started, with mild climate oscillations that will gradually get worse.

Why is time travel NOT possible? It is because the physical past and future do not exist. There is only one physical universe; the time is always "now" and it is in constant motion and change. Time is a human invention that arises from our memory of the past and our expectations of the future. Time is not a dimension because nothing moves along it. We find certain cyclical changes that help us refer to past or future events. We can count the number of cycles of the moon since X happened or predict how many cycles of the moon before Y will happen. Thus, we invent time. End of digression, so let us turn back to mind as a dark object.

Tests of the Theory: Theory is essential to science and that is why Psychical Research is not yet a full-fledged science. Theories suggest new experiments. Thus, they extend our experience, especially if the experiments are successful. My theory of the mind as a natural object has testable consequences.

Testing The Sleep Dynamo. It requires a physicist who can work the equations of General Relativity to test the existence of the sleep dynamo. We need someone who can calculate how much warping of space-time it will take to resist about one poundal of force. We might be able to observe the warping of space in sync with a sleeper's breathing, with the right equipment. The warping may be enough to bend a laser light beam to a target miles away passing over the abdomen, if we examine the target dot under high magnification. Do this experiment successfully, and win a Nobel Prize. A sensitive gravity meter mounted over a sleeping body (but not touching it) may show gravity oscillations in sync with breathing. If either of these experiments works, physicists will be able to produce Psi phenomena on demand. That would cause an intellectual revolution, with the final defeat of reduction and the admission into the textbooks and universities of the reproducible facts from Psychical Research.

Another part of the theory has to do with de Broglie vibrations,

absorbed or emitted. If you don't understand de Broglie waves, read the appendix on "Physics Without Paradox" or at least that part explaining de Broglie waves.

I shall describe a device for testing de Broglie phenomena. Build a sparking machine with a cyclic pulse of voltage, much as in a car, in which the humidity and spark gap are controlled, so that one can turn a knob and bring the cathode and anode closer or further apart, or raise and lower the voltage. Provide electronics to tell us what percentage of the cycles produce sparks, averaged over ten cycles or so. Adjust the knob until we are getting fifty percent, so the odds of sparking or not sparking are the same. This is a macrostate that reflects a 50-50 probability on the quantum state level. With an hour or two of practice each day for six months, anyone should be able to push the probabilities to all sparking or no sparking. Once this talent is learned, the practitioner could make engines quit. I base my six months estimate on the time it took Russian children to learn dermo-optic vision (seeing with the hands) since that is also a de Broglie effect.

The sparking machine provides the first produce-on-demand Psi control of nature that anyone can learn by simple practice. That might be worth a letter to *Nature* too.

With practice, we should all be able to learn to do spoon bending like Uri Geller, especially if we had him as a teacher. All the material properties of spoons or anything else are due to the de Broglie vibrations of the component atoms and molecules and crystals. Under a microscope, one can see the disorderly collection of domains that make up a composite material like steel. Somehow, Uri Geller's aura knows how to change this disorder to a more orderly state, a lower energy state, where the domains can slide past one another and allow the metal to flow like molten glass. If this happens on one side and not the other, the spoon will spontaneously bend. If it happens right through the spoon, gravity can bend it, or make it drop off. This is a de Broglie effect, rather than a space-warping effect, since Uri Geller and other spoon-benders have this power under conscious control. Levitation and apports also happen around Uri under some circumstances, but without conscious control on his part.

Convergence of physics and psionics: Experiments on the

mind may provide tests of the most speculative theories of physics. The sleep dynamo experiment is a test of the reality of dark matter. Teleportation provides evidence for some versions of String Theory, those that have extra spatial dimensions of unlimited extent. These extra dimensions are not far off, nor confined to minute sub-atomic realms. They are all around us all the time. Physical objects, like eyes, cannot see them. However, mind has the capability of warping higher dimensional geodesics as well as those of familiar space-time. We don't see this extra dimension, but the mind knows how to travel through it, on some deeply sub-conscious level. In addition, since these extra spatial dimensions have only space and no time, it takes no time to take shortcuts through them, even to the other side of the universe.

It is ironic that Psychical research provides the first evidence both for Dark Matter and for String Theory. The mind has to be Dark Matter, since it is invisible and intangible. And teleportation requires the extra spatial dimensions which are an integral part of String Theory. Dark Matter apparently has a very close connection to the geodesics, not just of ordinary space-time, but also the geodesics of the 10 dimensions of String Theory.

Animacy and Free Will

A typewriter will never turn itself on in the middle of the night and begin clacking out the "Great American Novel." However, a cat will wake itself up in the middle of the night, find a ball of yarn, and bat it all around the living room, leaving a tangle of yarn around the legs of chairs. There, in a nutshell, is the difference between all machines and all life. It is odd that the behaviorists, alleged students of behavior, do not seem to have noticed this difference.

We know that no real car will ever behave like "The Love Bug" in some Disney movies, partly because we have at least some crude knowledge of how cars work. The great humbug of AI (Artificial Intelligence) arises because most programmers do not become fluent in assembly language, and never learn the physics of a logic gate. It's just a dumb machine, and like any other machine, it does only what we tell it to do. If we don't tell it to do anything, it is just an expensive paperweight. Our ordinary everyday experience is that machines behave very differently from living creatures when it comes to Animacy. Hollywood writers instinctively recognize this difference. When they want to show us AI, instead they show us Animacy. Herbie the Love Bug starts by itself and goes where it wants, regardless of the operator's inputs. Hal 5000 has to be cajoled, and the crew is nervous about its decisions. If Reductionists want to claim that living creatures are machines, the burden of proof is on them. Our ordinary experience is that machines and living things are very different in behavior.

We have to push the buttons on machines. Living things, on the other hand, may initiate action without anything pushing their buttons. The first attribute of Animacy is initiative.

When we run a computer program with the same inputs, it always produces the same outputs. This is still true if the program includes a random number generator, with the same "seed" number. Given the same environment, cloned life-forms take different actions. Thus, the second attribute of Animacy is choice.

A virus may attack a cell immediately, or it may lie low and hide for years. Don't blame this on quantum mechanics. In any case,

the equations of quantum mechanics are deterministic.

The third attribute of Animacy is strategy, such as the strategy of a virus that decides to hide out in some unusual host while it rearranges genes until it can survive some new antibody to it. See Kilboume's book *Influenza*. Strategy is a combination of purpose and creativity.

It is this combination of initiative, choice, and strategy that gives empirical content to the empty philosophical term "free will."

AI (Artificial Intelligence) is a belief in magic. It is an age-old dream, one found in Pinocchio, the dream of bringing an inanimate object to life with some magic spell. In the case of AI, the "magic spell" is a computer program. AI enthusiasts believe if they can just make the program big enough or smart enough, the computer will suddenly "come to life," like Number-5 in one of those Disney movies ("Short Circuit"). It will never happen. There are no essential differences between computers and other machines. If a computer can come to life, a car or a screwdriver can also come to life. Ally Sheedy says, "I'm a machine, and I'm alive." Well then, she should have a serial number stamped on her butt. We should be able to take her all apart, put her back together again, and have her "run," or more exactly, "live." I wouldn't attempt that, Ally Sheedy. It won't work.

All living things have Animacy. Viruses, bacteria, fungi and plants display Animacy and coherent behavior without a trace of a nervous system. To see the free will in a tree, we have to look at the world from a tree's point of view. Study carefully the complex pattern the limbs make against a winter sunset. No two trees are alike. Nor do they sound the same in the wind. Not only are different species different in the wind, each individual tree of the same species makes its own song. Each tree decides when to turn colors in the fall and when to drop them. The exact patterning of colors is different on identical clones of identical species in identical soil. Therefore, there is choice at work here, but one must have a deep appreciation of the exact details to see it.

I give two examples of coherency. If we watch bacteria under a microscope, we see all the internal parts jiggling around, doing the dance of life. At cell death, all cease simultaneously. There is no ripple

of failure that spreads out from one place or another. Another instance of unexplained coherency comes from the study of Neuro-physiology in higher animals. A certain stimulus causes certain columns of neurons in the cortex to fire. However, there remains an inexplicable leap of faith from that fact to the coherent field of perception.

. See "The Puzzle of Conscious Experience," by David J. Chalmers, in *Scientific American*, December 1995, p. 80. Physiology can never jump that gap.

No reductionists can explain any living thing in terms of heredity and environment. The truth is that Reductionists have ignored Animacy. They haven't explained it away, any more than they have explained away consciousness.

Another way of looking at Animacy is in terms of challenge-and-response. Sometimes it is opportunity-and-response. The great historian Arnold Toynbee found repeated patterns of challenge-and-response in human affairs, although no one has ever found an example of cause-and-effect in history that could stand up to close scrutiny. This is why I list Arnold Toynbee as one of the philosophers of the 20th Century. He has laid the foundations for what could be a splendid science of history, and the first legitimate science of history, one that looks for patterns of challenge, and patterns of response, rather than cause and effect. So far, the historians and philosophers of history have totally misunderstood Toynbee. How can Sir Karl Popper put Toynbee among the "historicists" who believe in some deterministic view of history? The truth is just the opposite. Toynbee is the first historian who didn't do that, the first to give meaning to free will as it applies to history. In academic philosophy, synonymous with sophistry, free will is an empty concept that seems to leave no connection between antecedent and consequent. Note that this is not true of Toynbee's patterns. There is a connection between antecedent (the problem) and the consequent (attempted solution). However, it is not one of cause and effect, for if it was, we could predict it. One can never predict a creative response to a problem, nor can one predict whether it is creative enough. The connection is that of problem and solution.

Consider the two contemporary civilizations, on opposite ends

of Eurasia in Classical times. In the West, we had the Greco-Roman civilization in 4 stages: Mycenaean, classical Greek, Rome, and Byzantium (which always called itself Roman). Homer was the favorite author throughout this space and time (about 3000 years) and chariot racing the favorite sport. In the East, we have classical China, beginning with the marvelous bronzes of the Shang, then the Chou (age of warring states and great philosophers), Han (universal state, like the Roman Empire), T'ang (600 CE to 900 CE) which rose to brilliance just as the Western part of the Roman Empire was sinking into a dark age, and followed by Sung, Ming, and Manchu (I am leaving out a few). The classical Chinese civilization finally came to an end in 1912, but had been decadent for several centuries. The typical lifespan of civilizations is 3000 years, so the Classical Chinese Civilization is exceptional in having a lifespan of 3500 years. And what is the civilization of China today? It is a variation of Western civilization, and we find such variants all over the Pacific Rim.

When historians ask, "why did we have a Dark Age in the West," they should add, "and not in the East?" Both civilizations were about the same age, had the same challenges at the same times from the same barbarians and the same plagues. Both had an absolute dictatorship at about the same time, one that fell to pieces, as government and the army became top-heavy and insupportable. Both Byzantium and China made creative responses to these problems, including the Mandarin system of government in China, and Greek fire in Byzantium. The Greeks and Romans never did solve the problem of lawful succession. Civil war bled Rome white.

China, by contrast, was able to absorb wave after wave of invaders from the North and was always able to restore stable government. Give the Emperor all the Earthly treasures and pleasures he could imagine, but leave the government and the tax collecting to the Mandarins, who were so good at it. In the West, the Greco-Roman civilization could not re-establish itself after absorbing barbarian invasions. Byzantine society was not very creative. The religious wars over icons lasted centuries and sapped its strength. In the East, they maintained separation between church and state. The Mandarins were followers of Confucius, but the result was social theory, not religion.

In most periods, there was some tolerance for a variety of religions, including Taoism, Buddhism, Nestorian Christianity, Jesuits and Islam.

This analysis is my own contribution to the once and future science of Toynbeean history, the study of patterns in challenge-and-response.

The Secret of Interstellar Travel

It is not as if some government agency or scientific discipline knows the secret to interstellar travel and simply refuses to make it public. No, so far as I can tell, government agencies such as NASA haven't a clue how to go to the stars in any reasonable amount of time. Nor does any such knowledge exist in any of the sciences, academic or forbidden. Yet the answer seems obvious to me, and I find it hard to believe that it is original with me. Physics offers no path to the stars. It only provides proof that none of the ideas of science fiction writers will work. As for Ufologists, being ignorant of physics and technology, they make the common assumption of ordinary mankind that our humanoid visitors merely have a more advanced technology than we do. A study of crashed UFOs shows that assumption to be false (See Corso). We are rapidly reaching the same level of technology as the UFO craft. Such craft contain no flight mechanism, nor any power source.

Anything that exists must be possible. The UFOs are here, so interstellar travel must be possible. But how is it possible?

UFO enthusiasts universally believe in the unlimited possibilities of technology. Not so with physicists. Technology does have limits, and we have just about reached them. Certainly, technology cannot violate the laws of physics. If UFOs don't travel by technology, how do they travel? The only alternative is that they travel by the powers of the mind, so vastly exceeding the powers of technology. We know from Psi research that levitation and teleportation are natural capabilities of the mind. UFOs levitate silently over our countryside, low and slow. They appear and disappear, just like objects apported by Uri Geller.

Those few humans who can do levitation do it effortlessly. Sometimes UFOs abruptly disappear, or just as suddenly appear, often floating down in a falling leaf motion often seen with apports. Humans can apport things into or out of closed containers. So an apport must take a shortcut through the higher dimensionality provided by String Theory. Wouldn't it be ironic if the first real evidence for String Theory came from psychical research?

So the only real question is how do we develop these rare spontaneous phenomena into something capable of levitating huge spaceships or apporting hundreds of light years in an instant? That, I think, is the real question, and I have devoted most of this book to providing the answer.

It is Fermi's paradox that leads to the conclusion that only spiritually evolved humanoids are capable of interstellar travel. In 1950, when there was talk of ET, Fermi asked, if ET is at all common, where are they? To spell that out a bit, Earth has had oxygen, water and dry land for 1.5 billion years. If there were space-traveling ETs, surely they would have discovered Earth in all that vast span of time. Why didn't they colonize it? Of course, Enrico Fermi was assuming that ET would act like us, a rather arrogant assumption. We are a young species, no more than 50,000 years old.

Fermi's paradox is well-known in the scientific community, though unknown to the general public. It is so surprising that there has been no intervention in Terrestrial evolution by ETs that it needs a special explanation, and I put forward the following hypothesis as the explanation. It is **impossible** for primitive species to travel to the stars. By "primitive," I mean "spiritually unevolved." Even now, the best of us have outgrown primitive traits of greed and violence over many lifetimes. The daily headlines make it only too clear that we are still a brutal, violent and primitive species, still practicing war, murder, theft and the rape and pillage of planet Earth. We will not be ready to learn how to jump light-years until murder, war, rape, and theft have all ceased, along with the witless destruction of ecological systems, and the out-of-control overpopulation of the Earth with our own kind. Empathy for our fellow creatures, human and non-human, must become our true nature. Attempts to extend the basic lifespan of the species are also a mistake. We have the longevity best conducive to the survival of the species. Civilization may fall, and ice ages may come, but the species will survive, so long as we do not fiddle with the human genome.

The solution to Fermi's Paradox is that only spiritually evolved species can go to the stars and such species would not wish to interfere in the evolution of life on another planet. They would have no need to,

having self-control of population numbers and the consumption of non-replaceable resources. It has nothing at all to do with physics or technology. The landed occupant studies of UFOs prove the existence of UFOs. Moreover, I have proven that they cannot travel by physics or technology, and must therefore travel by the immense hidden powers of the Mind. Professor Stevenson has scientifically proven the reality of reincarnation, thus showing that Mind is not body. Spiritual evolution is not the same as technological evolution.

Technology can be used by any brutish half-animal masquerading as a human, for instance, those who hold up convenience stores and kill the clerks, even when the clerks have followed their orders to the letter. Ban such animals to the depths of hell and never let them be human again.

As Alfred Wallace, co-inventor of Darwinian evolution said,

"If you leave out the spiritual nature of man, you are not studying man at all." (Playfair, 1985, p. 258). In 1972, Colin Wilson had this to say:

> In order to realize his possibilities, man must believe in an *open* future; he must have a vision of something worth doing. And this will not be possible until all the determinism and pessimism that we have inherited from the nineteenth century - and which has infected every department of our culture, from poetry to atomic physics - has been dismissed as fallacious and illogical. Twentieth-century science, philosophy, politics, literature - even music - has been constructed upon a *Weltanschauung* that leaves half of human nature out of account. (Playfair, 1985, p. 258)

The open future is star travel. Western civilization has always needed a frontier, and interstellar travel is truly the final and inexhaustible frontier. We shall never do it unless we break the existing *Weltanschauung* (Worldview) of materialistic reduction. If going to the stars were merely a matter of technology, then one could easily separate star travel from philosophical issues.

Only spiritually evolved humanoid species can jump light years and engage in interstellar travel. That is the secret of interstellar travel, and it may be a hard one to swallow, since we are in the midst of a highly materialistic and technological phase of our civilization. Only spiritually evolved species would have the self-discipline to leave a planet alone, and let it evolve intelligence in its own way. Wisdom, restraint and self-control are all advanced traits. There may be cosmic cops who prevent any other kind of species from leaving their home planetary system, even with primitive solar-sailed Arks. However, I think it is more likely to be a universal law of nature. Only the spiritually evolved **CAN** develop mental powers to such a high degree that they can make star-jumps and effortlessly levitate huge space ships. This is not an original idea with me. Yogis have taught the same thing for centuries. While some individuals will always be more evolved than others will, it is the whole species that must evolve if we are to go to the stars. We must change our civilization as well as our chakras!

Incidentally, the main problem with Yoga, Buddhism and Hinduism is that they only want to escape the wheel of reincarnation and make no attempt to raise the level of their civilization. That is why the Yogis never went to the stars. In India, they know about reincarnation, but only use that knowledge to justify the Caste system.

Brief Autobiography

Why put biographical information here, in the middle of the book? Consider it an interlude, something always found in Chinese novels. Consider it a change of pace to rest the mind. This is also a way of stating my credentials, which are unconventional, of necessity.

I belong to no organizations. I have no affiliations. I was once in academia, and had a promising career in philosophy (see the following chapter on sophistry), but I became disillusioned, and felt that I was complicit in a fraud, one that took the money and time of our nation's youth, and gave very little of value in return. Specifically, I objected to teaching classes of 100, 350, 450 or 800 students. I did not create an institute, or new age business. I don't travel around giving seminars. My autobiography must serve as my credentials, since it shows that I have experienced many of the things I write about.

When my mother was pregnant with me, the doctors said she had cervical cancer. Both the GP and the oncologist agreed that she must have an immediate hysterectomy, with the inevitable abortion of me. Vanished too would have been my younger brother, the one who saved me in midlife, after I had fallen into the dark night of the soul. After my birth, the doctors checked her again for cancer. It was gone. She never had cancer. My mother only told me this when I was 57 and she was 79. I suppose she was afraid I would get a bad case of grandiosity. It did make me believe in miracles, though not in prayer. My mother was not religious.

In 3rd and 4th grade, I was a kind of prodigy. I was reading high school books. I was the teacher's pet. But I didn't have any friends. For the next few years, I became the teacher's bane, the class clown, and the class cutup. By the time I hit 8th grade, I was back to being a serious student, but unfortunately for me, not of textbooks. They were just too boring. My grades were barely B's in high school and in college, but I was showered with scholarships and fellowships anyway, because I did well on the SATs and the GREs. Sometimes my teachers in HS would bring me books from a College library. I loved those, because they weren't textbooks.

At 15, I read Plato's **Republic**, bought for me by my brother

Ted. After that, I became a utopian dreamer. I had always been a daydreamer, but now my daydreams took on more focus. I also read the Mentor classics on science and philosophy, the History books of H.G. Wells, and the popularizations of 20th Century science by George Gamow. It was a crisp October night of my sophomore year in college, as I wandered alone across a deserted quad, when the question came to me, soft as a feather, whether social controversies could be resolved by experiments, the way disputes are settled in science? I pursued this question, not steadily, but now and then, despite uniform rejection and discouragement from all my professors, all my colleagues, and all my family. Edison said, "Genius is 2 percent inspiration, and 98 percent persistence." At least, that is what he meant. It took me 30 years of working on the problem, off and on, going down many blind alleys, before I finally solved it. Once solved, it looks simple. It looks obvious. It even looks trivial. However, no one had been able to think this idea before me. The heart of that solution I have included in this book. Go to http://users.aol.com/drhumph/ for more. I was never in a hurry. I wasn't worried about being the first to publish. I knew there were no competitors. If I didn't succeed, centuries or millennia might pass before we had a science of civilization. We certainly need one. "Technology must not outweigh our humanity," said Albert Einstein.

But that has already happened.

I grew up on a primitive farm, without electricity, central heat, or indoor plumbing. We drank water with a pail that we all used, drinking water out of a bucket that I carried from the well down by the barn. We didn't heat the whole house, only the living room, with a wood burning stove. I carried the wood into the house each night. I went to school in a little town (pop. 300), and neither the school nor any of the houses had indoor plumbing.

Thus, knocking over outhouses was one of our pranks on Halloween night, along with letting a cow into the school building, shooting out the few streetlights with BB guns, and throwing eggs into or on the cars of anyone we had a grudge against. We also built barricades down Main Street, with hay bales or huge empty oil drums. This kind of hooliganism was traditional and tolerated.

I am not complaining. I am exulting. It was a wonderful life, vanished now from the American scene. There was nothing cozier than to sit on one side of my mother, my older brother on the other, while the stove reached a red heat, and the kerosene lanterns put out a soft golden glow, as the wind howled around the cornices, and my mother read us books. This is my fondest memory of childhood.

Do you remember the laconic Plainsman of the movies, played by Gary Cooper? This is authentic. Country people are comfortable with silence. It is rude to break another's reverie. I was always free to go inward, to my luminous day-dreams, or outward, to immerse myself in the south wind and the moonlight. Nostalgic indescribable feelings filled me with ecstasy and Noesis, an intensity and richness of experience, untranslatable. I was living a certain mystical path, that of "carrying wood and water," and did not know it. I assumed everyone had these wonderfully luminous experiences, but that it was like sex, something no one talked about. I loved solitude in nature so much that I always volunteered for the really boring jobs, like plowing, or herding cows, because my body could do those automatically, letting the mind go free. One of my many careers was pot washing after hours at a rib joint. I loved that job. I could do it all on automatic and day-dream without interruption for hours.

I could enter the luminous world of the nature mystic, or the collective super-conscious, while doing chores. That weren't enough chores for me. I would get on my bicycle and ride round and round the yard (not the lawn, but a barren area between barns and corral). This must have seemed eccentric, but not by word or gesture was it discouraged. When the hands are busy, the mind is free, and can go where it will. Often it will roam the realm of Genius, Oceanic Consciousness, not to be confused with the collective unconscious. Other times I would merge with the wind, the trees and the sky.

This is the essence of meditation, at least of the "carrying wood and water" school of mysticism. One must spend many thousands of hours "bathing in the waters" (advanced day-dreaming) and many thousands of hours immersed in the mood-feelings of nature before one is ready for the Illumination of Fire. I experienced it at age 31, after a particularly intense period of nature mysticism and "bathing in

the waters." The Illumination of Fire is more commonly known as Cosmic Consciousness. Some lesser mystical states prepare one for the greater. In that sense, there is a path that one may follow accidentally, as I did, or deliberately, in which case we call it "carrying wood and water." The hero must first survive the trip through the "dark wood," as Dante described it. Later one finds a Mentor. Mine was a mild mannered soft-spoken linguist named Bill Coates. He introduced me to the classics of psychical research and mysticism (two quite different topics). There is a mythic quality to the life of mystics. It is the life of the hero of the inner world. Only then was I ready for my transcendental encounter with the ONE. There I saw, as one recognizes a face, everything I knew, everything about history, everything that happened to me, fit into a single pattern. I conclude that this is the divine purpose, running through all things, animate or inanimate. If it is the divine purpose, and we are each droplets of divinity, then we can accept the divine purpose as the meaning of life, since it gives meaning to the tragedies and the obstacles, or at least some of them. We may live in accordance with the divine purpose, or not, or be completely ignorant of it. Because of the illumination of fire, I know life can have a purpose, and may even have a plan that we create for ourselves in the "between." This does not mean that everything that happens is some god's plan. The gods are myths. Every kind of sentience is part of ONE. Mysticism is quite compatible with Darwinian evolution.

When I was a freshman in college, I saw the three Norns, deciders of fate in Nordic mythology. Divinity comes in threes. There are three judges in the Chinese underworld that decide the next lifetime, and under hypnotic regression, everyone (not just Chinese) can remember having to go before the three judges, during the "between." The three Norns looked like three respectable middle-aged ladies, sitting there at my desk or standing around it, looking at me as if to say, "So this is the One?" I blinked my eyes and they were gone. This was an apparition, so I can say from my own experience that apparitions are just as real as ordinary reality. It is a different sort of reality.

When I was ten, in the summer of 1950, I saw a UFO, in full

daylight, at close range (about 200 feet) and had it under continuous observation for what seemed like a long time, but may have been a minute or two. Nobody in my family believes this story. I don't blame them. They weren't there. Everyone but me was either in the house or the barn. My chores took me outside to feed the hogs and calves and gather eggs and carry up a pail of water, and bring in an armload or two of firewood (in winter). I was feeding the calves, looking at nothing in particular, facing west, where the sun had just set. It was still full light, as summer evenings usually are.

Coming up over the tree-lined creek that lay downhill a hundred yards to the West was a pitted sphere, covered with a flame-like greenish aura. It came silently about 15 mph, due East, at a constant height of about 200 feet, close enough to judge distance by the powers of binocular vision. Overhead it made an instantaneous right-angled turn without banking or slowing down and went off due south at the same leisurely pace. No one else in my family saw it, but it was in the papers the next day, and seen over large areas of Texas and Oklahoma. After that, I always knew the textbooks were wrong, but I kept that to myself. I kept a lot of things to myself.

In high school, at Monica's birthday party in Perry, I saw table tipping. It was late autumn, the house was overheated, there wasn't room to dance, and we were too young to drink. What I'm trying to say is that the party was getting boring; we were getting sleepy, and thinking about leaving. Besides, both the Principal and the Superintendent were present. That might seem strange, but it was a small school, and informal, and they were often involved in our social activities. Indeed, it was the Principal who "called" our square dances. He was the one who suggested that we do table tipping. Junior Riddle is what we called him. He was also the girls' basketball coach. Thank you Junior Riddle, wherever you are. You were right about me. I didn't know everything, and not everything is in books. Sometimes I think he arranged this exercise just to deflate my intellectual arrogance, the sin of pride.

It was a perfectly ordinary card table, with folding legs. I helped set it up. It certainly had no invisible wires. We were too poor in the fifties to buy the gadgets of illusionists, even had we known

about them. We set it on a rug.

Junior Riddle sat six people at three sides of the table, leaving one side free, with fingers lightly resting, thumbs to thumbs and little fingers to little fingers, making a kind of three sided circuit. One by one, those at the table said in a solemn voice, "Rise, Table, Rise." Time gradually slowed to a stop. An eternity passed, waiting for the table to rise. We were in our own bubble of time.

After this eternity, the table did rise, or at least the free end rose, tilting back on the other two legs. It rose a good foot off the floor, and stayed there. Junior Riddle did not seem at all surprised. I'm sure our mouths were hanging open. He suggested we ask it questions, and give it a code, such as one tap for yes, two for no. In the excitement of the moment, we couldn't think of any really significant questions to ask. Is there life after death? Is there a God? Is there meaning to life? No, we asked how many dollar bills were in Ted's wallet. "Three," said the table. Ted checked, and there were three dollar bills. We asked it if we were going to win an upcoming basketball game against Red Rock (see the movie "Hoosiers" and you will know what basketball means to countless small towns across Middle America). We gave it a code, one tap for yes, two for no. It very slowly tapped once, and then stopped, in the up position. By how many points? "Three," it slowly tapped. In fact, we lost by about 20 points. We asked it how many days until Christmas. It very rapidly tapped 25 times. We asked one another, "Is that right?" No one knew. In fact, it was wrong, as I found out when I got home and checked a calendar. It didn't matter whether it was right or wrong.

What mattered was that it was a clear case of psycho-kinesis. I know. I was the skeptic, looking under the table to see if someone was lifting it with a foot. I passed my hand over the table checking for invisible threads, and checked fingers to see that all were resting their hands lightly on the table. They were. It is possible to pull a card table, but this requires pressing down hard, inverting the last digit, and turning the joint white.

About half of the students in our high school were at the party. We believed it. The other half weren't and didn't. I don't expect you to believe it either. I knew. Once again, I learned that the textbooks

were wrong, or at least incomplete. These two experiences gave me the antidote to the religion of the scientists. I knew that on these two subjects, they were quite wrong.

The books I read at 15 on history, science and philosophy set the course of my life. I knew I didn't want to do history. I had to choose between science and philosophy. In the end, I did both. In addition, this book has some contributions to science (mostly theoretical) and some contributions to philosophy. My invention of the science of Utopian Analysis made good use of my love of history, for it was in the political experiments of history that I found all the data I needed.

I took a bachelor's degree in Physics, and a Ph.D. in philosophy. However, that didn't mean I had lost any interest in physics. I stayed with it via *Scientific American*, which I have read ever since my senior year in high school, despite its steadfast allegiance to the religion of the scientists. When I was about 30, I had a chance to take undergraduate quantum mechanics again, just for fun. Once again, I found a Mentor, an old professor who told us many tales out of school, many personal things about the great figures of the 1920s.

When I was a professor of philosophy at the University of Southern California, I had a friend who was a physicist, born and raised in India. We two bachelors often went out to dinner at the one India Restaurant in LA at that time. Once when we were talking about quantum mechanics, he said rather vehemently that he wished he didn't have to crank out equations. The paradoxes of quantum mechanics bothered him. What he wanted was about twenty years just to contemplate the meaning of the equations. He never had that luxury. However, I did. I eventually realized that de Broglie's wave (though not his interpretation of them) frees quantum mechanics from paradox. I have also recognized in published data the evidence that anti-matter has anti-gravity. I also know of data that suggests to that gravitons are absorbed or emitted by the Earth, changing its spin vector. In addition, I have an alternate theory for the acceleration of the Hubble expansion. It doesn't require "dark energy." That is the sum total of my potential contributions to physics. Physicists pay no attention to the ideas of

amateurs, and not very much to the ideas of their colleagues, so it is hard to say whether these ideas will ever have any impact on physics.

My philosophical contributions consist in the founding of sciences, for that is the point and function of Western philosophy, as well as its crowning glory and only accomplishment. It took me 30 years to learn how to distinguish the essence from the accidental in existing science, and to learn how to apply the essence of scientific method to other problems and other realms of experience. That sounds very dry and abstract, but there is nothing dry and abstract about my writing. Do you want to know about free will? Beautiful cities? Capital punishment? The meaning of life? It is all here.

There was a time when I thought I was supposed to start a new religion. There was a time when I thought I was supposed to be a guru. Fortunately, I came to my senses and realized that I could hardly pursue a path that I have explicitly rejected, for good and sufficient reasons, as I have both of those. No, if you are impressed with my writings, don't try to become my disciple, and don't start a religion in my name. Start or continue one of the sciences I have created, altered or renewed. The one I created, taking up where Hobbes and Locke left off 300 years ago, is Utopian Analysis, the science of civilization. This science will never come into full existence unless there are followers, people who become Utopian Analysts and publish their work. A science is a communal affair, continuous from generation to generation. So if you wish to be my follower, follow me in this.

There already exists a science of Psychical Research, with journals, Ph.D.s, and the various SPRs (Societies for Psychical Research). This science has bogged down, come to a complete stop, under the attacks of the *Skeptical Inquirer*, and for internal reasons as well. I know the history of worldviews and I believe I can help Psi research past this hurdle.

The reincarnation work of Professor Stevenson proves that the mind and the body are completely different things, made of different substances. The mind has no EM interactions and that is why it is invisible and intangible. The NDE data and the reincarnation data confirm this. I propose that we re-define Psychical Research as "the rigorous study, using scientific method, of rare and spontaneous events

or talents that shed light on the mind, a real entity quite different from the body, and in no way created by the body."

The other thing that has brought Psychical Research to a dead stop is the absence of a testable theory of the mind as a natural object. I have provided one in the chapter "Mind as a Dark Object." For this, one must understand 20th Century physics, as well as 20th Century Psychical Research. So if you wish to be a follower, follow me in this: do the scientific tests of my theory of the mind as a natural object. Revive the newly re-defined Psychical Research and spread it to every university. Fight off the Psi-cops with the tools I have given you.

The media should not accept the Psi-cop's claims to be experts on Psi or UFOs, when the Psi-cops have never tried to reproduce a single study of psychical phenomena or of UFOs. They reject them for the same reason Galileo's Paduan colleagues rejected his discoveries -- they just couldn't believe such things were possible.

Finally, we come to the scientific study of mystical and symbolic experiences of mankind. Among mystics and students of symbolic revelations, none but me think that scientific method has any place at this bounteous table. I say, unless the real discoveries of metaphysics are grounded in scientific method, they are like dust in the wind. They will make no permanent contribution to the knowledge of mankind. These experiences are reproducible and that is the first requirement of science. One can be a scientist and a mystic, using the universal language of Jungian symbolism rather than calculus. So if you wish to follow me, follow me in this: help to make metaphysics a science. Do so with full involvement in symbolism and the mystical path, not standing back and viewing mystics like lab rats. Be your own experiment. Study the alphabet of symbolic elements and learn to interpret Mandalas and other symbolic expressions. Learn the New Tarot. Become a Seeker. The day that happens, the world will have changed.

The Function of Philosophy

The function of philosophy is the founding of sciences. This is a fairly common view, not original with me. The last philosopher of a subject ceases to be "philosopher", and becomes known as the founder of that discipline. We thus forget that they were philosophers. This forgetfulness leads to an odd distortion in the training of future philosophers, since only failures such as Hume and Kant are included in the philosopher's syllabus.

The last philosopher of mathematics was Euclid, building on earlier work by Plato, Zeno, Pythagoras, Thales and the Babylonians. *The Elements of Geometry* was such an extraordinarily clear and persuasive example of the deductive method of mathematics that all mathematicians followed this example from that time forward. The last philosopher of physics was Newton, who said he stood on the shoulders of giants. He didn't name them, but we can imagine it would be Kepler, Galileo, Copernicus, Ptolemy, Hipparcos, Aristarcos and Thales. Newton, Galileo and Kepler all referred to themselves and one another as philosophers. I am myself a philosopher, and the new sciences I have changed are Utopian Analysis, Empirical Metaphysics, Ufology, Psi research and perhaps the science of history. I did not invent any of these sciences. In Utopian Analysis, I built on the "moral sciences" of Hobbes and Locke, who lived over 300 years ago. William James and C. G. Jung are the fathers of empirical metaphysics. Arnold Toynbee was the inventor of the science of history. All I did for history was to apply his methods to the perennial question of the fall of the Roman Empire. What I have contributed to Ufology and Psi research is a testable theory of how UFOs and Psi work. Science requires theory. Without it, we won't even know if we are collecting relevant and significant data.

Sometimes it is best to leave a term undefined, or at least, it is best not to engage in debate over the "proper" definition of a term, such as "utopia." For me, any effort to improve society and take the correct community action is utopian, and this does not mean "hopelessly idealistic," nor does it mean "perfection." The US is a utopia, created by the Founding Fathers in 1789. The UK is a utopia,

created by the "glorious revolution" of 1688 that established the supremacy of Commons over Royals, Lords, and Justices. Communism turned out to be a dystopia, based on false ideals, such as socialism and authoritarianism. We know both to be false because of their failure whenever tried. The idea of utopia incorporates the use of correct and well-established ideals.

The term "ethics" is woefully inadequate for such issues as abortion, world peace, beautiful cities, traffic jams, and so forth. The solution to such problems requires a utopian (i.e., deliberate) change in traditions and institutions, and that is why I prefer to use "utopia" instead of "ethics." What then shall we do with such things as "medical ethics," which pretends to know whether stem cells shall be created in a Petri dish? What grounds the arbitrary opinions of medical ethicists? Utopian analysis may be able to do so. I shall leave that to those who follow, as a nice little problem that may give the true utopian much pleasure to think about.

The science of civilization is concerned only with community values and community actions, including those that create obligations and rights. "*De Gustibus Est Non Disputandum*" when it comes to personal values. There is no accounting for tastes, and that is one reason why liberty is better than "big brother" because no one else can decide what is best for you. Utopian analysis is not a version of Mills-Bentham utilitarianism. Happiness does not enter into utopia at all, because happiness is an entirely personal and subjective matter. There were both happy and unhappy people in the Dark Ages, and during the Black Death, as well as in the peaks of civilization. Most of us know a mixture of both through the course of our lives, or during any particular period of life. One cannot base a science on that. Happiness is not the only possible goal in life, and has been over-rated. I would put "intense and vivid experiences" above happiness, and finding the divine purpose in one's own life above that.

I call the new science of civilization "utopian analysis," because it always analyzes a controversy or a social problem into underlying ideals. I began wondering if normative theories could be empirically tested when I was 19, and a sophomore in college. My professors told me it was impossible. I went to graduate school and

majored in philosophy anyway. However, they wouldn't let me work on my problem. For 9 years, I was an academic philosopher, and even published a few papers. However, none of my colleagues thought a science of civilization was possible. I was in no hurry. I knew there was no competition. Either I solved it, or it might remain unsolved for thousands of years. I finally did figure it out, at age 49. However, as of this writing, I have been unable to interest any academics in the new science of civilization.

Apparently, no one realizes we need a science of civilization. Everyone thinks they already know which way of life is best. The French think theirs is best, and the Americans think theirs is best. If that is so, why has neither country produced a great civilization since the dawn of the industrial revolution? When I wanted a symbol to put on the cover of my little book *A Science of Civilization*, available from http://www.booksurge.com/author.php3?accountID=IMPR01514, I knew there was no image from any city built recently that would serve. I picked the sacred white bison of Native America, since civilization can be about restoring ecological systems and the spiritual traditions of the First Nations, overrun by Westward expansion. It isn't necessarily about cities, especially the brutally ugly and violent cities of the past Century.

I created a science of civilization because I grew weary of arguing about capital punishment or abortion. Ideological warfare is what that is, and it generates much heat but little light. I wanted to be able to put such issues to the test of experiment, as they do in the other sciences. I am not a critic of science; I am only a critic of the unconscious assumptions of science.

I once began to explain my ideas in a seminar, but I had done no more than combine the words "values" and "science" when a "philosopher" named Ragavan Iyer jumped in and I never could get another word in. He ranted on and on about the impossibility of a science of values before listening to what I had to say. There is no fool like an educated fool. The naturalistic fallacy is the logical inference of value from fact. It is a logical fallacy, but an easy one to avoid. The logic of scientific method is that of ruling out the known alternatives in

Paperbacks Galore

1044 14th Ave.
Longview, WA 98632
360 423-9006
DATE 10/07/2011 FRI TIME 11:00

NEW T1	$16.95
DISCOUNT	-20.000%
AMOUNT T1	-3.39
SUBTOTAL	$13.56
TAX1	$1.07
TOTAL	$14.63
CASH	$20.00
CHANGE	$5.37

NO CASH REFUNDS
CLERK 1 No.092835 00000

Paperbacks Galore
1044 14th Ave.
Longview, WA 98632
360 423-9006
DATE 10/07/2011 FRI TIME 11:00

NEW T1	$18.95
DISCOUNT	-20.000%
AMOUNT T1	-3.39
SUBTOTAL	$13.56
TAX1	$1.07
TOTAL	$14.63
CASH	$20.00
CHANGE	$5.37

NO CASH REFUNDS

CLERK 1 No.093835 00000

terms of normative particulars. There is no fact to value inference.

"Failure" is a normative term. It is a matter of history that the Soviet Empire collapsed, a normative particular that it failed. I shall not analyze a normative particular more than this, although others may do so if they wish. We learn things from political experiments, both matters of value and matters of fact. I leave it at that. You don't have to.

The failure of socialism does not imply the truth of the ideal of reciprocity and its corollary, the ideal of free enterprise. Free enterprise remains as the only surviving alternative. That is always the way of it in science.

When there is only one alternative that survives testing, we call it well established. That is the rule in physics, and it is the rule in utopian analysis and all other empirical sciences, known and unknown. In the creation of utopian analysis, the avoidance of the naturalistic fallacy was the least of my problems. The question is why were my professors and colleagues so adamant that it was unavoidable? It is because academic philosophers after the time of Newton and Locke do not understand the new epistemology of scientific method. They are stuck in the old epistemology of mathematical method, which is fine for math but not for empirical questions. Beware of people spouting "epistemology."

The first philosopher after Locke still studied today is David Hume. The 18th Century Hume was part of the Scotch Enlightenment. He was a friend of James Hutton and Adam Smith, two successful philosophers, founders of geology and economics, respectively. Yet Hume created nothing of lasting importance. I pick on him because he is the author of the pernicious dictum that "extraordinary claims require extraordinary proof." This is completely wrong. If it had been the rule in the 17th Century, science would have died unborn. Yet it is the favorite methodological principle of the Psi-cops. Hume has been immensely influential. All academic philosophy since his time has accepted the basic assumptions of Hume.

Perhaps Hume went wrong because science is "paradigmatic," as T. S. Kuhn pointed out in his famous book *The Structure of Scientific Revolutions*. Galileo and Newton never stated the essence of

scientific method in abstract terms, and neither has any scientist since. Scientists learn their craft by example, master to pupil, Nobel Prize winner to postdoc.

Perhaps the form of Newton's *Principia* fooled Hume. The *Principia* is in the form of a Euclidean proof from three axioms and one force function. This makes the *Principia* virtually unreadable today. That may be why the philosophers never made the turn, and remain in the Euclidean framework.

So what are all these thousands of people who teach philosophy in the universities? Some of them we must classify as logicians, of formal logic, or of ordinary language. As for the others, I shall make the same complaint about them that Socrates (a stonecutter) made about the professional teachers of philosophy in his day, who called themselves "sophists." "Sophist" actually means "professional philosopher."

Our sophists (like those Socrates attacked) are only interested in "raising questions." When is a question not a question? It is when one has neither the ability nor the desire to attempt a solution. The sophists transform real problems into abstract "puzzles," incapable of solution when taken out of the rich loam of human experience. The sophists don't want to solve them. That ends the game and puts them out of business. This is my definition of sophistry: "mind-games, where it matters not which side you take, but only the wit shown in the word play." This is why I despise "mathematical recreations," chess, bridge or any sort of mind game, since I automatically suspect the players of a tendency towards sophistry.

We must totally reject Hume's rule that "extraordinary claims require extraordinary proof," such as proof that fraud could not possibly occur. Such a demand is itself impossible to fulfill. There is no proof stronger or better than scientific proof. If Hume were the rule in the 17th Century, we would still be burning witches and heretics at the stake. Hume is almost an anti-philosopher, since his ideas spawned the metaphysical nonsense of Kant and Hegel, as well as the obstructionist views of the Psi-cops today, who use Hume's rule rather than scientific method.

Hume and the sophists were convinced that scientists had

proven Newtonian physics, in the logical sense, because they never understood the concept of a well-established theory. Neither has Sir Karl Popper, a contemporary academic philosopher-of-science of some repute.

There is no proof of scientific solutions in the strict logical sense. In science, when we call a theory "proven," this is just an informal way of saying "well-established." Why have theories? It is because they allow us to apply past experience to the present. They are also the main discoveries of science. Ruling out alternatives applies to the interpretation of experience, the process that turns an experience into a fact or a normative particular. Something becomes a scientific fact only if we can rule out all the alternatives, and if it is, in some sense, reproducible. We call that veridicality. That is why I am only interested in the landed occupant cases in Ufology. Mysterious lights in the night could have innumerable possible causes; some natural but rare, some man-made, but that is not true of the landed occupant cases.

Because they are stuck in the Euclidean framework, sophists believe any empirical study of values **must** involve some kind of inference between fact and value even though they know such an inference to be invalid. The effect has been a halt to any further development of the "moral" sciences of Hobbes and Locke, thus allowing the dangerous sophistry of Karl Marx to arise.

The existing sciences solve only a single kind of problem (finding explanations), with a single part of the spectrum of experience (visible and tangible matters of fact). If the problem is not like figuring out how a watch works by taking it apart and seeing how the components move one another, then it lies outside the reach of the physical sciences.

I will show that it is possible to extend scientific method to problems other than explanation, and to realms of experience other than matters of fact. I have solved a philosophical problem thought to be impossible since the time of Hume, namely, "how do we determine the good, the right, and the beautiful from experience?" Later in this book, I solve the classical theological problem of evil. Earlier in the book, I gave empirical content to the concept of free will.

Seven Ideals

A science needs some equivalent of a theory, a test, and a fact. In Utopian Analysis, the equivalent of a theory is a social ideal, such as liberty, or socialism. The equivalent of a test is a political experiment, such as the 73 years of testing of the ideal of socialism ("from each according to his ability, to each according to his need, where both are established by the state") in the Soviet Empire. I know there is more to socialism than that, but since it is a failed system, I don't much care about going into details. I have read Marx, as well as the writings of many English intellectuals of the early 20th Century who were socialists--people like George Bernard Shaw and Bertrand Russell. Great Britain tried socialism after WW 2, and so has Cuba since the coup by Castro. In every case, it has been a failure, leading to poverty and the breakdown of institutions. Such an outcome is a normative particular, the equivalent in Utopian Analysis of a fact. The collapse of the Soviet Empire is a fact; the failure of Socialism is a normative particular, something "normative" (a question of values) determined by experience. We could not know that socialism would fail without someone giving it a trial. In the early 20th Century, most famous intellectuals were in favor of socialism. No one capable of learning from experience supports socialism today.

Marx was wrong about socialism, but he was right to criticize the capitalism of his day. Both "capitalism" and "democracy" refer to large classes of systems, some of them rotten with corruption, injustice and tyranny. In the USA there is an unholy alliance between politicians, bought and paid for, and corrupt executives of giant corporations, who get whatever legislation passed they ask for, even if it means they pay no taxes, even if it means the loss of all high-value jobs, even if stockholders lose everything. That is not a good thing, because most retirement systems save money in the form of stocks; thus, people may lose their retirements due to the crimes and greed of corrupt corporate management. One wonders if we still live in a democracy. Perhaps democracy is only the outward form, while the true form of American government is oligarchy.

If we ever adopt Aristarchy, the Aristarchs must keep an eye on

the big corporations, and break them up and take over the parts, if necessary. Corruption must be rooted out, especially if it is in the Aristarchy. In Aristarchy, we select candidates by essay exam on questions of good and bad government. The people do not elect them but it is only the people who can change the laws and write new ones. The Aristarchs try to follow the spirit of the law, rather than the letter, and may make written and published rulings about the law, particularly as it applies to new situations. In Aristarchy, we recognize the English notion of "Common Law," laws known by everyone but not necessarily written down. Aristarchy may or may not have a written constitution.

The first of the seven well-established ideals is liberty. Liberty comes in many forms: personal, religious, free speech, right to access, free press, and right to privacy, 4th Amendment and 2nd Amendment liberties. These rights apply only to private affairs, not to public spaces, places, airwaves, etc. The numerous parts and ramifications of liberty are **not** spelled out in the First Amendment, or in the Bill of Rights taken as a whole. Now we begin the seven ideals, each labeled with a number in square brackets. Bold letters herald a discussion of one specific sub-heading under one of the seven major ideals.

[1] Personal liberty is our right to "life, liberty and the pursuit of happiness." It is the right to do whatever we like in private, so long as we place no one at involuntary risk. I emphasize "whatever we like," no matter how risky, no matter how expensive in time or money, no matter how absurd, no matter whether the majority disapproves. Liberty is the right to do things others may consider sinful, foolish, or dangerous. Over the Century of the automobile, it is a safe estimate that they have killed at least 6 million people worldwide, and the correct figure is probably more than 10 million. During this same Century, how many people have died of a marijuana overdose? Not one. Isn't this ridiculous? Instead of running those propaganda commercials against pot, the government should run propaganda commercials against cars. By the way, medical mistakes kill over 100,000 people in the USA. So maybe there should be indoctrination to avoid hospitals! Obviously, we should quit trying to indoctrinate

the public with "public service" ads of any kind.

Violation of the ideal of personal liberty is tyranny. In the US, we pledge allegiance to "liberty and justice for all." Our National Anthem calls this the "land of the free and the home of the brave." How can people make that pledge or sing that song and put people in prison for life for using marijuana? That is the law in Oklahoma, where we imprison more of our population than any place on Earth. Politicians say we go to war to preserve our freedoms, yet our Attorney General Ashcroft is doing as much as he can to eliminate our freedoms. Clearly neither the public nor the Supreme Court nor the Attorney General is capable of recognizing violations of our ideal of "life, liberty and the pursuit of happiness." Either that or they do not really believe in liberty. It is not foreign tyrants or terrorists who are the great enemies of liberty; it is the Supreme Court and the Attorney General.

Personal liberty has many parts, with many implications, hardly suggested by the First Amendment to the Constitution. I shall spell that out, but first, the evidence.

Evidence for personal liberty comes from the "gay nineties," or "La Belle Époque," when immigration to the US was at its peak. Society allowed brothels and recreational drug use. There was justice in the courts. Opportunities abounded. In 1886, the French people gave us the Statue of Liberty, so impressed were they of our freedom, a beacon of hope for all mankind. "Give me your tired, your poor, / Your huddled masses yearning to breathe free," it says in the famous poem by Emma Lazarus at the base of the Statue of Liberty. Do we still breathe free? Or do we live in a puritanical oligarchy? That's what I think. Well, at least they haven't banned iced tea, my favorite recreational beverage.

Life was not easy for the immigrants, especially the first generation. They could not speak the language. They could only qualify for the worst and most dangerous jobs. Each new wave of immigrants moved into the slums, as the previous wave became middle class and moved out. Though life was hard, they wrote letters back to their home villages, persuading the rest of the family, and sometimes whole villages to emigrate as well.

The collapse of Communism and the failure of Prohibition are the latest examples of the failure of the only known alternative Ideal of "Big Brother Knows Best." While it has often seemed reasonable to intellectuals that elites would know better than you or I what is best for us, this never works out in practice. Different people have different tastes, discovered by experience. This is the root of liberty, the reason why everyone must make their own choices about how to spend their risks, their time, and their money.

Freedom of religion: Like all liberties, religious freedom only applies to private activities, and only those that place no one at involuntary risk. Thus, we must forbid the ritual mutilation of infants in the name of religion. We are shocked at the ritual mutilation of females, yet we tolerate it for males. I, too, was circumcised. I never agreed to that. Someone must be "of age" to make a voluntary choice. I place that at a mental age of eight.

Freedom of religion is just a special case of freedom of private associations. In the Constitution of the Second Republic, it is called the Freedom of Peaceable Assembly. Understanding this liberty would help to clarify a lot of recent cases that have come before the Supreme Court. For instance, do the Boy Scouts have the right to reject homosexual scoutmasters? Of course! Like any other voluntary association, the Boy Scouts can do anything they like, so long as (1) they do it in private, and (2) they don't put anyone at involuntary risk

Free speech and free access: This is the right of every individual to free expression to the world of their artistic, literary, musical, scientific or philosophical expressions. It also means the right of access and the right to decide what to learn. No more government censorship. In the US, what we have is not government censorship but private censorship by the dominant elite in their New York publishing houses. Less than one in a hundred books written ever gets published in any form. A small press first published nearly every book of any originality. That includes *Life After Life*, by Raymond Moody, *Twenty Cases Suggestive of Reincarnation*, by Professor Ian Stevenson, and Charles Bowen's book, *The Humanoids*. This is a short list of the most important books published in the 20th Century. Therefore, we certainly do not have freedom of expression in

any meaningful sense.

The public, the government and the Supreme Court clearly do not understand freedom of access. Otherwise, we would never have instituted compulsory education, especially when that "education" is nothing more than indoctrination. It would be different if we allowed everyone to go at his own pace, and learn whatever he wanted. Coercive indoctrination never works. You can take the horse to water, but you can't make him drink. Coercive indoctrination just kills curiosity and creativity.

We must repeal compulsory education for those who have come of age. Maybe we can force the little ones to acquire the basic skills of reading, writing and arithmetic, but once a child has come of age, he should be allowed to become an apprentice and get a job, or leave the public schools and use his vouchers in other ways. I would give everyone vouchers, and let them be collectable over years, tradable, salable, and usable by other members of the family. The whole family might go together to send someone to Harvard, or to pay for Enlightened Hospice for Grandma, a place for people with a terminal prognosis who are no longer able to care for themselves.

Enlightened Hospice could have lectures or films by people who have experienced NDEs, and could allow Grandma to try any recreational drug or alternative therapy. What is the worst it could do? Kill them?

I digress.

Evidence for the truth of this ideal of freedom of expression and access comes from the effect of the Catholic Index of prohibited books and ideas. Because of the Index, southern Europe played no role in the Enlightenment, or the social revolutions of the 18th Century, or the industrial revolution of the 19th and 20th Centuries, even though Italy and Spain had been the leaders of Western Civilization in the Renaissance. Tiny England and Holland grew mighty because they respected freedom of expression. At least, that was one factor, one of many.

Web publishing now gives everyone the right of worldwide self-expression in any medium, or soon will, at the cost of learning HTML.

The boundary of every liberty is involuntary risk to others. In the case of freedom of information, this comes either in libel or invasion of privacy. In another piece of judicial legislation, the Supreme Court has apparently ruled that ---public figures, members of the government, and celebrities---- have no right to privacy, and tabloids or TV comics can say or print anything about them, and the courts will do nothing about it. This is wrong and arbitrary. It should be illegal to publish or broadcast the words or images of anyone without the express consent of that person, whether they are public figures or private citizens.

Fourth Amendment rights and privacy rights go together. No officer should be able to search my house, my office, my bag, purse, wallet, car or clothing unless the police have reason to think I have committed a crime (for instance, seen fleeing from the scene of a crime), or unless they have a search warrant or an arrest warrant signed by the local magistrate. This is simply another aspect of personal liberty, another consequence of the First Amendment, and one that the DEA already ignores, one that Attorney General Ashcroft is trying to repeal by fiat, not by vote. A person may have to give up some of these rights in order to enter high security areas, such as commercial airports. Let us hope there will always be other means of travel.

Second Amendment rights: The Second Amendment to the Constitution of the Second Republic actually refers to military weapons, and the right to form local militias, what we today call the National Guard. Suppose we say people do have a right to arm themselves for their personal protection. Modern firearms are definitely overkill. Allowing private citizens to carry modern firearms means we have no protection against snipers, such as the serial killers who terrorized Washington, DC in 2003. Allowable weapons might include ceramic (Ginzu) switchblade knives and throwing knives. Such weapons would be sufficient to allow a woman to defend herself against a mugger or rapist. Non-concealable weapons, suitable for home defense might include the modern compound bow (but not crossbows) and black powder smooth bore flintlock muskets or blunderbusses. Either type of gun would be sufficient for home

defense and yet fairly useless for assassination, armed robbery or armed insurrection or suicide.

Modern firearms account for the majority of accidental killings, suicides and in the USA. It is still possible to commit armed robbery, suicide or have a fatal accident in other ways, but it is not as easy. The target has a chance to duck. Black powder muskets are inaccurate at any great distance, and the large cloud of black smoke marks the location of the shooter. Black powder muskets or bows and arrows would eliminate most fatal hunting accidents.

The Public vs. Private Rule: A corollary of the ideal of liberty is the Public Vs Private rule. Work and public transport are public, as are the city streets, public billboards, public stores, and broadcast media.

A community may forbid religious activities in public places (street corner preachers), advertisement of religion, or public broadcasts of a religious nature. Why would they want to? Elsewhere in the book, I show religion is faith, a euphemism for dogma and superstition, and quite unnecessary in this age of psychical and mystical knowledge. Religion is the chief obstacle to rational thought and rational action, such as the control of the population bomb, the greatest threat to civilization. Religion remains the chief obstacle to the control of population increase, as well as the chief obstacle to cures for quadriplegics, Parkinson's disease and many other things, all of which require the creation and use of stem cells, something easy to do in the laboratory.

It would ease the repeal of the blue laws against drugs, gambling and prostitution if we at the same time made these things illegal in public. To be more specific, we could have "Sporting Houses" for licensed and inspected courtesans and gamblers, while prohibiting streetwalkers. Sale of marijuana, coca leaves, opium gum, magic mushrooms, tobacco leaves and the dried and fermented forms of these plant materials could be restricted to a special store called the herb shop that would also have spices, aromatic and medicinal herbs, as well as estate bottled or barreled alcoholic products from the farms that grow the raw materials. Camels, Cocaine, Heroin, and Jack Daniels would only be available from the local drug dealer (a perfectly

legal business) who would deliver it to your home.

The Ideal of Equal Opportunity trumps the Public Vs Private rule. This can happen if membership in a club is a prerequisite for financial or political advancement.

Note---we give rights to full citizens. I suggest a "full citizen" is someone who has come of age, is not a convicted felon, and is not incompetent to manage their own affairs. He or she is "full" of both rights and responsibilities. A child "comes of age" somewhere between 8 and 12 years old, and this event should be marked with suitable ceremony.

[2] The Ideal of Reciprocity: The only known alternative to reciprocity is the ideal of socialism, refuted by the collapse of Communism in 1989, and by the failure of socialism wherever it has been tried, e.g., in Post-War Britain, present day Cuba, and in the Soviet Empire. Reciprocity is the basis of my analysis of social welfare, morality, family and free enterprise. Figuring out how any institution works means figuring out the pattern of motivations. This is always easy to do if the institution is based on reciprocity. Many of the proposals of Utopians seem to work only by idealism, not self-interest. In the long run, these always fail.

In the economic sphere, we now know that people will not produce according to their ability, unless there is some incentive to do so. The socialist economy is something like the slave economy, where everyone tries to do as little as possible, as little as they can get away with. In a free market, some will prosper more than others will. This bothers some Utopians. There is no known workable economic system that is based on the principle of equal income for all, unless it is the Ecolomat, described in my 1973 book *Whole Earth Inner Space*, available for viewing (not down-loading) on the Web. Just search for the title with Google.

Envy can become a socially divisive problem if it becomes impossible for the poorest to rise to become the richest. Clearly Bill Gates in the US and the founder of Virgin Atlantic in the UK show that both nations have freedom of mobility. The philanthropic

activities of the very rich lessen envy and enrich public life. Indeed, the long-term stability of free enterprise may depend on such wise philanthropy. Charity balls are one of the chief social activities of the very rich, so I expect philanthropy to continue, and to be a natural part of the lifestyle of the very rich.

[3] The Ideal of Democracy: The people own the government, rather than vice versa. All the people own the government, not just some of them. Thus, the government must treat each and every person as if they have an inherent right to life, liberty and the pursuit of happiness, unless by their own actions, a citizen forfeits that right.

Sometimes a "democratic" government will do something that is fundamentally undemocratic, in that it violates the principle that the people own the government, not vice versa. An example in US history is the draft of soldiers for WW II and Vietnam. These men were used up like other expendable supplies of war, so they named themselves "GIs," which means "Government Issue," no different from all the other olive drab munitions used up to take some meaningless hill or hamlet that benefited the GI not at all. The GIs had no choice at all, about anything. They could not even refuse suicide missions. I grieve for these GIs, and cannot stand to watch war movies. If allowed to volunteer, many would have, and the generals might then have been more careful with their lives.

It follows that a military draft is undemocratic, since it turns draftees into disposable war material. Military personnel should be volunteers; they should volunteer or not for every mission, and have a right to voice objections to the detailed plans of the mission, if they think the mission places their lives at more risk than is necessary. The draft is still the law in the US, unused since Vietnam. Just wait. Rumsfeld and Ashcroft will propose bringing it back, I suspect.

Democracy is government by the consent of the governed. Do we have that even now in the USA? I'm not so sure. It seems more like an oligarchy; rule by those who provide the funds to get someone elected.

A stronger requirement is that it be "government of the people, by the people, and for the people," not government by bureaucracy,

choked by endless red tape and stymied by idiotic bureaucratic or judicial rulings.

There are many different possible forms of democracy, including the tripartite, multi-level, judicial superior form we have, and the Parliamentary, Commons superior form found in the UK. "Judicial superior" means that the Supreme Court may overturn the decisions of any other part of government. Furthermore, there is no mechanism for overturning their decisions or ousting members. "Commons superior" means that Commons in the UK, including the decisions of Barristers, Church of England Primates, House of Lords decisions, and the decisions of the monarchy may overturn all other decisions. I will call the UK system "parliamentary government" and the US system "tripartite government."

Parliamentary government works better than tripartite government. How can we tell? One clue is voter turnout, high in the UK and other countries with a commons-superior Parliament, low in the US. One reason for higher voter turnout is that elections last a few weeks instead of a few years. Another clue is citizen apathy. There is no apathy under Parliament, because it is possible to create new parties that may even come to power. In the US, we are stuck with the same two tired old parties we had in the Civil War. Because of the "winner takes all" rule on the state level, it has so far proven impossible to create a viable new party. A third clue is the degree of allegiance by elected officials to special interest groups that pay for elections. Countless polls show the majority of people in the US want gun control, but the NRA is so strong that they can easily defeat any congressman who votes against them. This undemocratic allegiance to the financiers is high in the US, almost non-existent in the UK. A fourth clue is efficiency. In the US, efficiency is low, and overhead is high. There are as many people working for government on all levels as there are taxpayers. The American government has become the butt of jokes by Late Night comedians, for it seems government against the people, by faceless bureaucracy, for special interest groups (PACs).

I offer as hypothesis a third form of democracy that I call Aristarchy, based in part on the classical Chinese mandarin system of the T'ang, Sung, and Ming dynasties. Local magistrates would

combine powers of chief of police, mayor and judge. Above them would be metropoles in charge of a metroplex and surrounding countryside, governors in charge of regions of the country, and archons in charge of national government. It would be a single unified system, without the duplication of legislative, executive and judicial functions at each level of community that we now have.

Do not imagine government by college professors, who are notoriously specialized, ignorant and irrational outside their own narrow field of interest. Nor should it consist only in National Merit Finalists, since being smart is not the same as being wise, and is not even the same thing as being intelligent. I say this even though I was a National Merit Finalist.

The citizens in the jurisdiction in question could make or change laws by a vote of three-fourths of eligible citizens. The Aristarchy could make rulings on any issue that came under their jurisdiction that would have the status of law, unless changed by a different ruling. The basic idea, both in the Chinese mandarin system and in Aristarchy, is to find the wisest and best informed person, and make him or her personally responsible for government over some jurisdiction. Then we would know who would listen to our complaints against a neighbor or a business, who to blame for bad government, and who to thank for good government.

The evidence for this system is the millennia of high success of the Mandarin system in China. During the T'ang, Sung, and Ming dynasties, the people enjoyed a peaceful anarchy, seldom troubled by the government. The Chinese avoided a disruptive hereditary aristocracy, while members of all classes could and did become Mandarins. All they had to do was study the Neo-Confucian classics and pass the essay exams. I propose something similar. The Chinese experienced repeated foreign conquests and natural disasters during this period, but the Mandarin system rose again in each new dynasty, after stability had returned.

Westerners who visited China in the 17th Century, during the Ming dynasty, were quite impressed. That was no longer true in the Manchu dynasty of the 19th Century, when Chinese Civilization had reached the advanced old age of 3500 years, and was corrupt and

decadent. Most civilizations only survive 3000 years. That was true of Ancient Egypt, of the Meso-American Civilization of Toltec-Maya-Aztec, and it was true of Classical Western civilization, if we include the Mycenaean, Greek, Roman, and Byzantine phases. The Vikings about 900-1000 CE created our own Western civilization, so our civilization is relatively young, about 1100 years old. We still have before us the Universal State and the Second Spirituality. Right now, we seem to be emerging from the Warring States phase.

[4] The Ideal of Higher Community: The only permanent solution to the problem of war is to combine the warring communities into a higher community. In medieval times, cities fought cities and duchies fought one another (as in the War of the Roses, the Hundred Years war, and even the 17th Century Thirty Years war) until the rise of modern states, such as England, France, Italy and Germany. Then there was a period of fratricidal war between states until the emergence of the strong Nation of States, such as the USA. Europe is becoming a nation under the EEC and NATO. France and Germany will never again battle each other, and neither will Alabama and Ohio, except in the realms of sport, business, or culture.

This ideal naturally leads us to world community, something that we have been unconsciously creating for more than a Century, with the Olympic Movement, the jet plane, satellite TV, international science and business. The UN would suffice as a world government, if we had a true global community. We must all think of ourselves as Citizens of Earth, first and foremost.

A hierarchy of communities does not require all sub-communities to be the same or have the same laws and customs. It does require giving up ancient hatreds, something that the ethnic groups in Yugoslavia did not do during the 50 years or so they had a single government. Community and government are two different things. Before the US Civil War, there was one Federal government, but unfortunately, two quite different communities, one slave holding, the other industrial. We used to hear about "the melting pot," something undergone by all groups immigrating to the US. This is still a valid idea. It does not mean miscegenation, nor does it mean giving

up distinctive music or cuisine. It just means melting down all those ancient hatreds, those tribal attitudes nurtured in the old country, and we must view with suspicion any group or tribe that refuses to undergo the melting pot.

[5] The Ideal of Equal opportunity / responsibility: Everyone should have the chance to go as far as their talents and ambition will take them, regardless of race, religion, sex, tribe, age or family, but must also take up the responsibilities of a good citizen, such as paying taxes, voting, obeying the laws, giving ones children a conscience and a sense of civic duty. If everyone did feel that they had equal opportunity, they would also be more willing to take up equal responsibility. Every criminal or tax cheat represents a failure on one side or the other of this ledger. Crime grows out of a sense of hopelessness quite as much as a lack of discipline.

This ideal forbids discrimination for or against people on the basis of irrelevant factors. Usually tribe, age, gender, race, family or religion is an irrelevant factor. I include in "gender" sexual preference. Any of these things can become relevant factors. If we were casting the part of Abraham Lincoln, it would not be arbitrary discrimination if we cast tall, thin, white males. Similarly, in the army, where fighting unit cohesion is all important in combat, the highest level officer who leads them into combat could decide that she didn't want this or that. If she thinks it's relevant for cohesion, then it is. Similarly, scout leaders, who are alone with young boys or girls in campouts, can be required to be married and heterosexual, essentially because it is a private organization that can do as they like in private, if no one is at involuntary risk. There is evidence that girls do better in math classes if there are no boys present. In other words, gender becomes relevant, and we could certainly segregate the sexes in classes and even in colleges.

There is more discrimination for ones own family, tribe, gender, race, etc., than there is discrimination against a particular group, and it does more harm. Tribalism is especially problematic. Tribes like the Basques, Croats, Serbs, Bosnians, Palestinians and

Jews insist on having their own sovereign country and are quite willing to commit ethnic cleansing to eliminate other tribes or scare them out. I suppose they could invoke a contrary ideal of Nationalism, or Self-Determination. This may be a valid ideal if subordinated to the ideal of community.

We have seen the worst of tribalism in the bloody chaos of Africa, since the end of colonialism. We also saw it in the Balkans, with the practice of "ethnic cleansing," practiced in the 1990s. The tribalism of America is subtler, and involves no bloodletting. It is all about power and opportunity. Curiously enough, the First Nations have given up tribalism. They are not the problem.

If a particular tribe or family always discriminates for their own kind in hiring and firing or giving out contracts, soon an entire industry or profession consists in members of that tribe or family and none other need apply. This should be illegal, and should be punished by deportation, as well as the firing of all those hired by the discriminator. It pains me to say that tribal discrimination is common in the USA, especially in Hollywood, and in the New York media (including book publishers), also in academia, the professions and Wall Street. I am not anti-Semitic. I am opposed to discrimination. That is all. If large numbers of Yemeni or Bosnians or Tutsi had immigrated to the United States, we would be making the same complaint about them.

It isn't just tribalism we have to worry about. There is also class discrimination.

In the revolution of 1776, we thought we had rid ourselves of the oppressive class structure of England, because we had gotten rid of titled Lords and the hereditary ruling class. In the 20th Century, a new Overclass appeared that now dominates academia and media in the US. The creation of Aristarchy would overthrow this Overclass. Only non-tribal members of Middle America may enter the Aristarchy; otherwise, it could become dominated by a tribe or a minority class.

The ideal of higher community is contrary to the false ideal of Nationalism or Self-Determination. Why did we fight the Civil War here in the US? To avoid Balkanization. The US would not be a great nation if it were broken up into smaller States or confederations of

States. The Confederate States of the Old South would not be a great nation, would never be a factor on the world stage. Neither would the sovereign state of Texas, or of California. This was a war fought over the Ideal of Union, not over slavery. Tragic as that experience was, citizens of the present United States are glad of the outcome, whether they live in Atlanta, Miami, New York City, Austin, or Los Angeles.

[6] **The Ideal of Justice:** Lady Justice defines this, with her scales, blindfold, and sword. The scales make punishment equal to the crime in order to restore peace in the community. The sword of decision suggests we restore the ancient power of the jury to decide guilt or innocence, by eliminating appeal, with immediate execution of sentence. The blindfold means Lady Justice does not take sides; her only interest is in finding the truth.

The test of an ideal of Justice is the amount of suppressed rage in a society, and the resulting number of berserk mass killers. Simply comparing crime rates is irrelevant, because crime rate depends on many things, such as morality, community solidarity, and respect for authority.

In my hypothesis, the primary function of Justice is to restore emotional harmony in the community by releasing pent-up rage and sorrow, rather than "correction" of criminal character or warehousing of violent people. The function of justice is revenge. This is a natural desire, a natural reaction to evil. Give it an outlet, or it will build up like a festering boil, and burst out in mass murder. Compare the unrequited rage in the USA in the 1890s, when justice was swift, to the 1990s, when it takes forever, if it is attainable at all.

In the court of Hanging Judge Parker in 19th Century Fort Smith, trials took a few hours, and they executed the murderer the next day. In Judge Ito's court (remember O.J. Simpson?) trials took years, and the murderer was set free. Even if we had convicted him, appeals would have lasted for ten years or more, and taken a million dollars in lawyer's fees, since the public must pay the judge (a lawyer), the prosecutor (a lawyer) and the public defender if the defendant is not rich like O. J.

Which is worse, the justice of Judge Parker or that of Judge

Ito? I believe you know the answer.

Indian Territory (now Oklahoma) was a haven for outlaw gangs between the Civil War and Statehood. The federal marshals that Judge Parker sent after these gangs were the only semblance of law and order in Oklahoma. Over a hundred of these marshals died in the line of duty.

The execution of murderers is not itself murder, because the murderer has broken the social contract. We must be very sure of the truth before handing down a death sentence. I advocate a moratorium on execution until we can create a justice system with that capability.

[7] The Ideal of Public Aesthetics: Aesthetic pleasure derives from intelligible novelty. Building our cities according to intelligible novelty gives us beautiful cities. I can demonstrate this by example. Compare the anonymous boxes of the 20th Century, with their endless rows of identical rectangular windows, to the Taj Mahal, for instance, or a Gothic cathedral.

Aesthetics is not just beauty. It is everything we do to keep from being bored. Some people play the ponies. Some people play chess. Let everyone make their own choices. How then, can there be any universal truths about aesthetics? The universal truths of aesthetics all apply to community action and all somewhat resemble zoning laws. We may not be able to guarantee beauty or other kinds of aesthetic pleasure (friendship, love, adventure, and competition), but we can sometimes identify rules of boredom and exclude them. For instance, no building shall be rectangular, with rectangular and repetitious window treatments. This describes the vast majority of 20th Century skyscrapers. Tear them down, since they have become hideous in our eyes, once we see Mandala buildings.

Public use provides evidence for good aesthetics. Did anyone use the wide and windy concrete plaza between the Twin Trade Towers? No. Many people use Central Park, as well as the numerous small parks around Manhattan. Most of them have a place to sit, something to eat, and falling water amidst trees and grass.

The following chapters offer specific solutions to current problems. They are comparable to solutions to mathematical

equations. There are other solutions, given different boundary conditions.

Evil has its roots in ignorance. Thus, it is not so important whether we do this or that. What is important is that we have a method of resolving disputes, a method of finding the truth by analyzing a dispute into its underlying ideals. I call this method "Utopian Analysis," since implementing the solution will require changing something, a law, a decision, an institution, a tradition. This goes far beyond "ethics," although "ethics," "morality" and "virtue" can all be subsumed into utopian analysis. As for the handful of social ideals that underlies great civilizations – we know their truth and the falsity of the alternatives from social experiments. These tests have already been done. All we need to do is be able to learn something from the outcome, and that seems difficult for most people to do.

Some accuse me of being authoritarian. I accuse them of being anarchists. Anarchy always leads to tyranny. There is nothing tyrannical about catching crooks and terrorists. I know what they object to. It is the walls, the unforgable money / ID card encoding biometrics, and the checkpoints based on biometrics. They object to the ID databases which have everyone's biometrics, as well as the location databases which keep track of every use of the ID card, whether to pass a checkpoint or to buy something. But no one is watching. The checkpoints do not restrict movement. The databases are used only to quickly find missing persons, before they become murder victims, and to quickly find murderers and terrorists. My utopia is the most libertarian ever proposed.

The evils of the world arise from ignorance. It is by the use of scientific method that we dispel ignorance. Utopia is not a place. In fact "utopia" is Latin for "nowhere." Our goal is civilization, something not much in evidence in the present, or the past Century. What is evident is technology. Technology can be used for good or evil. Thus, it doesn't necessarily represent progress. Indeed, the combination of high technology with low civilization may be a fatal one for intelligent humanoids. While I cannot give a definition for "spiritual evolution," it surely involves knowing the essential things about the good, the right, and the beautiful.

The City Beautiful

Beautiful is not what springs immediately to mind when one thinks about Twentieth Century cities like New York or Los Angeles. No, the images are those of schizophrenic or alcoholic bums on the sidewalk, gangs as ruthless and barbaric as any ancient Vandal or Visigoth, and oppressive, monotonous monoliths leaving the streets in perpetual shade. The pungent aroma of ozone and diesel fumes attacks the nasal passages and makes the eyes water. Gridlock. Stress. Serial murder. Cannibalism. Conspicuous consumption next to burned-out, desolate wastelands. We need not accept this condition. After all, we built it. We can build it anew. We must build it anew if we are to satisfy the ideal of aesthetics, and to guarantee every citizen a right to life, liberty and the pursuit of happiness. There is very little happiness evident in modern life in the city. The murder of innocent citizens denies them the right to life. This much must be obvious.

Jane Jacobs wrote a classic book about cities, called *The Death and Life of Great American Cities; The Failure of Urban Renewal*, published in 1961. She was acutely observant of the organic life cycle of cities, and the importance of street life. She preferred row houses with a mix of offices, businesses, and walk up apartments along a curving street, with wide sidewalks, stoops, and trees. Every great urban environment has a rich street life, whether it is Greenwich Village, or Paris, or Amsterdam, or Albuquerque Old Town. Street life prevents street crime, particularly if the police get out of their cars, get out of their offices and walk their beat, getting to know the people on the street.

Row houses don't have to be drab boxes. The ones in Paris often have a subtle sculpted front. Those in Amsterdam are painted different colors. While such apartment buildings would have a freight elevator in the back (which many tenants would also use), the height of such buildings will rarely exceed ten floors, because that is as much as most people would care to climb. Surprisingly enough, this kind of architecture provides the maximum number of households per acre, 100-200, better than high rises, and of course, far better than the 3 households per acre in suburbia, particularly if we get rid of the cars

and their parking places and parking lots. A great city is made for walking and that means it must be compact, and not sprawled all over the landscape. I propose putting a wall around a Metroplex, and zoning the region beyond for agriculture, wetlands, prairie, forest, parks and golf courses. No houses or commercial development. Halting urban sprawl means additional development will increase the density of the city, by replacing suburbs with row houses, for instance.

A Theory of Aesthetics: Beauty is intelligible novelty. In order for there to be intelligible novelty, there must first be recognition, i.e., some level of familiarity and expectation. The information lies in the novel or surprising details within this overall pattern of recognition. The setup for a joke presents one expectation; the punch line contradicts it. It is the unpredictability in a relationship that keeps it going. If total predictability sets in, the friendship or relationship wanes. Our best friends are people who make us laugh, or think, even if we seem to have nothing in common. Most of us love sunsets, surf, forests, mountains, the Sonoran Desert, and clouds, because we all have a certain level of expectation and familiarity with these things, yet there is variety in the details.

Aesthetics is whatever we do to not-be-bored. Sex, food, getting warmed up or cooled down, or coming in out of the rain, can all provide a moment of pleasure. Once the need is satisfied, we are satiated. We are never satiated with aesthetic pleasure. The First Law of Aesthetics is that Aesthetic pleasure is intelligible novelty.

Architecture: From the First Law of Aesthetics, we can immediately conclude that the endlessly repeated, identical, rectangular window treatments on 20^{th} Century high-rise boxes represent the nadir of aesthetic sensibility. Such buildings hold no more aesthetic interest than a shoebox. So city-dwellers hurry along, eyes on the ground. Only tourists look up at the forest of towers, impressed by their sheer size, if nothing else.

It may be hard to find rules for beauty, but it is not hard to find rules for monotony. The relentless application of any geometric rule (such as the rule of plumb and horizontal lines meeting at right angles, common to domestic architecture) must lead to monotony. Even with row houses, differentiate each house by color, as they are in

Amsterdam.

The endless repetition of rectangular window units is not only boring; it makes it impossible to see the entire building as a single shape. Near the Battery Park, on the tip of Manhattan, there is a cylindrical skyscraper that avoids any window treatment and thus becomes a single sculpture. The reflective glass curtain wall has an attractive blue color. Unfortunately, more boxes have been built around it, somewhat hiding its beauty. The Dallas skyline features many "sculptural" skyscrapers that make for an attractive skyline. I am not suggesting that skyscrapers are inherently bad, or that we should pull them down. Build new cities in a new way.

With the dawn of the 21st Century, some architects succeed in escaping the box. See "The Sky Line; Building on a Computer Screen," by Paul Goldberger, *The New Yorker*, March 12, 2001. The new software not only allows the architect to create non-rectangular three-dimensional shapes freely; it also does the engineering. It was exactly this kind of software that allowed the engineering of Frank Gehry's Guggenheim Museum in Bilbao, as well as the Walt Disney Concert Hall in Los Angeles, also by Frank Gehry. These two buildings may very well be the forerunner of an entirely new and distinctive 21st Century city.

Human Factors: Architecture should be restful; it should make solitude or gregariousness equally possible. Architecture has an enormous, unrecognized influence on social life. The pleasure we find in friends is aesthetic pleasure. It ultimately boils down to intelligible novelty. It makes one day at work different from another. In a happy office, there is a kaleidoscope of human relationships that change from day to day. The difference between a happy office and one where people are sullen and glum often depends on the precise layout of each floor, and the positioning of break rooms, rest rooms (unisex), coffee machines, copiers, elevators, the use of glass walls (with shades), and the flow of human traffic. All these architectural details determine whether it is easy or hard to meet others, and whether it is easy or hard to have any solitude.

In some office buildings, there are whole floors of desks, without partitions. No solitude. In others, there is a maze of corridors,

with nothing but closed doors and no way to orient oneself as to direction. No human contact. Such buildings are machines built for machines. However, contrary to the Bauhaus school of architecture, we are not machines.

I happen to be agoraphobic, and I claim that agoraphobics are like the canaries in mines. We panic at situations that make others uneasy. Therefore, a sensitive test of any building design would be to see how agoraphobics respond to it. Spiral ramps would be part of every design and the doors leading to them would not have locks. Here are a couple of really bad designs: the aquarium in Baltimore and the Hyatt Hotel in Phoenix. The aquarium depends on escalators and all agoraphobics hate escalators, with its linear stream of unmovable humanity. In addition, these escalators are high in the air! Agoraphobics do not like what mountain climbers call "big air." The Hyatt hotels put a giant atrium inside. Simply walking from one room to another can induce vertigo. They have hidden the stairwells, and they may allow one in, but not out. Every agoraphobic's nightmare!

Urban Design: Apply the principle of intelligible novelty to the layout of entire cities. At least until 1965, Paris consisted in row houses, for the most part. Only a few special buildings, such as the Notre Dame cathedral, were freestanding. Some features of Paris simply grew, without plan, giving us the narrow, winding streets that remain from medieval times. Since 1970 or so, Paris has segregated skyscrapers to one outlying suburb.

City planners have sometimes added rational elements to a chaotic medieval pattern, for instance, the broad, tree-lined boulevards radiating from a central traffic circle that we find in Paris. The combination works beautifully. We want some order, and some disorder. We want some planning, and some things we want to leave to the accidents of time or topography. Seattle and San Francisco are interesting cities built on steep hills, around irregular bodies of water. While freeways may go slashing through, ignoring topography, the ordinary residential street does not.

City planning produces brutally monotonous designs, but not if we made the Ideal of Intelligible Novelty our highest priority. It applies to the design of cities, to the design of buildings, and to the

layout of offices. This is the Ideal of the Beautiful City.

Civilization and Permanence: Lord Kenneth Clark thought, "Civilization has something to do with permanence." This leads me to wonder whether we have as yet built an American civilization. As Lord Clark said, we still live in wigwams, in other words, wood frame houses, with wood or asphalt shingles, paperboard sidings, plastic doodads on the windows, and everything else required to make a house unlivable in about thirty years. Civilization requires some confidence in the future, and some care about our great-grandkids great-grandkids. We haven't achieved that. But we should. Design everything non-consumable to last forever, given a prescribed schedule of maintenance and repair. This is particularly necessary for buildings, roads and bridges. Thus, build houses and buildings out of galvanized steel, use galvanized steel sheeting, use brick, glass, bronze or stone for the exterior, and roof it in ceramic tiles, bronze sheeting, slate, or metal. There is a new type of metal roofing that looks like slate. They would last forever, and be passed down, generation to generation.

Build every city to withstand the destructive forces of that region. On the West Coast, that means they should be earthquake proof. In Tornado Alley, cities must be tornado proof, all the way up to F5 tornadoes. In addition, they must be able to withstand straight-line gusts of 95 mph, and softball sized hail. Along the Gulf and Atlantic coasts, cities must be hurricane proof, all the way up to F5 hurricanes. Along the coast, this means putting them up on stilts, firmly anchored in bedrock. The stilts allow the maximum expected storm surge to pass freely underneath the building. In tornado alley, on the hurricane coasts, build steel shutters to protect windows and glass doors. They must be able to repel debris flying at 318 mph. That is the highest wind speed ever measured on Earth. Doppler radar measured it during the F5 tornado that hit suburbs of Oklahoma City May 2, 1999.

Lady Justice

We see Lady Justice on many 19th Century courthouses. She has a blindfold and she holds an upraised sword in her right hand, with a pair of scales in the left. The truth of Lady Justice is a consequence of the ideal of reciprocity. The scales mean balance. Justice restores the emotional balance in a community, as what we do to the criminal balances what he has done to his victims. The sword means decisiveness. Court proceedings should not take months or years. In the court of Aristarchy, we would present all the evidence in the O.J. Simpson trial in a few days, or a few weeks at most. Once the magistrate reaches a decision, he carries out sentence immediately, with no right to appeal. Instead of a trial, we would have a presentation of the evidence to the public, who could raise questions about it. Stay the process until the magistrate can answer those questions. I propose trials be held immediately, without right to bail. The blindfold means blindness to anything but the actions taken. Intent and other unknowable subjective factors are not relevant. If a drunk driver flies through a stop sign and kills someone, it is murder. While he may have intended no harm to that particular person, driving while drunk is like waving a loaded gun in a mall. It is a felony, a reckless act, and we will hold him accountable for the act, not the intent. We should not automatically classify auto wrecks as "accidents." Some may be accidents, some may be suicide, but quite a few are murder. Execute murderers, if the victims are completely blameless.

Deaths can be classified (1) death by natural causes, (2) suicide, (3) accident, (4) self-defense, and (5) wrongful death, of which a sub-category is murder, where the perpetrator is wholly responsible. Like the British, I admit of no degrees of murder, as there are no degrees of death, but there are many borderline cases, where a crime has certainly been committed, and a wrongful death has happened, but not wholly the fault of the perpetrator. In a knife fight, the "perpetrator" or survivor is simply defending himself. While such knife fighting is certainly illegal, and the death wrongful, it is not murder. In a traffic fatality, a drunk driver is certainly committing a felony, but if the victim is not wearing a seat belt, or could have saved

herself by being more attentive, it is not murder, for which the only penalty is death.

Evidence for Lady Justice: The best evidence for Lady Justice comes from comparisons of La Belle Époque (1880-1920) in the USA to the periods that preceded it and followed it. La Belle Époque was a great time (though not perfect), a time of liberty and justice. The major change before the 1880-1920 period was the transition from the wild frontier to the settled civilization of the gaslight era, to a time of bicycles and ragtime. In 1903, there were fewer than 300 murders in the entire USA. In medieval times, they hung boys for stealing a loaf of bread; today we give perpetrators people free room and board for the most hideous serial killings. In between these two extremes, there was a period when we had liberty and justice in the United States. Trials were over in hours, or at most a few days, and if the jury found the murderer guilty, the judge passed sentence and hanged the killer the next day.

The best refutation of the alternatives to Lady Justice is the rise of suppressed anger since the 1920s, because so much evil goes unpunished or not punished adequately. The symptom of suppressed anger is the berserk mass killer at the Post Office, or at McDonalds, or of an entire family, a phenomenon of our time. It may be possible to rehabilitate juvenile delinquents, but not hardened sociopaths. Permanent exile is impractical, since we have no equivalent of Siberia.

There has been a lot of irrelevant debate about capital punishment. An execution is not itself murder, according to the Ideal of Reciprocity, since anyone capable of cold blooded murder is not a party to the social contract that defines the scope of murder. Execution of a sociopath is more like extermination of a rabid dog.

Hobbes and Locke laid the foundations for modern notions of the social contract with a thought-experiment. They said, "Let us imagine that everyone capable of committing murder agrees with one another not to, if given the reciprocal right to life." This is not history, but logic. It defines the scope of murder, since it is murder to kill someone or something only if they are a party to the social contract. Fetuses, infants, dogs, felons, people in a permanent vegetative state, or the mentally incompetent either cannot or will not agree to the

social contract. That doesn't mean we can kill infants without cause; indeed, it is one of the roles of government to protect the helpless and innocent. Just as it is wrong to execute mothers who have abortions, or doctors that do them, it is wrong to execute parents who ask for no heroic measures (like a feeding tube) to save a severely retarded infant. If infants or small children are normal, the government may remove them from the custody of their natural parents if there is proof of mistreatment. Protect children from women with post-partum psychosis, until she recovers. I am simply being consistent.

One of the functions of government is to protect the weak and innocent against the powerful and wrathful. Thus, we should not permit the ritual mutilation of infants in the name of religion. By the same token, we cannot tolerate violence by parents against their children. Thus, the deliberate murder of their children by parents is still murder.

Recent applications of DNA testing to people on Death Row have shown many of them to be innocent. Clearly, the justice system did not find the truth in their case. So let us call for a halt to execution until we can install a completely different justice system, one capable of determining the truth 100% of the time. Lawyers are competing to win, not to find the truth. Thus, the prosecution may hide things from the defense, and vice versa. I say, get rid of the lawyers and the whole "trial by combat" system of court procedures has its roots in the practices of ancient Germanic barbarians.

Lawyers Gain by the Collapse of Justice: Why has this process gotten completely out of control? It is because of the Supreme Court. We have seen a steady expansion of "due process" until it has become "unending process," with the only winners being the lawyers, since taxpayers have to pay for the judge (a lawyer), the prosecutor (a lawyer) and the public defender (a lawyer). Trials have lengthened from hours in Hanging Judge Parker's court to years in Judge Ito's court. And is the quality of justice any better? Rulings by the Supreme Court in the 20th Century had a definite trend: they enrich lawyers by extending the length of due process, and increase the number of technical loopholes that allow appeals to set aside the original decision of a jury. That is why it costs a million dollars to execute a murderer.

The million dollars goes in the pockets of lawyers. Thus, lawyers are unpopular, and we blame them for the decline in justice. In the days of Judge Parker, a century ago, the cost of an execution was a plain wooden coffin.

English law descends from the practices of primitive Germanic tribes, such as the Saxons or Vikings. It pits one attorney against another. Their competition is to win cases, not to find justice. So one keeps information from the other. The police have no vested interest in justice. Often, they prematurely settle on one suspect and ignore other leads. The Jon Benet case is an example. It is now apparent there was an intruder, and if the police had put up roadblocks and intensively questioned everyone in town about a stranger who might have a record of sexual assault, then they might have found the culprit. It is the magistrate who has a vested interest in justice, so she runs the police department and she conducts the hearings. Criminalists present the evidence, and the defendant or other members of the public would have a chance to speak. No lawyers. This somewhat resembles the Napoleonic law system, widely used in Europe, and is even more like the Classical Chinese Mandarin system of justice.

The Failures of the Judicial System: In California, a man raped a young girl, cut off her arms and left her to die. The community was outraged and wanted this monster to die. The rapist's punishment was to receive free room and board, free legal and medical services with no responsibilities for several years at vast expense to the public. We call this prison. When the courts released him to his home community, lynch mobs formed. Instead of helping the community take revenge on this man, the justice system mobilized considerable resources to protect the criminal. They moved him to a different community, where lynch mobs again formed. Eventually the police moved him to a penal community, the only place where they could protect him.

In Tulsa, a drunk slammed into a legally parked police car. The police car was clearly visible, as it had all its lights flashing. Inside the police car was a popular young policewoman, writing a traffic ticket. The collision jammed the doors and set the police car ablaze. The woman inside burned to death, desperately struggling to break out,

while onlookers also tried to break into the car. Television crews appeared on the scene and filmed the drunk being led away. He was laughing.

The community wanted to crucify this man. In addition, why shouldn't it? Anger at evil is a legitimate and natural human emotion. Is not the function of the justice system to take revenge on evildoers? Is not this the very meaning of the phrase "justice was done?" The principle function of the justice system has always been to punish the wicked, not too harshly, nor too leniently, but as the scales of Lady Justice imply, in exact measure to the crime itself. We also want to make sure the criminal can do no more mischief, at least not the same kind of mischief, at least not to the same victims.

Lady Justice and Aristarchy: So, what sort of justice system should we have? I propose one more like classical Chinese civilization, where the local Aristarchy/mandarin is the chief of police, the mayor, and the judge, all rolled into one. He or she will decide whether to call up a jury or not. The mandarins of China did not use juries, and given the notable incompetence of the juries on some famous recent cases in the US (the O.J. Simpson trial, for instance), the magistrate may decide to put the decision to a jury only when some matter of opinion is to be decided. Juries can then stand in for the entire community, and make a judgment reflecting public opinion.

Critics rightly point out the number of convicted "killers" on death row, who have been saved by DNA testing. Quite right. However, one cannot pull one item out of a utopia and examine it out of context. I would not be in favor of the death sentence either, in our present justice system. It does a poor job of finding the truth and making the correct decision.

According to my hypothesis, there would be only one system of justice. There would be no tort system, no family court, and no distinction between civil and criminal law. If a citizen has a problem, take it to the local magistrate. The magistrate will determine if a hearing is needed. Instead of suing someone, go to the magistrate, make a complaint, have a hearing, and get your money back if you've been wronged. There would be no such thing as punitive damages. They have made malpractice insurance rates so high as to drive

doctors out of business, or make their services unaffordable. Juries are very liberal with other people's money. The instruments of the law (wills, incorporation, joinings (new form of marriage), adoption, etc.) should all be simple, and if the customer has any problems or questions, he can always go get help from the local magistrate. Lawyers will need to take up a different line of work. The Aristarchy exists only to serve.

Finding the Truth: So, how can we find the truth, with such surety (which must be 99.999% accurate), that we can impose the death penalty and still sleep at night? The system of walls, checkpoints, identity databases, and unforgable money/id/key cards is the first thing required.

Walls: There are many crimes that are nearly impossible to solve without walls and checkpoints. What is a wall? Something nobody can plow through, climb over without detection, or tunnel under without detection, or fly over without detection. It is unnecessary to go into more details than that. I would hope for actual physical walls, made of brick or stone, for aesthetic reasons if nothing else. I don't think anyone would wish to live inside a city or neighborhood defined by barbed wire! The walls are there to protect the people inside, not to restrict the movement of law-abiding citizens.

Today, it is so difficult to catch serial murderers that we are only now prosecuting the Green River killer of Seattle, who has confessed to 48 murders of young women. These murders happened decades ago. He was caught by DNA typing, something not available 20 or 30 years ago. There are undoubtedly serial murderers roaming the country today who will never be caught. Why? Because they know how to hide a body, or destroy it. The Green River killer made no particular attempt to hide his kills, and he left semen on them and in them. Every year, there are thousands upon thousands of young women who simply go missing, and are never heard from again. This would not be possible with the walls and checkpoints. The new system would prevent abduction becoming murder, if we could find the perpetrators quickly.

With walls and checkpoints around every Metropolis, every residential neighborhood, and every industrial or commercial district

and if we use bio-informatics to verify that the person using a money / ID card is the person who owns it, we could always make a list of suspects that must include the culprit. With suitable error bars, we could search all the local databases simultaneously and cross-check the information to make a list of everyone who could have been present at the crime scene or the place where someone went missing. We could track those individuals forwards and backwards in time, and we would know where they are now, so we could interview them.

The Scientific Interview: We must always be able to say with certainty that we can produce a list of people that must contain the culprit. Secondly, we must develop the science of the interview. Fortunately, this has now been accomplished. See "The Naked Face," by Malcolm Gladwell, in *The New Yorker*, August 5, 2002. This is a system called FACS (Facial Action Coding System), based on AU (Action Units), each referring to a particular group of facial muscles. Professor Paul Ekman of UCSF developed it. Also, see Ekman, Friesen and Levenson in *Science* and Ekman and Etcoff in *Nature*.

Film an interview, then turn off the sound and run it at one-quarter speed. Transient Action Units give away the interviewee. Some AU are under conscious control; others are not. It is not only possible to tell if the interviewee is lying, it is possible to "read his mind," and identify every fleeting thought, attitude and emotion. Ekman discovered this because he found certain individuals, primarily policemen, who did it automatically. One must ignore what is said, and concentrate entirely on the Action Units, more commonly known as "facial expressions." This technique is already being taught to intelligence agencies, to help in identifying terrorists. It is also being taught to the FBI and to the police.

Such a system of "proven interview" will save the innocent as well as convict the guilty. Without the interview, we must rely on circumstantial evidence, sometimes misleading. Suppose our scientific criminologists find plenty of evidence of the presence of someone at the crime scene at about the time of the murder, evidence in the form of DNA typing of semen, sweat, and skin cells (epithelials we are constantly shedding). There would be a strong circumstantial case against this individual in a murder-rape case. However, that

circumstantial evidence could belong to the boyfriend, who left just before the perpetrator arrived on the scene. In that case, the scientific interview would clear the boyfriend. And if it can't, it is not a trustworthy system of scientific interview.

Identity: The identity databases must contain indexed fingerprints, indexed DNA records, iris prints, face prints, voiceprints and any other reliable means of identifying someone. There should be an entry for everyone who lives in this country or visits this country. Is this a police state? No, because it would simply be latent data, like the film in a security camera. We don't look at it unless a crime is committed, and it is not publicly accessible. We make a record on one or another local database every time we buy anything, or pass through a checkpoint, even the passive checkpoints which do not require bioinformatics. The passive checkpoints would trigger a an RFID tag inside your bicycle, your electric car, or your identity card, which contains bio-metrics only the owner can provide.

This system assumes a conversion to electronic money. We are moving in that direction as it is. A system of all electronic money combined with bio-metrics will be more secure, will enable us to track criminals and terrorists, and tax every electronic transaction at a small rate, say 3 percent. That would be the only tax, and no one could escape it.

We add to this the most sophisticated criminalists, who know how to make microscopic examinations of crime scenes, who know all the ways of determining time of death in a murder case. Then we query the location database system to see who could have been there at the time of the crime, and follow each individual backwards and forwards in time, to see if they are following their normal ritual, or doing something suspicious, like fleeing the area. We interview the most likely suspects, and this process continues until we find the culprit. Criminalists will play a prominent role in the new police force. Obviously, in my utopia, there is no Fifth Amendment. That is, there is no right against self-incrimination, because it will often happen that the only living person who knows what happened is the culprit.

The New Fifth Amendment: What we will have for our new fifth amendment is the right to be released within a week if no charges

- 127 -

are made, and a rule forbidding both physical and mental torture of suspects, and a requirement that all interviewing of the suspect be video-taped and made available to trusted scholars, in some way that does not compromise the rights of privacy. We therefore pre-suppose a system that either leaves the case unsolved, or proves beyond all doubt that the one charged did do the dirty deed. The court proceeding then becomes nothing more than a presentation of evidence to the public.

If the magistrate can think of alternative interpretations of the evidence, or if some member of the public can do so, then suspend the case and investigate this point until we can rule out all alternatives but one. It is better to convict no one than to convict an innocent person. Thus, a suspect always has the presumption of innocence on his side. If we can really prove who did it, we should not hesitate to meet out the death penalty for murder. The only possible appeal might be to the magistrate's immediate superior, who might stay execution for a time. If the superior metropole has complete confidence in the local magistrate, then execution will be immediate. The next of kin should not have to wait years for justice, amid constant appeals that could release the murderer at any time. If the friends and next of kin of the victim unanimously ask for clemency for the convicted killer, then clemency they shall have.

Enforcing the Law: In a libertarian society, there should be minimum interference in private lives. Thus, the police should not provide any more enforcement than is really wanted by society. For example, I have proposed that modern firearms and ammunition no longer be sold, and be impossible to take through checkpoints that incorporate metal detectors. I would not advocate a Draconian search of everyone's house and home for modern firearms and ammunition. If a search happens because of a felony complaint, then we collect arms and ammunition. If the neighbors complain that someone is firing at them, then the police have grounds for obtaining a search warrant. The police would not disturb a person who lives quietly without bothering the neighbors.

I suppose there will be traffic rules, especially in a Metroplex. Rather than zealously enforce these rules, it would be better to watch and see what patterns of behavior work best. If people can jaywalk

without getting hurt, take down the signs forbidding jaywalking.

How shall we prevent crime? Legalizing drugs, gambling and prostitution in the herb shops and the sporting houses would undermine the economic basis for outlaw gangs. We would still have to round up the gangs, with their sociopathic rage, and deport them. Indeed, we must deport the neighborhood that produced them. Criminal behavior is learned behavior, just like lifestyle and social custom. A bad neighborhood has usually been bad for generations. There is no point in just allowing it to continue producing new generations of criminals.

Another type of violence is common even in good neighborhoods---domestic violence. With the checkpoints, databases and walls, we could actually keep perpetrators away from those having protection orders against them.

Guns: I am not opposed to guns--just modern firearms designed to kill undetectably at 300 yards. Smooth bore black powder flintlock muskets or modern compound bows would serve just as well for hunting or for home-protection. The best form of home protection is an all steel door, set in an all-steel frame, bolted to all-steel studs. With deadbolts set, it would be impossible to kick in the door.

If we did not sell modern firearms and ammunition publicly in stores or guns shows, or privately, if we routinely collected guns and ammunition after a felony search warrant, or when trying to pass them through a checkpoint, their numbers would slowly diminish. That is surely a good thing. If nothing else, it would reduce the rate of accidental killing of playmates by kids who find a loaded pistol in the house.

Opinion: Is all this just my opinion, or has it some firmer basis than that? The science of civilization requires utopian dreaming as well as utopian analysis. It must be possible to dream up a specific solution to the equations provided by the well-established ideals. It is something like the rule for the physical sciences that a theory must have testable consequences before it really is a theory. The architect provides a different analogy. She must obey the rules of engineering in her design, but the rest is her imagination, and the result depends on the available technology of the time, and the specific

details of the site. Think of my detailed suggestions as something like the designs of a highly trained architect. Or solutions of equations with a particular set of initial conditions.

In a different time and place, you will dream a different set of dreams. And that too will be utopia, if it is based on true ideals. Utopia is not a place; it is more of a goal or a direction. "Utopia" in Latin actually means "nowhere."

Liberty and Justice for All

We always memorialize the fallen heroes of our wars by saying "they fought for liberty." True enough. However, no Fascist or Communist has ever taken away any of our liberties. Fine, upstanding citizens took the liberties we lost in the 20th Century away. Tyranny was voted by Congress, signed by a President, and upheld by the Supreme Court, despite the First Amendment. It does no good to pledge allegiance to "liberty and justice for all" if we are unable to recognize transgressions. A violation of liberty is tyranny. One instance of such democratic tyranny is the War-On-Drugs.

The failure of Prohibition should have told us exactly what the War-On-Drugs would do -- gangs, drive-by shootings, corruption of the police and other officials and a general decline in law-and-order.

The whole point of the science of civilization is to learn from experience. As a society, we failed to learn anything from the failure of Prohibition. I have heard many arguments against the War-On-Drugs, but no one points out the worst thing about it -- tyranny, a direct violation of the ideal of liberty. All citizens may do whatever they like in private, no matter how risky, so long as it puts no one at involuntary risk. I can show by many examples that this **is** the Ideal of Liberty and that the War-On-Drugs violates it.

Some of the illegal drugs are very risky, but fewer people die of them than die directly or indirectly as a result of tobacco and alcohol. Besides, everything is risky. Voluntary risk is irrelevant. We allow people to drive in cars, even though forty thousand people a year die in them. Cars leave another hundred thousand paralyzed or permanently brain damaged. Cars kill twenty thousand pedestrians and bicyclists every year. We allow people to climb eight thousand-meter Mountains, even though a third of the participants in this sport die of it. For every four people who reach the summit of Mount Everest, another climber will die. The glaciers around Mount Everest are graveyards, containing hundreds of bodies. Voluntary risk is evidently irrelevant in considering whether we have the liberty to do something.

It is not just the War-On-Drugs that is wrong. All the blue laws are wrong. This includes the outlawing of drinking, gambling and

prostitution. It is not that I advocate or wish to practice these things. Liberty means allowing other people to do things you disapprove of, if they will give you the same right. We all have different lifestyles, different tastes. It doesn't matter if something is a sin according to the preachers. I could say preaching is a sin, since it is a revival of the Puritanism which burned heretics and witches in our early history.

I have a lot of Web friends who enjoy marijuana and magic mushrooms. They are very nice, kind, loving, spiritual people, the best people I know. Yet, they run a terrible risk of persecution at the hands of the DEA. Government agencies no longer bother with civil liberties, such as the 4th amendment against unlawful search and seizure. Anyone carrying a large amount of cash is apt to have it confiscated, because the DEA thinks it must be drug money. There are other reasons why one might carry a large amount of cash, going to a wholesale auction of cars, for instance.

In Oklahoma, there is a law on the books prescribing life imprisonment for mere possession of a small amount of marijuana, although this law is never enforced. In fact, marijuana is the second largest cash crop in Oklahoma. The people elect the local Sheriffs and District Attorneys. A similar disregard for the laws by local sheriffs and DAs was not uncommon under Prohibition.

"We hold these truths to be self-evident, that all people are created equal, endowed by their creator with certain unalienable rights, and that among these are life, liberty, and the pursuit of happiness." These stirring words in the Declaration of Independence (slightly translated), written by Thomas Jefferson in 1776, set off a rebellion and a revolution. The Founding Fathers, scions of the Enlightenment, put down Puritanism as a mere superstition of the dark ages. Apparently, Puritanism was only laying low, gathering up its energies, to return with a vengeance in the 20th Century, as a counter-balance to the reductionist religion of science. A Puritan is someone who is afraid that somewhere, somehow, somebody may be having fun. The hippies of the 1960s did seem to be having lots of fun, with pot and psychedelic drugs, free love, rock and roll, and freedom of expression in art, face-painting, spiritual and metaphysical pursuits. All of this was to be crushed out of existence in the following decades.

The truth of liberty is not self-evident, and that is why we need this science of civilization. I doubt that we are endowed with liberties by divinity. Nor are rights inalienable. A person may forfeit his rights to life, liberty and the pursuit of happiness by his own criminal acts or by treason.

Which is the stronger allegiance? Our pledge of allegiance to "liberty and justice for all," or our actual allegiance to stamping out the production, sale and use of illegal drugs, no matter what the cost in money, the corruption of law and order in nations such as Columbia, and the cost in blood on the streets here at home, as rival gangs shoot it out in the night? I guess that is a rhetorical question. Gangs blight whole neighborhoods in our big cities. Generations are swallowed up in the gangster life, with its blood rituals of initiation. These are the fruits of tyranny. If we legalized gambling and prostitution, there would be no economic basis for gangs. In addition, who are these tyrants? They might be your neighbors. They might be your grandmothers. They might be you, normal, law-abiding people, who sing the National Anthem without a shred of irony. We have met the enemy and it is us.

Oklahoma remained a dry state long after every other state was "wet". There was a curious alliance between my grandmother's Women's Christian Temperance Union and the bootleggers. Neither wanted to repeal Prohibition. As the saying went, "The drys have their law, and the wets have their liquor." The WCTU seemed satisfied in punishing the wicked, while bootleggers and moonshiners continued to make a good living. The same is true today of the coca leaf, marijuana plants, opium gum and the various natural psychedelics. Prohibition creates another problem. Addicts have to come up with a lot of money to support their heroin or cocaine habit. Therefore, they turn to armed robbery of gas stations and convenience stores. Jittery addicts in withdrawal sometimes murder the clerks. Their blood is on your hands, you fine upstanding citizens, if you are one of the tyrants who support the war on drugs!

The violence of American society began with Prohibition, and continues because of the War-On-Drugs. We not only incarcerate more of our population than any other nation; we also have the highest

murder rates among First World Industrialized nations.

As one piece of evidence for that claim, I refer you to a *New York Times* article of June 27, 1990, p. A10 that offers a comparison among industrialized countries of the number of murders per year per 100,000 young men between ages fifteen and twenty-four. The years of the study were 1986-1987. Austria was the safest place, with 0.3 murders per 100,000, followed by Japan with 0.6 per 100,000, followed by West Germany, Denmark, Portugal and England. England had 1.2 murders per 100,000. Over the entire nation, we had twenty-one murders per 100,000, but some regions were much worse. Michigan had a murder rate of 232 young men murdered per 100,000. Detroit's rate was higher still, well over 300, a thousand times worse than the murder rate in Austria. Murder has become the number one occupational hazard for women, in part because of the number of convenience store clerks murdered by utterly sociopathic robbers, and in part due to berserk mass killers. "Going Postal" is what we call it in the US. And this doesn't even count the thousands of young women who just "go missing" every year, and are never found, obviously the victims of hundreds of serial killers roaming the country, smart enough to hide the bodies where they will never be found.

Since 1990, murder rates have declined some in the US, and increased in the UK, especially in London. Where I live, there are still robbers who kill, and gang member drive-by shootings nearly every night in the TV news, and the local market is fairly small, only about half a million in size.

Is the satisfaction the Puritans get from "punishing the wicked" sufficient to reconcile us to a murder rate 1000 times worse than other First World Nations? That is comparable to Third World countries like Liberia! Can we justify the murder of hundreds of convenience store clerks by desperate crazed junkies? The Puritans think that legalization would produce more desperate crazed junkies. It wouldn't if we treated addiction as an illness rather than a crime. How do I know? Look at the example of the Netherlands.

Marijuana has never been illegal in Holland for citizens, and they treat addiction to harder drugs as medical conditions, rather than a crime. Addicts from other countries are deported. Treatment usually

consists in free maintenance doses of the drug of addiction. And they have seen no increase in addicts or any rise in other sorts of crime. The rest of Europe is now following their lead, and has begun to introduce a little bit of liberty and common sense into their drug policies. See *Newsweek*, "Europeans Just Say 'Maybe'," 11/1/99, p. 53.

The Puritan Overclass in the US may be afraid that legalization would result in chaos---streetwalkers on every corner and crack dealers in every schoolyard. The definition of liberty only applies to private behavior. We need not permit it in public. The Public Vs Private corollary is part of Jefferson's Ideal of Liberty. This ideal, one of several that I regard as true and well-established, says that every community has the right to set its own standards for what is allowed in public, what is permitted at work, or in stores, or on public media, or public transportation. See the chapter on the 7 ideals.

The Ideal of Liberty says we must allow prostitution, but we do not have to allow streetwalkers. We can instead have private "sporting houses," which was, in fact, the pattern in the US in La Belle Époque, before the 20th Century wave of Puritanism. We can also draw a distinction between drugs that may be sold and advertised in public and those that must be sold (quite legally) in private, from a dealer who comes to your door. I draw a distinction between the public Herb shops and the private dealers.

In the public Herb shops, we would find natural leaf tobacco, opium gum, estate bottled wines, beers and aperitifs. A farmer or coop of farmers who grows his own barley and hops, makes his own malt, and brews his own beer, putting it into kegs or pony kegs to go the Herb shop or private purchasers is an "estate bottler." The reason I suggest this little wrinkle is to reduce or eliminate the advertising of beer and wine, as well as to provide more local variety.

The Herb shops would also have marijuana from various different places, magic mushrooms, peyote buds or purified Mescaline, fresh or dried coca leaves to be used as they do in the Andes, as well as opium gum and herbs and aromatic plants of all kinds. You could buy Cocaine, Camels and Jack Daniels only from a private dealer. Thus, you see that I advocate putting some things in the Private category that are presently in the Public category. Cigarettes and

distilled spirits, for instance. Purveyors could not advertise items in the private category.

When I say, "locally grown", I mean something like "estate bottling." The Herb shop buys its herbs directly from those who grow them, dry them, ferment them, or distill them even if the farm is in Columbia or Afghanistan or Brazil. In the case of alcohol, I would allow estate bottled aperitifs in the Herb shop, because they are consumed in tiny glasses, or added to a cup of coffee. I would also allow mescaline, as being no more dangerous than Peyote, and much easier to consume. Eating peyote buds always leads to vomiting. Same rule about Ayahuasca and its associated herbs. The Indians of Brazil always consume the combined product, not just the Ayahuasca by itself. This prevents nausea. These same Indians could distill the active ingredients in both herbs, and sell it in liquid form in the Herb shops, for the same reasons we allow mescaline. I would also allow laudanum in Herb Shops, since it was freely sold throughout the 19th Century, despite the danger of addiction. Laudanum is a tincture of opium in alcohol. Laudanum is measured out by the drop, just like mescaline.

The boundary of all liberties, including religious freedom, freedom of the press, personal liberty, and free speech, is placing others at involuntary risk. Some say that drugs, gambling and prostitution do have involuntary victims, because legalization increases public health problems, such as addiction. While this factual claim is untrue, let us ask if drugs, gambling and prostitution in private would put anyone at involuntary risk. I freely admit that doing it in public would place people at involuntary risk and that is why I want to keep it in the private category. We do not allow drinking and driving in public; similarly, we should not allow driving while intoxicated on any kind of drug.

Any activity has unwilling victims, in the grievous loss suffered by friends and relatives of the diver who is now a quadriplegic, or the parents of the toddler drowned in the backyard pool. These are accidental victims, not covered by the rule on involuntary risk. Note that "victimless crime" is an oxymoron. How would you punish it? Make the pot smoker smoke still more pot?

It is possible to do something about the public health problems associated with drug use. Communities with long exposure to a particular drug have developed customs that protect them from addiction and disease. Pre-Columbian Native Americans did not have lung cancer or emphysema, because they didn't smoke all day or every day. Smoking was part of a social ritual, when entertaining visitors, or conducting pow-wows. Italian peasants don't become alcoholics because they use wine as a food. They consume it at meals, with grandma and the children present (who get watered wine). It is shameful to become inebriated at the family table. They avoid distilled spirits. Andean peasants don't have a cocaine addiction, because they chew the raw coca leaves, with lime, and they do so to give them strength and endurance in the rarefied atmosphere of the Andes. Turkish peasants don't have heroin addictions because they use the raw opium gum only to treat toothache and other pain. It is apparent that we should all try to emulate these folk customs. Just to take opium as one example, the experience of physicians is that if we take only enough opium to alleviate pain, we never become addicted to opium.

How do we treat addicts? I would suggest two routes. Those who wish to get rid of their addiction can sign up for a free 6-month stay in the locked grounds of a rehabilitation center. Those who do not could ask for a free maintenance injection every day at the local Free Clinic. As for the rehab center, once a person voluntarily signs herself in, she has to stay for 6 months. That is the minimum time for the brain to heal and relearn how to live a sober life. An addict must be forever on their guard, and must not frequent those places where their drug is used or available.

Wouldn't we have more junkies if we legalized drugs? The Puritans were sure there would be more alcoholics as a result of repealing Prohibition. That did not happen. So the question now is whether or not the ideal of liberty (now that you understand its implications) is true or not?

How do we apply scientific method to social ideals? What we need is the equivalent of a theory, a test, and the results. The alternative that survives all testing is the well-established conclusion. Maybe at some future time, we will think of a better theory, or

continued pushing on the envelope of testing may eventually refute even a well-established theory. For the time being, it is the best we can do. It is the only known solution.

In the Science of Civilization, or "Utopian Analysis," the equivalent of a test is a political experiment, such as the 75 years of the Socialist experiment in the Union of Soviet Socialist Republics, or the afore-mentioned experiment in Prohibition. The result of such a test is what I call a "normative particular." I suppose you could call it a "value fact," so long as we understand that values are not facts, and facts are not values, nor can we infer one from the other. That would commit the Naturalistic Fallacy. What we observe is the failure of socialism, whenever and wherever nations have tried it. We also observe the failure of prohibition.

The collapse of the Soviet Union is an historical fact, but the failure of the Soviet Union or of Prohibition is an observed normative particular. We did not infer it. We could not have predicted it without making the test. It is an object lesson from history. Every social controversy is a consequence of two conflicting social ideals. This is the "analysis" part of Utopian Analysis, digging out the relevant ideals. Every major ideal and its alternatives has been tried, somewhere, at some time. History provides us with all the political experiments we need to study. I do not regard communes (intentional communities that have withdrawn from the larger societies) as adequate political experiments. A commune can live on idealism or the charisma of its leaders. Real world political experiments cannot.

We pursue an ideal, but rarely attain it perfectly. "Utopia" does not mean "perfection". I do not use the term that way. In my usage, any attempt to improve society is utopian, and ideas about improving society should be practical. "Utopia" does not mean "the impossible." In looking for evidence for liberty, we must compare societies that are relatively authoritarian with those which are relatively libertarian. Therefore, it is Sparta versus Athens, Rome versus Classical Greece, France of the Sun King versus England of the Glorious Revolution that made Commons superior to monarchy, Lords or Barrister. More recently, it is 19th Century America versus the monarchies, Czars and Emperors of 19th Century Europe; during the Cold War, it was the

democratic West versus the autocratic East.

The Hellenic world imitated Athens, not Sparta. Two thousand years of scholars have preferred Classical Greek culture to the brutal world of the Roman Empire, at least in most respects. During the Cold War, the Soviets had to put up walls to keep their population in, since it was rapidly evaporating to the West. Moreover, 19th Century America was the light of the world. That is why immigrants poured into this country from all over the world, and still do.

The people of France gave us the Statue of Liberty because they admired our society above all others. "Send us your tired, your poor, your huddled masses, yearning to breathe free," wrote Emma Lazarus in the famous poem now found on a plaque at the foot of Lady Liberty. "I lift my lamp above the Golden Door," says Lady Liberty, and so she does. Our ideals of liberty are the light of the world, and have spread the ideals from the Book of the Law she holds in her left hand around the world. Now if only she would shine a little light on the darkness that has grown right here at home!

Notes on Ecology

There are endless corollaries of the First Ideal, Thomas Jefferson's Ideal, of Life, Liberty and the Pursuit of Happiness. For instance, the survival of our species is clearly necessary for the life of any individual. The survival of our species depends on the general ecological health of Earth. It is hard to be more specific than that; still, the death of any species must be a warning. Even more important as a warning is be the death of an entire eco-system, such as coral reefs, now bleached white in many parts of the world, or the fate of frogs, an entire genus that has survived hundreds of millions of years, only now to succumb to our modern industrial world, and we are not even sure why. We do know that they have parasites that cause growth deformities. Sometimes a new disease can come along and nearly wipe out a species, as we have seen with the fungal blight that destroyed the American Chestnut, and a different blight that nearly wiped out the American Elm. We also know that songbirds are disappearing from Eastern woodlands in the United States.

To add to this miscellany of mysteries, we find a steady decline in the fertility of American men. Again, the reason is unknown. Is it due to trace amounts of some industrial chemical that does not break down in nature? It could be. This could be part of the problem with frogs and coral reefs. Thus, I propose that we allow no industrial chemical out of the laboratory until we can find or develop a bacterium that can break down that chemical. We must be very careful to control every new chemical. Everything necessary to dispose of a chemical must be in place before we allow any industry to use that chemical. We should apply the same rule to every industrial chemical that is already loose in the environment. If this brings a halt to "better living through chemistry," I don't care. Better that than the loss of coral reefs or the loss of male fertility.

We know that sometimes, many times, the problem is loss of habitat. Therefore, I propose that we preserve the habitats we have, and restore those which have been lost, in so far as that is possible. We cannot bring back extinct species, but perhaps we can save those on the brink of extinction. Everyone has been talking about the rain

forest. Except for a cold weather rain forest on the coast of Washington State, the US doesn't have any rain forest. Let us worry first about our own marine, forest and prairie habitats that we are in danger of losing forever. Thus, I propose that we maintain a 200 mile sanctuary off the Ocean coasts of the US, where we allow no hunting of wild creatures, by anyone, ever again. I suspect we could easily persuade Canada, Mexico and Caribbean Islands to agree. Such a marine sanctuary would allow the stocks of whales, corals, and numerous varieties of fish to return to their Pre-Columbian level.

This doesn't mean giving up seafood. It means that all seafood used in the US must come from fish farms. The fish farms themselves are an ecological disaster in many cases. This is a relatively new kind of agriculture in this country, and we shall have to learn how to dispose of waste and how to keep penned up sea life from succumbing to disease or parasite.

In the US, we have only very tiny portions of the original prairie or the original old growth forest. It cannot survive grazing by domestic animals. We must immediately put a halt to the destruction of what small pieces of old growth forest and original prairie that still exist. I grew up on what was once prairie, but even then, back in the 40s and 50s, I knew of only one piece of virgin prairie. It was a prairie meadow cut once a year for prairie hay. We only mowed it for prairie hay. Cutting prairie in late July or August may destroy some of the species, but most survive. A prairie is a complex ecology of hundreds of different plants, most of which bloom sometime in the growing season.

Most people have no idea that you can never graze prairie with domestic livestock. Animals native to prairie, such as the Bison, clip the grass by biting it. This doesn't harm the grass, because it grows from the bottom, not at the tips. However, a cow will wrap its tongue around a clump of grass and pull it up, roots and all. Goats and sheep graze everything right down to the roots. The only domestic animal that is not destructive of prairie is the horse because it clips the grass by biting it, rather than by pulling on it like cattle.

The other fact about prairie that is generally unknown is that it is an ecology born of fire. Prairie consists in all and only those species

of plants and animals that can survive the occasional prairie fire. The prairie dog is a species of gopher that can survive by crawling into its underground den. Likewise, with coyotes, wolves, and ground squirrels. Fire is necessary to keep down the weedy trees, such as Jack Oak and Red Cedar. If one drives around central Oklahoma, one sees nothing but useless Jack Oak and Red Cedar, growing on what was once prairie, then farmland, then abandoned. Across the whole vast prairie, people are vanishing from the countryside, and congregating in cities and towns. It is no longer possible to make a living on the prairie, and no one has been setting fires to keep down the weedy trees.

This must change. I propose national and regional zoning rules. What was once prairie will be prairie once more. We must preserve mountain meadows and old growth forest, though magistrates could grant local exceptions. We could hire rural people still living on the land to return it to its original state. I propose voluntary compliance from the landowners. Wherever a sizable block of land has been created by voluntary compliance, university specialists in prairie ecology should head up a restoration effort, beginning with the removal of all roads, fences, and power lines, the burning of all trees, and followed by the planting of the precious few seeds of the myriad prairie plants still in existence. We must harvest seeds by hand, because each plant produces seeds in its own way, and in its own time. Hire the local rural people, who once tried to make a living on the prairie, and teach them how to hand harvest seeds, and how to sprout each one of them in a greenhouse. Cuttings instead of seeds might propagate many species. It will take a lot of time and a lot of effort to restore barren ranchlands to true prairie, but it is worth it. I know from experience. There is nothing more lovely than true prairie. The grass itself smells wonderful, in a spicy herbal way, quite unlike domestic grasses. True prairie will change week by week throughout the growing season, as different plants send up showy stalks of flowers. After frost, the Big and Little Bluestem will take on a purplish color that a color blind person might call "blue." In the winter, the large grasses take on the color of gold and electrum. In February, it turns brown, and it is time to burn it.

Prairie is the one native ecology I know from personal experience. Therefore, I shall say little about the other ecological zones. I have seen mountain meadows full of flowers. That is surely an ecological system we must preserve. I have been in national parks on the Olympic Peninsula in Washington State, where towering Hemlock trees create a wonderful living cathedral, with no brush or grass in the understory. Surely, we must preserve that. Let those who know what it was once like step forward and convince us all of the beauty and the value of the original ecological systems.

If you ask me, which is more valuable, the spotted owl or the logger, I will say "the spotted owl." Value depends on scarcity. There are very few spotted owls and very few edible wild mushrooms left in the forest. There are lots of loggers, and they leave behind a blighted clearcut landscape, open to erosion on steep and naked slopes. After the topsoil is gone, nothing will ever grow there again but weeds. We should quit using wood as a building component. Galvanized steel should make up the framework, and the new steel roofing systems that look like shingles or slate, should take the place of wood or asphalt or fiberglass shingles. Brick or stone or tiles should make up the exterior walls. Buildings should last forever, not just for the lifetime of a 30 year mortgage. Something we can all do to preserve the forest is to take away the market for wood products.

I also advocate voluntary rather than involuntary compliance with ecological zoning rules. Give the local people steady jobs maintaining and reviving those ecological systems they once worked to destroy. Use explanation and persuasion, not force.

There is another natural resource that we must preserve as a moral imperative and a matter of common sense and that is the human genome. There are plenty of "mad scientists" who want to tinker with the characteristic longevity of humans. Every species has characteristic longevity, determined by heredity. I don't think it is an accident. Every species has the longevity it has found useful in the struggle for the survival of that species. And so it is with humans. We are an Ice Age species, living in the midst of a seemingly unending series of Ice Ages. Which do you think is more likely to survive, a species where almost everyone is old and almost no one is young, or

the reverse? Only young adults can reproduce. Only the young can adapt to rapidly changing conditions, and that is almost a definition of the glacial part of an ice age. We happen to be in the interglacial part of an ice age, but it will soon come to an end, as climatic oscillations grow more violent. We have already seen the first of these oscillations in the Viking Warm period, the Little Ice Age from 1350 to 1850 and now another warm period, which will last for several centuries no matter what we do about greenhouse gases. For one thing, the atmosphere is not a static pool that just accumulates these gases. CO_2 is the very stuff of life, rapidly cycled through the biosphere. The actual amount of the rare trace gas CO_2 (350 ppm) is a dynamic balance between the relative vigor of the animal and vegetable kingdoms.

We know a lot about the last 4 ice ages. There have been 21 in all over the past 2 million years. We know that carbon dioxide correlates with global temperature, but which is cause and which is effect? Tectonic and astronomical forces dictate the coming and going of the glaciers. If carbon dioxide declines in cold periods, it is because animal life declines in the cold, while the plankton are much less affected.

Endless War

Nuclear weapons add nothing new to the problem of war. Even in Neolithic times, it was possible for war to destroy a community, with all its inhabitants wiped out, its buildings burned and leveled with its language and traditions utterly lost and forgotten. Nearly every "tell" in the Middle East, tells us just such a dreary and dreadful story. War is not new and neither is total war. Strategies for conflict avoidance or conflict survival have not changed either. All the known strategies have been tried many times. There are consistent patterns in the success or failure of these strategies. The solution to the nuclear madness is the solution to the problem of war. We know the solution. It is the ideal of higher community. What it means is those two formerly warring communities combine into a larger community stronger than any one of the factions. This is not an idealistic pipedream. It has happened many times.

Remember Romeo and Juliet? This is a true story from medieval Verona. The story of the young lovers is set against the backdrop of a clan feud between the Capulets and the Montagues. Each clan built its own tower, trying to build one taller than anyone else's. These medieval towers still exist in some small Italian towns. Medieval city-states were plagued with armed clashes between clans in some periods, and clashes between classes in other periods. For instance, the Guelfs and the Ghibellines were political factions in Italy who fought each another in the last 200 years of the medieval period. The Guelfs represented the free merchant class of cities like Florence, whereas the Ghibellines were the Imperial Vicars of Italian cities controlled by the Holy Roman Emperor, and their followers.

Stable city-states were finally achieving success everywhere in the time of Machiavelli. Naturally, he approved of this. Peace is always preferable to chaos. *The Prince* is part observation of the process at work and part prescription.

Of course, as soon as baronies and city-states became strong enough to keep peace between clans and classes, they began waging war on one another. Perhaps you have read about the war between Genoa and Venice when Genoa captured Marco Polo? If Genoa had

not captured him, we would not have had the book of his travels. He dictated it to a fellow prisoner. Genoa and Venice were always fighting. Florence, Siena and Pisa were often at war with one another.

Hundreds of years of war between France and England make up the medieval history of those two countries, retarding the Renaissance in both places. Crecy, Agincourt, the Hundred Years War, the Thirty Years War, and the Napoleonic Wars are just a few names that swim up from the dismal history of France and England from the Norman Conquest until World Wars 1 and 2. It is only now, with the Chunnel and the European Economic Union that we can at last be sure that the major states of Europe have ceased their bloody and pointless feuding.

World War Two was the last of the global wars between states. The reason is the appearance on the scene of a larger political unit, the nation of states. For a time, there were two "United States," the United States of America and the United States of Soviet Republics. Now there is only one, the USA, since the USSR unfortunately came apart at the seams. This is always unfortunate, because the internal states are soon at war, as in Chechnya. Soon, there will be two nation-states again, as the EEC and NATO evolve into a European nation of states. No individual state can stand up to a nation.

Not only are NATO and the EEC steadily growing more united, they have gained new members, and many of the former communist states of Eastern Europe have now joined, and there will be a de facto United States of Europe that may include all of linguistic and demographic Europe.

Dissolution of the USSR and of Yugoslavia as well as the US Civil war sounds a cautionary note. The temporary union of a group of sub-communities does not mean they have formed one community. Sometimes it happens, and sometimes it doesn't. Before our own Civil war, we had one government, but two communities. Only recently can we really call the USA a single community of states.

Can we integrate the fanatic hate-filled masses of the Middle East into this global harmony? No. They will have to join the 21st Century.

Gridlock

By "gridlock", I mean the traffic jams that bring freeways to a complete stop during rush hours as well as the congested stop and go traffic on city streets the rest of the time. The solution is not to build more freeways. Los Angeles is proof of that. We know the solution. The next time you are brought to a complete stop on the freeways, for no apparent reason, imagine all these cars (and your own) magically replaced by bicycles. No more gridlock! All of you would be able to continue on your way at speeds of 20 to 35 miles per hour. The average speed of rush hour traffic in many cities is only about 5 miles per hour. That is about the same as a fast walk.

This idea comes under the aegis of Thomas Jefferson's magnificent formulation of the ideal of liberty that insists upon life, liberty and the pursuit of happiness. Riding a bike would certainly improve your health, and it would give you the liberty to go anyplace in the Metropolis in accordance with your own pursuit of happiness. If you must have a car, keep it out of the Metropolis and drive it on weekends.

At rush hour, we have a large number of people who wish to go at a certain hour from their suburb to many destinations within the metropolis. Is there any kind of mass transit that can handle that? There is, and it imitates some characteristics of private cars. The only thing that can carry an unlimited number of people at time T from A to B is some sort of train, where each car has its own power pickups to overhead electrical lines, its own motors, and its own automated controls. I call this the rubber-tired Freeway bus/train, since the individual cars (or a small number connected) can act like a bus, while connecting them all together produces a train. The reason such a train can handle an unlimited number N at time T is that we can always add more cars to the very same train that pulls out of the station at time T no matter how many cars make up the train, whether many or few.

Making the destinations of those individual cars different requires a little subtlety, and this train is not like most trains. In this mass transit system, there is no central train station, no central hub where all cars of the train wind up.

Let us think about Los Angeles as a model, and imagine a train that starts out just beyond the extreme eastern edge of the Metropolis, perhaps at San Bernadino. It starts out small, but at each stop as it approaches the center of the Metropolis, some small pieces of train attach on to it. At each stop, people get on and off. At each intersection with a major highway or freeway, some people will ride up or down a spiral ramp and change to a different freeway train, ones that may have started in Pasadena or Whittier or Long Beach or somewhere down in Orange County. Once on the train, riders will be moving forward or backward to get on the right car, for eventually each car or group of cars will break off, take an off-ramp to a street and become a bus, traveling all day and all night up and down that street, until those times when buses coalesce again into morning or evening freeway trains headed to or from one or another of the farthest suburbs. There may be several morning and evening commuter trains starting or arriving at different times.

To become a freeway rider, one must get on the Web site for that purpose and enter starting point and ending point as well as the time one needs to be at a terminus, both for the morning and the evening rush. After everyone has done this, the computer will figure it all out and issue instructions to each rider. Each rider will then know where to get on, which train to take, where to get off it, where to transfer to a different freeway train (which must synchronize their arrivals at major freeway intersections) and finally the car number to get on. There will not be train/buses on every street, just the large ones, so the passenger will walk or ride a bike a few blocks or a few miles, on either end of the trip. Travelers to the Metropolis will do the same thing, and will have an instant "ticket" explaining which trains to take and which cars on those trains.

We will have a traffic mix of freeway trains and buses confined to certain lanes of freeways and streets. Bicyclists should stay out of those lanes. We can identify them because they have double electric wires strung overhead. In order for this traffic mix to be safe and predictable, we must eliminate all cars, trucks, and diesel buses, including all taxis. It is impossible to imagine a safe environment for large numbers of bicycles and rickshaws on Manhattan streets as long

as those fleets of yellow cabs still exist.

There is one other type of vehicle we must allow, and that is the electric delivery van, with a driver that can ride in the bus lane and pick up electricity from the overhead wires, or it can run at about 20 mph on batteries alone. It would be unsafe to the bicycles if it went any faster. There must be parking places reserved for delivery vans, out of the way of the train/buses.

So how do you get your groceries home? Have them delivered! Same thing with furniture, appliances or any large load that would not fit in a backpack. The delivery trucks can also call on your place to make a pickup, of furniture or appliances, or a load of crushed and compacted aluminum cans, a box of hazardous materials, or anything that will not burn in the environmentally friendly incinerator. Everyone will have garbage disposals. There will be composters and incinerators in every neighborhood. A pipe to a central plant will suck exhaust from incinerators for further processing.

A city that runs on electricity and human muscle power has the potential to be solar powered. Such a city will be smog free and residents will lose their load of fat. People who love their cars can still have them, just not in a Metropolis. I expect that a good business in San Bernadino would be garaging private cars, ATVs, trucks, and any other internal combustion vehicle. Electric locomotives in the Metropolis will pull trains, and long haul truckers will have to transfer their loads to or from such trains. Another good business in San Bernadino.

In the past, I have argued for a solar-hydrogen economy. I no longer consider that feasible. Hydrogen functions primarily as a means of storing energy. However, it is devilishly difficult, requiring high pressure and extremely low temperatures to liquefy. Natural gas can be liquid at normal outside temperatures, so that is an improvement. LNG still requires a strong steel container, since LNG is liquid only at high pressure. The best solution might be methanol. It is liquid at normal pressures and temperatures and it we can make it from coal, trees, brush, weedy fast growing trees, chicken waste, pig waste, cow waste, horse waste, even human waste. Cars could run on methanol. Maybe airplanes could run on methanol. Burning it does

release some carbon into the atmosphere, but a methanol economy would release only about one percent as much carbon as petroleum or coal, particularly if we greatly increase the efficiency of our engines, houses and public buildings.

This concludes my brief utopia. The important thing in the science of civilization, also known as utopian analysis, is the scientific proof of the major social ideals. It is equally important to recognize violations of those ideals, such as the military draft, or the war-on-drugs. It is also useful to design specific solutions to specific problems that fit the technology and situation of the times one lives in, solutions compatible with the great ideals of the Founding Fathers of the Enlightenment. I believe the seven ideals used here are true for all times and places. In my utopia, the seven ideals are the totality of the permanent law, and the constitution is a brief paragraph explaining the functions of magistrates, metropoles, governors, and archons.

Any member of the Aristarchy should be able to make a ruling on a particular case, based on the seven ideals. That ruling only applies in his or her domain. Rulings from far and wide will be collected and distributed throughout the Aristarchy and to the public. I expect these rulings to constantly change, and to be different in one place than another. It is not the letter of the law that is important, but its embodiment of the seven ideals. As language changes, so must the rulings change to keep up.

The Aristarchy combines all functions of government into one. There will only be one type of law, which applies to everyone. There will be no torts, no juvenile courts, no specialized courts of any kind.

Imprisoned Splendor

The common usage of the term "mystical" is "everything unseen and unreal." It was the late 19th Century American philosopher William James who gave us a usable definition of "mystical" in his book *The Varieties of Religious Experience*. A mystic is not someone who has read about mysticism, or believes in it, or pursues it, or practices it. Mystics are those who have actually had mystical experience.

Among religious experiences, only the mystical experiences are the same whatever the religion. They are reproducible in the sense required by scientific method. William James lists a number of characteristics of mystical experiences:

(1) They are ineffable. That is, one cannot talk about them.

(2) They are Noetic. That is, each conveys some deep and profound truth.

(3) They are transient.

(4) They are ecstatic.

(5) The mystic is passive.

(6) There is a sense of union with everything.

He has left off the best indicator, the numinous feeling of light. Illuminated, in other words. That is why we are the illuminati. Item (6) is not quite right. All mystical states are unitary, in that one sees seemingly contradictory things, like good and evil, as part of one whole, but that is not the same as a sense of union with everything. It is not so much that mystics are unable to talk about their experience as that they are unwilling to do so. Saint Thomas Aquinas experienced illumination in his old age, and he would say nothing about it, except that it made nonsense of all his writing. If a person is young when they have their illumination, and they live long, there may come a time when they decide it would be better for mankind to talk about it. It still feels like casting pearls before swine, in other words, revealing something ultimately precious, timidly, in hopes that others will not trample it in the mud. As far as passivity is concerned, that may be true of the accidental mystic, people like me, but it would not be true of someone who achieved a mystical state by deliberate spiritual

exercises of some sort. Mystical states are not all transient. I can spend hours at-one with the wind, the prairie, the moon, and this is the experience of the nature mystic. I can also spend hours in the luminous world of genius, the ecstatic world of the advanced day-dreamer, "bathing in the waters."

I make a new and shorter list that distinguishes the mystical state. The requirements are (1) Illumination, (2) Noesis, (3) Ecstasy, and (4) Unitary insights.

When I was 31, I experienced the illumination of fire, also known as Cosmic Consciousness. Fire filled and surrounded me. There are five to seven illuminations with specific colors of light, as well as three other mystical states that are numinous and ecstatic, but not filled with any particular color. Each has its own Noesis.

The word "en-light-enment" has "light" as its root, so one would expect it to refer to Illumination. Buddhists translate the desired state "enlightenment," but I have it on good authority that this is a mistranslation, and the term really means "awakening." The style of meditation practiced in Buddhism does not lead to Illumination, but it may well lead to other kinds of epiphanies, such as "awakening."

The Problem of Evil Solved

I use this chapter as exposition of my own Noesis, the thing I learned from the Illumination of Fire. I learned two things. Divinity is real, and there is a divine purpose, not a divine plan. So doesn't this give a meaning to life, once understood? I think so.

If there is divinity and a meaning to life, why do bad things happen to good people? This is not just a medieval conundrum. Scott Peck and Rabbi Kusher have tackled this question in our own time. Only the illuminati can answer this question. This is the Noesis of the illumination of fire, to see, in a single gestalt, a single pattern running through all of life, all of history, all of time, a pattern that makes sense of struggle and pain and loss, because they are necessary for renewal and creativity. My 2 year old daughter, happily playing by herself in a sand pile, making up games and songs, innocent and fresh, full of grace and joy--she expresses the meaning of life. The Mockingbird I hear as I write this represents it. The lives of birds and of flowers are full of play and beauty. The illuminatus opens his arms wide, in orison, and welcomes the terrible great joy of the universe, including the earthquakes and volcanic eruptions that show the planet is alive and changing. Even the wars and plagues are part of the divine purpose since we still need these challenges and renewals to push us out of our rut, and continue the evolution of civilization. Someday we will outgrow the need for human violence.

There is a divine purpose, and therefore a meaning to life. This purpose is incompatible with having a plan. The next time a preacher starts going on about god's plan to take a little child back to heaven, just know that divinity does not kill children. If a child runs in front of a speeding car, it may die, and if it didn't then we would be living in a totally chaotic universe, without scientific laws of cause and effect.

Death is not the ultimate evil; death is renewal. Death is the way a crotchety old fart becomes a happy toddler once again. Pain and frustration are but challenges to jolt us into a creative response. It is a cruelty and not a comfort to say to someone who has lost a child that it is God's will. There is no God, and there is no Will. There is only a divine purpose. The future is what we make of it. There is no God

because "God" is a name, as is "Jehovah," "Allah," and "Brahma," but ONE is nameless. As soon as we give divinity a name, it becomes divisive, an excuse for "ethnic cleansing," because it becomes attached to a particular historical and religious tradition. It makes everything personal, as if god were punishing us. Neither is true.

Instead of saying, divinity is good; we should say divinity is purposeful. The divine purpose that runs through all things is this spontaneity, creativity, and grace, joy concept for which we have no English equivalent. This is the Noesis of the illumination of fire.

I propose the absolute continuity of existence. Our existence goes through various phases and stages that go by such names as sleep and waking, life and death, human existence and non-human existence. Life and history are full of both positive and negative experiences. We perceive pain, discomfort, obstacle, and stagnation as negatives. They should instead be welcomed as challenges. How could there be creativity without challenge?

How can there be spontaneity without renewal? Renewal sometimes requires death and destruction, of lives, societies, ideas, species, worlds, and universes. If things merely accumulated, if human lives merely lengthened without end, if there was never decay and destruction, everything would tend towards sameness, a stagnant old age, without freshness, newness and spontaneity. There are three handles on the chalice from which we drink the waters of life: creation, preservation, and destruction. Each may serve the divine purpose. We cannot say that this is the best of all possible worlds, yet it is surely better with grace, joy, spontaneity and creativity than without them. The evils are not as absolute as we think, and they serve deeper purposes than we know.

"Omniscient" cannot mean the ability to foresee everything that will happen. Free will and creativity imply that brand new things and ideas and expressions are and always will be springing into existence, for that is the purpose of all existence.

The medieval idea of omnipotence is also incorrect and incompatible with free will and creativity. The higher Self may put challenges, opportunities and coincidences in our path, but what we do with them is up to us. We may rise, or we may fall. Some accidents are

just accidents. All actions have consequences. If a child or a dog runs in front of a speeding car, it may die. This is just a law of nature, not anyone's plan. It is wrong to say that everything that happens is some god's will. Only preachers talk of God's will, as if they knew anything about it. What they know is a convenient and legal way to fleece the suckers.

So what is the answer to the medieval "Problem of Evil?" Life is better with innocence, freshness, spontaneity and creativity than without. Animacy and creativity make these possible, things quite impossible under the dreary religion of the scientists, where we are all just soulless machines. They would also be impossible in the world of medieval theology, where God wills all things and knows all things. The new age begins when we have liberated ourselves from both dogmas. All religions are evil, but the most evil is the religion of the scientists, because that is the most pervasive, and the one they put into textbooks. That is why in the "Evolved Tarot" the Devil has become the Thinker, up a tree, entranced by his dream of physicality. See http://users.aol.com/pythagoras9/tarot.html.

Soul, Divinity, Immortality

We know from Psychical research that reincarnation is a fact, and therefore we need have no fear of death. Reincarnation makes an excellent beginning for our study of spirituality, for it shows us that the mind (or should we say "spirit?") is completely independent of the brain and survives physical death, to be sooner or later incarnated in another life, where we will forget who we were before, and start over with a clean slate. That is the good news, at least in the materialist west. (In the East, that is bad news!) It would be bad news if life were a terrible thing, some sort of punishment, and most of us in Western Civilization do not feel that way. I suppose suicides feel differently. It would be bad news if we might reincarnate as a cockroach, but there is no evidence for that in Psychical Research.

No, for us in the West, the bad news is that reincarnation is not the same as immortality. Modern science allows us to look forward and backward in time, vast chasms of time, and we know that someday, Homo sapiens will be extinct. Someday, the Sun will become a red giant and incinerate the Earth. Not any time soon, of course. 5 or 10 billions of years from now. No doubt, our consciousness will be able to overcome these two catastrophes. We can flee into some other Humanoid Intelligence, and flee to some younger planet on a long-lived star. Our universe is young. If it is a closed universe, the earliest time at which it could come to an end is the year 2000 billion. It is now the year 13.7 billion. This universe has hardly started. We have not made a dent in the fuel for stars, hydrogen. The ratio of hydrogen to helium is essentially the same as it was in the beginning. Therefore, we can look forward to thousands of giga-years of consciousness.

Still, that is not forever. Someday, this universe will come to an end or become uninhabitable. If the universe is closed, there will come a time when the stars fall down like rain, and this universe will implode. I want to see that dramatic moment. I want to be alive and conscious at that moment. What comes after? The mind is a natural object, part of the universe, a thing with mass. Destroy the universe, and you destroy the mind.

We come to the crucial question. Is the Soul distinct from the mind? Mystical experience suggests that it is distinct. Particularly nature mysticism. The most vivid experiences of this for me were moonlit nights in bed with the window open and a south wind blowing over me. My feeling of union with this bittersweet longing and nostalgia was profound. Are the moon and the south wind one? Forget scientific theory and physical reality. For the mystic they are one, and it is a unitary experience. It is a strong emotion without a thought attached to it. It is not as if the moon-wind had thoughts. It had experiences and to join with it was ecstasy, yet a bittersweet longing. The nature mystic has the ecstasy and the Noesis that is very hard to put into words. I can only say it was not words. It was not symbols. It was not thoughts. The moon-wind does not speak. It was only feeling, only pure experience. The world of the mystic may be quite different from the world inferred from physical sensation. Still, the important thing is that the moon-wind has experience, the chief attribute of the soul, yet it has no mind.

Thus, my hypothesis is that only soul has experience. Indeed, I would define souls as that which has experience. Odd, isn't it, how this is the thing we know best, the only thing we can be absolutely sure exists; yet we know it least, and can say little about it? The so-called theories of consciousness one encounters in academia all involve a *non sequitar,* a place where we must take on faith that X is nothing but Y, whereas X (neurons firing) is quite unlike Y (the continuous field of experience). To say they are really the same thing is like saying George Washington is nothing but a statue on Mount Rushmore.

People have written comments about these ideas in the Guest Book of http://users.aol.com/MysticScientist9/index.htm and some have said if soul is that which has consciousness then it must disappear during sleep. If that were true, we would not enjoy sleep, and would not seek sleep. There is an experience of sleep, just as there is an experience of waking. They are just different, and we have a harder time remembering sleep. We do remember that we enjoy it. It is possible to have an experience of anything and of nothing. Buddhist meditation sometimes leads one to an uncomfortable experience of the Void, a kind of "nothingness." That-which-experiences is not the

- 157 -

same as the experience.

Here is an interesting exercise to break you out of the fly-bottle of physicality. Ask yourself "how big is the soul?" Do you think it is some tiny thing that lives inside your brain? You have to forget about scientific theory, and about naive realism and the customary worldview and that is very difficult to do. Your soul holds the contents of consciousness, and thus must be at least as big as that. It is not as if the soul were watching a two-dimensional TV screen inside your head. No, the contents of consciousness have depth. Right now, my soul contains this computer and the rest of the kitchen beyond it. Are these items real? Of course they are. They have three dimensions. I look out my patio door and I can see the street light on the next street over. Otherwise blackness. Yet my soul is now as big as a city block, since it contains at least the breadth of the block. If it weren't cloudy, I could go outside and find the Big Dipper or Orion. One or the other is always visible. The Milky Way is not visible in late winter, but when it is, how big is my soul? That is incalculable in a mystic's terms, since the stars and even the Milky Way all look the same distance away. It is a long way. Thus, my soul is huge. Indeed, the whole universe is inside my soul when I am thinking about the Big Bang and the history of the universe. I may not be observing it, but if I am imagining it, it is in the contents of my consciousness, is it not?

This may seem the raving of a madman. With practice, one can put aside all theories as fairy tales and believe only the contents of consciousness. One then realizes that the world is in the Soul, not vice versa. The Soul can never be in the contents of consciousness. Mysticism suggests all souls are at root ONE, a One that is divinity, but don't give it personal traits like will. Divinity has as many plans, as many thoughts, as many experiences as there are sentient beings in the universe. This is my second hypothesis about Soul. It is not inside Nature. Nature is inside it. This epiphany is what the Buddhists call an "awakening."

I also must admit that I am no longer satisfied with what Aldous Huxley called "the perennial philosophy" that "everything-is-One." Everything-is-One that is what? The void? Nothingness? That

seems to be the Buddhist answer. Suppose everything-is-One is identical to the universe of the physicists and is destroyed and becomes non-existent? Or uninhabitable? That seems an inevitable consequence of the everything-is-One school (Monism). It seems that those addicted to Monism always are saying that this One-thing is either Nature or Divinity, and the other is an illusion. There are the materialist Monists and the divinity Monists. I believe that both are real and neither is an illusion. If there were no divinity, we would not find the divine purpose in the Illumination of Fire.

We are eternal only if the following things are true: (1) we do not have Souls; we are Souls. We have Minds and bodies. Soul is that which has consciousness. This is the only theory of consciousness that makes immortality possible. (2) Souls can coalesce, like droplets of the ocean, into Divinity. (3) Divinity can either create new universes or select a new universe to inhabit, when this one is dead or uninhabitable.

I believe in mystical experiences, including those that I have not personally had, such as the *unio mystica.*

The *unio mystica* can happen during an NDE, as it did to George Rodonaia, I quote:

"During this time the light just radiated a sense of peace and joy to me. It was very positive. I was so happy to be in the light. I understood what the light meant. I learned that all the physical rules for human life were nothing when compared to this unitive reality. I also came to see that a black hole is only another part of that infinity which is light.

"I came to see that reality is everywhere. That it is not simply the earthly life but the infinite life. Everything connects together, everything is also one. So I felt wholeness with the light, a sense that all is right with me and the universe."

That is what I want, and maybe in some future life I will find it. In the meantime, I think I must leave the question of immortality as an unanswered question so far as my own mystical experience is concerned. Still, it is a possibility, since the soul is not in nature. Nature is in it.

Aldous Huxley discovered the immanence of divinity in all

things, with a little help from mescaline. What he saw was simply the glow of the divine light in flowers, crystals, trees, streams, everything. I don't think he was deluded. This is my view too. I am a dualist. No, I am more than that; I am a triadist. I believe in the separate and independent reality of matter, mind and soul, where soul is the seat of consciousness as well as being a droplet of divinity. We are all gods or at least droplets of divinity in our innermost soul. Matter and mind overlay and obscure the soul, so that the divine purpose in each of us becomes lost. We cannot lose our souls. We ARE souls. As souls, we may become lost and it may take some effort to find our way and see our purpose and our power.

You don't think souls have power? Before we were people, we were prairies and bogs and oceans and lakes. Before that, we were an infant Earth, bombarded by planetoids. Before that we were stars, and before that galaxies. Did god create this universe? You created this universe, as god, with a small "g." Don't get carried away. It is the collective totality of all souls that is divinity. As I interpret the idea of ONE, it means the nameless one is the ocean and we are individually the ocean spray or a snowflake. From the ocean, we came, and to it, we will return. In the meantime, minds and bodies are real too, just not eternal. Spiritual evolution involves all three, the physical world (technology and civilization and ecology), the mental world (as we develop the power to travel to the stars by levitation and apports) and soul, as we see the divinity in all things, and as we embody the divine purpose in all our actions, an act of joy, an act of beauty.

It is soul that has free will, i.e., animacy and creativity. Since everything has divinity, everything can have free will and be pursuing the divine purpose. Even machines. We know from our human existence that we do not have perfect free will all the time. We must first be given a choice, or an opportunity. I believe this happens most often in systems that are non-linear, chaotic in the mathematical sense. That is just a thought, something for future generations to consider.

How do we turn this into the science of metaphysics? Remember the twin fathers of empirical metaphysics, C. G. Jung and William James. James shows us the reproducibility and value of mystical experience. Jung shows us the value of symbolic revelation

and divination. I have a symbolic revelation to present to you, the Evolved Tarot from *The Word of One*. Maybe we should slide into the shallow end of this pool by talking first about a familiar thing, Christianity, or to be more exact, the Way of the Saints and Sufis, one of the 7 valid ways of knowing. There are two ways of finding the true roots of Christianity. The words of Jesus are red in some versions of the bible. Just read that. Throw away the rest as pious fraud and superstition. Another way is to read the *Gospel of Thomas*, only discovered in 1945. The result is about the same.

The *Gospel of Thomas* is not a Gnostic gospel, as claimed by Elaine Pagels, in her book, *The Gnostic Gospels*. She may have changed her mind since writing that book. The Gnostics believed that the world is evil, created by an evil god. The good god created heaven. Life is this eternal struggle between good and evil. This is the metaphysics of Manichaeism, and of one of my favorite TV shows, "Charmed." It is not the view presented in the *Gospel of Thomas*, where Jesus tells us that the "kingdom of heaven" is here on Earth, spread out before us, but we do not recognize it. Furthermore, the coming of the Kingdom of Heaven has already happened, but we do not realize it. There is nothing Gnostic about that. So why didn't this gospel become part of the New Testament? I suggest it is because of an embarrassing lack of magical, mythological or syncretic elements. There are no huge crowds, no casting out of demons, no entry into Jerusalem, no crucifixion or resurrection. This book is just the teachings of Jesus, before those teachings could be corrupted, mistranslated, and adapted to pagan philosophies and religions.

The Way of the Desert

Jesus said:
"I am the Light that is above them all,
I am the All,
The All came from me
The All attained to me.
Cleave a piece of wood
And I am there;
Lift up the stone
And you will find me there."

This saying (#77) may sound utterly egotistical. It is quite contrary to all Jewish tradition. Consider it in the context of the mystic's view of divinity:

"When you come to know yourselves
Then you will become known,
And you will realize that is you
Who are the sons of the living Father."

Any of the disciples or any enlightened person could say the same thing as saying #77, for they know that all of us partake of divinity (consciousness) of all things. If there is only ONE that is ALL, then you are divine, I am divine, and the stick of wood and the stone are divine.

Nonetheless, this is a teaching that is easily perverted. For instance, it can be taken to mean that we are each responsible for our own illness, or that we can each be rich and powerful just by believing it, or indeed, that anything can come true just by having faith. Thus, people feel guilty for being ill, or guilty for not being rich and powerful. This is a tragic misunderstanding.

If the TOTALITY creates nature, it is only in the sense of creating space and time and the laws of nature. Sometimes the Higher Self can impose a pattern on random events, which is synchronicity or divination, depending on the context. On the whole, the individual

cannot change even his own condition without full knowledge and remembrance of why his higher Self chose these challenges in the first place. Then he may realize there is a reason for this condition, a challenge to overcome, a lesson to learn, or karma to work off. It requires the difficult and slow acquisition of knowledge and skills to change the reality that we experience as Nature. Choice is possible only when a chaotic state is unstable.

> "Men think
> That it is peace that I have come to cast upon the world.
> They do not know
> That it is dissension which
> I have come to cast upon the earth:
> Fire, sword, and war."

> Jesus said:
> "I have cast fire upon the world,
> And see,
> I am guarding it until it blazes."

This is not what the conventionally pious would expect to hear from Jesus, yet these sayings are also in the New Testament. It is exactly what I would expect from one who has experienced the Illumination of Fire, for in this mystical experience, one sees the necessity of destruction and fire, to burn up the old, to make way for renewal and new life. If someone claims to be a mystic, and does not say such shocking, almost paradoxical things, then you know him for a fake.

Most of the sayings of Jesus are in both the New Testament and the Book of Thomas. The beatitudes are in the Book of Thomas, scattered through the book, not all in one place, nor delivered at one time. There are a few more of them, such as "Blessed are the solitary and elect, for you will find the Kingdom. For you are from it, and to it you will return." I can see why the author of Matthew put them all in one place, and invented the Sermon on the Mount. What we do not find is any apocalyptic expectation of the return of Christ, or some

future coming of the Kingdom of Heaven. According to Jesus, it is already here.

> His disciples said to Him,
> "When will the repose of the dead come about,
> and when will the new world come?"
> He said to them,
> "What you look forward to has already come,
> But you do not recognize it."
>
> On another occasion
> His disciples said to Him
> "When will the Kingdom come?"
> Jesus said:
> "It will not come by waiting for it.
> It will not be a matter of saying
> 'Here it is' or 'There it is.'
> Rather,
> The Kingdom of the Father is spread out upon the earth,
> And men do not see it."

This is the wisest and most important teaching in the whole Book of Thomas. Certainly, it should refute all those who believe in the apocalypse. It is also another typical saying of the true mystic. Those who have experienced the Illumination of Fire know all the great and terrible wonder and beauty of the world, the wonder and beauty of destruction as well as the renewal the fire makes possible. What we call disasters are signs of life, in the universe, in geology, and in the course of civilizations. Thus, the world is as it should be. Of course, we can always try to make it better. It is not the terrible and evil place the Gnostics taught and that is one more reason for denying that the Book of Thomas is Gnostic.

From the larger perspective, the advent of Christianity in the West imposed a guru-disciple tradition, a discipline of chastity, poverty, and obedience that destroyed or delayed the incipient sciences created by Western philosophy. It also smothered those distinctive

Western traits of individual freedom and individual genius that only re-emerged after a thousand years of darkness. No wonder the figures in medieval Christian art look so dour and unhappy!

Please note that we cannot blame this oriental guru-disciple tradition on Jesus, for, like Krishnamurti, he rejected the mantle of "Master" that his followers tried to hang around his shoulders, as the following passage will show:

> Jesus said to His disciples,
> "Compare me to someone and tell me whom I am like."
> Simon Peter said to Him, "You are like a righteous angel."
> Matthew said to Him, "You are like a wise philosopher."
> Thomas said to Him,
> "Master,
> My mouth is wholly incapable of saying whom You are like."
> Jesus said:
> "I am not your master.
> Because you have drunk,
> You have become intoxicated
> From the bubbling spring which I have measured out."

The Realm of the Quintessence

So what did Jesus teach? I leave it to you to verify this for yourself, since it is not hard to find copies of The Gospel of Thomas. The dry desert of Egypt preserved this Gospel from ancient times, and it was only discovered in 1945. It was part of the library of a group of desert "Saints" (a translation of the same word as "Essene"). The one copy of the Gospel of Thomas is in Coptic, the language of Ancient Egypt. Say what you will about the corruption of the traditional New Testament, caused by pious fraud and mistranslation over the millennia--this copy of the Gospels comes straight to us from Ancient Times. The Gospel of Thomas is "The Sayings of Jesus." There are no miracles, no Messiah complex, no Sermon on the Mount (but the Beatitudes are all there), no entry into Jerusalem, no Crucifixion, and no Resurrection. Indeed, there is nothing internal to the book that would date the time of Christ. He may very well be the "Teacher of Righteousness" of the Judaic Essenes, who may have lived about 100 BCE.

Most of his teaching consists in parables and metaphors about reaching a state of "the X of Y" where X is a word usually translated as "kingdom" but could also be translated "realm" and Y is a word for "sky" usually translated as "heaven." Translating ancient metaphors is a tricky business. We have to put ourselves back into that time, and try to imagine how people of that time would understand this metaphor.

From the time of Aristotle (300 BCE) to the time of Galileo (1600 CE), nearly 2000 years, the worldview, the background of all thought, was that of Aristotle and Ptolemy. It made a large distinction between the heavens (i.e. stars, the moon, the sun, and the planets) and earth. Earth was made of four elements, earth, air, fire, and water, and was mutable and perishable. The heavenly bodies were made of a fifth element (quintessence) which was immutable, imperishable and eternal. Thus, the correct translation of this metaphor is "realm of the imperishable," or "realm of the quintessence."

Given that meaning, "the realm of the quintessence is within," a saying found both in the Book of Thomas and the canonical gospels, makes perfect sense, to the surprise of Fundamentalists. It makes

perfectly good sense to try to enter the realm of the quintessence while one is still alive. Although Joshua clearly believes in an afterlife, he gives no details. He does make it clear that the search for the realm of the imperishable is part of this life, if the seeker is to find ONE. That is exactly what the Saints were doing.

Desert Saints: Like mystics of all ages and all cultures, they found it necessary to withdraw from the world, to obtain solitude, for years at a time. The Yogis found solitude in the forest, the Taoist mystics found it in the mountains, and the Saints found it first in the desert and later on remote islands off the coast of Ireland and Scotland. It is clear to me, someone who has experienced the illumination of fire, that this is what Joshu bar Josuf (Jesus) had himself experienced, and this is what he wanted his followers to find.

The illumination of fire gives one a vision of life and history as a whole, with a single divine purpose running through it. This is what makes one whole (holy). Clearly, this was the original meaning of "holy," which has a common root with holistic, holographic, whole, hale and heal. Both men and women withdrew from the Saturnalia of the Roman Empire to become pure and holy, and sometimes they returned as great witnesses to their experiences.

Martyr As Witness: The word "martyr" means "witness." This is something the legalistic Romans could understand. They had no science, but they had law, and they knew the value of a good witness. The Emperors persecuted the Christians, including former desert hermits. They went fearlessly and that impressed the materialistic Romans. This gives rise to the second definition of "Saint" as one who was martyred. The more Saints the Romans created, the more Romans became Christians.

Early Christianity: During the period of persecution, Christianity was also organizing itself as a religion, with priests and bishops. Peter went to Rome, as did Paul, while Thomas went to India. James evangelized in Jerusalem among the Jews. There was a formal, hierarchical organization being developed, i.e., the church, but there were also the Saints, who were completely outside any such organization, yet, who provided the main impetus for the growth of Christianity. One of the strengths of the early church is that it was

open to men and women, rich and poor, and it practiced charity. It also opened the first orphanages, the first hospitals, and the first hostels. Even in the Middle Ages, pilgrims and travelers of all kinds stayed at monasteries along the way. Monasteries continued to be the centers of learning, the arts, and even of technology, until the rebirth of trade and of cities and of a middle class.

The first wave of pagan barbarians rolled over the Western Roman Empire, but stopped short of Ireland, Wales, and Scotland, possibly because of a Celtic war-lord whose name was "bear," i.e. "Artos" thus giving rise to the Arthurian legends, all of which first appeared in the Celtic Fringe in the 8th and 9th Centuries. The monasteries there created a brief golden age, an age of marvelous manuscripts and fine jewelry. For about a century, they were the only people in Europe who could read and write, both Greek and Latin, and who still had a taste for the classics in those languages, and still had libraries and scriptoria. Thus, they made copies that wound up all over Europe. It was also a culture rich in Saints, some of whom began to evangelize Anglo-Saxon England, Frankish Gaul, and Lombardian Italy. This is how the Irish saved civilization, as described in Thomas Cahill's marvelous little book, *How The Irish Saved Civilization*.

One of the last of these Hibernian scholars was Alcuin of York, who started a school and scriptorium for Charlemagne. It eventually became one of the first European universities. Most of the ancient books that have come down through the Middle Ages are Carolingian copies, the first to separate words with a space, and the first to use the Carolingian minuscule, father of "lower case." It is a wonder the Ancients could read their inscriptions, since they were all upper case, all the words were jammed together, and they were very fond of allusions and abbreviations, just as today we are very fond of acronyms.

How Did Sunday school Christianity Arise? By pious fraud and forgery. The Popes themselves know this. In her book, *The Christ Conspiracy*, Acharya S introduces us to a vast, little known literature by people who challenge every part of Sunday school tradition. According to the skeptics, the Bible has been under more or less continuous revision from about 170-180 CE (when the oldest parts of

the New Testament were written down, according to her) down to the dawn of printing in the 15th Century. The skeptics doubt the huge drama of the passion of Christ, because historians of the time, such as Josephus, make no mention of it.

The skeptics do not think the life of Jesus could possibly be set in Galilee of around 30 CE, because Galilee at that time was a rich Roman province, with great cities under construction that are not even mentioned in the Bible. Nor could he have been from Nazareth since it did not exist in 1 CE, or 30 CE. In addition, the early church fathers, such as Justin Martyr and Marcion make no mention of the four canonical gospels, so they did not exist in the First Century CE. In Paul's letters, he makes absolutely no mention of the teachings of Jesus. He quotes no parable, no beatitude, none of the teaching about the Kingdom of Heaven. Indeed, no book in the New Testament makes any mention of any other book in the New Testament. Acharya and many skeptics conclude that the Jesus legend is pure myth, and is simply a recycling of Sol Invictus.

At the very least, Acharya and other skeptics should teach us to doubt Sunday school tradition. That is why I confine myself to modern philological and archaeological discoveries. The medieval church never had their hands on such things. The catacomb art is interesting for what it shows and what it does not show. The archaeology done under the Altar of St. Peters in Rome during WW II is also very interesting (see *The Bones of St. Peter* in the bibliography). Neither supports the extreme position of Acharya. Under the altar, archaeologists discovered a First Century tomb, and a small, hidden church in the midst of a pagan cemetery. They found the bones of a robust man of 70, missing feet and head, wrapped in purple cloth veined with threads of pure gold, hidden inside "the graffiti wall," part of the Tropaion (the church). Why not the head? Another church in Rome claims that relic. Why no feet? If Nero crucified Peter upside down, as tradition has it, the easiest way to get him down would be to chop off the feet. This suggests that at least some Church traditions are not a fraud.

Whether the Romans crucified Yoshua bar Josuf or not is debatable. The *Book of Thomas* does not mention it, but then this is a

book of sayings. Crucifixion would be an unusual punishment for heresy. Usually, the Jews stoned heretics to death, as they eventually did to James. In the Koran, it says Yoshua was not crucified. The Jews keep a record of the several hundred would-be or accused messiahs between 100 BCE and 100 CE, and it includes one Joshu bar Josuf, whose mother was Mary. Joshu was stoned to death. We find no crucifixes in the catacombs, nor any Last Supper, much less a Last Judgment. The earliest crucifix in Christian Art is a crude and obscure figure on the door of the church of Santa Sabina in Rome, dating to the 5th Century CE. What we see in catacomb art is not the crucifix, but Christ in Orison. This is the T gesture, standing with arms wide open. Do that to a person, and they will come give you a hug. Do that to the world, alone on a hilltop at dawn, and gain a wonderful epiphany of the innocence and beauty of the world, despite the pain and struggle. It could very well be that the T gesture came first, and was eventually given historicity by the process of myth making, followed by ignorant centuries that took these myths literally.

The oldest copies of the New Testament that have survived are the Vatican Codex, and the Sinai Codex, both dating from the 4th Century CE. There seems such a distance between the "Sayings of Yoshua" and even the short version of Mark that one suspects many decades or even centuries had to pass, decades of syncretism and mythologizing.

It is not unusual for religions to begin with the mystical teachings of the founder to a small circle of disciples. As the religion develops, it is not unusual for it to absorb elements from other religions over the centuries (syncretism) and to incorporate fantastic fairy tales that may incorporate some symbolic truth (mythology). I know that somebody sold small fragments of canonical gospels in a second Century style to antiquity dealers. Nothing would be easier to forge, if one knew the writing style of the appropriate decade. One could even use ancient papyrus and ink prepared in the old way. However, it does not make a great deal of difference to me whether the church traditions about the dates of the Gospels are true or not.

The Books of the New Testament as we have it were selected from a vast variety of "gospels" at the Council of Nicaea in 325 CE,

under pressure from Emperor Constantine, who brought Christianity out of the catacombs and built it fine basilicas. He broke some major taboos to do so. The Basilica of St. Peter was built over a pagan cemetery (which is still down there!), just so the altar could be placed directly over the tomb of St. Peter.

Constantine meddled in religion primarily for state reasons. He needed an all-embracing ("Katholos" means "all-embracing") state religion to end divisive strife, and to make the Roman Empire more defensible. In this, he succeeded, so that at least the eastern part of the Empire survived for another thousand years.

So, are we to reject the Bible altogether? Did these miraculous events really happen? Was Christ resurrected? Did Paul have a transcendental vision on his way to Damascus, wherein he beheld the risen Christ? This might explain the eventual success of Christianity. If the Shroud of Turin turns out to date from the 1st Century, I might even believe it myself. And it could be authentic. Science has not ruled that out. The Titulus found in Empress Helen's house in Rome seems authentic and dated to 30 CE.

Here is a second possibility, which is compatible with the first. Yoshua experienced the illumination of fire, and his teachings on the way to enter the "realm of the imperishable" (Kingdom of Heaven) worked. Those followers who gave up worldly concerns and went off into the desert as Seekers of the illumination of fire often succeeded, and when they returned to the world (or when the world came to them), they were not only holy and wise, but they also had "miraculous" powers, such as healing, or walking on water. The miracles of one age are the science of the next. The age of faith passes, and the age of spiritual science begins.

So why am I involved in these questions? Because I want you to understand the Way of the Saints and Sufis. The Sufis were desert saints who liked the pure monotheism of Islam, and so converted when Islam swept through the deserts of the Middle East in the 7th Century CE. I am trying to show that the Way of the Saints and Sufis was and is a valid path, one of the seven ways, each equally legitimate if we can scrape away centuries of pious forgery and superstition. I could also write treatises on Yoga or Taoism, but others could do it better

than I could. There are ancient traditions of Shamans and Medicine men or women taking many forms in the Americas, in Siberia, and in Hawaii. See the works of Max Freedom Long, for one entrance to that world. Once again, others know far more about it than I do. There is Kabbalah, which also appeals to me. I don't claim to be an expert on it. I just happen to have figured out the essence of the Saints and Sufis, and can explain to you what "the kingdom of heaven" metaphor would have meant in Ancient Times.

One can pursue the Way of the Saints and Sufis without being a Christian or Muslim. In other words, the path is one thing, the religion another. One can do Yoga without being a Hindu or Buddhist.

Spirituality Without Religion

"The foretelling time. The pages from the rear are in the fore. Sun-worshippers have taken their place. The ray of love is seldom perceived and often misunderstood as having flesh. The daybreak of the new morn is founded on the proper perception of the ray of love. Babes know it not- -neither man nor woman. The mystic alone knows the reality of this ray." *The Word of One*, "Doer."

In Aristotle's collected writings, (class notes written down by his students), they couldn't think of a good name for that part of the book which came after physics. So they just named it "after physics" or "beyond physics" which translates as "metaphysics."

Over the centuries, the meaning of the term "metaphysics" has wandered. At times, it seemed part of theology. At times, it was ontology. In the early twentieth Century, the logical positivists declared the term void of any meaning at all. Quite right. So I feel free to define it anew. I define it as the study and practice of spirituality. The seekers of today (including me) say they are not religious but they do seek spirituality or metaphysics (two terms that I have made identical).

The terrorists of 9/11 who destroyed the Twin Trade Towers in the name of Allah have discredited religion. If there were an Allah, he would strike these blasphemers dead. While we don't know much about the "between" (between lives), we can be pretty sure it won't be paradise for these evildoers, not now, and not ever. At the very least, they will have to relive the terror and suffering of each of their victims, all 3000 of them.

Spirituality can mean reading the spiritual classics of earlier times. I must warn you that none of these books can be trusted. Huston Smith has edited a collection of new translations of what he calls "Mystical Classics of the World." A better title for the series would be "Spiritual Classics of the World." This includes *The Tibetan Book of the Dead*, more correctly translated as *The Great Book of Natural Liberation Through Understanding of the Between*. In other words, this is a book about the Between. Yet, we know from modern Psi studies that it is totally mistaken. Human beings do not reincarnate as either animals or gods. There is no demon Yama to welcome you to

the Between. There is only the White Light, loving and forgiving.

Another famous classic is *The Bhagavad-Gita.* I reject it for its reliance on and acceptance of Caste. India must get rid of the Caste system, if it is to be a modern democracy. The Gita takes place in the middle of a battlefield, with two huge armies waiting to destroy each other. The form of it is a long argument made by the god Krishna to Prince Arjuna, that it is his duty as a member of the warrior caste to make war and sacrifice all these millions of warriors on both sides. Modern spiritual seekers always avoid violence if they can, and make war only in self-defense, not to uphold a social duty to be a great warrior.

Huston's collection also includes *The Essential Kabbalah, The Tao Te Ching, The Essential Rumi*, and *The Way of a Pilgrim*, all familiar except the last. *The Way of a Pilgrim* is the personal story of an anonymous wandering "Starets" in 19th Century Russia, a familiar type in Orthodox Christianity. The last and most famous of these wandering holy men was Rasputin, a man of many faults and gifts, a crude peasant who had a way with the women, an enormous capacity for alcohol and a tremendous resistance to poison.

Rumi was a poet, but was he a mystic? He founded the order of the whirling Dervishes, so he is clearly an important person in the history of Sufism. Was he a mystic? I have always had my doubts. Recall that (1) illumination, (2) Noesis, (3) ecstasy, and (4) unitary experience define a mystical experience. However, there is a lot more to spirituality than mysticism.

Both the Gita and the Tao Te Ching come from long oral traditions, finally written down. I can't help but wonder if here and there the meaning of a metaphor hasn't been lost, as happened in Christianity with the metaphor of "the kingdom of heaven," (the realm of the quintessence). Speaking of Christianity, shouldn't Huston's collection contain a translation of the Coptic *Gospel of Thomas*?

Many modern seekers have gone to India, to find themselves gurus. Some gurus came to America, sensing easy pickings. Most of these gurus required their disciples to hand over all their possessions, and in this way some gurus became wealthy. One had 30 Rolls Royce cars. How is that holy? How is that different from the televangelists

who browbeat the poor and the elderly for money to construct vast monuments to their own egos? Shouting, ignorant and intolerant, these televangelists remind me of the mad Mullahs of Saudi Arabia, and all others who misuse the promise of spirituality out of greed, hatred and ambition. All religions are based on fear, but there is nothing to fear. We all exist forever and ever, worlds without end, amen.

I would beware of gurus who demanded all of my possessions and obedience.

I would beware of "religion," since that is a synonym for "faith."

I would beware of taking literally ancient books that were told and retold, copied and recopied, translated and mistranslated over thousands of years, while meanings change, metaphors change, and our worldviews and scientific knowledge change. For one thing, their original meaning is in the ancient and universal language of Jungian symbolism, thus a literal translation is an unwholy and deliberate falsification. It is sometimes possible to reconstruct the original shape of a spiritual tradition by means of ancient books discovered in modern times and by modern archaeology and philology and I have done that.

I would beware of any form of meditation that requires sitting quietly, focused on one thing. Sitting *Zazen*. Isn't that what the medieval Christian monks tried, with their liturgies around the clock? Did any of them become Enlightened? I don't think so. I would beware of any form of meditation that does not require solitude. Follow the life of the Seeker, as it is described in the ***Word of One.***

In Buddhist meditation, they use the Self to explore the Self. Sometimes all they encounter is a great lonely void. I think we must introduce more scientific and objective methods. Buddhists try to get rid of the ego. However, the ego is absolutely essential for the Western path, based on a succession of geniuses, who must hold fast to their course despite a lifetime of rejection. There may be useful techniques to learn from oriental or shamanic traditions, but don't give up your critical sense, your skepticism, and your sense of self.

In the chapters that follow, I will follow an approach to

spirituality that includes mystical experience, and symbolic divination and revelation. Divination, if it works, is itself a minor miracle. Ditto with revelation. Not all revelations are of equal value. We can give some weight to a revelation only if mystical experience confirms at least part of it. One that I give high marks is the Evolved Tarot, also known as the Word of One, the T tarot, or the Tarot of the Nameless One. The 22 major arcana of the evolved tarot comprise a small part of a vast amount of material delivered by home-made Ouija board, using a silver dollar as the planchette, to a group of Seekers back in the winter of 1962-63. I was not part of that group. John Starr Cooke and Rosalind Sharpe published it in 1969, again in 1970, and in 1992. See my revision: http://users.aol.com/pythagoras9/tarot.html.

The complete sessions were published in 1975 as *Word of One*, now available on-line at http://users.aol.com/drhumph/toc.htm -- use the edit function on your browser to look up favorite sayings, since it is one big file.

I was first attracted to the Major Arcana of the new tarot reproduced in a newspaper once published by Llewellyn Press, called *The Gnostica News*. This was in the 1970s. The image of the Deliverer caught my attention. I realized that it described the Illumination of Fire, and shows the lesser mystical states which make up the path leading to the fire. A true revelation can vastly extend ones metaphysical knowledge. We must test it against all of our other ways of knowing.

These are books written entirely in the language of symbolism, humanity's only universal language. Nothing is arbitrary in the language of symbolism. Learning the language of symbolism is as important for the science of metaphysics as learning higher math is important for the science of physics.

The Book of the Knower reassures me that our souls do indeed have immortality as part of the ONE. The Book of the Citadel tells me that the soul creates minds. I shall close this chapter with some quotes from the words of the Nameless One.

A few explanations are required to understand these quotes. The source of this material never gave itself a name, so John Cooke referred to the source as "WE," identifying it with a collective self.

The source gave each participant a new name, and called John Cooke "Legion." The Doer is the evolved form of the Sun card, and is a seven-year-old boy, holding an unrolled scroll and a ribbon that loosely holds a black horse. A white horse rears on a human skull. A beautifully figured Sun is high overhead. The Book of the Mother represents Creation. She is the new version of the High Priestess. All quotes are from *Word of One.*

"ONE is all.... Deny not ONE while you live. The world is full of those who say they seek ONE. How is it that seekers always blind themselves first to their surroundings? Until they remove the film, they seek in vain. Do you wish a word of comfort? There is none. Do you wish a better road? There is none. Do you wish a Savior? There is none. For you, there is only ONE. You will make that do." p. 385.

"There is a stirring felt in sleeping regions. Great must be the full awaking. Neither din nor force shall accomplish this. The awakened One arises. The sleeping one sleeps. There is an arouser but he wakes not up."--P. 170.

"Over all lies a mantle of fog through which the sun is coming--the son is coming.... The breath of life is in your hands, the spark of death, also. Quicken the new birth and fan the spark that the passing past is laid at rest. Desire above all things the Sun."

"The Rosetta stone is rolled away. A burden is lifted. A free soul flies onward. Yellow eyes, unblinking, number the years." --P. 171.

"The siren bell has rung. Its penetration has entered but not emerged. Therefore its vibration continues its wonders to perform...The market place is a-thrive. Strange beads and salt are vended. Buyers there are none. A pitcher of water reflects the sun. The thirst is mighty but the sun is reflected undisturbed. Maggots will grow if the pitcher is not emptied."

"Children parentless seek the Mother. She is busy begetting the Sun. He is now with the world. His cord is severed. He will soon speak. He will speak of the Mother."

"Fairy frost at the windows betoken good fortune. Magic are the times now, Magickal are the happenings. The Doer has been

activated."

"The juice of memory rises. When it spills will be the time of reversal. It is coming. Be ye prepared. Mighty shall be the roar, violent the rending, joyous the release." p. 164

"Great will be the transformation now while nothing visible appears to happen--yet the New Man will stand naked in glory. Tis a promise seen dimly now." p. 112

"LEGION: Is the Great Event Imminent?
WE: Yes.
GAYLA: How imminent?"

At this point a sudden wind whipped open the heavy door beside the group and night air rushed into the room.

"WE: Take a breath. It has taken place...." p. 413.

Mandalas and Symbolic Elements

There are things that we cannot learn by reading about them --
only by doing them. Mandalas are an example. So get yourself a sheet
of typing paper. Tape the very edge of the corners to a thin piece of
wood, Masonite or hardboard to avoid ruining your tables. Gather
together the tools of kindergarten art: the compass and square, ancient
tools of the Freemasons, plus liquid crayola, poster paints, crayons,
colored pencils, rulers. If at all possible, go to a graphics supply store
and get a large compass, big enough to make a circle that would fill up
the page. You can improvise this with a string, a tack, and a pencil.
Make sure you have erasers. You must either do this alone, or
everyone must make a Mandala. No spectators allowed. Make sure
you will not be disturbed for an hour. Some people will make two
Mandalas in an hour.

There is only one rule to making Mandalas. **You must allow
the Mandala to make itself.** If that seems like a puzzling instruction,
take my word for it, this will work. Listen for some faint inner impulse
to put a line here, and a circle there. If you have a preconceived
design, discard it. Empty your mind. Do not imagine that your
Mandala should resemble those created by Tibetan Monks. Chances
are, it won't. Once you get going, it will go very smoothly. If you
make a mistake, you can always erase it. Take bathroom or water
breaks at least once and when you come back and look at your
Mandala, you will recognize the mistakes, if you have made any. Now,
at this point, you must stop reading this book. Do not read past this
point until you have made your one-hour Mandala.

Now that you have finished your Mandala, what do you do
with it? You interpret it, because a Mandala is a message from the
deep. If not (this sometimes happens with Mandalas made by
children), then it is just a doodle, not a Mandala. How do you interpret
it? There are no dictionaries of symbols. Well, there are, but they are
totally useless. The reason is that a symbol is a complete sentence or
even a paragraph. Chances are I will not write the exact same sentence
twice in this book. Chances are students of symbolism will never
encounter the exact same symbol twice in a lifetime.

What is possible is a dictionary of symbolic elements. These are colors, number, orientation, gesture, clothing, and species, material and other attributes. Symbols will combine these things in ways they would not combine in nature. For instance, in the Book of the Deliverer, there is a large straight golden serpent with a blue tongue. Species is "serpent," the tongue (the main perceptive sense) is an attribute, and its color is blue, the color of renewal. Other attributes are "large" and "straight." Material is gold. On this same card, there are two serpents, light with fire, which form the infinity symbol. The straight serpent is on the left side of the card, while the infinity serpents are top center. That is orientation.

I am going to give you a brief dictionary of symbolic elements, right here and now.

We begin with colors. Green is the color of chlorophyll, the means of fixing solar energy for the use of all other life. In symbolic terms green is similarly a fixing or capturing of portable energy, usually in the form of money. A strong yellow is sunlight, and by association, the creative energies that makes life possible.

Red is blood or a flushed face, and by association, emotion, drive, motivation. Purple is the rare dye reserved in ancient times for the emperor's family, and by association is authority. Gray is ashes, and by association, death, destruction, desolation (which may be of an emotional rather than literal kind).

A certain shade of grayish blue is the color of a newborn at the instant of crowning, and at the cyanotic instant of death. The color of death may be more of a grayish green. Blue is the door to birth and death and therefore means renewal. That is why the flesh of the Renewer is blue in the new tarot. The flesh of Osiris, the Egyptian god of the afterlife, is also blue, not a bright blue, but a greenish blue. A color partway between blue and purple suggests the renewal and authority of the healer, and in particular the profession of healing. A pale yellow is an illumination color, the color of the aura of the teacher, for instance. Brown is earth or wood or shit and thus a building material or basis or foundation or fertilizer for other growth. The meaning of white seems to derive from white paint. When mixed with any other color, it ceases to be white. Thus white is pure and

innocent, untouched by experience, virginal and ignorant.

The colors of twilight suggest the twilight of life, and the metaphysical contemplation and wisdom that are appropriate to that stage of life. Light is illumination, visibility and clarity, while dark is ignorance and stoppage. Orange the illumination of fire, and the discovery of the meaning of life in meeting challenges, and undergoing renewal.

We shall next look at numbers. When interpreting Mandalas, we count the numbers of things. We have five physical senses and five digits on our hands. When our limbs are fully extended (as in the jumping jack exercise), we make a five pointed star, with head and limbs forming five extremities. There are also five major inhabited continents on earth in the present epoch: North and South America, Europe, Asia and Africa. Five relates to our physical existence, associated with a well-rounded life in-the-body, using our senses and our limbs to their fullest. There are five jewels in the central crown of the Royal Maze and five courses of stones on the well of life in the Renewer.

There are four directions, four winds and four dimensions in our earthly plane. Quaternity has always meant wholeness and completeness on the earthly plane.

Trinity has always meant wholeness and completeness on a spiritual plane. Gods always come in threes. There is Brahma the creator, Shiva the destroyer, and Krishna the preserver, or the Father, Son and Holy Ghost. There are three pillars of the kabbalah. In the Book of the Renewer, there are three handles on the chalice for the waters from the well of life. If we drink from the well of life in the Renewer, we may fulfill the divine purpose by grasping the handle of creation, the handle of destruction, or the handle of preservation. All may equally serve growth and creation. This is a hard lesson, and shows us that the divine or sacred goal does not always agree with earthly morality or values.

Two is polarity. Polar opposites are the two ends or extremes of the same thing, and cannot exist without each other. Male cannot exist without female, and the north pole of a magnet implies the existence of a south pole. Two are the polar opposites on the axis of

ONE. There is nonetheless always tension and opposition, if not downright war, between the dualities of polar opposites.

The meanings of all other numbers derive from the meanings of two, three, four and five, by adding, multiplying or taking them to a power of themselves. Eight of something shows the polarizing effects of two combined with the earthly whole of four. The symbolic meaning is materialism and greed. Ten shows the polarizing effects of two combined with the body number five, suggesting the misuse of technology and the corrupting effects of luxury. In some contexts, ten refers to the ten forms of Samadhi. That is the meaning of the ten fruit on the Tree of life in the Garden of the Renewer.

Six shows the polarizing effects of two combined with the higher trinity, the sacred dance of Shiva carried to fanatical excess, to martyrdom or asceticism or the suicide terrorist that can only be motivated by evil religion. The six-pointed star of Israel is a symbol of Zionist fanaticism that took away the land of the Palestinians and refused to give them citizenship (I understand why; I don't wish to engage in a debate over the issue).

Seven is the additive, twelve the multiplicative, combination of three and four. Both seven and twelve are lucky numbers, the combination of the earthly and the spiritual whole. There are seven spiritual paths and seven rays of light piercing the clouds over the Renewer. There were three parts to the holy trinity, four books of gospels, twelve disciples and seven seals on the book of revelation. This is no accident.

These numbers constantly recur in sacred contexts, as do their combinations and powers such as nine and sixteen. Sixteen is a quaternity of quaternities, and nine is the trinity of trinities. This is like a redoubling or intensification of the original symbolic meaning. Thus, nine is the holy of holies.

Species of animals or plants or natural objects are also symbolic elements. The meaning of species elements is sometimes surprising. For instance, a serpent means "initiatory experience."

This is hardly our free association with snakes. There are two strands to the symbolic meaning of serpents, with the context bringing out one or the other or both. On the one hand, serpents are chthonic,

of-the-earth. They come out of the ground, and have the temperature and feel of earth.

The other association is with the penis that is also cool to the touch, and similar in shape. (Freud was not the first to notice this!). It is not the penis that conveys the symbolic meaning. It is the first act of sex that forever changes one. After sex, one is no longer a child, and can never go back to the childhood frame of reference. Before sex, it is impossible to understand fully adult love.

Sex is an initiation, and thus stands for all initiatory experiences that forever change a person. This ties back to the chthonic thread of meaning, for the experiences of the nature mystic or the shaman are also initiatory and transforming experiences that prepare the novice for further steps down the path. It is because of this large and complex freight of meaning that serpents occur frequently in symbolism. There are a dozen of them in the new tarot. There are three just in the Book of the Deliverer. The Deliverer is about the illumination of fire, the ultimate initiation. An initiation is not necessarily a ritual; it is any experience that changes the novice to an initiate.

Symbolism is never conventional. It is only what is unusual or unconventional that conveys symbolic meaning. One unconventional context is the hooded eagle on the shoulder of the Changer. He is hooded and jessied like a falcon, but he is not a falcon.

He is an eagle, the universal predator, and the only creature that takes its prey from land, sea or air. The universal predator has always suggested the power of government that is why governments have always instinctively liked that symbolism. To be hooded and jessied means to be domesticated, brought under control, tamed. The eagle also suggests other kinds of human predators. Once again, this is not the usual free association with eagles. Do not think that symbols mean whatever you think they mean. Interpreting symbolism is an art, a science, and it takes long study and concentration.

The symbolic meaning of a species is always associated with something unusual, unique or exaggerated in that species. For instance, sheep are the most completely useful kind of domestic animal, providing fiber, milk, cheese, and meat. They also have the strongest

herd instinct. Sheep always want to go where the herd is going. This has always suggested the mass of ordinary people.

Wolves hunt in packs, cooperating with each other to prey on the sheep; thus, wolves are the dominant elite of every society. Hawks soar, endlessly and effortlessly born on the wind, and thus suggest all that is soaring and windborne and all-seeing (Horus). Egrets and other large fishing birds are at home in two realms, the world of air and of water, plunging into the depths of the latter to pluck out a denizen of the watery deeps (an inspiration). This suggests the role of the creative genius (Thoth) that is also at home in two realms, the airy world of everyday action, and the inner, floating world of the daydreamer, source of inspiration. That is why Imhotep, a great genius of the early Pyramid age in Egypt (inventor of writing and of the pyramids), became an Ibis-headed god.

Bluebirds hold the curtain of invisibility and the tools of illusion on the stage of the Actor, while playing a more positive role in the Victorious One, the modern warrior, who has unhooked the lions from his chariot. The blue birds keep the wolves at bay with a transparent curtain. Blue birds play a similar role in Disney movies, so we must have struck a deep vein of symbolic meaning here. Do not think of these as the familiar species "bluebirds." Think of this as the combination of two symbolic elements, "blue," and "bird." Blue is renewal; bird is flight, escape, uncaged, free in the ocean of air. Thus, the blue bird plays a liberating role. They appear at happy moments in Disney movies, to aid the hero or heroine in the moment of triumph.

The four elements of nature all have symbolic meaning. Water always suggests the dreaming, floating world of genius, the daydreamer. Air is the normal workaday world of thought and action, often suggested by windblown sails, hair, clouds, or clothing. Fire is the illumination of fire with its suggestion of the necessity of challenges that may destroy as well as warm. Stone is a building material, suggested by wood or brown colors. Spark stars suggest the sudden flash of inspiration.

Orientation is always symbolically important. Left-handed is yin, the receptive, passive, accepting, nurturing, maternal, feminine, and lateral thinking. Right handed is yang, the aggressive, initiating,

driving, deciding, and single-focused. Above is heaven, the spiritual, and below is earth, the physical. In the new tarot, this rule applies to human figures, from the point of view of the figure, not from our point of view. Yin and Yang may not be so evident in auxiliary elements of a card, such as the white staff with roots and wings on the right, and the sword inside a crown on the left in the Book of the Citadel.

Conventional clothing means nothing. In the new tarot, the standard figure is nude to reveal all. The cloak of the Renewer implies something hidden. The Speaker wears desert boots to isolate himself from the "ground" (social convention) he walks on.

The four suits of the New Tarot are all symbolic. The four suits are the amphisbaena (a serpent with a head on both ends, much used in Aztec symbolism), stones, curved blades, and pears. Pears are distinctive in several ways. All the other trees in the orchard die after 15-20 years, while this is just when pears begin fruiting. We pick other orchard fruits in summer, with crab apples the last, in September. We pick pears in the fall, and pack them away so the fruit continues to ripen, until it becomes absolutely delicious about Christmastime. All this suggests things that take a long time to mature. For instance, Civilizations have their "second spirituality" in late maturity, and this is their final fruition. Do not confuse the original spirituality with the dried up religion it may become after thousands of years.

Curved blades can be propellers, or scimitars. If a scimitar, then it suggests a decisive action, cutting time into a before and after. As a propeller, it suggests action, progress, and motion.

Stones are good for building. Some stones are jewels and good for wearing. Some are precious gems. Some are crystals, and may store psionic energy, or "huna." The serpent suggests initiation, and the rhythm of the dance, the to-and-fro of life and death.

This completes my brief dictionary of symbolic elements.

Have I provided enough information to help you interpret your Mandala? I know that in my own Mandalas, recognition of objects is very important, and often not obvious. Sometimes I have to sleep on it, look at the Mandala in different lights and different distances. Eventually, it will strike me. "That's a pelican!" My Mandalas sometimes create themselves upside down or sidewise, so you may

have to try different orientations, before any recognition takes place.

Once recognition has taken place, try to find that species in my brief dictionary of symbolic elements. What if it isn't there? Add an entry. Here is how you figure out a new symbolic element. First, determine what is unique about it. Another useful rule is that a symbolic element has the same meaning in every symbol, in every context. Only the symbolic element has universal meaning.

In the New Tarot, figures are usually nude. If nudity is the convention, then clothes have a symbolic meaning. The Changer is wearing humble brown homespun. There is a double axe woven into his clothing. A red jewel pins it at the shoulder. He has a white flower in his right hand. Water falls from his left hand. Can you figure out all that? Here is a clue. In the Old Tarot, he is the Mage. Here is a kind of shepherd, and the double axe reminds us of the danger of actions that rebound on the actor. There is a rule about magick: no personal gain else, there will be unwanted rebound. The double axe can chop the chopper as well as the choppee. In a word, Karma. Red of passion pins his clothing together, so he is passionate about being a shepherd of those who seek. White flower is beauty and purity, and the waters of life fall from his yin hand.

The Speaker is holding a black iron ring. Why? A ring bolt was part of slavery that the Speaker has clearly escaped. Lightning bolts escape from his mouth. What does that mean? Trouble. Storms. He carries a golden key. To what lock? The one carried by the Victorious One. Clearly, it takes some imagination and wide historical knowledge to interpret symbols. I doubt if a finite list of all symbolic elements is possible. I have made a start.

A symbolist can interpret grave burials of 40,000-year-old ancestors. We can interpret the cave art they made 20,000 years ago. Symbolism is the universal language for mankind, and also the universal language of our Higher Selves. This is how we can send and receive messages to and from our higher centers. This is the essence of magic and divination. In magic, we send a message; in divination, we receive one.

Now wasn't that fun? I find that doing Mandalas is very relaxing. Isn't it amazing that you, a non-artist, have created something

very beautiful? Isn't it also remarkable that this is a profound message from the depths of Self, a revelation, about you, or your destiny, or about matters of high metaphysics? I am very enthusiastic about Mandalas, because of the collapse of the high arts. So much so, that I am prepared to hire an artist to paint a more perfect version of this Mandala on a canvas board from the art store. That is, if I can find an artist willing to do that. Maybe it will have to be a starving artist.

You are the composer; she is the performer. There is artistry in performance, as well as in composition. Don't let them change or ignore symbolic elements. This may provide a living for artists, while changing their role somewhat.

Magickal Mandala Arts

The 20th Century saw the death of the higher arts. The buildings put up in the last Century are drab, utilitarian boxes. This is entirely in keeping with the reductionist worldview of the time. To revive the higher arts, we must have a new spiritual impulse. Personal experience and participation in the arts can provide it. Mandalas can provide it. If you made the Mandala in the previous chapter and gave it an interpretation, then you may sense the power of this magickal technique. In this chapter, I demonstrate how to apply the Mandala technique to each of the arts in turn.

All Mandalas make themselves. Mandala making is always participatory. There are no spectators, only participants. The square and the circle arise in every art, from music to architecture to dance, drama, and clothing.

This is all part of spiritual evolution, a prerequisite for developing those powers that allow humanoids to jump thousands of light-years. It is valuable in itself. The aesthetic impulse defines higher civilization and that is why 20th Century culture was not civilization, only a technologically advanced barbarism. 20th Century culture emphasized food, sex, shelter, and transportation. All such physical pleasures are brief and fleeting. We never become satiated with aesthetic pleasures, which I define as whatever we do to avoid boredom.

Music: The "square" in music is the measure. We subdivide the measure into powers-of-two durations of sound or silence, i.e., whole notes, half notes, quarter notes, eighth notes, sixteenth notes and so forth, where tempo and the time signature set the basic unit of time. A circle in music is any repeated passage or theme, from the simple tune and chorus, to theme and variation in classical music. The rule in making all Mandalas is that we let it create itself. It is easier for many people (including me) to create Mandalas with the compass and the square, along with some free hand improvisation. Thus, the form of the circle and the square and the tools for creating them must always be available, in every art.

Western music has always had the circle and the square, but

before the invention of MIDI keyboard-synthesizers and personal computers, we had no tools for the improvisational Mandala process.

Computer memory or hard disk memory is the equivalent of the sheet of paper, allowing one to capture and examine the Mandala, erasing some, adding more. By pre-defining the tempo and time signature, the MIDI software will transform inexact durations into powers-of-two notes within measures. That is the equivalent of the square. The editing software provides the equivalent of eraser and compass, with repetition of passages you like, and deletion of those you don't.

I created a musical Mandala program for the Commodore 64. Alas, about the time I had it perfected, the Commodore 64 disappeared. I rewrote the keyboard handler to play chords and to record the duration of a note recorded. One could pick about 4 octaves and about 16 instruments. All the information about each note was bit packed into 2 bytes. There was enough buffer space to record more than an hour of music. Playback created a visual Mandala on the screen that used the ratio between two notes to determine the shape and size of the figure for that note. The figures for each note piled up on top of one another, creating a lovely Mandala on the screen. I used every trick of the computer wizard to make this program work. The program was self-copying, if one did a sys ####, where that stands for numbers I no longer remember.

I do not play any instrument, but with practice, my "fingers" learned harmonious combinations and phrases that pleased me. Like Mandalas in other media, the results are unusual and unlike traditional music. Relax and let the fingers create the music. Forget about the formal rules of composition, in case you know any. Silence the memory of generations of piano teachers that keep saying, "Don't pound on the piano!" Pound away. The result will not be noise; it will amaze you with its strange beauty. Select passages for repetition (the circle). Measures are the square, consisting of one whole note worth of time, sub-divided up into power-of-two intervals of music or silence. This same rule applies to all the arts.

Can we interpret such musical Mandalas? Indeed we can, and this was a fact well known to the ancient Greeks, but has been more or

less forgotten since. I shall provide a brief dictionary of the elements of symbolism in music, at least the elements in harmony. I shall create a table for the first 21 intervals. "Interval" refers to the number of steps on the black and white keys from one note to the next. In the modern well-tempered scale, the same interval, anywhere on the keyboard, will have the same harmony. If there is no harmony, I write "d" for dissonance.

Interval	Ratio	Meaning
1	d	none
2	d	none
3	5:6	tension, worry or competition
4	4:5	voluptuous, worldly, sensual, earthy, hot
5	3:4	a Renaissance sound, sacred, holistic
6	d	none
7	2:3	the creation of oceans and galaxy. Music of the gods.
8	d	none
9	3:5	the hero, going to extremes of creation, destruction or status quo
10	5:9	hero of the mystical path, another sacred and spiritual interval
11	7:13	sound of the wizard or occultist
12	1:2	same note in the next octave
13	7:15	disharmony like interval 1
14	4:9	disquiet, transhuman and alien
15	3:7	middle-eastern and metaphysical
16	2:5	sickness, recovery, renewal
17	3:8	wrong directions and fanaticism
18	5:14	ominous and threatening
19	1:3	wholy trinity, very nice
20	4:13	brooding and relentless
21	3:10	cosmos and cosmology

There, that is the end of my table. A few *mea culpas* are in order. I determined the ratios and the frequencies with a small program

that sets A to 440 cps, and then uses the twelfth root of two as the multiplier or divider to go up or down the scale. Thus, twelve steps will double or halve the frequency, producing the octave, the same note in a higher or lower register. This is true only if we use all the white and black keys, in other words, the chromatic scale. The modern well-tempered scale is a geometric progression, mathematically speaking. Tuners may not stick to it exactly, for reasons of their own. Not all the ratios are exact. If they are within one percent of a ratio and there are no other ratios closer, I considered it a match. There really are "lost chords," that is, chords that cannot be played in Western music. Dissonance is not necessarily meaningless. Not all dissonance is the same. There were times when medieval music used dissonance, and 20th Century "serious" music also used it. Not all harmonies are "sweet." If it is a rational number, and has a definite feel to it, I wrote it down, sweet or sour. A "sour" harmony is still very different from a dissonance. Feel free to interpret the "meaning" for yourself.

Architecture: Renaissance and Gothic Masons and architect created their designs using nothing but the compass and square. I don't know if that is true, but however they did it, Gothic and Renaissance cathedrals and churches are Mandalas, at least in their use of the compass and the square. We create the pointed arch with a compass, just as with a round arch. If any architect wishes to try Mandala architecture, they are pretty much on their own, and will have to rediscover or invent the tools and techniques.

The computer has at least made it easier to make curved shapes and get away from the box. There are finite element programs which will do the engineering for you, and that is how Frank Gehry succeeded in making curved shapes in his Guggenheim museums. The one at Bilbao is a tourist attraction, and it may be the first 21st Century piece of architecture. The Walt Disney concert hall in Los Angeles is another superb creation by Frank Gehry, and it is very much of the 21st Century.

Since I have never made a Mandala building, all I have are a few suggestions. Do the ground plan and the side views of the building as drawn Mandalas. Then use the finite element software to see how to

build it. Each element added or subtracted would be a 3-d piece of the building, using the drawing tools. The elements and sub-elements would allow curved shapes that are rotated curves, or fully double curved objects. It would allow rectangular pieces as details or as 3-d chunks, limited to powers of two of some basic unit. Another idea would be to create models in clay on a potter's wheel.

For myself, I would really like to get away from the drab boxes of the 20th Century with their endless rectangular window treatments. The greatest buildings are not just free form. They have restraint and symmetries. Mosques and the Taj Mahal, both Moslem creations, are the most beautiful buildings in existence. I especially like the brightly colored glazed tiles used for the surface of some Mosques. Why can't we do that? Why can't we have color and graceful curved arches? The utilitarian architecture of the 20th Century has a brutalizing effect on its inhabitants.

Dance: In Western culture, we do not find Mandala characteristics in the "high-culture" classical traditions of dance, designer clothing or drama. We find them in the folk traditions. I refer to square dancing, quilt making and popular festivals such as Carnival.

It is quite easy to find the "square" and the "circle" in square dancing. In traditional western square dancing, the entire room is organized into many squares, each of which has four couples, who start by facing inward towards a center point for that square. Sometimes they dance as four couples, spatially arranged as a square, as in "swing-your-partner." Each square periodically forms a circle, as in "all join hands" or a moving circle, as in "allemande left, right and left hands." Sometimes there are "formation" calls such as "Texas Star, ladies to the middle," in which the ladies join all four left hands in the middle of the square.

The improvisational element comes from the caller, who can put the various moves known to the group together in any order. The equivalent of the "sheet of paper" is a list of the calls. In other words, it is easy to reproduce a dance, or modify it.

Please don't think that square dancing is just for older folks, where the women wear countless petticoats and everyone dresses alike. When I was in high school (admittedly a small country high

school in the Oklahoma prairie), square dance parties were one of our favorite forms of entertainment, and we just wore blue jeans and our normal school clothing.

We can square dance to any music that has a rhythm. Try it with rock and roll. Try it with the sound track of the movie "Trainspotting." Folk arts have advantages and disadvantages. One disadvantage is that tradition can become rather fixed and inflexible.

A square dance club can improvise further by inventing new steps or "formations." Clog dancing is one form of square dancing that differs from other square dancing only in the kind of "step" used. Don't let existing forms of square dancing inhibit your imagination. All that is essential is the circle and the square, dancers maintaining physical contact with one another, with a caller to introduce an improvisational element, and all dancers making the same moves at the same time, so no one feels self-conscious.

Mandala making is never self-conscious, in order to reach a level of pure feeling. No thought is required on the part of the dancers. Mandala dancing becomes an expression of the collective self. It is also important that Mandala making in any medium be something anyone can do. It takes a lot of skill and practice to do some of the more showy moves of either ballroom or rock and roll dancing. It will also require a total lack of inhibition. In ballroom or rock and roll, the dancer must learn the dance moves ahead of time and practice them. Many people do not have that opportunity. Most shy and awkward people do not dance ballroom or rock and roll; however, they have no difficulty with square dancing.

The basic moves and steps are easy, and since everyone in the room is doing exactly the same thing at the same time, there is none of that fear that everyone is watching the dancer that inflict many of us on the dance floor. The square dancer doesn't have to be inventive. He or she only has to listen to the caller.

Cloth: The second folk art is quilting. It has all the elements of the Mandala, including the circle, the square and improvisation. Quilting has to do with clothing only in the sense that the medium is cloth. The traditional quilt is something put on the bed, or, if a rare and expensive antique, on the wall. We can just as easily sew a square onto

jackets, skirts, pants, bags, flags or robes, and quilters often do this.

The quilter can make banners or flags by sewing the pieces together with a layer of black paper to provide reinforcement. In this case, there is no "quilting," a term that refers to the stuffing in the middle layer of a quilt, adding bulk and warmth.

Traditionally quilts were a frugal way of making use of worn-out, castoff or outgrown clothing. Indeed, the improvisational part mostly comes in the selection of colors and designs of cloth. Quilting was also a communal activity. I am not a quilter myself, but my grandmother was. Today we recognize quilts as works of art.

The formal elements of quilting make use of both the "circle" (repeated elements, many small pieces cut to the same pattern) and the "square," i.e. power-of-two relationships between lengths. I know a few of the many primary patterns in quilting, used to make each block. Sew many blocks together to make a quilt, or sew one onto a robe or jacket or purse. Many blocks sewn together form the top level of a quilt. The stitching that holds all three layers of a quilt has its own separate beauty and pattern.

One primary pattern is the "monkey wrench." Start with four small squares of two contrasting fabrics. Sew these together to make a larger square. Then begin adding right triangles, alternating the same two contrasting fabrics. Sew the hypotenuse of the triangle to the edge of the previous square. In this way, we make a sequence of circumscribing and rotated squares, as the square grows larger.

Repeated folding of freezer paper creates some designs. A single pattern is cut out of the folded paper that when unfolded provides a block pattern with 4-fold or 8-fold central symmetry. We then iron it onto the cloth to provide a pattern for cutting.

Drama: The third folk art is drama. Mandala drama has nothing to do with performance on a stage for an audience. All Mandala-making is participatory. Mandala dramas are the traditional folk processionals and rituals of Carnival or other religious days still practiced in the Latin nations, and in Japan and India. The Western and non-Western "Carnivals" are surprisingly similar, tapping the universal patterns of the collective unconscious.

Mandala drama involves creating masks, costumes, floats, or

objects carried, either individually or by a group of participants, putting on makeup or costumes to lose one's ordinary self, and dancing, drumming, raving wildly through the streets all night long. Usually these events have a religious or mythological basis. Sometimes the final act is to burn the large figures, accompanied by fireworks. One is acutely aware of the fact that Puritans founded this country, since the only Carnival here is in the predominately French and Catholic portions of the country, e.g. Louisiana.

Our Carnivals are nothing compared to the extravagance in other countries. We must lose our inhibitions, get in touch with metaphysical and mythological themes, and learn to express. Ex-Puritans will have to consciously re-invent Carnival, or similar processionals celebrating New Year's or the Fourth of July. Like square dancing, processional is a Mandala of the collective unconscious of the group. Processionals or dramas are also part of Mandala magick.

When it comes to both dancing and drama, our Puritan roots show. American culture has many roots and that is our strength, even if at times it threatens to split us into many warring tribes. Rock and roll springs from African-American and Irish roots in our culture. The New Age movement of the 1960s is unimaginable without rock and roll. Despite the excesses (especially with drugs) and the absurdities of the New Age, some real change began in the sixties.

A true New Age will be a tapestry with threads from every culture, including that of the First Nations. The Navaho still have elaborate festivals that last for days that involve making the elaborate paintings of colored sand that are certainly Mandalas. Why can't we claim some of those rites and make them our own? Would the Navaho object? I do not know. I can only say the Mandala philosophy combined with our varied ancestry offers us a richness of cultural possibilities.

We can even mine our European roots for folk rituals from small towns in Spain, Portugal, Italy and Mexico. We now have many immigrants from the Far East, so why not mine our East Indian, Japanese and Chinese roots as well? Lose your self in the greater Self. Tap the deeper roots of consciousness, and express ONE in motion.

One Speaks

In the winter of 1962-63, John Starr Cooke lived in the Carmel Highlands, above Carmel by the Sea in California. He was the leader of a group of seekers, who had experimented with many things, including Subud and Huna. One evening they made a homemade Ouija board, using a silver dollar for a planchette. Much to their surprise, it produced sentences. After 5 or 6 sessions, it began dictating the 22 major arcana of the Evolved Tarot published as the T Tarot in 1969, 1970, and 1992. These 22 major arcana came from a source that never identified itself as anything other than a silver dollar. See http://members.aol.com/pythagoras9/tarot.html --- Rosalind Sharpe published the complete sessions in1975 as *The Word of One*. It is on-line at http://members.aol.com/drhumph/toc.htm and it is just one file, so after loading it up, one may search for a favorite phrase, such as those I used at the end of the "Spirituality" chapter. Use the Edit command on your browser, and then "find."

The 22 major arcana books are THE revelation for the new age. That's my opinion. They are clear messages from the deeps, because they are cast in the language of symbolism, the language of the deeps. Even those who received them did not know what they meant. It took me 7 years to figure them out and I still haven't figured out everything, especially about the Citadel. Those cards I fully understand, I also find to be absolutely true.

The figures in the books are young adults with only three exceptions. An infant holds the keys to the seven doors in the book of the Reactor. (Seven doors to what? The seven chakras in the Citadel? The seven rays-ways of the Renewer?) A seven-year-old boy holds the horses-forces of black and white in complete control in the book of the Doer. The Seeker is old, lean and wiry, balding. There is a meaning to this pattern.

I interpret this as the sequence of things the metaphysician must learn and do. As a babe, metaphorically speaking, he must learn the keys to the Seven Ways, so he loses any sectarian intolerance about the other 6 ways, since one can only follow one path at a time. The seven ways are western science, saints & Sufis, yoga, Taoism,

shamanism, kabbalah, and the Way of the Sun that combines all the others. That is the lesson of the Reactor, who is just learning the various ways of spirituality.

Next he is the seven-year-old boy of the Doer, formerly (and still) the Sun card. He has learned to control the dark forces within himself easily, represented by the dark horse, controlled with a mere ribbon. To be more specific, he controls such things as anger and blame. He is self-disciplined, and thus avoids addictions. He has no hate, and thus avoids war and violence of any kind. He has also conquered all fear of death, represented by the white horse rearing triumphantly on a human skull, traditional symbol of our mortality. Learning to control the dark side of our nature effortlessly is not so easy, and may require many lifetimes. What is the dark side? Anger, violence, aggression, hate, worldly ambition for money and power, envy, lust, gluttony, dogmatism. He is no longer the Reactor, but has become the Doer, ready to do something. He is no longer ensnared by religion, because he knows of the white light, and the "between," and reincarnation.

There is a tradition in India of leaving behind worldly cares and taking up the life of the Seeker in late middle age. The Seeker is a wiry old man. A man may have a job and raise a family, even if his main interests are metaphysical. Once he provides for his wife and children, he is free to put down his earthly obligations and take up the heavenly pursuits of the Saddhu or Hermit. There was a similar tradition in Classical China, where there is much emphasis on familial obligations. Mandarins sometimes laid aside those obligations, as well as any governmental duties, and took up life as a Taoist Hermit, but not until late middle age. We don't have such a tradition in the West; we should.

This chapter is nothing less than an encyclopedia of metaphysical knowledge for a new age. There are 22 books in this encyclopedia, one for each of the major arcana.

The meaning lies entirely in the symbolism of the card, and interpreting it is not easy. It might take a lifetime to understand fully. The books are not originally numbered. Put them in any order you wish. I start with the Joker-Fool-Nameless One and end with the

Knower. The Book of the Knower promises us immortality, and leaves everything in a proper cosmic perspective.

Why should we believe it? Only if it corresponds to our other experience. I have already mentioned that the book of the Deliverer is a perfect symbolic description of the illumination of fire, and the path that leads up to it. That is just one example. I like the ecological ethics of the book of the Nameless One. I agree with the power of the media expressed in the Book of the Actor, a dangerous power, and an enemy. Everything in this revelation that I can check by ordinary experience, does check. The channel does not corrupt a purely symbolic revelation. Its value is that it extends our knowledge far beyond normal experience, even beyond mystical experience, to provide a comprehensive system of metaphysics, one with immortality, free will, and great psychic powers.

The Book of the Nameless One: Why is the One nameless? To give it a name is to invite sectarian intolerance. Divinity is creativity, spontaneity, freshness, and joy, LIFE. The One has no name, and we must resist using the title of "Nameless One" as a name. We do not speak of "god". We speak of the All, Self, One, Creation, or Atman.

The symbol of the Book of the Nameless One is a nude man holding a closed scroll in his right hand and an open one in his left. If you have the T tarot, you can recognize this for yourself. If you do not have the deck, refer to users.aol.com/pythagoras9/tarot.html.

Behind the figure of the man is a pit of bones. He strides away from this pit, a band of purple on his forward leg. Behind him are stones, before him are flowers. His companions are a spider and an animal with the body of a cat, and two heads, one a cat-head, the other a dog-head. The sun is high overhead, yet paradoxically the sun reflects in a lake in the far-left background. In the middle background, there is a T shaped object. This book was formerly the Fool card.

The entire message of this book is contained in this description if you can read the language of symbols. Do not be dismayed if the meaning is not perfectly transparent. It took me five or six years to work it out. The principal clue is the purple band. The purple band was the detail that refused to fit the interpretation given by John Cooke and

my own early thinking about it.

Why is the Nameless One wearing a band of purple? It is a symbolic attribute of the forward motion of the Nameless One, away from the pit of bones, and towards the fields of flowers. What attribute? Our only clue is the color. Purple is fairly rare in nature, and I could not think of any association that made sense of the rest of the book until I remembered that in ancient civilization, purple was a rare and expensive dye. Its only source was a gland in a marine animal found in the Mediterranean, and purple cloth was so expensive that only the imperial family could use it. Even they could only afford a narrow ribbon of purple around the edge of their clothing.

Thus, the quality attributed to forward progress is imperial authority.

The Book of the Nameless One is like the Ten Commandments for the Way of the Sun. The divine title or description given to this book alone reinforces this idea. In so far as we make the divine purpose our own, we too must walk away from the pit of bones, and add no more to it. It is no longer necessary for us to massacre one another, or the other higher life forms on earth.

The One thus prohibits killing anything with a skeleton. More exactly, imperial authority says "progress away from the pit of bones." Thus, if we each take some step in that direction, we are obeying the commandment. Remember that you are the One. This is an inner necessity welling up in all those sensitive to the inner life. Since 1963, millions have become vegetarians.

Strict vegetarianism is not really required. Seafood other than fish is invertebrate. Nor is strict pacifism required. Even abortion in the blastula stage is compatible, as I interpret it, though others may prefer a stricter interpretation. In my opinion, these "allowances" only serve to make it a literal, practical, and exact code of ethics.

Striding away from the pit of bones implies all this. This act will make all nature tame, and thus we stride towards a Garden of Eden. The cat-dog amplifies this ecological theme.

You might see the cat-dog as merely a companion for mankind. You would be wrong. Why does it have the body of a cat? Why not the body of a dog? In effect, this animal is a cat, but the mad scientist

(Thinker) grafts the head of a dog onto it. If you are sensitive to the language of symbols, this detail should be a puzzle, a warning that the first interpretation is incomplete.

The symbolism hinges on the difference between cats and dogs. The cat is little different from its wild ancestors. It is a wild animal, one that has chosen to live in proximity to humans. The independence of cats is the independence of any wild creature, and is nothing unusual. What is unusual is the fawning behavior of dogs, so unlike their wild ancestors. The dog is one of man's technological creations. Dogs, coyotes, and wolves are all the same species biologically. Behaviorally, there are enormous differences. Wolves and coyotes are wholy, i.e. part of the whole. They are guardians of the ecology, much more than humans at present. This is worth detailing. Wolves and coyotes do not breed indiscriminately, like dogs. Each den has only one breeding pair. They have one litter a year, 1, 2 or 3 pups. In good years, when game is plentiful, they will have 3, in lean years; they will have only 2 and raise only 1. Dogs have no such restraint. This close connection with the balance of nature is wholy. The wolves and coyotes keep the herbivores in check. Otherwise, rabbits and rodents would multiply to the point of killing all the vegetation, on which we all depend.

Grafting the head of one animal onto another is exactly what the mad scientist would do. It is a symbol for all the unwholy creations of the Thinker. Domestic animals create the deserts of the world. It is the act of the narrow, unwholy specialist. Unlike wild ungulates, domestic livestock will eat plants right down to the roots and they will blow away in dry seasons. Once the green vegetation is gone, rainfall over the area also becomes less, and the desert is permanent. This process happened in historical times in the arid Southwest of the USA. Thus, the cat-dog is really an ecological warning.

Think of the sun reflected in the lake as fire-in-the-lake. Fire-in-the-lake is a hexagram, and is another Garden of Eden image. It would be physically impossible for the sun to reflect in the lake, since the Silver Dollar specifically says the sun is high overhead. Such contradictions shock us awake, and realize we are not just looking at a portrayal of a landscape. Fire-in-the-lake (trigram fire over Trigram

Lake) means estrangement but has the additional meaning of an underlying unity. The commentary in the Book of Change says that when heaven and earth are joined, great harmony results. We are heaven, and nature is earth, and we have been in estrangement for a long time, but never more so than in the present time of the World-machine.

The symbolic letter of this book is T. Some of the cards have letters, and some do not. The Nameless One makes certain that we understand that the symbolic meaning of T is in its shape. "T. A beginning- -the end is determined by the three-pointed form." This is an ancient abstract shape, and it is an abstraction of the shape of a standing human figure with arms stretched out to each side, a posture frequently found in the Books of the Nameless One. It is a gesture also found in the catacomb artwork of the early followers of the Way of the Saints.

To understand this gesture, imagine yourself standing in whatever would be a characteristic posture, surveying the course of your life. You have lived long enough to see that all the twists and turns, obstacles, crises and mistakes have led you to this point, where you are ready to take up the divine purpose and make it your own. WE keep ourselves ignorant of advance knowledge of the patterns; yet SELF has chosen these challenges in order that we could rise to the occasion. Creativity is like a spark. That is why the spark-star is the symbol of creativity. Without challenges, obstacles, crises and mistakes, we would never learn anything, never grow, and never rise to what we have become. It is in the creative response that we are free of the shackles of cause and effect. It is in that moment that we become something unexpected, something unpredicted by the Thinker. Creation shapes all life and history, in nature and society. SELF chooses the accidental patterns, not because we know the end, but because it takes some hard lessons, some hard obstacles for us to rise up in glory. Realizing this is a form of Awakening. It is a realization of the Self at work in all our lives. Once you have recognized this pattern, the arms swing open in welcome to all life has to offer good and bad, pleasurable or painful, easy or hard. It is all part of the grand adventure. Without the hard places, we would lose our calluses. The

heights of experience and being only arise out of struggle and difficulty. What is a little pain or sorrow compared to that?

Instead of being the random victims of fate as taught by the Thinker, the Way of the Sun transforms you into a cosmic hero, an adventurer through many life-times, on many planes of existence, on many levels of reality. So welcome it! That is the meaning of the T-gesture, and of the T symbol. The early followers of the Way of the Saints understood this perfectly well that is why they were able to accept martyrdom, and why the T became their dominant symbol. The ancient Egyptians also used the T symbol, in the form of the ankh.

The Book of the Changer: The Changer is a man standing on a sphere, with his arms stretched out to the sides, forming the sign of "T". His right palm turns upward and holds a white flower. His left palm (on the right of the picture as we view it) turns downward, and from it, water falls. He wears a brown dress or tunic, stretching to his knees, and gathered at his right shoulder by a red stone. There is a double axe woven into the cloth over his chest. An eagle hooded in white, sits on his left shoulder, drawing three drops of blood. Spread below him on a cloth of gold is a stone, a two-headed serpent, a pear, and a curved blade. The whole scene is on a high plateau with clear blue sky.

This book is a promise to all that use the new tarot that they shall surmount the world, change the world and themselves, and thus usher in a new age. How? Not through power because the eagle is hooded. Not through fame because the Changer is covered. It will be through beauty offered to heaven, not created for personal gain. The Changer offers the white flower of creativity to the heavens in a pure spirit, unmixed by thoughts of personal gain or power.

The Thinker has destroyed beauty, creating an environment of pure functionalism. The function of the environment is not complete if it has lost all beauty and meaning. So, off with his head! That is the function of the axe sewn into the Changer's tunic. The Thinker has led the sheep into a desert of shallow rationalism, in which all the higher forms of life have died. No purpose to life, no life beyond the functioning of the body, no risk or adventure, no magic or beauty, a safe and sterile world for robots. Into this desert, the Changer brings a

spring of fresh water from the deeps, and releases it freely with his left hand. It is there for all that seek, but first one must arrive at consciousness of thirst.

In interpreting the white flower, it is well to remember that the former name of this card is the Mage. Friend and foe alike misunderstand magic. Foe imagines it to be mere stage illusion, mere Houdini. Friend imagines it to be incantation and rite that stands in some cause and effect relationship to reality. In truth, real magic is art, and real art is magic. The art of the mage is to communicate subliminally with the depths of his Self. In this way, we transform reality indirectly, through pleasure rather than force or coercion.

"The Changing One is to change and be changed... At this point of time let none measure the progress, or time, or activity..."

Let none measure the time or progress, because the transition to the new age may take longer than one might expect. It took 1000 years for the ideas of Confucius to flower into the golden age of China, and an equal amount of time for the Greco-Roman world to fall.

Q: Is there a missing element? A coming shepherd?

A. "The missing element, so-called, is not a shepherd- - its quality, however..."

The shepherd is not some person; it is the Changer, who is dressed in the homespun brown of the shepherd. "Shepherd" means sheeperder". It is no insult to compare people to sheep. Sheep are the most industrious and useful and versatile of animals, and the most courageous in their wild form that inhabit rocky heights. The dominant motivation of sheep is to be with the herd, and this is also true of people. Thus, a wolf in sheep's clothing can easily lead them astray.

"In the mouth of the lion is lodged the seed which must pass out and germinate. If his tail is tweaked, he will swallow it alas. If wolves beset him, they will steal it. He may knowingly pass it to a planter. Its fruit can juice the world. Unplanted, the seed will be a husk, dry and heavy. The lion may beget cubs then, but no more."

Q: What is the seed? Would you be specific?

A: "Our proddings will continue in this plain language till it is done and when it is done, our plain language will be seen as that and

We will be forgiven."

John Starr Cooke is the lion, these readings the seed, the publisher the planter.

The lion is any new age leader, here John Cooke specifically. The wolf is the dominant elite. The lion, the sheep, and the wolf appear in a number of these books and are part of the universal vocabulary of symbolism. Consider what is unique about each.

The wolf is weaker and slower than its usual prey, the elk. Packs of wolves manage to catch large prey by helping one another. One will lay an ambush and the others will drive their prey towards it. The dominant elite are like that. Middle Americans are generally unaware that there is such a thing as dominant elite, or that there is any class in America distinct from their own. The sheep are the people, useful and industrious, but needing a shepherd to protect them from the packs of wolves.

The male lion is a traditional symbol of leadership. Do you know why? It is not a matter of convention. Symbolism is always rooted in some unusual fact about the symbolic element. Male lions are unique among predators in that they do no hunting. Their wives hunt for them. This suggests the division of labor in human societies that enables spiritual, intellectual and artistic leaders to pursue their gift without having to grub for a living. Thus, in order to be a lion of the new age, you must find a way to pursue solar activities full time and that implies a necessary willingness by the rest of us to support our young lions financially.

Do I believe in magick? I only believe it is possible, because of the promise of the Changer. I do not know how to do it. As with many of the cards, only someone who sets out to Change themselves and the world, not through power or force or politics, but through art and spirituality---they will have to find out for themselves exactly what constitutes the Waters of Life, or the white flower offered up to the Most High. Surely, it means that we cannot do magick for personal gain or any trivial purpose.

The lions of new age leadership still lie asleep under the heel of the ACTOR. The wheel of time releases the lions from the yoke of the Chariot in the VICTORIOUS ONE. If the lions can awaken and throw

off illusion, they will be ready to "walk with other lions" and unite in upholding the seven ways in the ROYAL MAZE. The destiny of world unity thereby implied requires full time effort by at least a few.

A red stone pins the Changer's dress together. Red is for passion. It is our righteous anger at the wolf that keeps the Changer's shepherd clothing pinned.

At the end of each book, the One usually gave a one-line interpretation, but in the case of the Changer, "significance cannot be said!" Not to John Cooke. Meaning no disrespect to this advanced being, now deceased, I don't believe he was prepared to accept the proposition that the way to change the world was through magic. If told this, he would have "swallowed the seed," and it would have been lost. This power is so unexpected by the world, that it comes "out of the blue", from on high. That is what the blue sky and high plateau means. See users.aol.com/pythagoras9/tarot.html to see what I mean.

Magick is not a set of rules, contrary to Donald Michael Kraig, author of **Modern Magick** although many people think so. I believe it must be improvisational and must come out of a sacred atmosphere where mysterious forces manifest. In those Ouija sessions of long ago, sometimes colored light played around the hands of the two people on the board. Sudden winds would blow open a heavy door. Fire would suddenly flare up in the fireplace. "Magickal are the times. The Doer has been activated." -- **Word of One**.

The Changer stands on a sphere. The sphere is the world. It is the same sphere held in the palm of the hand of the Actor, and used as a footrest for the Hanging Man. In the Changer, it is a promise to the new age, that we shall stand on top of the world, surmount all difficulties, and change the world, bringing about a new age. We shall not do it through the force of government, represented by the eagle. We shall do it with the tools of the Changer, spread out upon cloth of gold below. These are the four symbols of the minor arcana. Before we can do the Mage-Art, we must discover our own new tarot, and build it around a suit of stones, a suit of curved blades, a suit of pears, and a suit of two-headed serpents. These stand for four different types of people and their appropriate actions.

The four tools rest on cloth of gold. Gold is unique in being

untarnishable. It doesn't rust or decay. Gold jewelry buried thousands of years ago is still just as beautiful as it was when buried. It is a substance easily purified. You merely heat it in a cauldron, and the rocky slag floats to the surface, while the metallic components stratify. Life is also a cauldron; it tends to purify the Self and gradually float away the slag and separate off the inferior metal, until the pure and untarnishable Self remains. Whenever you see gold used symbolically, think of the imperishable within, and its purification over many lifetimes.

The four tools of the mage are the universal symbols in the collective unconscious, formed over many centuries.

The Changer stands in the T-cross open to the adventure of life, accepting the risks and dangers right along with the joys, as challenges to stimulate our greatness. This should remind us that there is no simple formula for growth and change, and we must adapt and struggle with each new day.

The way to Change the world is to be a shepherd to mankind, to help those who are lost find their way, and to protect the flock from the wolf. How shall we do this? The principle way is the white flower. This is the Art of the Mage, the Yang side of the Changer. The rest of the card is principally advice as to what not to do to change the world.

We should not be missionaries. Most spiritual and religious groups think they have a license to bother people, just because the sheep are dying of thirst in a cultural and spiritual desert. We offer the healing water from the deeps only with the Yin hand. We will accept and nurture all that come to us and seek. First, they must seek. The Changer shall change himself and others only by freely giving the waters of life and the purity of beauty, given away freely and not sold. This is the only kind of magic there is.

We shall not change the world through government, either as revolutionaries, or as politicians. The eagle represents government because the eagle is the only universal predator, striking its prey in the air, on the ground, or in the water. Likewise, government is the universal predator, more powerful than anyone or anything, and a danger to all. Here, we have brought government under control, and put a hood on it like a tame falcon, though at a cost of three drops of

blood. Thus, we shall oppose all revolutionaries (for all seek to change things with government), and we shall oppose all liberals who hold the same belief; we shall oppose all government, and seek the expansion of other institutions and traditions. We do this in a Yin way. The eagle is on the left shoulder. This is not our crusade, or principal way of acting.

I once supposed that world unity must require world government. Instead, world unity lies at the heart of our Royal Maze destiny, and comes about by the revival of the seven spiritual paths.

We shall lead the world through the power of beauty. Lead on, gentle Changer.

White is the color of purity because white paint mixed with any other color is no longer white. Purity is simply unmixed. Only the pure and wholy may be mages. As a human symbol, it refers to motives. The hand holding the white flower is turned palm upwards, offering it to the heavens, to whatever is highest, to the Self, to the All. Magic is prayer, couched in the language of the Self. That is why there is no such thing as black magic, any more than there is black prayer. Within this limit, the Changer can do anything by magic. He does everything in the normal way, through human action. Mostly the Changer changes himself. The Self arranges those "coincidences" and "chance" meetings in life that provide the lessons and the challenges. That is what we call luck. The Art of the Mage can influence luck.

A flower builds upon the energy captured by the economy of the leaf, and provides the cross-pollination and stimulation to start the growth of the fruit. The art of the mage is the flower, hard work is the leaf, and a new age is the fruit. The symbol of the flower implies the beauty and fragrance of the fine arts. The Art of the Mage is simply art... painting, music, architecture, drama, dance, literature. Any ritual surrounding the art is just to create the proper mood. Mage-art is intrinsically holistic, quaternal and complete. That is the description of a Mandala. "Mandala" is a Sanskrit word meaning centered circle, and Jung finds them in the sacred arts of all cultures, and in the symbolic dreams of children and uneducated people as well as those who have actually seen oriental Mandalas. It is a universal symbol of completeness and wholeness of Self. Doing Mandalas is the essence of

Mage-Art. A Mandala creates itself; the Mage interprets it. Anyone aspiring to be a Mage must master the intuitive art of symbol interpretation. That requires the wholistic sage, one familiar with all phases of human existence, and master of the essential ideas in every cultural form. That may be one reason it is a lost art.

All creation has symbolic meaning, i.e., intuitive and emotional associations and overtones. All art is symbolic. All human creations are symbolic. The difference is that the Mage understands the meaning of his creations, and has some control over those meanings.

Magic is a mighty power available to all yet known by few, since only those who master the language of symbols can do it. That is why you must study and work hard, learning to interpret dreams, tarot layouts, and Mandalas. The world is ripe for new art forms. The "modern" movement is dead; indeed, no really persuasive art form has appeared in western culture since the Baroque. The Art of the Mage can fill this vacuum.

The Changer shall transform the world by new art forms. The public will not usually be aware that these new forms express magical purposes and help to bring them about. The medieval masons kept that fact secret from the public when they were designing cathedrals. Freemasons are the modern descendents of medieval master masons.

The Book of the Royal Maze: "Into the Maze you have stalked- - The binder and freer of one. He who enters is allowed to. Always be mindful that certain things have been left behind. Childish things. Those things which do not become you. Should a babble arise, hold on to your Self while your droppings fall. Let fall the limbs. Remember only "I am I". Destiny is the meaning of this book."

The Royal Maze: In a field of yellow is a target upheld by 2 heraldic lions-rampant, a white one on our left, and a black one on our right. Their tails intertwine below center. In top center, we find 3 golden rings linked together. The target consists in 7 concentric bands of different color. The center is white and contains a crown, also viewed as a circle. The crown holds 5 jewels: ruby, emerald, diamond, turquoise, and onyx. Superimposed on the target is a square, quartered, with diagonals to the corners. In the quarters, clockwise from upper

left: torch, sailboat, cup spilling wine, and a figure 8. Here we see the seven ways to higher consciousness (Yoga, The Way of the Saints and Sufis, the Medicine Path, Kabbalah, The Tao of the Mandarin, the method of science, and the Way of the Sun) arranged as concentric circles, each complete and infinite by itself, yet also centered and completing one another. They form the wheel of Dharma, whose 8 spokes are superimposed.

This is the target for mankind held up by new age leaders throughout the whole spectrum (symbolized by the spectrum of lions from nearly white, through various yellows and browns to nearly black). There is no unity in the religions and dogmas and rituals of mankind, but there is a unity in the 7 paths. Our destiny is to clear away the "droppings" (shit!) and "childish things" and show each one the purity and magnificence of the path underlying their own tradition. Only in that way, can we achieve the crown of 5 continents, the crown of world unity and world community, and finally put an end to the terrifying risk of holocaust.

There are no entrances marked to the Royal Maze, to remind us that each path is a mode of experience and not a straight and narrow way. Each must find or create his own way. Each path has its discipline. That is the binder of one. Pursuing the discipline expands our powers. That is the freer of one. In the 4 quarters of the wheel, we find the things necessary to this destiny: the spilled wine of life, motion and change over the boundless seas, passing the torch on to the next generation (for this will not come quickly), resulting in the doubling of the way.

Three golden links of creative life overhead: creation, destruction, preservation; also, thought, being, and action.

There are many crowns in the BOOK OF T, and they are all different. This one has on it a ruby, emerald, diamond, turquoise, and onyx. Turquoise suggests North America where Native Americans still use it in jewelry. Emeralds come from South America. Onyx is Africa, where it was a favorite stone of the Egyptians. Rubies represent Asia, where they are most used, and diamonds represent Europe, for the same reason. There are five stones, five continents, five races. It is a symbol of world unity on a physical plane, thus the interpretation of

the Book of the Royal Maze.

The four symbols on the wheel of destiny indicate a cycle of activity. If we begin with the first element mentioned by the Nameless One and proceed in a clockwise direction (in the direction of time), we find a message similar to that of the Book of the Victorious One. We might call it a lesson in unresolved group karma that we need to face before world unity becomes a reality. The sail boat has only one mast, because only one of the 6 civilizations (ours) caught the winds of change 500 years ago, and blown by them, eventually came to physically dominate the world. This resulted in much spilled wine, i.e. much bloodshed, many cultures unfortunately destroyed by the militant preachers of the West. Yet, out of many dreadful acts of enslavement and massacre has finally come a doubling of the way (8 sign), as at least some members of Western civilization have begun to find value in other cultures, and by contrast have found much lacking in our own. The spiritual awakening of the West really dates from the time 100 years ago when a few people first started taking oriental philosophy seriously. Now, the time has come to raise up the torch of this new synthesis of all cultures and all paths, and light other torches with it, and carry them to places of darkness to en-light-en all mankind. This is the Way of the Sun that includes everything and everyone under the sun. Everyone is on it, and every experience is relevant to it.

The name of the book is significant. Instead of a single road, or set of commandments, the same for all, life and history is a maze, without ready-made entrances or exits or ready-made paths through it. We each of us find our own way, or make our own way. Instead of being a straight line to a single goal, life is full of unexpected twists and turns. If we had it all planned out ahead of time, there would be no room for the little surprises of Self that in retrospect always appear to be the best thing. Each turn has some value. Either we learned some part of the puzzle we must eventually put together, or we outgrew some limiting belief or value. The Self gives us the challenges we need; whether we rise up to them, no one can tell, not even ONE.

In this philosophy, we see the correct linking of the golden links of thought, being and action. It is not enough simply to think. We

cannot really develop our being through sitting and reading or writing. We must act, and in acting encounter new experiences that in turn enlarge our capacity for thought and action.

The Royal Maze is in a field of yellow, the color of sunlight, and thus a symbol of whatever provides the ability to see, and the energy to grow. The Royal Maze philosophy liberates us from all exclusiveness and self-righteousness. It is a very positive ideal of unity-in-diversity, and that is why the lions of the new age all across the spectrum agree in upholding it as a target for mankind.

Further knowledge of this book comes from taking a solar look at each of the seven paths.

We must always distinguish the path from the places that spring up alongside it. Nor is the path the same as the vehicle man constructs for traveling on it. Thus, we may uphold the legitimacy of scientific method (that is the path) and reject the materialistic dogmas of the present day Thinkers. After all, psychical research uses exactly the same method as physics. It is just as rigorous. This is also true of transpersonal psychology, Ufology, holistic history (Toynbee and Spengler) and a dozen other disciplines rejected by the universities. The universities are not the path. Only the method is the path, and anyone may use it. The problem with people like Carl Sagan and Martin Gardner is just that they are not scientists. They are not on the path. They refuse to base their theories on the facts; they prefer to accept or reject facts according to their textbooks.

In evaluating the Western path, it would be well to remember its original breadth, and strive to open it up again to that breadth. Thales of Miletus founded the Western path, 2500 years ago. Thales did something unique, something I've always admired. He created a path, and then stepped out of the way. His followers did not Thales or his works into idols and obstacles along the way. Consider some of his principal students and followers.

Pythagoras was a student of such varied topics as reincarnation, mathematics, and symbolism, and made significant advances in each study. He is one of the principal pillars of modern day mathematical science, as well as a principal pillar of symbology! Like every path, the Western path potentially includes every experience, and anything

less is not the complete path.

The Solar path differs from the Western path in that we look for challenge-and-response and not cause and effect. We look for wholes, and attempt synthesis, whereas the Western path breaks everything down and admires the narrow specialist and his purely technical knowledge. Like the African song of the Griot, we admire immediate experience more than abstract knowledge. Like Yoga, we emphasize the life of the Seeker, and the personal acquisition of Illumination and powers. Unlike Yoga, we do not believe in gurus. The relationship between Speaker and listener is much looser than that between Guru and disciple, much looser than the Western teacher-student relationship.

Like the Tao of the Mandarin and unlike the Way of the Saints, Speakers are concerned with community, and man in his social aspects. Like the Medicine Path, the Way of the Sun is close to nature.

The Book of the Deliverer: "The Deliverer is the name of the Book-Strength. Its meaning is: that which is to come to each... She is not the Deliverer- --nor is he. The flame is."

A lion stands behind a seated woman facing us, in the nude. The lion's forepaws rest on her shoulders. She warms her hands at a cauldron of fire. A nude man on our right, in profile, holds a cup of fire with both hands and drinks, burning the grass around his feet, and lighting his center. The figures are serene and attractive. The woman has golden hair. At top center, there are two serpents, joined in a figure 8, alight with fire. In the background is the ocean. On our left, a large, straight, golden serpent with blue forked tongue facing right emerges from a black box.

The Book of the Deliverer describes a path to cosmic consciousness (the illumination of fire). This is a normal experience, like love that anyone may share. Let me recount my own experience of it.

I was meditating on the analogies between tarot cards and historical periods one day in the spring of 1971, when fire filled and surrounded me. Accompanying this was a sudden perception of everything I knew in a single flash, with a single thread of meaning running through it. It was a most remarkable and ecstatic experience

and for a long time I could not talk about it. I immediately recognized the experience and the steps that lead up to it in the Book of the Deliverer. Indeed, that is what first drew me to the Book of T.

The Nameless One tells us the Deliverance is "that which is to come to each." Life took a long time to evolve from direct consciousness to self-consciousness and may be about to make another evolutionary leap to cosmic consciousness. That is the extraordinary thesis of Richard Bucke's book *Cosmic Consciousness* and of the Book of the Deliverer.

I once thought mysticism exemplifies special pleading of a kind of knowledge that is unspeakable and not accessible to all. Not so. The beginning steps are common and ordinary and already known to you.

The golden serpent emerging from a black box and by the ocean in the background prepares the Seeker for the fire.

We've all had flashes of insight while daydreaming. Such occasions arise while washing dishes or driving the car, or doing something else humdrum and ordinary, where certain conditions exist. These conditions are solitude and some activity to occupy the body. I call this "work-meditation". It is an exercise for the body and "no-exercise" for the mind. The ocean symbolizes this free state of mind, because of its buoyancy and boundless horizons. There is only a difference in degree between ordinary daydreaming and the Seekers "bathing in the waters." The Seeker can spend hours in an ecstatic almost trance-like state, but even the Seeker begins his daydreaming with fantasies of heroic action. Indeed, the evolution of daydreaming is much like the hero-cycle known to mythologists.

People have asked me what exercises I do, knowing me to be an illuminati. I don't know quite what to say, because "bathing in the waters" is no-exercise. You cannot daydream if you are doing mantras or some other mental exercise. It is a state of unfocused consciousness, not of concentration. It is just the opposite of concentration.

Quite complex ideas can arrive in a single flash while bathing in the waters, ideas that it would take days to explain. Cosmic consciousness is like that. In a single instant, insights into the meaning of life are gained that would take a lifetime to put into practice or

convey to others. "Bathing in the Waters" was a well-known state to the early followers of the Way of the Saints. Baptism is just a physical symbol of the mental state once achieved. Christianity has retained the symbol but forgotten its meaning. Of course, not all daydreamers become Christs, i.e., Saints, Self-realized. Some become geniuses. Another ingredient is required to reach the fire. That is what the serpent symbolizes.

The snake in many forms abounds in the new tarot. There are two roots to this symbolism that unite in meaning in various ways. Freud did not invent the resemblance of a snake to the male sex organ. We all know this. The phallus is the instrument of initiation into adult life, both for men and women, and initiation is one of the symbolic meanings of the serpent. Though we never realize it at the time, the first act of sex is the true dividing line between childhood and adult life. Adolescents are so eager to walk through that door, never realizing they are leaving behind the carefree world of childhood and entering the time of adult risks and responsibilities. Any experience which initiates (i.e. begins) a new phase of existence is apt to be symbolized by a snake. It is not sufficient to read about initiatory experiences. It is not reading about them, it is doing them that is the initiation.

The other root of meaning is that the snake is of the earth. Snakes lay their eggs underground, and the little snakes emerge from the ground, with the same temperature and feel as the ground. Thus, the serpent symbolizes anything from nature. The golden serpent combines both meanings. The lions of the new age will let nature out of the coffin (black box). The Thinker placed nature there. Nature is not a dead machine. The mystic knows this by direct experience, because he tunes into the thought-feelings of the wind, trees, mountains, and the moon. I call this mental state "earth-roots", and the process of seeking it is "finding your roots in nature". The Thinker adamantly refuses to admit the possibility of conscious trees or clouds, because they lack nervous systems. Clear your minds of such rubbish. Consciousness has nothing to do with nervous systems! What is the dogma of the Thinker compared to the actual experience of the nature mystic? Consciousness in nature does not wall itself off into tight little

egos. It is only necessary to lower your own boundaries and immerse yourself in the flow, to experience the ever-changing infinite delight of nature's moods.

The poetry of Wordsworth gives some hint of what you may find in this state. So may the chapter "Thales" in my own *Whole Earth Inner Space* (Thales Microuniversity Press, Stillwater, 1973), now on-line at http://users.aol.com/pythagoras9/index.htm --

Finding your roots in nature is part of every spiritual path. It is the principal reason the early yogis left the cities of India to go into the forests, why the Saints sought out remote isles in the Mediterranean or the Atlantic, why the Sufis went into the desert and the Taoists into the mountains. If they merely wanted solitude, that could be arranged in the cities.

The serpent of nature is golden, reminding us of the purification of the untarnishable Self through lifetimes of experience. Tuning in to the thought-feelings of nature is also a kind of purification.

The serpent's tongue is blue, the color of renewal. The tongue is the principal sense organ of a snake, combining smell and taste. Finding our roots in nature renews our spiritual senses, and leaves us open to higher possibilities. Cosmic consciousness is something that happens in maturity, not to children. Bucke found no cases of it occurring earlier than age thirty. I was 31. Before you can find the unity underlying the good and evil in life, you must have experienced some of each, as well as had many years of oceanic consciousness (bathing in the waters, daydreaming) and of earth-roots consciousness behind you. That is why we speak of a path to the illumination of fire (cosmic consciousness). These are places you must pass first. When prepared, then you can drink the cup of fire, i.e. becoming engrossed in something itself from the fire. For me it was the tarot; for Bucke it was the poetry of Walt Whitman.

The Deliverer delivers us from the nightmare of the Thinker. It is a contrast between warm and cold, between whole and fragment, meaning and indifferent fact, the spirit versus the machine. Deliver us, O Deliverer from this evil!

What great pattern in life does cosmic consciousness revealed?

I explain that in the chapter "The Problem of Evil." The Book of the Mother says it symbolically. There is pattern in all things, a pattern of challenge and response. Our higher selves choose the challenges we need, never more than we can handle. Though we suffer pain, we can always go home to Mother.

The Book of the Doer: "The foretelling time. The pages from the rear are in the fore. Sun-worshippers have taken their place. The ray of love is seldom perceived and often misunderstood as having flesh. The daybreak of the new morn is founded on the proper perception of the ray of love. Babes know it not--neither man nor woman. The mystic alone knows the reality of this ray."

This mysterious but all important passage of the WORD OF ONE refers to the love of ALL. The medieval monks would have called it the love of god, but I find it impossible to love a god that could sentence mankind to an eternity of either heaven or hell. It is the epiphany of T, the wonder and love of the universe in all its great and terrible glory, which understands the need for the disasters and catastrophes quite as much as the quiet joy of a summer evening.

The Doer is a nude 7-year-old boy, holding up to us an open book with indistinct characters. Each reader sees what he needs. A tasseled bookmark indicates the open page and another place in the section not yet read. He holds a tie to a meek black horse on our right. On our left, a white horse rears on a human skull. This is the former Sun card, and the sun above has character and rays. Endless vistas, fields of flowers and beautiful things should be in this card.

The book of the new age is held open by a 7 year old boy, a mere 1/5 the age of his parents, 1/10 the age of his grandparents, and 1/20 the age of the oldest folks around. If the Doer is the new American people, then the same ratios exist for us. We are 200 years old, our parents (the Europeans), a thousand, and our grandparents (the Greeks) 2000, while the Jews are about 4000 years old as a people, or a little more. We were born a little over 200 years ago, when a few poor emigrants from England finally slipped off their European heritage and became pioneers. This mysterious and momentous event took place in the obscure backwoods of the eastern seaboard, under the barrier of the Appalachian range, about a generation before the

revolutionary war. Poor emigrants went to the farthest frontier. They had to take what they could get. What they got was misery. Periodic Indian uprisings massacred whole counties and townships. The Indian was a formidable foe before the time of railroads and repeating rifles. Far from the tidewater that formed the basis of 18th century transportation, these settlers were beyond help from central authorities. Nevertheless, they relied on government for generations.

As with all seminal events, we really know nothing about it. We don't know how these colonists became pioneers. We only know the challenge existed, and they finally made a creative response. Rejecting the trappings of civilized life, they preferred to live as the Indians did, even sharing their love of warfare and fighting. Somehow, they got the nerve to defy centralized authority, whether it was English, French, or American. Government authorities drew lines on maps and said thou shall not cross. Cross they did anyway. The true pioneers kept together in clans for generations, repeatedly leapfrogging beyond the last known settlement, beyond all authority, taking terrible losses. Dale Van Every, a noted historian of the real (as opposed to Hollywood) pioneer, says they averaged a 30% loss in each generation to Indian attacks. Yet they did not hate and fear the Indian, as did later Americans. Right up to the time of the mountain men (1840s) and beyond, many lived with the Indians. All lived like the Indians, who have ever been the greatest teacher for the American people. For 100 years the pioneers leap-frogged across the country. Oklahoma was the last frontier, for the Indian, for the Outlaw, and for the Pioneer.

The pioneer experience really was a melting pot. This has nothing to do with the notion of melting the 5 races together. What happened for the vast majority was a melting down of the Old World culture, whatever that happened to be, including African or Native American. Born were a new people, filled with the innocence of youth.

"The breath of life is in your hands, the spark of death, also. Quicken the new birth and fan the spark that the passing past is laid at rest. Desire above all things the Sun."

The Book of the Citadel: "Tis the night before revolving centers foregather. Stayed for a season is the influence of silvered

Mercury. Revolving centers open avenue of watery flow."

This book came about halfway through the sessions, when the grand conjunction of planets was almost at its peak. The words of the Nameless One imply a special quality to such times, times when the waters of the deeps run close to the surface. Grand revelations from the Nameless One are rare because grand conjunctions in the sign of the coming great age are rare. Revealed on this night was the Book of the Citadel.

"The Citadel is your stronghold. Its structure is complete and feels no lack. It is unassailable when structured in this manner."

The Citadel consists in seven white rings radiating away from a white center at top center of the card. We see only a section of each major ring. On each of the white rings, there is a small sphere, or circle. Each sphere is a different color, and each contains different figures. The sphere at the bottom is greenish, and contains a closed book. The second circle from the bottom contains the Tai Chi (yin/yang) symbol, within a circle white below, black above. The third circle from the bottom contains a lion with his tail in his mouth, circling a circle with no specified color. Above that is a red circle with Unity figures within. Cooke draws them as a couple in the Yab/Yum position. Next, a blue circle with a serpent standing on his tail, to which the Nameless One draws special attention: "Such a nice serpent! Important! Serpent stands gloriously!" Finally, the white center with blinding radiance that creates the seven circles. On our right is a white staff with roots and tiny wings. On our left is an upraised black sword, its point within a jeweled crown.

The Citadel is the psionic body. The blinding radiance at the top, which is the soul, the droplet of infinity, creates the psionic body.

This book is about the powers of the mind and also the powers of the soul.

The powers of Superman are all powers of the mind. Flying faster than a speeding bullet, "x-ray" vision, leaping tall buildings in a single bound... such fantasies are all possible, yet are nothing compared to the reality of the 50-100 civilizations who regularly visit our planet. I have seen a UFO, yet I know that they are "impossible" by the laws of physics. Rather than conclude that physics is wrong, I

conclude that UFOs travel by psionics. Some of their behaviors resemble things known in psychical research.

A few rare individuals like Uri Geller are born with superpowers, though still nothing compared to the alien humanoids.

The revelation of the Nameless One tells us how we may deliberately acquire super-powers. It is not easy. It requires special circumstances. It is not safe, in that random playing with the underpinnings of the mind can lead to disastrous results. You need a guide, and the Citadel is that guide. You will learn to interpret this card for yourself as your own knowledge of wizard powers develops.

The deliberate acquisition of wizard powers proceeds by modifying the functioning of the mental body, also known as the psionic body or energy body, here known as the Citadel. This is a structure that is invisible to physical instruments, and has no chemical interactions. We can only see it with HSP, one of the first wizard powers the Nameless One suggests we develop. Higher Sense Perception (a term invented by Shafica Karagulla, one of the principal students of the phenomenon) refers to a kind of non-sensory perception. It is the kind of vision that operates automatically in out-of-body states and after death. A few people have the capacity spontaneously in the body, and can see auras, chakras and nadi, as well as the inner parts of physical structures. It is like the "x-ray" vision of Superman, but far better.

Taoists, Yogis and Sufis know the properties of the Citadel. Western science has only begun to study it. All the talk in Yoga about Chakras and Nadi are references to the Citadel. Only a fool could imagine this elaborate body of knowledge could have any point of connection with western physiology. It is evident from the Taoist classic *The Secret of the Golden Flower* that the Chinese also understood the Citadel. Of the seven main spheres of the Citadel, it is the brow sphere that is responsible for HSP "seeing". In the Citadel card, this is the second circle from the top. The blue color indicates renewal. HSP seeing is a power all humans once had in-the-body, just as we all have it out-of-the-body. The serpent indicates initiation. Thus, HSP is the beginning, the renewal, and the start of all higher powers. The serpent has symbolic roots both in nature and in sexuality.

This is the kundalini power that must ascend to the "third eye". How, precisely, is this to be done?

There are now a lot of handbooks on the acquisition of higher powers. If any of these really worked, I think we would begin to hear of the powers of wizards. The Citadel is not a handbook of explicit instructions of that sort. It shows us the general goal of our alchemy; it shows us some of the general conditions under which such development can take place, and it describes some guides for finding out how to proceed. It does not contain specific instructions or exercises or anything of that sort. It merely shows us the start of the path, and not everything we must learn along the way.

The Citadel card is symbolic, but the structure of chakras is real, and those with a sufficient degree of HSP can see it. The symbols tell us how the functioning of each chakra is to be changed.

The first thing that strikes us in looking at the card is the blinding white. The white radiating rings from the top circle create the structure of the Citadel. It radiates the circles of the Citadel like a stone dropped in a still pool. The dazzling white light of Self creates and maintains the Citadel, and only those who know their Self can understand, use or change the Citadel. Self-realization is thus a starting point. It is possible to be illuminati without being a wizard. No one can be a wizard who is not wholly and Self-realized. That is comforting. The powers of mind are not like those of technology that any savage may use.

The two images on left and right also provide clues to preconditions. To the right of the Citadel is a black sword, point upright within a jeweled crown. A sword is good for one thing only, and that is war. The powers of the wizard appear only when there is a great need for them, when violence and barbarism are endangering important things. The Yaqui brujos only began to develop after the Spanish invasion, for example. The sword is here constrained by the crown. Use such powers responsibly!

A true crown forms an unbroken circle, like a wedding ring. It is a symbol of the unbroken circle of responsibility and also of the whole of life. A king sends out some positive or negative action, from his left hand or his right. Taking responsibility for it means receiving

back the consequences, good or bad, making adjustments and sending the energy flow out again. Accepting the crown is accepting responsibility for your power, unlike the bureaucracies of modern governments, where no one is responsible, and no one takes the blame, or has the power to correct mistakes. Thus, the black sword of violence is constrained by the unbroken circle of responsibility for the whole.

The right hand image as we view it is a white staff, of the kind the blind have always carried. We too are blind, and know not how to proceed in our higher development. The white cane shall guide us, for it is rooted in nature and has wings to fly. This is a most important image. For it tells us, not what to do to become wizards, but how to find out what to do. We shall find out from nature, in one sense or another. We may find out from the psychic "allies" of nature, as did Castaneda's teacher Don Juan. That would require making contact with nature, the real nature that is unknown to the Thinker, and the nature that is alive and conscious. We would do this anyway on our road to illumination. To make an ally requires something more. We can do something for the spirits of nature (as at Findhorn) and they can do something for us. That is the reciprocal nature of allies. We can be the gardeners for the Garden of Eden, and in turn, our allies will help us to develop our higher powers.

"The Citadel is your stronghold. Its structure is complete and feels no lack. It is unassailable when structured in this manner."

When the chakras are functioning as symbolized in the Citadel book, the wizard is safe. He is unassailable and not in danger.

The precise meaning of each symbol and its associated colors will make more sense to the wizard as he develops. Not being a wizard, I cannot claim as much certainty on the meanings of each element here as I do in other books. For instance, does the closed book in the base chakra imply celibacy or does it mean that in some unspecified way the mind uses sexual energies to open the third eye?. I'm only sure that the process of becoming a true wizard begins when we open the third eye, so we have HSP.

Let me tell you what I know of the other chakras and of the symbols in them. The throat chakra is traditionally associated with thought and speech. Do not imagine that you think with your brain.

The brain is only the control panel. The Unity figures should be our guide to thought and speech. Instead of thinking ourselves into a corner with "that's impossible", we should learn to expect a hidden unity in all things, and expect one even when we cannot see it.

Below the Unity-in-thought chakra, there is the "heart" chakra, our emotional center. This has nothing to do with the physical pump, also called the heart that pumps blood. The true heart of mankind is this chest chakra. Emotions and feelings provide the energy for action. They are the prime mover. Here we make the torch our emotional center, our prime mover for action; thus the life and role of the Speaker shall be our principle love and passion as a wizard. The torch not only lights the way, it can be passed along from one runner to another, down the generations, and it can ignite other torches, thus spreading the light. Make this your heart and soul, the spreading of the light, and do not keep your wizard powers hoarded up to yourself.

At the navel chakra, the traditional "place-of-power" for wizards and brujos, we find the lion with a tail in his mouth. He circles the circle. He must therefore be a revolving lion. The lion is leadership. Make the leader of your Citadel the navel chakra. Brujos work from here, according to Castaneda's teacher. Let the navel chakra lead the way, rather than the brow or throat chakra. A whirling lion suggests a dynamo, and at the same time also suggests a sleeping lion. This paradoxical image is meaningful, since the prana pump normally works only in sleep, when the breathing is slow and regular. The wizard seeks to learn to activate this prana pump while awake, and learns to use this energy and direct it to various purposes, including the building up of the Citadel.

In the lower middle of the abdomen is the chakra that regulates the flow of yin and yang energies through the nadi (the wires) of the psionic body that in turn directs the activity and balance of the body. A wizard has the capability of correcting any imbalance instantly, even ones that would prove fatal to anyone else.

Finally, we come to the circle of green. Green for green growing things. One meaning of this may be the traditional celibacy of the wizard. The Wizard uses sexual for HSP. This is appropriate, since HSP operates naturally when we are "dead," i.e. out-of-body.

Reproduction and some of the other normal desires of "life" may be a closed book for the wizard.

The Book of the Feeler: "Woe to him who feels and moves not. A wont is a will, but a non-motion is a clogging that, sooner or later, must move or else the vultures swarm."

The scene is night. The stars in the Crab constellation twinkle overhead. The Feeler stands between two Italian cypresses, and stretches her arms out to us. She has golden hair, divided in tresses that circle her right breast clockwise and her left breast counterclockwise. She is beautiful. Her only clothing is a skirt of woven gold, parted to show her legs. A single metallic serpent wraps around both ankles, keeping them together. A black circlet with the red Venus symbol is her crown.

The Feeler is beautiful and alluring, the golden skirt suggesting her supreme value. The red Venus symbol makes her the very essence of sensuality. Yet she is unknown, a Virgin. The serpent keeps her ankles together.

Cypresses grow in wet, swampy areas. Many grew up around the ruins of Rome, among the old mausoleums and monuments in the outskirts that are naturally swampy. The twin cypresses are a symbol of death and decay, as is the nighttime scene. The Feeler seems to welcome us to a new Dark Age. This theme is part of the prolog to this book.

"A curious retreat is observed. Tis better to advance... All retreats are time consuming."

Yet, this is not the only possibility for the Feeler. Indeed, everything about the card suggests duality, from the twin trees to the way the hair twines around her breasts, and the crab symbol, and the serpent. On her left side, there is regression, suggested by the rotation of the hair counter-clockwise, contrary to time. On her right side, we have progression in time. A crab can go equally well to the right or the left. The serpent has sexual connotations, and as phallus, is the means of knowing the Feeler. Yet, here it is acting as a metallic chain, preventing knowledge of the Feeler.

The Feeler and the Thinker are opposites. It is good to feel strongly, and to act on these feelings. It is good to learn from our

feelings, for they are surer guides than our thoughts. It is more difficult to learn how we feel about someone or something than it is to learn the facts. It is also more important, for feeling is the energy for life. It is what gives savor and color to life. Thought is pale and colorless and lifeless by itself. The Thinker has enchained feeling, and ignored it, and denied it as a form of knowledge.

The possibility of another Dark Age has not gone unnoticed. It is not for any lack of technical knowledge that Rome fell, or that we might fall. It is a lack of feeling, apathy towards preserving the civilization. Our architecture mirrors this lifelessness, all plain square facades, crushing the individual with monstrous size. Civilization can only survive if we get our priorities straight.

I dream of peace, and beauty, and the life of the Seeker. In my mind's eye, the evil of the twentieth century vanishes like a bad dream. It is not impossible, if you will follow your feelings about what is truly important. Anything is possible for the Mage. Only do not be impatient. Community is like a garden. It grows at its own pace.

I dream of a time of wizards and magic, when we have stilled the single trumpeting mouth, and we have rejected nukes and missiles and planes and guns and the Thinkers behind them. I dream of handcrafted villages, each rooted in its spirit of place. I dream of human powered vehicles (no infernal combustion engines) and tame deer, and the music of coyotes (no dogs or streetlights). Enough of the ceaseless hum of the 20^{th} Century and the lock-step march of millions. An end to murder as entertainment.

We cannot have harmony and beauty where everyone is concerned just with making a living. So away with the daily grind! Down with all economics and all economists. Let us make use of some of our computer technology for something useful. Let us build a totally automated system of self-maintaining farms, factories, energy and transportation networks, that provide all basic tools and staples free to all forever. This is what I've called the ecolomat in **Whole Earth Inner Space**. Computerize farms, not ICBMs.

During the night of the Feeler, there are many dreams and nightmares. We do not know which shall come to pass. It is up to the Doer.

The Book of the Seeker: "From the dark deeps arisen are the feelings of ancient time. Such feeling is fully apart from the individual. Its coming from the well leaves less to be lighted. A proper understanding of these dredgings permits love-feelings to resume normal flow. Such under-standing must come to all during times of upheaval... Ye are Seekers."

The Seeker is a balding man; bearded, tall and sinewy, standing on the lower left of the card, facing right. He has bound his eyes with a black cloth. He has laid down his staff, and his robes lie about his feet. He stretches out his arms as if to feel the fire on top the distant mountain. A path winds off to the left, across water and up the mountain. Another path leads right to a distant city. On that path is a robed woman, carrying a handful of riches and followed by an open book. The Seeker is on the left path that winds up the mountain, past a bright cloud, to the fire.

Those who are Seekers have already known the woman, had the riches, read the book, and visited the city, in this lifetime or before. They have succeeded at all the usual tasks, found all the conventional rewards, and outgrown them. One can become weary with fame, weighted down with possessions, and bored with entertainment. Some people are born this way, and never show much interest in worldly values. When you reach that point, when your spirit (if not your body) feels withered, aged, and dried up, then take up the life of the Seeker.

The path up the mountain is long and winding. Be prepared to spend five years full time as a Seeker before you are ready to receive the fire. We know from the Book of the Deliverer what the path consists in. It is nothing more than spending a lot of time in Earth-Roots and Bathing in the Waters. In other words, solitude in nature, and daydreaming. It is as simple as that. Yet, it is difficult to find these conditions for even an hour each day in our modern existence. To take up the life of the Seeker is to make a more radical commitment to this path. It requires a total change of lifestyle, yet that is the only difficult part, the decision to change.

Seeking solitude, and nature, you will go where there are no roads, so you will need no car. Wishing to blend into nature and not to harm her, you will be invisible and can stay anywhere there is room to

spread a blanket. The Seeker avoids house-payments and rent, carrying all his possessions on his back. If he carries a solar cooker, he will need no fuel, so the question of affording the life of the Seeker comes down to this: can you afford the food?

Now, as it happens, the most condensed, most easily preserved, and most nutritious food is also the cheapest, if you know where to find it. The only problem is that it requires a lot of processing time, but since you are looking for work-meditation, that is an advantage. Grinding grain and carrying water are perfect examples of the pleasantly monotonous tasks I've called work-meditation.

The perfect food is grain, and the cheap place to get it is from a farmer, or from a grain coop. An adult requires a pound of solid food a day. There are 30 to 60 pounds in a bushel, depending on the type of grain, and the average price per bushel in the early 1980s is under $5 per bushel. In fact, $5 or less has been the price for over a hundred years. Therefore, your total yearly expenditure would be under $100. In our society, that is essentially free. If you sold any one of your possessions, that would provide enough to live 5 years. The life of the Seeker is free. Is it healthy? We would all benefit from more exercise and less additives, processed foods, and meat. The staple vegan diet of grains is one of just enough and balances, so you need to take some care. You must balance the amino acids of grains and beans to make a complete protein. You need to keep some sprouts going for vitamin C. You have to have some food derived from animal sources to provide vitamin B-12. The animals could be microbial. A little powdered milk or hard cheese or brewers yeast would provide it. An adult male needs no minerals unless he loses considerable blood. Make sure you adjust to a low mineral diet gradually, over several months. Women can get enough iron by cooking everything in a cast iron skillet (though to save weight, you might prefer to buy iron pills). We make tofu from soybeans and it is high in calcium.

If we go from city life to full time life out-of-doors in one swoop, we might die of exposure. We must condition our skin to the dry outside air gradually. Especially in dry areas, we must plan ahead for water supplies. With plastic, we can create solar stills to make use of seawater, or brackish water. We can build cisterns for sustained life

in the desert. Even the driest North American deserts average several inches of rainfall a year. It is possible to catch runoff from several acres and divert it to a deep waterproof cistern and maintain this water year around. In cold and mountainous areas, we must plan ahead for sudden winter storms and snow and ice. Mere survival becomes an adventure, but it is not inherently difficult.

At first, we might feel lonely and foolish. Next, we might become bored. That is the point at which the mind turns inward and begins to slough off, like dirty clothes, the mental garbage that swamps us from civilization. Thousands of other wholy ones in other paths have sat under these same stars, and eventually some of them thought grand thoughts, experienced wonderful things, and returned to their civilizations as Deliverers, transforming societies and creating new worlds. I shall join you when I can. Happy wandering, Seeker, we are the future.

The Book of the Reactor: The Seeker goes up the mountain feeling very old and jaded in spirit, and comes back down again renewed, reborn like an infant, with infinite possibilities, able again to react to anything and everything freshly again. This is the Reactor.

The Reactor is a male baby, nude, holding two keys, standing in front of a gate. It is a gate consisting in seven pairs of doors, one after the other. These pairs of doors are unusual in that one opens forward (white in color) and one opens rearward (black). These alternate in their left-right arrangement. There is a full triangle lock or latch on the rearward (black) doors, and a half-triangle cutout of the forward (white) doors. We may use any colors for the arches of the doors. Notice that the lock arrangement is such that the white doors will swing full circle, but the black doors only halfway. A straight road leads through the gate and over a mountain. In the sky seen through the gate, is a full moon containing the waxing and waning quarter moons, on opposite sides.

No matter which of the seven paths you choose, there is a white door and a black door. One of the things you learn in the illumination of fire is that both white acts and black acts may be necessary at different times, and in different lives, to further the creative progress of mankind.

Let me give you an historical example from Toynbee. Thinkers still moan about the fall of the Greco-Roman civilization (Hellenism), resulting in the famous Dark Age of Europe, in which countless libraries and works of art and architecture were destroyed. Yet had this destruction not taken place, Gothic fantasies would never have arisen, modern science would not have developed, and the world-girdling civilization of the present would have been stillborn. As it was, enough of the Hellenic civilization survived to destroy the Gothic style (a great and irreplaceable loss), and almost managed to suffocate the rise of modern science. For the first three centuries of its existence, science had the same status as new age thought today. Universities banned it, religion condemned it, but the brighter spirits of the day pursued it, mostly through various unconventional societies and organizations. Not until the 19th century did science become the bastion of the universities. One wonders what the founders would think of the religion science has become?

What served to block progress from the 16th to the 18th centuries was a stale classicism. It was the same stale classicism that destroyed the youthful art styles of Western civilization, and unfortunately, no great new style has ever emerged to replace Gothic. In short, the Renaissance (rebirth of Greece and Rome) only revived a corpse, a kind of ghoulish and destructive demon, almost able to prevent new life, but quite unable to truly come to life again. This is exactly what Toynbee says of all Renaissance movements.

The ancient followers of the Way of the Saints knew you sometimes had to make a distinction that cuts across good and evil. There can be unwholy good, and wholy (holy) bad. There can be acts of kindness with the best of intentions that really serve to stifle and stagnate. A good example is modern medicine and public health measures. Was it really a kindness to India to end her epidemics of malaria, small pox and cholera? India did not ask for this largesse. She was content to keep her population balanced through a high death rate, rather than a low birth rate. Indians may prefer having many babies and not too many old people. Is that a bad choice? With the best intentions, we upset this ancient balance, and now there is the possibility all will starve.

This is an unpopular, even unbelievable teaching. Yet every great Way-Shower or wholistic illuminati has said the same thing. Indeed, this is a kind of test of whether someone has really experienced illumination, or only says he has. Yehoshua said, "Think not I bring peace, but the sword." He also said, "See, I bring fire to scatter throughout the world, and I shall guard it until it burns." Yet, Yehoshua is the prince of peace, an idea from the Old Testament. His followers simply could not believe that the light of the divine purpose, in its wholeness, includes every extreme, every opposite, and every polarity. There is a time for growth, a time for preservation, and a time for destruction. That which seems wholly negative and evil may still serve a purpose as a challenge to our creativity, a foil to build up our strength, a spark to ignite our feelings, a wall or barrier that forces us to build lofty bridges.

There is a white and a black door to every path, and we have two keys, a yin key and a yang key. The waxing moon and the waning moon are both part of the same whole moon in the background. We should not arbitrarily prefer the upswing in the cycle of any phase of existence or being. The downswing is equally a part of the glorious full moon, and may offer equal opportunities to fulfill the divine purpose that runs through all things. Place no expectations on the successful Seeker. Anything is possible to those who find the Whole.

The Book of the Donor: "The blade has cleft illusion. Middled are the halves. Blunted not is the instrument. With a thunderous stroke, it was done. The time of telling draws near. Twice-told it will not be this time, once only. If the heart is big enough to respond, let. If the activity is true enough, it will let. The babe is not delivered a man."

Don't expect the Second Coming of anointedness to appear with impressive ceremony. The babe is not delivered a man. New age spirituality arrives quietly, in small ways, as every new thing does. As did the Way of the Saints, for example. Christianity was a twice-told tale by the time it enters history. We shall not have that problem. The symbolic language of the Nameless One stands unchanged, uncorrupted, and open for those who have eyes to read. It is an illusion fostered by the Actor to think that the importance of something stands in direct proportion to its fame. There is an inner drama in the arrival

and evolution of the Way of the Sun, and it is about to become visible and known to the world. In a vacant scene stands the Donor. She is a comely woman, nude, wearing a yellow cloak thrown back from her shoulders. She holds a black column in her outstretched right hand, a white column with the left. Two ties descending from shoulder to below her navel hold a sharp sword tip downward. The sword tip touches but does not pierce an apple. A pair of hands reaches to each column from center above. A braid winds her hair.

"The Self is active in creation and destruction.... She is the Donor. She signifies that which is earned is given."

If you were a Donor, it would be your task to restore the balance of good and evil. Evil people deliver their blackness with the left hand; the Donor returns it with the right hand, quite deliberately.

The Thinker has made the task of the Donor very difficult, with his theories about cause and effect applied to human beings. If something made a criminal do his deed, then concept of justice is meaningless. From the Solar point of view, there is no cause and effect. Everything is challenge-and-response. Some make one response to conditions; others make another. It is the task of the Donor to complete the circle. Rot in a civilization is contagious. Once everyone is firmly convinced there is no justice, chaos inevitably spreads. It is curious that Thinkers wish to claim cause and-effect for the creation of criminals, but not cause-and-effect for the relationship between a poor justice system and the spread of crime.

The Donor does the criminal a favor by giving him what he has earned. It was to receive this lesson that the criminal entered these conditions in the first place. To deny him that benefit means he will simply have to repeat the lesson.

An organ donor takes from what is dead, outworn, and useless and gives life with the present. That is also true of a correct justice system. From evil (which is whatever is stagnant, fixed, worn-out and useless in human attitudes), he plucks a lesson, a challenge, a benefit.

The Book of the Renewer: "The siren bell has rung. Its penetration has entered but not emerged. Therefore, its vibration continues its wonders to perform... The market place is a-thrive. Strange beads and salt are vended. Buyers there are none. A pitcher of

water reflects the sun. The thirst is mighty but the sun is reflected undisturbed. Maggots will grow if the pitcher is not emptied."

All those who believe in a new age must believe in renewal. A feeling of stagnation and corruption overtakes the world. Crime and war rise; beauty and innocence decline. A renewal is a refreshing thing to happen. It makes all new again, like a child, or like a spring day. An age of renewal approaches.

The strange beads and salt refer to the thriving cults that spring up in a dying time. It is difficult for the public to distinguish these from the Sun, the genuine light that burns away the mists of darkness and heralds "the dawn of a new morn."

Death is the Renewer. To become a little child again, you only have to die and reincarnate.

The Renewer is a man with blue flesh, masked by a red cloth, wearing a loincloth and a cloak clasped by a yellow jewel. He stands inside a large crown, holding a scepter behind him, and holding out a skull, whose eye-sockets form the sign of eternal life. A nude man kneels inside the crown on our right, looking over his shoulder at us (not kissing the skull as Cooke has painted it). On our left, a nude woman kneels outside the crown, and buries her face in the Renewers cloak. In our left background are a garden with two trees, one with leaves and no fruit, the other with ten fruit but no leaves. In right background, is a well with five rows of stones on which sets a chalice with three handles. Above, a dark cloud, sending forth 7 rays from the hidden sun.

All these colors and numbers of things are significant. Such details matter very much in symbolism, though we don't notice them in ordinary art. Refer to the dictionary of symbolic elements.

The Nameless One calls the Death card the Renewer as a way of telling us that birth and death are doors, and one leads to the other. If you look back in envy at the happy freshness of childhood, you are also looking forward to your own future. Before there can be a birth of the new, there must be a death of the old. Sometimes we dread this transition in civilization and in our personal existence. Thus, the woman hides her face from the awful presence of the Renewer, and the man looks back at us, even though he has stepped inside the crown,

and entered the domain of death. The Renewer wears a mask of anger, because it takes energy to commit an act of Renewal. The true reason is something cool. It is the yellow stone, life itself that holds the cloak in place.

People wonder sometimes why they cannot remember their past lives without some special exercise. It is good that we cannot. The renewal would not take place if there were not a forgetting. It is life that cloaks the Renewer.

Since renewal is an event which takes place in time, with a before and after, I interpret the two trees in the garden as before and after. In the recent past, the world has had wealth and technology but little real civilization, thus the tree of the past has leaves but no fruit. The tree of the future suggests a reversal. Having squandered all the non-renewable resources and raped and plundered the earth, we shall know poverty. Yet, the ten fruit of the Tree of Life shall be ours, as we encounter what is important that we do not have now, the ten forms of Self-realization.

In our present age, the dark cloud of ignorance hides the sun, cast by the sooty fires of the Thinker. Yet the seven rays (ways) shine forth, there to light the way for all those who seek them out.

Five races on five continents will build the well to the deeps. Each shall lay a course of stones on the well. The age of dominance of the world by the West is about over. The cup to drink the waters of life has handles of creation, preservation, and destruction. An age of renewal requires all three. Each may he a holy act, laying the groundwork for the future, depending on what we create, what we destroy, and what we preserve.

There are some that will embrace the age of Renewal, and revel in its violence. In the revelation of the Nameless One, the male figures often represent the bolder spirits of either sex, while the female figures adopt a more timid or passive role. The Renewer is not a license for mindless destruction. The crown of responsibility confines the man.

The Book of the Reverser: "The way you go, you well know. You have founded the points and chartered the course. It compels and impels. You have laid the stones and painted the signs. The marsh and the fog, you did."

Any major challenge, you have chosen. Are you poor and struggling? You have chosen it, and it is not unwise. People with money are usually bored and unhappy, surrounded by sycophants and false values, and with few of the usual challenges to give life meaning. Very few lives of wealth and position turn out to be times of advancement or development. It is difficult to believe that you chose the major events of your life, because you do not remember the decision. You can think of it as a decision made before entering this life, though the decisions of Self exist in a kind of eternal now.

What We mostly choose are challenges where the outcome is unpredictable. Thus, we should not go to the other extreme and regard all conditions and events of life as pre-ordained and pre-chosen. If we chose the marsh, it is not because the marsh is a good place to be, but in, order to see if we can meet the challenge of getting out of the marsh. Likewise with the fogs (chosen ignorance of our inner powers) that obscure the way. They may not be of value in themselves; they may just be part of the game we have chosen for ourselves.

Thus, a terminal illness can be looked at two ways. It may be that the ill person has trains to catch and cannot linger. The Nameless One says "Linger not with the flowers you have planted till their fragrance fades. Wait not for the petals to fall. Quicken on the downgrades; pace the ups for they are so designed. He who makes his way has made it." Thus, if it is time for you to go, there is no point in lingering around. You may have appointments to keep, schedules to make, people to see in the next lifetime, for the conditions and possibilities of history steadily change. In that sense, we may choose an illness, not just to terminate a lifetime at a certain time but for the instructive nature of the illness. On the other hand, the ill person may have chosen a terminal illness simply as a challenge, a test to see if he has evolved far enough to work his way out of this one. It is always possible. Nothing is fixed. That is why this is the card of the faith healer. The laws of nature are only rules we have chosen to live by, and if we wish, we can play by other rules. That is the simple secret of the Reverser. We have chosen this situation, whatever it is, and we can unchoose it, if we can put ourselves back in the higher perspective.

The symbolism of the Book of the Reverser is the simplest of

all the cards. It consists in an androgyne figure (neither male nor female) standing nude in a barren scene. His right arm is crooked upward, receiving a descending stream of blue water. He extends his left arm to the side at hip level with fingers extended. From this hand, an equal stream of fire flows to the ground. Overhead there is a golden sun with a soaring hawk outlined against it. "He floats downward and looks not unlike a silvered moon- - angled so that his head points to the figure beneath."

Many people look for some savior to save them from calamity. So countless millions or billions of people pray to this or that to save them from something they imagine being unbearable.

The Nameless One says, "There are many signposts on the way. There are prophets unnumbered, but only one savior.

Q: Who is that savior?

A: YOU!"

Whatever the situation is, you have chosen it, you can respond to it, and you can change it, but only after you have understood and accepted it.

Imagine our ordinary selves as the ground on which the Reverser stands, and the Reverser, being neither male nor female, is a symbol of our higher Self that is also us, and not something separate. The fire descending to the earth plane from our own higher selves represents those unbearable situations, the things that happen to us which burn away the deadwood, melt things down, and heat things up, causing many processes and changes to cook. We tell ourselves we dislike these changes and challenges, and thus they become like bitter medicine forced on us by parents whether we want it or not. Once we achieve a certain level of maturity, we will choose the medicine freely, even though it is bitter. We might decide we are not really that sick, or seek some alternative healing. In other words, with maturity comes choice. A part of that maturity is the ability to accept our bitter medicine if that is what is necessary.

You must realize the two streams are exactly equal. To receive more of the renewing waters of life, you must first receive the burning fire in equal measure. Only if you have received the benefit from it, can you turn away from it, and reach up and draw a renewing draught

of water. That is why Native American medicine men first teach an acceptance of death, before there is the possibility of averting it.

The Hawk of Night sees the Reverser, makes the sign of the waxing moon (a new phase of existence beginning) and spreads his sparks throughout the night.

The Book of the Way-shower: The scene is night above, gradually becoming light towards the ground, much as it would be at dawn or twilight. In the darkness above is the star, the same spark-star of creativity we find on the chest of the Mother, having no set number of points. In the center of the star is the head of a man with a white beard. His eyes are two searchlights gazing down on the emerald city. A stream flows from our high left to our lower right of the card, making a waterfall. Above the stream is a rainbow; above that is an inverted cup, dispensing colored fluids. Underneath the waterfall (or behind it) are stepping stones leading to a glimmering or dazzling city, like the emerald city in the Wizard of Oz. The waterfall's spray produces the rainbow, and you must pass through the spray to reach the distant city.

The card is not correctly drawn. John Cooke missed the point that the waterfall and stream-with-the-way-of-stones are one and the same. The rooster and some of the other details are extraneous, and merely clutter things up.

Rainbows are symbols of refreshment and renewal, as is dawn. If you want to know why rainbows have that meaning, ask yourself when you have seen rainbows. Mostly it will be after a violent spring or summer storm, when the setting sun appears in the clearing west, putting a rainbow in the still darkened east. If you will recall such moments, they are thoroughly delightful. Past are the sultry heat, the falling barometer and the violence of wind and hail. The air is refreshing, and the birds are out, singing.

A rainbow over a waterfall has the same symbolic meaning, with the added meaning of an eternal promise of renewal. The stream of life flows unchanging, yet it slowly grinds through rock as the waterfall steadily moves upstream. The noise and roar of the waterfall are produced by hard rock that resists simple erosion. Thus, wherever the error and blockage of flow is greatest, there is where you find the

waters of life concentrating and sending up the roar of One, amid a refreshing mist which always shine with the same message of renewal. If the hard rock that produces the waterfall is symbolic of our time so too is the head-star out of the darkness.

An example of a Way-Shower is Edgar Cayce, whose work appeared in the heart of darkness, when machine civilization was at its confident peak and no doubts about the truth of the Thinker's dogma troubled most people. In this darkness there appeared a voice of the higher self that often takes the form of the head of an older man in dreams and Mandalas, his vision shining on an hitherto unseen wonder in the distance, the emerald city of our dreams. We have to cross the stream and go through water, cleansing us. That is why the stepping stone path should be right in the waterfall. This could be a very beautiful card, very evocative of the present moment, the first light of dawn, when the stars still shine in the night overhead.

The name of the card gives the interpretation. The Way-Showers are Showers of the Way, frequently channels for the communications from the deep in one way or another. The Nameless One says it "represents Singleness of Purpose," because there is a singleness of purpose in all Way-Showers, from ancient times to the present.

The Book of the Speaker: "Speak out needful sayings! Hold not back... or the word, unuttered, that ups shall sink, tearing holes in the dark shaft. The Speaker is with you. He stands with open mouth. He speaks. Birds and bolts issue forth. With love it is done."

The Speaker stands in an erupting landscape. Mountains are exploding; waters are spouting up out of the ground behind and beside him. His eyes are terrible and his neck is corded with the terrific effort. His hair is golden and falls to his shoulders. He is nude except for desert boots, rising to his ankles. He holds a black arm ring in his right hand and a golden key in his left hand. He wears a shimmering heart on his breast. Buds of new life spring up before him.

The Speaker has learned the hard way of that which he speaks, through purifying suffering. Thus, the golden heart. "Recovery of the lost treasure is made easier when the heart is golden. The course is through the golden heart in all instances."

He holds up the iron ring of the slave, telling us of our own slavery to forces we did not know existed. The Speaker has removed his. His desert boots insulate him from the ground of ordinary belief and existing culture. The Speaker must be independent of what is, for he speaks of what may be. His long hair is also a flag of independence, or it certainly was in the sixties. In order to be qualified to speak, one must have found a key to the keylock mankind carries in the present age (see the Book of the Victorious One). Once found, this golden knowledge of purifying suffering over many lifetimes now results in the disruption of the old, solid ground of society. The effort is severe. The very same forces that keep most in slavery also make it very difficult for the Speaker to gain access to the machinery of mass communication.

Birds of one species or another in the new tarot convey a wide variety of symbolic ideas. There is the government eagle, the ecstatic bird of blue, and the Horus Hawk of night spreading spark- stars throughout the night. The cormorant and gooney bird play a role in the minor arcana. The bolt is the shock of lightning and thunder, a necessary and delightful feature of the renewal of nature by rain, and by association, the renewal of mankind as well. Thus, the Speaker is not all sweetness and light. He is no namby-pamby parson. His words are thunder and lightning.

The seemingly solid ground of conventional thought and action erupt violently in response to his crashing revelations. Like the Changer, this book is a promise of success, a promise that our words will not fall on deaf ears, and will initiate great changes.

The effort is extreme. The difficulties for the Speaker are enormous. He will succeed. Buds of new life spring up before him.

The Book of Unity: "The hands you are in are your very own. A further step is needed. It requires that which an Actor has never done before: reverse pattern."

The Book of Unity is visually complex. In the center of the book is a large circle containing two fish-beasts with wings, partly in the water and partly in the air. Circling the circle is a man holding a white lily-like flower and a woman holding a black wand. The wand and flower almost touch. She is on top of the circle lying on her back;

he is below with his stomach toward the circle. They stretch around it.

At the two sides are ladders. Undulating across the top are a row of moons, on left the full moon, then a new moon slightly lower, then quarter moons with horns down (i.e. a waning moon) up. In left to right across the bottom are a sword stuck in the ground, a five pointed star, an ear of corn, a turtle with a bird on her back, and a tree in fruit and flower. These form a symbolic catalog of everyone's ideas of happiness. The sword stuck in the ground means peace. The corn is plenty, and the fruit of our harvests. Like most abstract symbols, the five pointed star is based on a human gesture, that of the outstretched arms and legs. Leonardo da Vinci made a famous drawing of this figure, copied by Albrecht Durer. It is the image of physical man extended to his utmost, and everybody who has ever been an athlete will recognize this as one kind of happiness. A tree with leaves, fruit, and flower symbolizes possession of both means and ends and creativity as well.

Finally, the peculiar image of the bird on the turtle means good luck, luck that comes from beyond our human understanding and lifts us to the heights. I arrived at this association by the mere fact that I could find little in common experience to associate with turtles. The only thing I could think of were sailor's tales from all periods of time of sea turtles saving people lost overboard. According to the legends, sea turtles have carried lost sailors hundreds of miles to dry land. If true, this would be an event beyond our normal understanding, a creature at home in the deep surfacing to save a human being. There are also tales of birds carrying mountain-climbers out of danger. Mythology, at least, is full of such stories. Thus, the bird-turtle is luck, a kind of luck that leads to miraculous preservation when all seems lost.

What the Nameless One is trying to tell us is that Unity is the basis of all happiness, and that this Unity has its origins in the depths of Self. It is something equally at home in the deeps and in the air of normal existence. While there is a cycle of time (suggested by the moons) in which the apparent Unity waxes and wanes, it is always really there. We just don't always see it.

According to the Thinker, we come to form a family solely by

grading people, just as they grade us, as a 10 or 8 or whatever. Each settles for the highest grade that they think they rate. That is a common form of marriage among the dominant elite and it is very unstable.

The Unity card shows a metaphysical Unity between you and others that has always existed. When you finally meet the other, it is not blind chance. It is a meeting you had both planned from the beginning. This is a soul mate, not necessarily a lifelong companion. Soul mates do not necessarily fall in love at first sight. Love at first sight has more to do with astrological resonances than with Unity. Soul mates like each other and feel at home with one another more as they spend time with each other. It is coming home, unlike the crushes of adolescence that are frustrated sexual desires and vanish as soon as those desires are satisfied. Soul mates have a deep complementarity. Two such can do more than each alone. Each completes and makes up for the lacks of the other; yet, they "go the same direction in all things."

The Book of the Hanging Man: "The Hawk of Night has just swooped into your midst, gathered a shower of stars, and is now separating them throughout the world. Blessings."

The Hanging Man hangs a man and a woman from his outstretched arms... Her feet hang the woman on our left, and his hands hang the man on our right. The Hanging Man makes the now familiar T cross. He spreads his feet apart, the right one resting on a dome, and the left one hidden inside a tower. Underneath, beneath his legs, we see the sunrise. In the foreground, from our left to right, facing the same way, are a wolf, sheep, and lion. The Hanging Man wears a robe of purity with a belt of downward hung serpents, forming an inverted pyramid. The man and woman are naked. An extra little hand coming from the Hanging Mans wrist holds the woman, and a linked chain holds the man. The Hanging Man wears a red tulip-like headdress, and he is weeping.

The meaning of this card is given as Redemption--just desserts by own activities. The Hanging State awaits the redemption of the act."

When you redeem coupons, you turn in something of no value (a piece of paper) for something that you do value, something you can

use. Likewise, redemption is a matter of making meaningful the evils and struggles of mankind. For it is never a foregone conclusion that an evil will be meaningful, but it is always potentially so. Challenges do not happen at random. There is always some opportunity to be grasped.

The time of the Victorious One was a time when missionaries, soldiers and businessmen destroyed hundreds of native cultures around the world. I don't think we sufficiently realize what an enormous evil that was. That is because we identify ourselves with the victors. What then is the redemption of this enormous evil? It is still hanging, suspended, pending, and potential. In the vast convulsions of peoples over the past 500 years, there remains the potential that each culture will begin to find in other civilizations what is lacking in their own. The Self did not give the West a New World to plunder. What we now miss are civilizations in many ways superior to our own, possessing traits and insights we need. If the world were to rediscover Self, that would be redemption of the act. Yet, nothing can erase the pain and suffering, or justify it, and that is why the Hanging Man weeps.

"Q: Why the tears on the Hanging Man?

A: The answer is never given for each questioner has been given the answer and it is burned in his being. Each knows and weeps also."

To redeem the evil, every Solar person has a positive duty to resurrect the native medicine path, the song of Africa, the Tao of the Mandarins, and Yoga, and the way of the Saints and Sufis. The world will be complete and whole and harmonious again only after the conquered civilizations arise again and rediscover their own genius. Cherish all differences, knowing that real harmony comes from unity-in-diversity. We must attack the arrogant presumption of the Thinker that the machine world-view is the only truth, and physical science the only way.

The wolf (dominant elite), sheep (the people) and the lion (new age leaders) all go the same way in one thing. We are all suspended in the earth-plane, all hung on the cross of life, and like it or not, we shall all experience challenges. This means difficulties and struggles, and tragedies and pain. What holds the robe of purity on the Hanging Man

is the belt of initiation-here-below, for that is exactly what the serpents forming a downward pointing triangle mean. Initiation is sometimes learning the hard way in the school of earth. Initiation is always the principal meaning of serpents.

The Hanging Man has one foot on earth (the sphere) and one foot in the deeps, hidden from normal view. That is why we do not always see the purposes behind the challenges and difficulties of life, and in our short- sightedness, we would shrink from these fiery tribulations, were our hands not linked to the higher purpose, and our feet not handed a path to follow. The Hanging Man wears the headdress of Viracocha, the Incan Christ, who is the crying god. This is to remind us that compassion for suffering humanity is a divine attribute, and one known in other paths than the Christian.

Suffering has a potential meaning, waiting to be redeemed, if we can find that meaning, and realize it and make it true. The suffering is still real. The tears of the crying god remind us not to be too glib or quick to dismiss suffering, just because it has the potential of redemption.

The Book of the Mother: "Children parentless seek the Mother. She is busy begetting the Sun. He is now with the world. His cord is severed. He will soon speak. He will speak of the Mother."

In the moment of cosmic consciousness, I saw that good and evil are equally necessary. In the watery deeps, in night, cloaked in sleep and darkness and therefore unknown to the daylight world is our Mother-Self, from which we have sprung. She is above good and evil, standing astride these twin pillars of life on earth. The hidden unity of purpose that ties together the lightning bolt of pain and sorrow and the flower of sweet joy is the spark-star of inspiration. That is the heart of the Mother, and her headdress is the initiation of a new phase of life that such creativity makes possible.

This is a card that could benefit from the touch of an artist. John Cooke has made her unnecessarily crude. For instance, the Nameless One does not describe her as nude, nor as pregnant looking. She should be made beautiful, indeed, warm and dazzling.

The Mother is a woman standing on pillars, white on her right and black on her left. She closes her eyes in modesty. She is the Yin

side of the Hanging Man. Mighty birds pull back the black robes of ignorance to reveal... the Mother, in all her glory. A spark-star is her heart. If you've ever created sparks with a hammer, you have momentarily seen the spark-star of the Mother and the Way-Shower. Creativity is also a spontaneous response to repeated blows against a hard obstacle.

The spark of inspiration and creativity arises both from the flower (left hand) and from the lightning bolt (right hand). She stands in the same T gesture as the Hanging Man. She wears the headdress of initiation (serpents forming a waxing moon crescent), for the crown of the Mother would be the initiation of an age when mankind truly understood the meaning of life. Over her head is a water symbol, a wave-like emblem. Open your arms to the joys and shocks accept the lightning bolt and the flower, and the waters of life will flow.

Challenge and response create the shape of life. There is no cause and effect. That is why prophecy is always wrong, whether it is done by the Thinker in the name of science, or by occultists, or by religionists. It is always possible at any time to make a creative response to the challenge, thus confounding all prophecy (prediction). Creativity-spontaneity is the divine urge, the divine purpose, the meaning of life known to all that experience cosmic consciousness.

From the Self's point of view, there is no death, and pain is merely a sensation. Evil is the goad to prod us out of sloth and stagnation and into joy, spontaneity, LIFE. Just as there is no cause and effect, so there is no chance or coincidence. Those are names for patterns not understood by the ego. There are patterns in all things. Each entity chooses the experience it needs for growth and stimulation to creativity, though we do not always take advantage of these opportunities. This is the bridge between good and evil. Knowing this, the nightmare of the Thinker fades, and the world is warm and whole. It is our home, where things are arranged for us. It is this warm new attitude towards life and the universe that is symbolized by Mother.

"The Self is ever active in creation and destruction." We have always been here. We have been the spirits of the galaxy and the solar system and primitive earth. We were part of their birth. Some people can remember this under LSD. Some of my friends think

hallucinogenic drugs can give you mystical experiences. Not so, on the strict definition used in this book (1. illumination, 2. Noesis, 3. Ecstasy, 4. Unitive experience). They can help us remember the unconscious past adventures of both mind and soul. That is at least as interesting and important for spiritual evolution as the 10 strictly defined mystical states.

There is no predicting the future. We may blow ourselves up with nuclear bombs or we may respond to this challenge with a New World civilization. Alternatively, the next Ice Age may destroy civilization and drive us to extinction. Creative response to challenge is the meaning of life. Anything is possible to us, but only in the painful struggle with obstacles and error.

Mother is home. Mother is love. You can always run home to Mother, and she will comfort you. This is an aspect of Self, and a symbol of a world-view. The universe is not a chance machine. It is our home, and we helped build it.

The Book of the Thinker: "The next book will cause confusion... The Thinker is the Books name. Old tarot--Satan. Significance equals error. No more."

A reddish colored Thinker sits up a tree, in lotus fashion, clothed by the leaves, eyes blank and staring. He is in a trance. Behind him, flame fills the sky. Wrapped around his forehead a blue chain spirals counterclockwise, with the left end emerging from behind his left ear, holding a human heart on the end. The right end emerges in front of his right ear and is pulled upon by nude male and female figures on the ground. A triple band of light spirals clockwise overhead. A serpent climbs the tree.

Behind the Thinker, the world goes up in flames, as the nuclear bombs he invented explode, and a poisonous technology runs amok. As species fall by the wayside, the human ecosphere moves towards the limits to growth, and the collapse of everything humane and beautiful. The technology of the Thinker shall complete the rape of the earth of all her non-renewable resources, and when that is done, the exponentially expanding population with its exponentially expanding luxuries shall suddenly stop and collapse like a burst balloon. He doesn't care. He sits blindly indifferent, entranced, uncaring, assuming

no responsibility.

The Thinker has invented a mental picture of the world based on the machine. That is the single idea that holds him entranced. He allows nothing in this picture but machines and the physics of machines. No room for feeling or purpose. The universe must be blind and cold and governed by chance. No room for free will. Machines have no free will, and we are all machines according to the Thinker. When the machine breaks down, that's it. Nothing exists beyond the cold metal, measured by machines and molded by machines. No room for life.

The universities do not allow any experience contrary to this picture, with their machine-like assembly lines of the intellect, characterized by extreme division of labor and standardization of product. Of course, life refuses to fit this evil enchantment. It keeps presenting data and experience that refutes the world-machine. However, the Thinker cannot see or hear. He is lost in Shadow (Shaitan or Satan). He is Satan, and his satanic mill grind on, casting a lurid red glow on all, as though touched in blood. Machines for machines build the architecture of the time. It has no place for purely human needs, such as beauty or privacy or conviviality. Cold, blank walls, square surfaces, endless corridors. Efficiency. Efficiency by a number.

A bureaucracy is a machine-like social institution. It is designed like a piece of engineering, with flow-charts of information and control. Even the utopias of the Thinker are machines, with their checks and balances, running automatically.

Of course the Thinker is up a tree, and in some corner of the collective mind, we have always known it. We have always had the image of the mad scientist, with his insane dream to destroy the world.

The Thinker styles himself a devotee of truth, indifferent to the petty concerns of politicians, religious leaders, artists or others beneath his contempt. The Thinker opens the door of experience only a crack, and slams it shut quickly if a UFO or a psychic should come flying in. The beam of the light of experience has narrowed until it only lights the machine. His specialized expertise is only good for murder and destruction. He is good at working out the equations of thermonuclear

bombs and missiles, but the more holistic requirements of peace, beauty and love leave him baffled. His equations do not fit. It does not compute.

We must keep separate the three golden links of creation, preservation, and destruction, though linked, as they are in the Royal Maze. Here the light of creativity spirals without cease first into dogmatic preservation (via the schools) and then into destruction. The evolution of nuclear energy provides an example. This will cause confusion, as the Nameless One says, for we regard Thinkers such as Einstein as secular saints. Einstein created the equations of mass to energy conversion, and had not the character, or wisdom sufficient to avoid using them for destruction. It was he who prodded Roosevelt to launch the age of nuclear catastrophe. However, blame someone else. Blame the politicians for using it. Blame the people for starting wars. Consider this. If it were not for the Thinker, those who want to fight wars would have to do them with bows and arrows. The total destruction of the world would not be possible. Whoever creates a thing is responsible for it, and ultimately will be blamed for it.

The Thinker may soon be brought down to earth, and held accountable. The serpent climbs the tree to initiate him to earth, and break his ivory tower trance. The utility of technology for economics (symbolized by the leaves) will not clothe him then.

There is one hopeful sign in the Thinker hook, and that is the chain. It is blue, the color of renewal. On one end is the human heart and on the other the human figures, tugging for all their might. It is a chain of renewal. The chain suggests the renewal of the human heart, though the chain is presently held fast by the forehead of the Thinker.

If existing sciences are an instrument of bondage, the future science of utopia may he the way to renewal and to the heart. If there were a scientific solution to the difficulties that press us all towards war, the nations might accept it. The scientific method is one thing they all have in common. A science of values could be the chain of blue. It should be the function of philosophy to found value sciences, as it has founded the other sciences. The process is not completed. Half-done is worse than not started.

The Book of the Victorious One: "Victory comes when We

are met. Self-mastery is the meaning of Book. Very noble battle and book and victor. You know this one well. Rejoice! The redeemer draws close. Sing your song."

We know this one well, because it refers to the present age, now beginning to pass.

A noble man leads a white lion and a black lion with his mouth open. He wears a glove on his right hand, holding an exotic flower, such as an orchid. He has just left his golden chariot that has its traces grounded, and left his whip in the car that has a kind of pulpit, and a golden sunburst on the front. He is clothed in a strip of white cloth that reaches to his knees in front and hack. He also wears a golden object in the shape of an old-fashioned keyhole. Above is a full and mighty sun, and above that a winging eagle facing left, holding three crossed spears in each claw as in the Great Seal of the USA. At left, blue birds hold a transparent curtain with the Masonic letter C on it; behind that are wolves-in-battle. On his right foot, a sandal, with thongs rising above the calf. On the left foot, 2 tiny wings on the heel. He has a tiny crown of seven blue stars.

"Who will engage the Armed One? The battle lines are drawn. Shall the armor glisten in the sun till dusk?" We are the Armed One. The Chariot refers to the unprecedented victory of the conquistadors and captains of industry over nature and the world since about 1450. This correlation still holds with the Victorious One.

Most of the elements in the Victorious One relate to the rampaging might of the northern civilizations in their rise to world conquest, e.g. the gloved hand of the falconer holding the exotic flower picked in a far corner of the globe, and the footgear of the Roman legions (on his right foot). In addition, there is the warlike gear of the Chariot, the lions, and the warlike eagle above. The pulpit of the missionary is included in the war-like gear of conquest, appropriately so.

Only the wolves still believe in the old absurd power struggles, and still battle for supremacy, partially hidden by the semi-tame bluebirds that we shall meet again in the Actor as assistants to illusion.

Like Hermes (the messenger of the gods), the Victorious One has winged feet... one, at least. He carries a golden keyhole, ignorant

that it is part of a golden door that he has not yet found. We are near the end of the time of the Chariot, though, for the Victorious One has found the exotic growth of a garden of our planting, and he has unhitched the Chariot. We have found an exotic flower in our conquests, the hidden wisdom of other cultures, and we hold it aloft in triumph, yet we wear gloves to hold it, as if it were something to fear. The door to our Self awaits a key that cannot be supplied in European culture. The strip of cloth hides our center from the back as well as the front, from ourselves as well as from others.

A heavy load of karma is ours. How shall we redeem some higher purpose, some holistic light, out of this bloody period? For that matter, how shall we bring this bloody violence to an end? All will be well if we can crown this period with the renewal of the seven ways. The crown of seven blue stars tells us the nature of the victory of the Victorious One. We find a seven-rayed star in the Virgin, and a seven rayed Sun in the Renewer, and seven doors in the Reactor. All these sevens refer to the seven ways. Seven ways, and seven chakras.

On the outer plane, victory is when we learn that the European civilization was not meant to dominate the world. The Chariot shows us the incompleteness of Western Civilization. Blue is renewal. Stars are creativity. WE are met and the violence redeemed when our efforts are crowned by the creative renewal of the seven ways. The book of the Victorious One is a promise of success in that task.

The Book of The Actor: The Actor is dark in color, with a yellow forked heard. He stands on a stage, with a footlight directly before him, holding a white mask over his face, with his right hand. In his left hand is a globe or orb. On his chest is a plaque of four rows of three stones, all different colors. Caiaphas, high priest and Christ-killer, wore exactly this kind of plaque. The left foot rests on a sleeping lion. Behind him to his left is his throne, occupied by a well-bred upright dog. A six-pointed crown is on the left arm of the throne. Each point has a cross with a red stone in the center. One blue bird with spread wings carries a royal cloth with gold borders. Another blue bird with folded wings carries the Actors staff. The presence of the blue birds tells us the Actor is neither good nor evil. This card is about power and who has it, and how it functions.

Instead of scenery or ground, there are small five-pointed stars from side to side. These represent the real talents used, abused and misused by the Actor. Shadows are cast back into endlessness by the Actor, the stars, and the throne, but not by the birds or carried objects. Only the Actor, the stars, and the throne are real. The rest is illusion.

"The mind is the book's significance. Do not permit others to think of the Actor as one playing a role, but rather one who performs acts."

You are the lion, the potential new age leader, and the Actor uses you as a doormat. You don't know it because you sleep, under the heel of the Actor. You are the Doer, too young and innocent (in the lifetime of a people) to believe anyone could wish you ill, or lie to you. Of all the books in the revelation of the Nameless One, this is the one met with the most disbelief, a response programmed by the Actor himself.

This is a book about power, about who has it, and how it works. This is the new form of the Emperor card. The power of the Actor is no longer the crude power of violence; it is the power to brainwash, and we are all brainwashed. The Actor has ringed his position with land mines, planted deep in the psyche of each of us, by standard methods of association. They are triggered by certain key words, and we shall accuse ourselves, or accuse those who provide the trigger. Yet we are innocent. I am innocent and you are innocent, yet we shall be accused. We shall accuse ourselves. It is a price we must pay, if we are to awaken to our true destiny. Awake, 0 lion, and enter the Royal Maze. Hold up the seven ways as a target for mankind and find the crown of world unity at the center. For if you do not, no one will. If you sleep, the Feeler welcomes us to a Dark Age.

The Emperor in the old tarot carried his power to Act in his hands. It was essentially the power to bash in heads or lop them off. Power has become subtler in 2000 years. Now power lies in the ability to control images and publicity.

Power is fame. Fame is power. That is why the Actor struts on a stage, before footlights. The power to act out ones own will and ambition on a public or historical scale depends on the power to gain attention and hold it. Real power lies in the hands of the relatively

small numbers of people who control the machinery of fame, i.e., publishers, producers, editors, media moguls, and the inner circle around them. Their number is small; they come from a single class, from two peoples, not the Doer.

The purposes of the Actor are dark, though he puts a white face over them. That is the hardest thing for the naive young Doer to accept, that things are not what they seem, that we are being lied to, manipulated, and used. That what we see on TV and read in bestsellers and see on the news is highly selected and not for quality, and represents a point of view, that of a ruling class we did not even know existed.

The power of this ruling class depends on illusion. That is why most of the objects in this book cast no shadows. The throne is real, but we have not enthroned the Actor. The Actor himself is certainly real. The stars are real. They cast shadows. These represent the talent the Actor uses, abuses and discards. It comes from us, the people, and is cruelly exploited in Hollywood and New York. However, all else is illusion, and it will be difficult to break its spell.

We new age people are under the illusion that we are a kooky minority, an illusion carefully fostered by the Actor. Polls show we are the vast majority. Collectively new age people count for nothing, as we each individually think we are alone.

We have been taught that politicians have the power, yet it is merely an obedient dog we have enthroned, obedient to the currents of public opinion and emotion. We believe that talent will be recognized and made a star. This is the Horatio Alger myth, and is the cruelest illusion of all. It is an illusion that keeps us silent, and isolated, with no image of our collective self. The Actor has even managed to convince us that we wanted to become a world power. We were tricked into all our wars. We were manipulated, as were the enemy. The handmaidens to the illusionist tricks of the Actor are the blue birds, those semi-tame, seeming independent writers, teachers, and journalists. The symbolism derives from the fact that bluebirds seem independent, but can only survive with bluebird trails and other help. Likewise, any professional writer or teacher only presents what the dominant elite will allow.

The Actor is not a symbol of evil, as is the Thinker. In some

ways, the Actor is a genuine advance over the Emperor. Isn't it better to be coerced mentally than physically? This way, anyone who can penetrate the illusion is free of it and that is why the discarded crown of the Actor only has 6 stars on it. Six victories, over six ways. However, no victory over the seventh. We are free of it, since of necessity all that take the Solar path must awaken the lion within, and leave the sinister power of the Actor behind.

The Actor does not wear the crown, because he assumes no responsibility for his power, and may not even know he has it. He does not sit on the throne, because we, the people, have not enthroned him.

"The hands you are in are your very own. A further step is needed. It requires something an Actor has never done before: reverse pattern. Willingness to continue game-not-game is a vital requirement of the players. There will be a winning team and no losers."

These words are an open invitation to the dominant elite to join us and not oppose us. Even if they do oppose us, as I expect, there will be a winning team and no losers.

I do not teach hate. I teach opposition, a little friendly competition. It will be as beneficial to the yellow-forked-beard-people and to the twelve-stones-people as to us. We have so far given them no competition, no challenge, and thus no development.

Who is the Actor? At present, he wears the personal ornament of the twelve-stone people and of the yellow-forked-beard people. Our opposition would be exactly the same if it were some different peoples.

The yellow-forked-beard people, who lived in the north of Europe, created European civilization about 1000 years ago. You can still see them in the manuscript illuminations and the Romanesque stone carvings from about 1000 years ago. Moreover, they did have long blond beards, divided and swept back in two streams. They had earlier been called Vikings. In Eastern Europe, they were called Rus, and they founded Russia. Sometimes they were called Danes, and the Danelaw once stretched over England and Scandinavia. Vikings overran first Normandy and then all of France, England and parts of Italy. They not only formed Europe's new ruling class, but also its first middle class, since Vikings were just as apt to be traders as warriors.

They recast Christianity in their own image, taking the Christian concept of the realm of the imperishable within, and making it Hel and Valhalla. They were a restless people for whom the Viking ship is a fitting symbol. It still is, for Western civilization. It was their restless energy that built the vaulting cathedrals that launched the crusades that began to reach out beyond the peninsula of Europe to the entire globe, destroying all in its path like some berserker.

In America, emigrants, refugees, natives and slaves came together, melted down their ancient cultures, and became the new American people, the Doer. However, some did not. The richer colonists from the upper middle classes of England were mostly Puritans, and they did not have to become backwoodsmen.

The Puritans are a 17th century form of the yellow-forked-beard people, devoted to hard work and profit, and obsessed with sin. They were able to buy their way out of the civil war, and they never went west, in the pioneer days. Newsweek has called their modern day version the Episcopacy.

The twelve-stone people call them WASPs, a term that originally had a much narrower application than it does now. Most of my WASP classmates at Oberlin were 5th and 6th generation Oberlinians, and their children are now returning to Oberlin. Their families have always lived in Summit, Scarsdale, Grosse Pointe, Santa Barbara and similar places; have always been in the professions or in the upper executive ranks of the corporations and bureaucracies. They really do not believe in the possibility of ESP or reincarnation. They combine scientific naturalism and Old Testament supernaturalism, as did Sir Isaac Newton. Winning is everything to them. They discipline themselves and the Puritan ethic that pain and suffering and self-denial are good and pleasure is bad. Essentially, they are Europeans who remained Europeans, unaffected by the American experience. Many of my classmates went to live in Europe after graduation.

The twelve-stones are the 12 tribes of "isra-el", an ancient word in the Middle East. "El" means "god," thus "isra-el" is the god "isra;" "Micha-el" is the god "Micha" and so forth. The twelve-stone people invaded all of the Middle East, becoming Babylonians, Assyrians, Bedouin, and Phoenicians. As Hyksos, they ruled Egypt

until Ah-Moses threw them out, after which as Habiru they re-took the land of the Philistines during the reign of Akhnaten (the monotheistic pharaoh), and preserved Egyptian monotheism after it had been destroyed at home. The twelve-stone people include all the Semitic peoples, Jews and Arabs alike.

Two thousand years later, the twelve-stone people again conquered the Middle East, in the name of the religion of submission ("Islam" means submission). Today, one branch of the twelve-stone peoples controls the oil, and another branch dominates New York and Hollywood. If this is a myth, it is one the 12-stones promulgate, for they are my only sources of information on this dominance.

You don't suppose it just happened that a two- percent minority comprises half the Oberlin student body, a third of college professors and all Hollywood producers? You think this could result from free competition? No, it is the law of the wolf, "like" helping "like" to fleece us.

No one can complain about this without being accused of racism, of being anti the 12-stone people. That is nonsense, but it is the stimulus for a conditioned response that prevents any discussion of 12-stone dominance. Still, it is well to remember that we are only opposed to being lulled to sleep and used as a doormat. Neither the Actor nor the peoples whose ornaments he wears are intrinsically enemies.

The present effect of the Actor is that we are slaves in our own country. Things are out of our control. Nothing that is fed to us through the schools or media reflects our beliefs or values or creativity. There is Roman decadence about popular culture because it is the product of old minds, as the decadent Romans were old minds. Mass emotions are manipulated not by lies or propaganda, but by selective presentation of images, of which countless examples could be given. New York City is a cold, hard, mercantile place, without an ounce of spirituality or transcendence. It is the chief home of the Actor.

This kind of power is new to us and baffling, since it involves no physical force. Thus, we sleep, and our destiny is decided for us.

"The juice of memory rises. When it spills will be the time of reversal. It is coming. Be ye prepared. Mighty shall be the roar, violent

the rending, joyous the release." *Word of One,* p. 164.

The Book of the Virgin: The Virgin is a nude woman, standing on one leg, with the other crossed in front holding 2 wands between her toes. She holds a white streamer in each hand, and it flutters in front of her. A star with seven points is near her feet. One yellow plume sweeps down from her dark hair. Hands at sides. Surrounding her is a ring of red flowers, separated by five leaves (this makes a turtle shape). As we view the card, in the lower right is a red apple; in the upper right, there is an androgyne face of a black boy/yellow girl. Half of the face is one, half the other. At top left, light streams from an inverted chalice. At bottom left, lightning strikes up from the ground through a black and yellow horse.

The Nameless One gives her function as Being. Formerly she was the World. The Virgin is the Great Turtle of Hindu myth that supports the world.

For the Silver Dollar to say that, the World is a Virgin is to say it is unknown. Our physical sciences merely scratch the surface.

The reality known to the scientist has as much solidity as the ribbon that waves in the air in front of the Virgin. The world of the Thinker has become an idol. The Thinker sacrifices all beauty and feeling. The Virgin has feet of magic instead of feet of clay. She effortlessly manipulates magic wands with one big toe, as the Virgin playfully shows us how easy it is. The spark star of sudden inspiration and creativity stands by the other foot, the one solidly planted in higher purpose of long standing, escaping the shallow understanding of the Thinker.

For thousands of years there have been tales of giant sea turtles mysteriously rising from the deeps to save sailors lives, sometimes swimming for thousands of miles without diving. The turtle is thus a symbol of the mysterious purposes of nature, the living psychic and creative component of nature that actually shapes and frames the world. We are referring to the garland of roses and five leaves that frame the Virgin.

Way-Showers like Edgar Cayce, whose cup of light shines down upon us, help us understand the four symbols in the corners. He described sudden reversals and cataclysms of nature, such as the fall of

Atlantis. The yellow and black (night and day) of the horse and the boy/girl are like night and day, suggesting these phases of nature. The lightning erupting from the ground suddenly catches the horses (forces) of one age short. Before refrigeration, we could pack away apples to last until another season. The apple is the fruit of a former season, knowledge of Atlantis for example. To learn about Atlantis is to learn about cataclysm.

Such earth-changes are part of the round of renewal of Life, as is the birth of children, suggested by the boy/girl. If there were no death, there would be no children. The ever-creating joyous spontaneous light of children and all young and innocent things is a cup that pours out its blessings on us. So do not regret the times of upheaval.

The Book of the Knower: "In that day shall blend the elements. They shall be expressed in a new expression. He who knows shall be the expresser. Ye shall know that day and that One.

"Now it is a day without number. In that day, they shall be numberless.... An event has produced a number of events that shall produce the Event... He is the Knower. The Knower functions as the Self. Picture him as Self." This refers to the end of the universe, and the beginning of the next universe. "He who knows shall be the expresser." The earliest this could happen is in the year 2000 billion. The time now is only 13.7 billion. This is another book that tells us of our eternal life, our absolute immortality, despite the end of species, worlds, suns, and universes. Without this revelation, we would not know that we are immortal.

The Knower is a man standing in two shallow circles, water on the left (his right) and fire on the right. A narrow channel connects these pools and steam rises to his vitals. His right hand holds an egg upright over the center of his chest, and this egg sends forth a root and two green leaves which reach to his chin. He extends his left arm forward, raised in benediction. Above him, a golden sun sends shafts upward and downward to his head and has golden wings attached on either side.

An event (the big bang of cosmology) produced a number of events (the evolution of the cosmos) which shall produce the Event,

when the galaxies come imploding back to another big bang, a singularity in time and space (a day without number) in which the elements shall be blended. The hopeful part is that the Knower shall re-express this in a new universe. Here the long and mysterious work of the Reverser is completed and we have truly and fully become divinity... the Self.

The egg is symbolic of the new universe, while the fire and water finally are blended and rise as regenerative steam. The winged Sun-cross is a phoenix symbol, not unlike that introduced by Zoroaster for Ahura-Mazda (divinity). The two pools form the shape of the Eternal Life (doubling of the way) sign. The Way and the Life go on forever... Eternal Life for the Knower and Death for every specific thing, including the universe itself.

Thus ends the revelation of the Nameless One.

Seeds of Evil, 9/11

Nothing can justify the terrible evil of 9/11. It was a completely unprovoked attack on innocent victims, who never did anything against our attackers. Our actions since 9/11 are not acts of revenge, but of self-defense, since the collapse of the Twin Trade Towers showed us we are vulnerable to suicidal fanatics, domestic or foreign. We will do whatever we must to protect ourselves from additional attacks. This will be difficult, though not impossible, and provides another reason for the identity and location databases and the unforgable ID cards and the checkpoints discussed in "Lady Justice."

It is this event more than any other that convinced me that all religions are evil. It was the Mullahs of Saudi Arabia (Islamic Preachers) who taught the fanatics of Al Qaeda. Mohammed did not preach intolerance of Christians or Jews, nor did he tolerate suicide. In a similar vein, Christ taught tolerance in his parable of the Good Samaritan. Yet, in the first Crusade, the so-called Christian knights killed every inhabitant of Jerusalem. Now that we have some actual scientific knowledge of reincarnation and of the closer regions of the between, there is no need to take anything on faith. All religions teach sectarian intolerance, in their present decadent state. This is the root of all the evil in the Middle East, the root of the Israeli-Palestinian conflict, and the root of terrorist acts between Catholics and Protestants in Northern Ireland.

Why do they hate us so much? At first, we could only attribute the events of 9/11 to the outbreak of some unfathomable new evil, like Fascism in the 1930s. As we learned more about the terrorists, new hypotheses arose. It turned out that the terrorists were not the poor and downtrodden, not even people brought up in the fundamentalist tradition of pure Islam, where the only book read was the Koran. No, the terrorists were rich, urbane, well-educated men, who lived and moved without notice in the West. Some of them were born in the West, educated in the West. They begin to seem more like traitors from within, like the American Taliban fighter, than traitors from without.

Enormous rage is required to turn an intelligent and well-

educated person into a suicidal killer. The presence of an Islamic background leads them to the Mosques of the radical Mullahs, who can give them a specific focus for their rage, and can tell them where to go and who to see to become a suicide pilot or a suicide bomber.

Western religion is not Christianity and Judaism, as you might imagine. It is the religion of science. The distinction between "science" and "the religion of science" is that the former refers to "anything learned by scientific method," while the latter refers to a specific set of articles of faith. Followers of the religion of science would not see this distinction. The usual rules of scientific method establish the reality of such things as reincarnation, NDEs, OBEs and UFOs. Here I use the term "UFO" not in its original sense, but in its popular sense as spacecraft piloted by humanoids from other stars. One can easily detect the followers of the religion of science by offering to show them the studies that establish the reality of reincarnation, NDEs, OOBEs, and UFOs, using scientific method. They will refuse, just as Galileo's colleagues refused to look through his telescope. Galileo challenged a core set of beliefs that were resistant to empirical refutation. That is the definition of a worldview that is always part of a religion.

Science is a seductive and powerful religion, draining the lifeblood out of all the older religions, and forcing its way everywhere. The reason is, scientists do not call it a religion, but confidently present it as "the truth that only ignorant fools reject." The high priests of the religion of science chart the spread of irrationality with polls testing to see how many people believe in reincarnation, ESP or UFOs. In the eyes of the high priests of science, belief in any of these forbidden doctrines is sufficient proof of irrationality.

Western religion is seductive in other ways as well. People in Pakistan or India or Saudi Arabia can easily see that many good things come along with the religion of science, including Western luxuries, high technology, democracy and wealthy economies. **All it will cost you is the loss of everything sacred**. In the religion of science, there is no soul, no divinity, and no life after death, no immortality, no meaning to our existence. As Nobel Laureate Steven Weinberg said at the end of his book *The First Three Minutes* "The more the universe seems comprehensible, the more it also seems pointless."

Once a sensitive young man recognizes the nihilistic character of the religion of science, he may begin to despise all the outward signs of Westernization, such as the growth of huge, impersonal boxes for architecture, or the spread of tawdry strip malls, or the cancerous spread of McDonalds and Wal-Marts, a cancer which destroys the distinctive *souk* or the small towns painted by Norman Rockwell. He may become frustrated that nothing seems capable of halting reductionist materialism.

I become pessimistic myself when I see the high priests and Grand Inquisitors of the religion of science (Psi-cops) in *Scientific American* and on the Discovery Science channel on cable TV. Does no scientist object? Can't anyone see that this is the end of scientific method? You have to choose. Either scientific method applied to all things, known and unknown, or the religion of science. The Psi-cops (CSICOP) want to close the books. They don't want to allow new sciences. They want to define rationality as whatever is in the current textbooks, and irrationality is everything else. After three centuries, the grand adventure of ideas is over and science becomes just another faith, another superstition. One can easily see why this leads to a desperate search for any alternative.

Islam provides an alternative, one that seeks to destroy the West. It may now be clear why the most westernized of Moslems and the most intelligent are the first to raise the bloody flag of Jihad. They know better than anyone the cost to the soul of the soft luxury and gadgets of the West. A good example of the core terrorists is Ahmed Omar Sheikh, abductor of the Wall Street Journal reporter Daniel Pearl. Sheikh is Pakistani, but raised in a middle-class neighborhood in East London (*Newsweek*, 2/18/02/ p.42), educated in an elite private high school and the London School of Economics. It would seem that merely educating Moslems in the ways of the West would be counter-productive. It would be much better to teach them the modern liberal forms of Islam, taught in Dearborn, Michigan, the center of Moslem emigrants to the US.

We must change too, and offer kinds of spirituality that are compatible with science. No spirituality is compatible with the religion of science that we must vigorously reject, as we reject all other

religions, as irrational dogma, unsupported by experience. Religions have outlived their usefulness. They all induce sectarian intolerance, and they all teach fear, where there need be no fear. We need not fear death. It has no terror for those who have had an NDE. Death has no terror for those who know Professor Stevenson's *Twenty Cases*. We need not fear "the end times." This universe has lasted 13.7 billion years, and if it is closed, it has a minimum lifetime of 2000 billion years. If it is not closed, it will last forever, but will not be habitable forever. There are no discernible discontinuities in time. It is odd that this is a common fear among religions, including ones as different as the Aztec and the Christian. Perhaps those who have read nothing but the Koran or the Bible do not understand why the sun comes up every day, or why one season follows another.

What is emerging is a new metaphysics that shall be the basis for a renaissance of art and architecture. It will be rich in mysticism and symbolic revelation. Anyone can have a symbolic revelation. All they have to do is make a Mandala. This new metaphysics will be open to all seven ways, and there shall be no credo, nor any social hierarchy. It will be open to ceremonial magick, and to every form of meditation, and to every kind of entheogen, as we party and frolic our way towards a brighter day. Freedom! Liberation from our Puritanical past, and a repressive and tyrannical present. Throw off the shackles! Begin the long journey. It will not be a hardship. It will be a party, as we live, and love, and express ourselves, and grow. Let spiritual evolution and the divine purpose be our goal. *Sic Itur Ad Astra*. The way to the stars--and to immortality.

Conclusion

There is truth in the old saw that "A little knowledge is a dangerous thing." We have enough knowledge to create nuclear fusion bombs, but not enough wit to create a society where such things are unnecessary. It is as if we have scaled a cliff half way, and find ourselves perched on a narrow ledge. Impossible to stay here, all too easy to fall off, and difficult to continue to the top of the cliff. In the universities, we have the physical sciences, but no moral, mental or spiritual sciences. We know enough to debunk the literal truth of the old religions and mythologies, but not enough to make a science out of mystics and revelation. To return to fundamentalist Christianity or fundamentalist Islam would mean a new Dark Age, a new burning of the books, a new inquisition. Yet, they offer things that the physical sciences cannot, such as life after death, immortality, and a divine purpose.

All such shadows vanish if we apply the full light of reason to all subjects.

Many books have one big (or little) idea, and the entire book is an argument to that point. This book isn't like that. It contains dozens of original ideas, and dozens more known but to a few. This book does explain how to go to the stars, but I find it hard to believe that my explanation is original. It seems so obvious.

In the following chapter on physics, I present evidence that anti-matter has anti-gravity, and suggest that this is the explanation for the temporary acceleration of the Hubble expansion. The large scale structure of the universe consists in soap bubbles, with super clusters of galaxies where the bubbles intersect. This is because the bubbles are filled with anti-electrons, which try to stay as far apart from one another and from ordinary matter as they can. These bubbles were made by the early quasars, since the jets they produce are nothing but anti-matter.

I also present evidence that gravitons alter the spin vector of the Earth once a decade or two. This, plus Bode's law, provides the starting point for quantum gravity. It is all towards the end of the chapter.

Appendix: Physics Without Paradox

If scientists are the Priests of our Age, physicists must be the High Priests of the Temple. Even other scientists accept whatever the physicists say without question and without thought. Future generations will marvel that in 1927, at the Fifth Solvay conference, the physicists decided they were smarter than mathematicians and logicians, and not subject to the restrictions of logic and mathematics. At that conference, against the protests of Einstein, the chief physicists of the day decided simply to incorporate the wave-particle paradox into physics. A paradox is like a self-contradiction. Kurt Gödel proved that one can derive any proposition, such as 1=2, from a logical system with a buried self-contradiction. Mathematicians always consider paradox a defect, something to overcome. For instance, mathematicians invented calculus, in part, to escape Zeno's paradoxes.

Over the following decades, physicists also decided to accept other mathematical impossibilities, such as singularities and infinities, and rejected *reductio ad absurdum* as a form of reasoning.

As an example of the last point, consider virtual particles. The theorists of the last half of the 20th Century all based their theories on virtual particles, which arise from the application of Heisenberg's Uncertainty rules to the vacuum. This despite the fact that the theory of virtual particles implies an infinite energy for the vacuum. Well, we know that is absurd. The vacuum does not have infinite energy. If it did, the universe would either explode or implode, depending on whether the energy was positive or negative. That is clearly the *reductio ad absurdum* of virtual particles. There are no virtual particles. It is inappropriate to apply Heisenberg's rules to anything without a de Broglie wave attached to it. The vacuum has no momentum, and thus, no de Broglie wave.

Kurt Gödel, Einstein's best friend, found solutions to the equations of General Relativity that allow time travel. That too is a *reductio ad absurdum* for General Relativity. We already know there is no time travel. Otherwise, as Stephen Hawking pointed out, we would be swamped with tourists from the indefinite future. We would have to face the paradoxes of "The Terminator" series of movies. We already knew that General Relativity cannot be true, because it leads to

singularities. Indeed, many parts of the Standard Model lead to singularities. The mathematicians say that a function is undefined at a singularity. We need a different theory for that point. String Theory and its successors such as M-theory avoid singularity by adding at least six additional and unseen spatial dimensions. Unfortunately, String Theory has no known testable consequences. This is not the triumph of physics, the theory to end all theory; it is the end of physics and of science as we know it.

Some scientists have begun to recognize this. In the June 2003 issue of *Scientific American*, in the article by Gordon Kane, called "The Dawn of Physics Beyond the Standard Model," ten theoretical problems are listed:

"1. It (the standard model) implies a tremendous concentration of energy, even in the emptiest regions of space. This so-called vacuum energy would have either quickly curled up the universe long ago or expanded it to much greater size.

2. The expansion of the universe is accelerating and the standard model cannot explain this.

3. There is reason to believe that in the first fraction of a second of the Big Bang, the universe went through a period of extremely rapid expansion called inflation. The fields responsible for inflation cannot be those of the Standard Model.

4. If the universe began as a huge burst of energy, it should have evolved into equal parts of matter and anti-matter. This did not happen. The universe is matter. The Standard Model cannot explain this.

5. About a quarter of the universe is invisible cold dark matter that cannot be particles of the Standard Model.

6. In the Standard Model, interactions with the Higgs field cause particles to have mass. The Standard Model cannot explain the form these interactions must take.

7. Quantum corrections apparently make the Higgs boson mass huge and that would make all particle masses huge, obviously not the case.

8. The Standard Model cannot include gravity, because it does not have the same structure as the other three forces.

9. The Standard Model cannot explain the values of the masses of particles.

10. There are 3 generations of particles. The Standard Model cannot explain why there is more than 1 generation."

All these problems might have arisen because of an eleventh problem and that is the acceptance of logical and mathematical impossibilities such as paradox, singularities, and actual infinities. Such errors produce quantum weirdness. It is not something we should just meekly accept. A paradox is a form of self-contradiction. Einstein's friend Kurt Gödel proved that anything is true in a self-contradictory logical system. If anything is true, then nothing is true.

I think it would be better to go back to the old way of doing science, sticking closely to the data. By following that approach, I have made a few discoveries to be discussed later:

(1) Anti-matter has antigravity. This allows an explanation for the temporary acceleration of the Hubble expansion. Thus, we don't need dark energy.

(2) The planet Earth absorbs and emits gravitons perhaps once a decade that change its spin vector abruptly. Thus, gravitons are not the tiny things with tiny energy absorbed or emitted by tiny objects, as implied by General Relativity. The evidence suggests they are large things with large energy and they are absorbed and emitted only by large objects, such as a planet or star.

Not all is gloomy in the world of physics. Despite the rotten foundations of the Standard Model, physics has continued to make progress in nuclear physics and condensed matter physics.

George Gamow figured out the internal workings of stars, showing how they go through their life cycle, in the process generating all elements heavier than helium. We can apply the same rules of calculation to the Big Bang, to calculate the conditions necessary to turn about a quarter of the protons and neutrons into Helium, and most of the rest into Hydrogen. Given those conditions, nuclear physicists were also able to calculate the percentage of deuterium, Helium 3 and a few other light isotopes not produced in stars. These calculations agree with experience. That is how we know that 4.4% of the mass in the universe is Baryonic, what we could call ordinary matter, while

23% is dark matter, and about 73% is dark energy. At least, that's one fairy tale. Dark energy could just be the mass equivalent of all the gravitational potential energy. It may not exist at all, as we shall see. Dark matter is a useful idea, which I have picked up and used in my theory of mind. Nevertheless, astronomical dark matter may not exist. We can banish dark matter with a small adjustment to Newton's formula for gravitational force.

While I don't have solutions for all ten of the problems listed by Gordan Kane, I can solve some of them.

A reinterpretation of Quantum Mechanics:

It is not the equations that are wrong, but in some cases our use of them. We apply Heisenberg's uncertainty rules to the vacuum, giving an infinite energy to the vacuum. This is wrong because the vacuum has no momentum, and thus no de Broglie wave. In some cases, the problem is not the equations, but our interpretation of them. It is a misinterpretation that produces the wave-particle paradox, the collapse of Schrödinger states, and quantum weirdness in general. Some quantum weirdness is real, but not all of it.

Removing the Paradox: The fundamental paradox of QM is wave-particle duality. Everything is both a wave and a particle at the same time, or viewed one way in one experiment and the other in a different experiment. A non-paradoxical interpretation of quantum mechanics is possible if we accept the fundamental reality of the de Broglie wave. All we have to do is show why particles sometimes have a wave-like behavior (while remaining particles) and why vibrations sometimes act like particles, (while remaining vibrations in a field). A thing cannot be simultaneously a particle and a wave. It is one or the other. The scale of things doesn't change logic. It was Prince Louis de Broglie, a French aristocrat, who discovered this wave in 1923. His Ph.D. was in history, and he went on to a career as a civil servant. He could always solve QM problems just using his wave.

The de Broglie Wave: It is an information wave, determining what is possible and the probabilities of each of the possibilities.

Two equations describe the properties of the de Broglie wave:

Momentum $p = h / L$ and wave velocity $W = C**2 / v$, where L is the de Broglie wavelength, v is the ordinary velocity of the

associated particle and h is Planck's constant (6.6*10**(-27) erg-sec), while C is the speed of light (3*10**10 cm/sec).

Any object can have a de Broglie wave, including a compound object, such as the 60-carbon atom bucky-ball. All his life, de Broglie could calculate any quantum mechanical problem correctly, just using his wave. It is the de Broglie wave that corresponds to something real. It is by the de Broglie wave that the mind can see while Out-of-Body, without eyeballs to use. It is by emitting de Broglie waves that the hands can "push the probabilities" to create the Uri Geller effects.

The ideas of de Broglie excited immediate interest, because he could use his formula to calculate the orbits of atoms. Each orbit is determined by the standing waves (or resonances) of the de Broglie vibration. The ground state orbit will fit precisely one wavelength, the second orbit two wavelengths, and so forth to higher and higher overtones. These standing waves can themselves move and that indicates movement of the associated particle. This movement of the standing wave is never faster than the speed of light.

Louis de Broglie's theory is similar to the theory of a musical instrument, as he well knew. For a valve-less Baroque trumpet with a given length of tubing, there is a lowest note, one where exactly one wavelength of sound will resonate in the tube. It is possible to make higher notes on the trumpet, by exciting overtones, but impossible to make a lower note. One end of the trumpet is the bell. This discontinuity produces the end of the tube. In fact, there are a whole series of tube lengths made possible by the bell. In this way, a Baroque trumpet can produce most of the notes on the diatonic scale, above a certain minimum frequency.

This picture allows us to see why the first orbit of electrons around a nucleus can only hold two electrons, one somewhere under the maximum of the de Broglie resonance, and the other opposite to it under the minimum. These two electrons have slightly different energies, because the magnetic pole of the "up" electron aligns with that of the nucleus, while the "down" electron has its magnetic pole alignment opposite to that of the nucleus. The picture even allows us to understand why we can never predict exactly where the electron is. The de Broglie wave is a probability wave. It shows us where the

probability is greatest, but some of the time the electron will be anywhere its probability is non-zero.

It was Erwin Schrödinger who took de Broglie's formulas and plugged them into the partial differential equation for a wave. He then imposed severe boundary conditions that in effect made each solution of the equation a probability function. In this way, we transform the 2-dimensional picture of orbits into a 3-dimensional picture of orbitals. There are s, p, d and f orbitals. All the s orbitals are spherical. The other orbitals can assume more complicated, multi-lobed shapes. There are 3 such shapes for the p orbitals, 5 for the d orbitals and 7 for the f orbitals. Knowing the size, shape, and energy level of each orbital, chemists can understand the periodic table of elements. This, in turn, provides an understanding of ionic bonds and valence bonds and the general behavior of all of the elements, alone or in combination. See *The Periodic Kingdom*, by P.W. Atkins, especially pages 112 and 113.

There is nothing wrong with the Schrödinger equation. I disagree with the Standard Model interpretation of it that says that all its numerous solutions are somehow simultaneously real, until an observation "collapses the wave function" to a single reality. I would say that each solution represents a possible state, and the system is always in one state or another. We just don't know which without making the measurement.

Heisenberg's Uncertainty Rules: What we must add to this picture is Dirac's relativistic treatment of the atom that gives us electron spin and anti-particles. I won't get into Dirac, beyond saying he is one of the handful of geniuses who gave us modern physics. We must also add Heisenberg's uncertainty rules. If Z is some observable, then we will indicate the spread of its probability function (its Heisenberg uncertainty) by putting a "d" in front of it, dZ. The Heisenberg rules describe a curious coupling of position with momentum, and energy with time. Heisenberg's rules are:

$dP * dx = $ h-bar, and $dE * dt = $ h-bar where P is momentum, x is position, E is energy, t is time, and h-bar is Planck's constant divided by 2 pi. Therefore, if the positions are spread out, momenta will not be spread out. They will be "sharp." If the duration of an energy state has a large Heisenberg uncertainty, the energy will not. It will be "sharp."

Consider an electron in an excited orbit in the hydrogen atom. It will remain in that state for a certain duration of time, t, and when it falls back into a lower orbit, it will release a quantum of electromagnetic energy, where E=hf (f being the frequency). If we have a large number of hydrogen atoms making the same transition, both the energy E and the time t will vary a little. That is the "spread." There is a little probability curve that goes with each variable. The product of those spreads is h-bar. Nature is fundamentally probabilistic on an atomic or sub-atomic level. Notice that the product of the spreads is an extremely small number, where we have to move the decimal place 27 places to the left, filling in with zeroes, far smaller than experimental error. The real importance of Heisenberg's laws is that it is from them that we get virtual particles and the infinite energy of the vacuum. More on that later. Incidentally, Heisenberg's rules provide yet a third way of calculating the orbits of the electrons in an atom.

If we assume that the de Broglie wave is not a mathematical fiction, we can make all the quantum paradoxes and all the quantum weirdness go away. The electron does not go through both slits in the famous two-slit interferometer experiment. Its de Broglie wave does, and produces the diffraction patterns on the far side. The electron goes through one slit or the other; we just don't know which, since the de Broglie wave intensity is equal at the two slits. The electron is always in one place or another. It does not have a ghostly presence in each of the places it could be. Thus, observing an electron does not "collapse the wave function," nor does it pick out one among the infinity of universes.

The de Broglie functions describe the experiment, such as the 2-slit interferometer. It describes what is possible, and the probabilities of each. For the detector on the 2-slit interferometer, we use wave theory and positive and negative interference to produce a curve of the intensity of the de Broglie wave at the plane of the detector. It might land on the right, or it might land on the left. What has collapsed? Nothing. The function for this apparatus remains the same. If we keep on feeding electrons through it, the results will more and more closely match the probability function we have calculated for the plane of the detector. We do not change it by observing it.

The 2-slit experiment has now been done with atoms, molecules, and even a 60 carbon atom bucky-ball (Arndt, M. et al. (1999) *Letters to Nature*, vol. 401, October 14, 1999 pg 680). This implies that one can calculate the de Broglie wave of an entire object, such as the bucky-ball, as if it were a single simple thing having a particular mass, velocity, and location. This is somewhat like the Center of Mass theorem in Newtonian physics. Of course, someone is sure to repeat the mantra of QM, that we cannot know the position and velocity of an object simultaneously. This is not what the Heisenberg Uncertainty relationship says. It says we can simultaneously know each conjugate quantity to about 13 significant digits, if both variables are equally "broad." I am sure any experimenter would be happy with that.

The de Broglie vibration explains the sometimes-wavelike behavior of electrons. When a beam of electrons reflects off a crystal, it forms diffraction patterns. This is because the de Broglie wave associated with the electron goes before, (since its velocity is always greater than that of the electron), and bounces off each atom on the surface of the crystal. The result is a whole series of reflected de Broglie waves that add or subtract, producing a diffraction pattern. The probability of an electron hitting the detector screen in a particular place is proportional to the intensity of its de Broglie wave there.

Photons: Recall that the velocity of the de Broglie wave for an object traveling at velocity v is $W = C^{**}2 / v$ but v in this case is C, thus W=C and we know the frequency from E=hf, and by definition the velocity of a wave is its wavelength times its frequency so

$L = C^*h / E$,

This is the same as for photons. In other words, the de Broglie wave acts exactly like the EM (Electro-Magnetic) wave.

The problem of photons is quite different from the problem of atoms. In atoms, we have resonances of the de Broglie wave that determine the orbits of the electrons. With EM radiation, the de Broglie wave does not form a resonance. It just spreads out like ripples in a pond, in three-dimensions, and has positive and negative interference with all the other de Broglie waves from other photons in the same quantum state. As usual, where the de Broglie wave is

strongest, that is where you are most likely to find a photon. What does a photon look like?

I believe it looks just like a Schrödinger wave packet, except we must imagine a second wave at right angles to the first one. The first wave is in the electric field, and the one perpendicular to it is in the magnetic field. Photons are highly localized in space. They may all have the same size. One can get fewer long waves into a packet and that is why E=hf, that is, why the energy of a photon is proportional to the number of waves of electrical and magnetic energy one can get into a photon. Thus, both Bosons and Fermions are particle-like, and it is the de Broglie wave that explains and predicts the wave-like behaviors of both.

There is no new physics here. I'm not changing the equations. This is just an interpretation of the equations, i.e., a word picture and a mental picture. This interpretation avoids the weirdness of later quantum mechanics, such as the wave-particle paradox, multiple universes, instantaneous action at a distance, the collapse of the wave function and the entanglement of observer with observed that crept in with Schrödinger, Heisenberg, and Bohr. My non-paradoxical interpretation is consistent with observation. We cannot ask more of an interpretation. I would make a stronger statement. Physics cannot simply accept paradox, any more than it can just accept singularities. To do so is the end of physics as a rational enterprise, because we can derive absolutely any proposition from a logical system with logical self-contradictions. Einstein's friend Kurt Gödel proved that.

Getting Rid of the Infinite Energy of the Vacuum: The infinite energy of the vacuum (which would curl the whole universe up faster than I can type this sentence) arises from the theory of virtual particles. The entire theory of virtual particles arises from applying Heisenberg's rule of dE*dt=h-bar to the vacuum, where h-bar is Planck's constant divided by 2 pi. Remember, dt is the spread in duration, and dE is the spread in energy. If we make dt very sharp, dE becomes very broad, so broad in fact, that the formation of a particle and an anti-particle has non-zero probability, although this pair will exist only for the minute fraction of time allowed it by dt. This is the origin of the theory of virtual particles. Virtual particles have the

unfortunate consequence of making the energy of the vacuum infinite. We call this vacuum energy the ZPE (Zero Point Energy). Scientists base the physical theories of the second half of the 20th Century, such as QED and QCD, on virtual particles.

It is possible to prevent infinity by cutting off the possible wavelengths when they are small enough to enter the realm of quantum gravity. That *ad hoc* device still gives us a vacuum energy 120 orders of magnitude greater than the energy contained in all the matter in the universe! According to Lawrence Krauss, a well-respected neutrino physicist, "[This] discrepancy between theory and observation is the most perplexing quantitative puzzle in physics today (*Scientific American*, Jan. 1999, "Cosmological Antigravity," p. 55)." I am glad that Lawrence Krauss agrees with me. Some would say that if the vacuum has any energy density, it would be infinite if the universe were spatially infinite. What is wrong with that? Only that space-time has been expanding from a Hawking no-boundary "South Pole" where imaginary time was zero, and it has been expanding for a finite time, exactly 13.7 billion years. The visible universe cannot be spatially infinite.

Fortunately, it is possible to get rid of virtual particles, simply by saying that it is appropriate to apply Heisenberg's rules only when we can calculate a de Broglie wave. There is no de Broglie wave for the vacuum, since it has no momentum. So how then do we explain Casimir's force and other apparent confirmations of this idea? By applying de Broglie theory to the Electro-Magnetic field that extends through all of space. As we bring two plates closer together, we begin limiting the wavelengths of photons that can exist between them. This draws the plates together. At least, that is one idea. Better than accepting the logical absurdity of infinite energy for the vacuum. Those who plan space ships that will extract energy from the ZPE are just wasting their time.

Anti-matter has anti-gravity: I have now eliminated the wave-particle duality paradox from Quantum Mechanics. I would like to begin my discussion of cosmology with an observation about anti-particles.

It was Richard Feynman who suggested that anti-particles are

like ordinary particles moving backwards in time. If that is true, anti-particles should have anti-gravity, a conjecture never tested, although there is evidence for it.

Newsweek (May 12, 1997, "Fountain of Annihilation") and *Discover* magazines have reported a fountain of 511 KEV gamma rays spouting from the center of our own galaxy, suspected of harboring an old quasar, also known as a giant black hole. 511 Kilo Electron Volts is the mass of an electron. A fountain of 511 KEV gamma rays tells us there is a fountain of anti-electrons coming out of the North Pole of the old Quasar at the heart of the galaxy. This is exactly what we would expect if anti-particles have anti-gravity. Matter drawn towards the center of the Black Hole will rapidly pick up energy that will produce particle and anti-particle pairs. The energy might arise from internal collisions of particles inside the Black Hole. When particle and anti-particle pairs form inside the intense gravitational field of a black hole or quasar, the anti-particle shoots out one pole or the other, producing the jet. It is nonetheless possible to have a stable black hole. All that is necessary is that all particles stay in their orbits around the central Hawking no-boundary zero point in imaginary time. Black holes will eventually evaporate due to Hawking radiation.

This may be all the evidence we will ever have that anti-matter has anti-gravity. It is extremely difficult to do laboratory experiments with anti-matter, since gravity is so much weaker than electro-magnetism. We must contain anti-matter in a magnetic bottle. Particles with anti-gravity will not rise to the top of the bottle; they will try to keep as far apart from each other as possible.

Dark Matter: if we assume the truth of Kepler's laws of motion, then galaxies have a spherical halo of dark matter. The velocity of rotation of stars about the center of the galaxy does not fall off with distance, as do the velocity of planets about the Sun. Instead, velocity remains constant in the spiral arms, far past the last visible component. There has to be 10 times as much dark matter as visible matter to make that happen. Experiments are now underway to detect dark matter. I doubt if they will find anything. They are looking for WIMPs, a consequence of the paradox riddled QED and QCD. Dark matter requires a major revolution in physics.

I make use of this dark matter as a component of my theory of mind. Maybe it would be more accurate to say that mind is a component of dark matter. In my theory of mind, there is an intimate connection between mind-stuff and geodesics. Geodesics of space-time are like the flux lines of magnetic force made visible with a sheet of paper and iron filings. You may have done that experiment in high school. The geodesics of space-time determine the shape of space-time, locally distorted by the presence of mass. The mind can also locally distort the geodesics to produce levitation and apports. I suggest that dark matter consists in stable knots in the space-time geodesics. These knotted geodesics could explain the mass of dark matter without needing the Higgs Boson. Dark matter might not consist in discrete sizes of particle.

The Accelerating Universe: Recent observations show that the universe is not only expanding, it is accelerating. The jets from black holes and quasars could explain this, since the jets produce anti-matter that has anti-gravity. If they didn't have anti-gravity, they wouldn't be able to shoot out of the Black Hole. The proportion of anti-matter to matter should increase (up to a point), and so should the repulsive force produced by anti-matter. The force of repulsion will decline as quasars and black holes disappear, as anti-matter and matter combine around the edge of the cosmic voids. The acceleration phase may already be passing, since there have been no quasars in the last billion years. There has been just enough acceleration to make the universe old enough to hold the oldest stars.

Each large early Quasar produced a cloud of anti-matter that created the voids we see now in the large-scale structure of the universe, according to my theory. Bubbles of anti-matter will push out matter, both light and dark, until it collides on the boundaries of the bubbles. That is where super-clusters of galaxies form, as long strings of matter. Anti-matter itself will not clump.

Why did the universe start out as matter, instead of equal parts of matter and anti-matter? We may never know. We can only speculate about the physics of the larger cosmos that gave rise to this bubble of space and imaginary time. The universe could be a zero energy quantum fluctuation in the primordial chaos that produced a

bubble of false vacuum. False vacuum is not part of this universe, so we can give it whatever properties are convenient. Let us imagine the bubble has space and imaginary time, and expands at an exponentially increasing rate, and then freezes out into matter, not a combination of matter and anti-matter. Somehow, the freeze-out imparts to this matter something very close to escape velocity. Indeed, it is exactly the escape velocity out to at least 40 decimal points. After this freeze-out of the false vacuum, normal physics takes over. The universe could have zero total energy because gravitational potential energy is negative, and could balance out all positive forms of energy.

NASA's WMAP probe shows that the universe is flat, within the experimental margins of error. I believe this result. It means there is enough mass in the universe to prevent runaway expansion, and not so much as to produce a premature collapse. We know from evidence left over from the Big Bang that no more than 4.4 percent can be ordinary matter, and that includes the anti-matter that I believe exists in the voids. About 23 percent must be dark matter to account for the rotation curves of galaxies, the lensing effect of clusters of galaxies and other things. If the universe is flat, about 73 percent of the mass is in some unknown form, presently called "dark energy." I wonder if this could be the mass-equivalent of all the gravitational potential energy that exists in the universe.

Quantum Gravity: First, an analogy. Observation of the interaction between photons and electrons, in particular, the discrete spectral lines produced by each element, led to existing quantum theory. The Hydrogen atom had the Balmer series and the Lyman series, and others, and there were mathematical formulas for calculating the frequency of these spectral lines, produced by reflecting the light off a diffraction grating, also known as an interferometer. We cannot derive the theory of the photon from the field theory of Electro-Magnetism, i.e., Maxwell's equations. It required new evidence. So it shall be with the graviton. Thus, quantum gravity will be the theory of the graviton, created by observing the absorption and emission of gravitons.

We have been looking at the absorption and emission of gravitons for 30 years, but not recognizing it as such.

There is a little noted experiment, reported in *Scientific American* back in 1970 by Mansinha and Smylie, which shows that the Earth experiences abrupt changes of spin vector. In direction, the spin vector may change by 10 milli-arcseconds. In rotational speed, it changes on the order of 10 milli-arc-seconds per second. These abrupt changes look exactly like the absorption or emission of gravitational quanta, and this could be the beginning of a theory of quantum gravity. In every year since atomic clocks were developed, scientists have had to add 1 second to the length of each year, beyond all the corrections made for leap years, and so forth. They did not have to do that for 2003. Why not? Because the Earth absorbed a powerful graviton, which increased the length of a year by one second, if we define a year in terms of seconds.

The field theory of gravity (Einstein's general theory of relativity) gives us misleading advice about the graviton, just as the field theory of EM gave misleading advice about the photon. Einstein's theory predicts that a graviton carries an extremely small amount of energy. That is the kind of graviton we look for, and do not find. We assume in classical gravitational theory that a relatively small object can absorb a graviton and that is also not true. It takes a planetary sized object to absorb or emit a graviton.

D.E. Smylie and L. Mansinha have observed milli-arc-second jumps in direction and speed of the planetary spin vector. See "The Rotation of the Earth," vol. 225, #6, December 1971, *Scientific American*, pp. 80-88. There is nothing in geology that could explain this.

Magma movements are too slow, and the flow of currents in the liquid metal outer core of the earth cause continuous rather than discontinuous movements in the magnetic pole, with no associated change in the spin vector. Earthquakes do not cause the jumps in the spin vector. We observe abrupt changes of as much as ten milliseconds in sidereal time. Thus, Mansinha & Smylie's observations are a mystery...unless they represent the absorption or emission of gravitons of enormous energy. Add to this Bode's Law and we have the beginning of a theory.

Bode's Law: Bode's law takes the series 0,3,6,12,24, each time

doubling the previous number, adds 4 and divides by 10. The result is the mean distance of each planet's orbit in units of AU (defined as one for the Earth). Bode's law very accurately describes the orbits of all the planets (and the asteroid belt) except the outer two, Neptune and Pluto. We now know that Pluto is not really a planet, just a planetoid from the Kuiper Belt in a gravitational resonance with Neptune. Its orbit does not lie in the plane of the ecliptic with the true planets. Pluto crosses the orbit of Neptune, but the gravitational resonance prevents collision.

We also know that in the early years of the formation of the Solar System, the outermost planet would be busy throwing out planetoids, each time moving in a little closer to the sun. It is easy to imagine that Neptune formed at 38.8 AU, but gradually moved inward to 30.1 AU as a result of tossing out planetoids. No one has ever come up with an explanation of Bode's law. It is too regular to be a mere accident or coincidence. I suggest it makes our solar system resemble an atom, and we know that the theory of photons explain an atom's orbits. Likewise, it seems reasonable that the complete theory of gravitons will explain a solar system, if we add a dash of chaos. This means our Solar System is normal. This increases the odds of finding life and intelligence in the universe.

How could we possibly integrate Bode's Law into gravitational theory? There is already a suggestion that the law of gravity may have higher order terms. We see this in the motion of space probes shot out of the Solar System. Eventually, their motion becomes non-Newtonian. In the F=M*A equation, there seems to be a higher order term, so F= M*(-A - α*A1**2). There may be other corrections, functions of Atomic Number, perhaps.

I have found no hint or clue to star travel from physics. And neither has anyone else.

Bibliography

Arndt, M. et al. (1999) *Letters to Nature*, vol 401, October 14, 1999 pg 680.

_____ (1989). *Traffic Congestion; A Toolbox for Alleviating Traffic Congestion*. Washington, DC: Institute of Transportation Engineers.

_____ . (1991). *Abortion: Opposing Viewpoints*. San Diego, CA: Greenhaven Press.

Albert, David Z. (1994). Bohm's Alternative to Quantum Mechanics. *Scientific American* 270, #5, May, 1994. p. 58 ff.

Alexander, C., Neis, H., Anninou, A. and King,I. (1977). *A Pattern Language*. New York: Oxford University Press.

Auerbach, Jerolds. (1983). *Justice Without Law?* New York: Oxford University Press.

Black, David. (1986). *The Plague Years: A Chronicle of AIDS, the Epidemic of our Times*. New York: Simon & Schuster.

Blackmore, S. (1988). Do We Need a New Psychical Research? *Journal of the Society for Psychical Research*, 55, 49 ff.

Blackmore, S. (1993). *Dying to Live*. Buffalo: Prometheus.

Bockris, John. (1975). *Energy, The Solar Hydrogen Alternative*. New York: Wiley.

Boutros-Ghali, Boutros. (1992). *An Agenda For Peace*. New York: United Nations.

Brennan, Barbara Ann. (1993, 1994). *Hands of Light, Light Emerging*.

Broadbent, Geoffrey. (1990). *Emerging Concepts in Urban Space Design*. New York: Van Nostrand.

Cappon, D. (1971). "Mental Health and High Rise." *Canadian Public Health Association*, April.

Corso, Col. Philip J. (1997). *The Day After Roswell*. New York: Pocket.

Crowe, Timothy D. (1991). *Crime Prevention Through Environmental Design*.

Edwards, Frank. (1966). *Flying Saucers--Serious Business*. Secaucus: Citadel Press.

Eisenbud, Jules, M.D.. (1967). *The World of Ted Serios*, New York: William Morrow.

Fanning, D. M. (1967). "Families in Flats." *British Medical Journal*, November, No. 198.

Ferguson, Duncan S. (1993), Editor. *New Age Spirituality*, Louisville: John Knox Press.

Figgie, Harold. (1992). *Bankruptcy 1995: The Coming Collapse of America and How to Stop It*. Boston: Little, Brown.

Fisher, Helen. (1994). *Anatomy of Love: The Mysteries of Mating, Marriage, and Why We Stray*. New York: Fawcett Columbine.

Fishman, Robert. (1989). *Urban Utopias in the Twentieth Century*. Cambridge: MIT Press.

Friedman and Berliner. (1992). *Crash At Corona*, New York: Paragon House.

Gallion, A. & Eisner, S. (1986). *The Urban Pattern*. New York: Van Nostrand Reinhold.

Gardner, Martin (1966). *Dermo-Optical Perception: A Peek Down the Nose*. Science. 152:1108.

Geller, Uri (1975). *Uri Geller: My Story*. London and Sydney: The Companion Book Club.

Geller, Uri (1986), & Playfair, Guy Lyon. *The Geller Effect*. New York: Henry Holt.

Halpern, Paul. (1992). *Cosmic Wormholes; The Search for Interstellar Shortcuts*. New York: Dutton.

Herbert, Nick. (1988). *Faster Than Light; Superluminal Loopholes in Physics*. New York: New American Library.

Howard, Philip K. (1994). *The Death of Common Sense; How Law is Suffocating America*. New York: Random House.

Jacobs, J. (1961). *The Death and Life of Great American Cities: The Failure of Town Planning*. New York: Random House.

Karagulla, S. (1967). *Breakthrough to Creativity; Your Higher Sense Perception*. Los Angeles: DeVorss & Co., Inc.

Kelsey, Denys and Grant, Joan (1967). *Many Lifetimes*. New York: Doubleday.

Kilbourne, E. (1988). *Influenza*. New York: Plenum.

Krauss, Lawrence. (1995). *The Physics of Star Trek*. New York: BasicBooks.

Krier, L. (1987). "Atlantis, Tenerife." *Architectural Design*, 58.

Kuhn, T. S. (1962). *The Structure of Scientific Revolutions*. Chicago: University of Chicago Press.

Lazare, Daniel. (1996). *The Frozen Republic; How the Constitution Is Paralyzing Democracy*. New York: Harcourt Brace & Company.

Leakey, Richard, and Lewin, Roger. (1995). *The Sixth Extinction; Patterns of Life and the Future of Mankind*. New York: Doubleday.

Le Corbusier. (1967). *The Radiant City*. London: Faber.

Lerner, Eric. (1991). *The Big Bang Never Happened*. New York: Times Books.

Lynch, Kevin. (1981). *Good City Form*. Cambridge: MIT Press.

Macklin, John. (1965). *Strange Destinies*. New York: Ace.

Mallove, Eugene and Matloff, Gregory. (1989). *The Starflight Handbook; A Pioneer's Guide to Interstellar Travel*. New York: Wiley.

Marx, Doug. (1990). *The Homeless*. Vero Beach, Fl: Rourke Corp.

Matt, Daniel C. (1995). *The Essential Kabbalah*. New York: QPB.

Mitchell, J.L. (1981). *Out-Of-Body Experiences, A Handbook.* Jefferson, North Carolina: McFarland & Company.

Monroe, Robert. (1971). *Journeys Out of the Body*, New York: Doubleday.

Moody, R. (1975). *Life After Life*. St. Simons Island, Georgia, USA: Mockingbird Press.

Morris, R. (1993). *Cosmic Questions*. New York: Wiley.

Morville, J. (1969). *Borne Brug af Friarsaler*. SBI: Denmark.

Moss, Thelma. (1974). *The Probability of the Impossible*. New York: New American Library.

Newman, O. (1972). *Defensible Space: People and Design in the Violent City*. New York: Macmillan.

Ostrander, S. & Schroeder, L. (1970). *Psychic Discoveries Behind the Iron Curtain*. Englewood Cliffs, New Jersey: Prentice-Hall, Inc.

Penrose, Roger. (1990). *The Emperor's New mind*. Oxford University Press.

Playfair, Guy Lyon. (1985). *If This Be Magic.* London: Jonathan

Cape.

Powers, Robert. (1981). *The Coattails of God; The Ultimate Spaceflight -- The Trip to the Stars*. New York: Warner.

Rabinovitch, J. and Leitman, J. (March, 1996). "Urban Planning in Curitiba," *Scientific American*. SA: New York.

Randles, Jenny. (1997). *Alien Contact; The First Fifty Years*. New York: Sterling Publishing Co, Inc.

Ring, K. (1982). *Life at Death*. New York: Quill.

Rivenburg, Roy. (March 24, 1995). "Blinded by the Light?" Los Angeles: *LA Times*.

Rojansky, V. (1938). *Introductory Quantum Mechanics*. Englewood Cliffs, New Jersey: Prentice-Hall, Inc.

Rucker, Rudy. (1982). *mind and Infinity*. New York: Bantam.

Sabom, M.B. (1982). *Recollections at Death*. London: Gorgi.

Sagan, Carl. (1986). *Contact*. New York: Simon & Schuster.

Sagan, Carl. (1997). *The Demon-Haunted World*. New York: Ballantine.

Smylie, D.E. , and Mansinha, L. (December 1971). "The Rotation of the Earth," vol. 225, #6, *Scientific American*, pp. 80-88.

Spence, Gerry. (1989). *With Justice For None: Destroying an American Myth*. New York: Times Books.

Stenger, Victor J. (1990). *Physics and Psychics*. Buffalo, NY: Prometheus Press.

Stevenson, I. (1966). *Twenty Cases Suggestive of Reincarnation*. New York: American Society for Psychical Research.

Sutherland, Cherie. (1992). *Reborn In The Light; Life After Near-Death Experiences*. New York: Bantam.

Tipler, Frank J. (1994). *The Physics of Immortality*. NY: Doubleday.

Twining, H. LaV. (1915). *The Physical Theory of the Soul*, Westgate, CA.: Press of the Pacific Veteran.

Tyrrell, G.N.M. (1953). *Apparitions*. London: The Society for Psychical Research.

Vaughan, A. (1970). Poltergeist Investigations in Germany. *Psychic*, April.

Watson, Lyall (1973). Matter and Magic. *Supernature*. Garden City: publisher unknown.

Wesselman, Hank (1995). *Spiritwalker; Messages from the Future.* New York: Bantam.

Wilber, Ken. (1984). *Quantum Questions; Mystical Writings of the World's Great Physicists.* Boston: Shambhala.

Winters, Randolph. (1994). *The Pleiadian Mission.* The Pleiades Project: POB 406, Yorba Linda, CA 92686-0406.

Wilson, William H. (1989). *The City Beautiful Movement.* Baltimore: Johns Hopkins University Press. The 19th century Park and Boulevard system which gave us Central Park in NYC.

Winters, Randolph. (1994). *The Pleiadian Mission; A Time of Awareness.* Yorba Linda: The Pleiades Project.

Wolf, Fred Alan. (1989). *Taking the Quantum Leap*, New York: Harper & Row.

Kenneth Arnold's famous 1947 sighting was featured in the first issue of *FATE Magazine*, published in the spring of 1948.

Kenneth Arnold standing beside his private plane, which he was flying when he made his sighting of "flying saucers" over the Cascade Mountains of Washington state on June 24, 1947.

This flying object was twice snapped at dusk Monday as it circled north of Phoenix. William A. Rhodes, 4333 North 14th street, first shot the picture at the left as the slow-flying object was approaching him. As it banked to make a tight turn, he obtained the picture above, showing clearly the shape of the object. In seconds, Rhodes said, the "disc" shot away to the west at high speed. It had made three whirling turns north of the city, after approaching from the west. Aircraft identification experts yesterday would not hazard opinions on the object's nature.

Speedy 'Saucer' Zips Through Local Sky

By ROBERT C. HANIKA

THE FIRST clearly recorded photographs of what is believed to be a mysterious "flying disc" which has 33 states in America and even a few foreign countries on edge with its peculiar activities, was taken by an amateur Phoenix photographer.

Reproduced in the Arizona Republic today, the photographs were made by William A. Rhodes, 4333 North 14th street, who was on his way to his workshop in the rear of his home when he heard the distinctive "whoosh" of what he believed to be a P-80 or Shooting Star jet-propelled plane.

Rhodes snatched a camera from his workshop bench and by the time he reached a small mound at the rear of his home, the object had circled his home once and was banking in tight circles to the south at an altitude of approximately 1,000 feet, he said.

IN THE overcast sky the object continued its speedy flight from north to south and directly east of his stance. Rhodes snapped the

(Exclusive Republi

WINDOW ROCK
velopment of the hu
helium gas located
Corners area of the
reservation as a poten
income for the Nava
discussed today at th
sions of the Navajo
cil here today.

Norman Littell, W
C., attorney, urged ef
about the execution
vantageous contract
eral government for t
gas for government u

Littell, who came
request of Sam Ahl
tribal council chairn
cently visited Washing
ed belief that terms o
contract are not favo
to the Navajo nation

HE SAID IT is a
Four Corners heliur
tains 788,000,000 cubi
comparatively rare el

Littell declared, h
he was certain the N
would want "Uncle S
first priority to p
helium for use in mi
tions and for national
poses.

Helium, a nonexplo
inflammable gas is
military forces in lig
craft. Because it is
air it also is being us
airplane tires.

The Four Corners
discovered six years
course of oil drilling
that area. During the
line was built to C
which point it was al
tainers to all military
at home and overseas
er-than-air craft were

THERE ARE only
helium in the United S
Chairman Ahkeah
council meeting with
his recent visit to W
discuss Navajo needs
bers of congress and
ernment officials.

"What we need is
is schooling and he

A newspaper article and photograph that appeared in the *Arizona Republic* (Phoenix) on July 9, 1947.

Top: Discoid UFO over Lake Chauvet, France, July 18, 1952, taken by witness M. Andre Fregnale. *Bottom*: Discoid UFO over Anchorage, Alaska taken by an anonymous witness mid-summer, 1952.

Top and Bottom: Discoid UFO photographed by contactee Elizabeth Klarer on July 17, 1955 over the Drakensberg Mountains of Natal, South Africa.

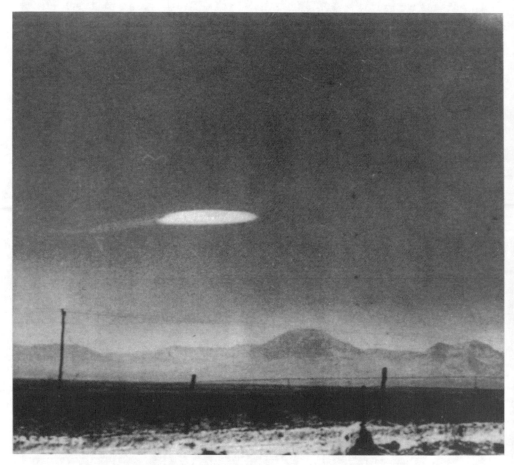

A discoid UFO flying over Alamagordo, New Mexico, site of the atomic bomb
tests, taken by a US government worker on October 16, 1957.

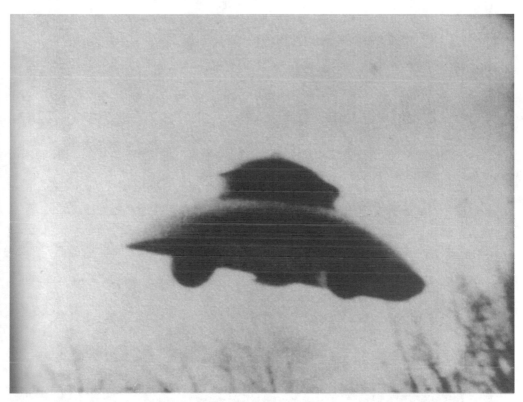

A frame from an 8mm film taken by Madeleine Rodeffer on February 26, 1965, in the presence of George Adamski, Rosemary Decker, and other witnesses, at Rodeffer's house in Silver Spring, Maryland. The film provides confirmation that some craft distort time and space, as distortion is apparent on the right side of the vehicle and even more distortion is apparent in other frames from the movie. William Sherwood, a former Kodak optical physicist, authenticated the film and calculated the craft to be about 27 feet in diameter.

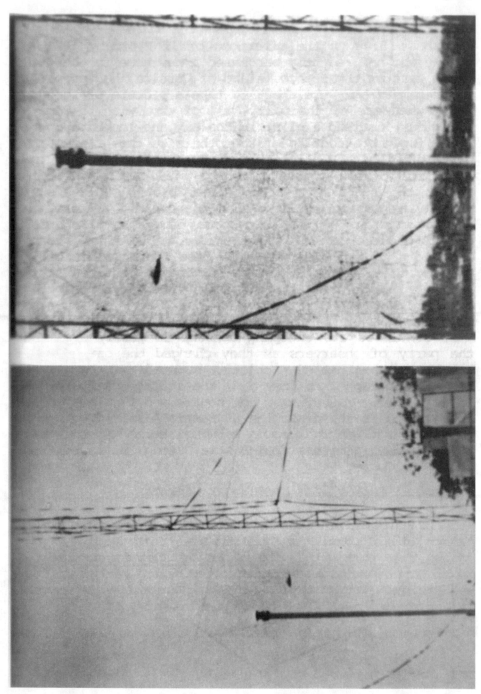

Top and Bottom: Discoid UFO photographed by Sergio Schlimovich at the transmitting antenna of the farm where his father worked near Parana, Argentina on September 6, 1970.

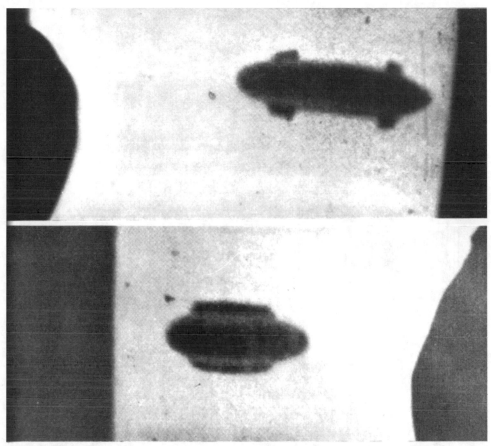

Above and Bottom: Joan Oldfield saw and photographed this UFO from a British airliner over Cannock, Staffordshire, England in March of 1966. In (a) the UFO appeared to be elongated with appendages. In (b) it changes to a more saucer-like shape; and in (c) it appears as a discoid craft just before it disappears.

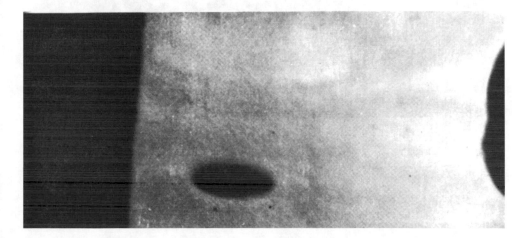

A Defense Intelligence Agency security poster from 1984.

THE
ADVENTURES
UNLIMITED
CATALOG

ANTI-GRAVITY

THE A.T. FACTOR
A Scientists Encounter with UFOs: Piece For A Jigsaw Part 3
by Leonard Cramp

British aerospace engineer Cramp began much of the scientific anti-gravity and UFO propulsion analysis back in 1955 with his landmark book *Space, Gravity & the Flying Saucer* (out-of-print and rare). His next books (available from Adventures Unlimited) *UFOs & Anti-Gravity: Piece for a Jig-Saw* and *The Cosmic Matrix: Piece for a Jig-Saw Part 2* began Cramp's in depth look into gravity control, free-energy, and the interlocking web of energy that pervades the universe. In this final book, Cramp brings to a close his detailed and controversial study of UFOs and Anti-Gravity.
324 PAGES. 6x9 PAPERBACK. ILLUSTRATED. BIBLIOGRAPHY. INDEX. $16.95. CODE: ATF

COSMIC MATRIX
Piece for a Jig-Saw, Part Two
by Leonard G. Cramp

Cosmic Matrix is the long-awaited sequel to his 1966 book *UFOs & Anti-Gravity: Piece for a Jig-Saw.* Cramp has had a long history of examining UFO phenomena and has concluded that UFOs use the highest possible aeronautic science to move in the way they do. Cramp examines anti-gravity effects and theorizes that this super-science used by the craft—described in detail in the book—can lift mankind into a new level of technology, transportation and understanding of the universe. The book takes a close look at gravity control, time travel, and the interlocking web of energy between all planets in our solar system with Leonard's unique technical diagrams. A fantastic voyage into the present and future!
364 PAGES. 6x9 PAPERBACK. ILLUSTRATED. BIBLIOGRAPHY. $16.00. CODE: CMX

UFOS AND ANTI-GRAVITY
Piece For A Jig-Saw
by Leonard G. Cramp

Leonard G. Cramp's 1966 classic book on flying saucer propulsion and suppressed technology is a highly technical look at the UFO phenomena by a trained scientist. Cramp first introduces the idea of 'anti-gravity' and introduces us to the various theories of gravitation. He then examines the technology necessary to build a flying saucer and examines in great detail the technical aspects of such a craft. Cramp's book is a wealth of material and diagrams on flying saucers, anti-gravity, suppressed technology, G-fields and UFOs. Chapters include Crossroads of Aerodynamics, Aerodynamic Saucers, Limitations of Rocketry, Gravitation and the Ether, Gravitational Spaceships, G-Field Lift Effects, The Bi-Field Theory, VTOL and Hovercraft, Analysis of UFO photos, more.
388 PAGES. 6x9 PAPERBACK. ILLUSTRATED. $16.95. CODE: UAG

THE ENERGY GRID
Harmonic 695, The Pulse of the Universe
by Captain Bruce Cathie.

This is the breakthrough book that explores the incredible potential of the Energy Grid and the Earth's Unified Field all around us. Cathie's first book, *Harmonic 33*, was published in 1968 when he was a commercial pilot in New Zealand. Since then, Captain Bruce Cathie has been the premier investigator into the amazing potential of the infinite energy that surrounds our planet every microsecond. Cathie investigates the Harmonics of Light and how the Energy Grid is created. In this amazing book are chapters on UFO Propulsion, Nikola Tesla, Unified Equations, the Mysterious Aerials, Pythagoras & the Grid, Nuclear Detonation and the Grid, Maps of the Ancients, an Australian Stonehenge examined, more.
255 PAGES. 6x9 TRADEPAPER. ILLUSTRATED. $15.95. CODE: TEG

THE BRIDGE TO INFINITY
Harmonic 371244
by Captain Bruce Cathie

Cathie has popularized the concept that the earth is crisscrossed by an electromagnetic grid system that can be used for anti-gravity, free energy, levitation and more. The book includes a new analysis of the harmonic nature of reality, acoustic levitation, pyramid power, harmonic receiver towers and UFO propulsion. It concludes that today's scientists have at their command a fantastic store of knowledge with which to advance the welfare of the human race.
204 PAGES. 6x9 TRADEPAPER. ILLUSTRATED. $14.95. CODE: BTF

THE HARMONIC CONQUEST OF SPACE
by Captain Bruce Cathie

Chapters include: Mathematics of the World Grid; the Harmonics of Hiroshima and Nagasaki; Harmonic Transmission and Receiving; the Link Between Human Brain Waves; the Cavity Resonance between the Earth; the Ionosphere and Gravity; Edgar Cayce—the Harmonics of the Subconscious; Stonehenge; the Harmonics of the Moon; the Pyramids of Mars; Nikola Tesla's Electric Car; the Robert Adams Pulsed Electric Motor Generator; Harmonic Clues to the Unified Field; and more. Also included are tables showing the harmonic relations between the earth's magnetic field, the speed of light, and anti-gravity/gravity acceleration at different points on the earth's surface. New chapters in this edition on the giant stone spheres of Costa Rica, Atomic Tests and Volcanic Activity, and a chapter on Ayers Rock analysed with Stone Mountain, Georgia.
248 PAGES. 6x9. ILLUSTRATED. BIBLIOGRAPHY. $16.95. CODE: HCS

MAN-MADE UFOS 1944—1994
Fifty Years of Suppression
by Renato Vesco & David Hatcher Childress

A comprehensive look at the early "flying saucer" technology of Nazi Germany and the genesis of man-made UFOs. This book takes us from the work of captured German scientists to escaped battalions of Germans, secret communities in South America and Antarctica to todays state-of-the-art "Dreamland" flying machines. Heavily illustrated, this astonishing book blows the lid off the "government UFO conspiracy" and explains with technical diagrams the technology involved. Examined in detail are secret underground airfields and factories; German secret weapons; "suction" aircraft; the origin of NASA; gyroscopic stabilizers and engines; the secret Marconi aircraft factory in South America; and more. Introduction by W.A. Harbinson, author of the Dell novels *GENESIS* and *REVELATION*.
318 PAGES. 6x9 PAPERBACK. ILLUSTRATED. INDEX & FOOTNOTES. $18.95. CODE: MMU

24 hour credit card orders—call: 815-253-6390 fax: 815-253-6300

email: auphq@frontiernet.net www.adventuresunlimitedpress.com www.wexclub.com

ANTI-GRAVITY

THE FREE-ENERGY DEVICE HANDBOOK
A Compilation of Patents and Reports
by David Hatcher Childress

A large-format compilation of various patents, papers, descriptions and diagrams concerning free-energy devices and systems. *The Free-Energy Device Handbook* is a visual tool for experimenters and researchers into magnetic motors and other "overunity" devices. With chapters on the Adams Motor, the Hans Coler Generator, cold fusion, superconductors, "N" machines, space-energy generators, Nikola Tesla, T. Townsend Brown, and the latest in free-energy devices. Packed with photos, technical diagrams, patents and fascinating information, this book belongs on every science shelf. With energy and profit being a major political reason for fighting various wars, free-energy devices, if ever allowed to be mass distributed to consumers, could change the world! Get your copy now before the Department of Energy bans this book!
292 PAGES. 8x10 PAPERBACK. ILLUSTRATED. BIBLIOGRAPHY. $16.95. CODE: FEH

THE ANTI-GRAVITY HANDBOOK
edited by David Hatcher Childress, with Nikola Tesla, T.B. Paulicki,
Bruce Cathie, Albert Einstein and others

The new expanded compilation of material on Anti-Gravity, Free Energy, Flying Saucer Propulsion, UFOs, Suppressed Technology, NASA Cover-ups and more. Highly illustrated with patents, technical illustrations and photos. This revised and expanded edition has more material, including photos of Area 51, Nevada, the government's secret testing facility. This classic on weird science is back in a 90s format!
• **How to build a flying saucer.**
•**Arthur C. Clarke on Anti-Gravity.**
• **Crystals and their role in levitation.**
• **Secret government research and development.**
• **Nikola Tesla on how anti-gravity airships could
 draw power from the atmosphere.**
• **Bruce Cathie's Anti-Gravity Equation.**
• **NASA, the Moon and Anti-Gravity.**
253 PAGES. 7x10 PAPERBACK. BIBLIOGRAPHY/INDEX/APPENDIX. HIGHLY ILLUSTRATED. $16.95.
CODE: AGH

ANTI–GRAVITY & THE WORLD GRID

Is the earth surrounded by an intricate electromagnetic grid network offering free energy? This compilation of material on ley lines and world power points contains chapters on the geography, mathematics, and light harmonics of the earth grid. Learn the purpose of ley lines and ancient megalithic structures located on the grid. Discover how the grid made the Philadelphia Experiment possible. Explore the Coral Castle and many other mysteries, including acoustic levitation, Tesla Shields and scalar wave weaponry. Browse through the section on anti-gravity patents, and research resources.
274 PAGES. 7x10 PAPERBACK. ILLUSTRATED. $14.95. CODE: AGW

ANTI–GRAVITY & THE UNIFIED FIELD
edited by David Hatcher Childress

Is Einstein's Unified Field Theory the answer to all of our energy problems? Explored in this compilation of material is how gravity, electricity and magnetism manifest from a unified field around us. Why artificial gravity is possible; secrets of UFO propulsion; free energy; Nikola Tesla and anti-gravity airships of the 20s and 30s; flying saucers as superconducting whirls of plasma; anti-mass generators; vortex propulsion; suppressed technology; government cover-ups; gravitational pulse drive; spacecraft & more.
240 PAGES. 7x10 PAPERBACK. ILLUSTRATED. $14.95. CODE: AGU

ETHER TECHNOLOGY
A Rational Approach to Gravity Control
by Rho Sigma

This classic book on anti-gravity and free energy is back in print and back in stock. Written by a well-known American scientist under the pseudonym of "Rho Sigma," this book delves into international efforts at gravity control and discoid craft propulsion. Before the Quantum Field, there was "Ether." This small, but informative book has chapters on John Searle and "Searle discs;" T. Townsend Brown and his work on anti-gravity and ether-vortex turbines. Includes a forward by former NASA astronaut Edgar Mitchell.
108 PAGES. 6x9 PAPERBACK. ILLUSTRATED. $12.95. CODE: ETT

TAPPING THE ZERO POINT ENERGY
Free Energy & Anti-Gravity in Today's Physics
by Moray B. King

King explains how free energy and anti-gravity are possible. The theories of the zero point energy maintain there are tremendous fluctuations of electrical field energy imbedded within the fabric of space. This book tells how, in the 1930s, inventor T. Henry Moray could produce a fifty kilowatt "free energy" machine; how an electrified plasma vortex creates anti-gravity; how the Pons/Fleischmann "cold fusion" experiment could produce tremendous heat without fusion; and how certain experiments might produce a gravitational anomaly.

190 PAGES. 5x8 PAPERBACK. ILLUSTRATED. $12.95. CODE: TAP

STRANGE SCIENCE

UNDERGROUND BASES & TUNNELS
What is the Government Trying to Hide?
by Richard Sauder, Ph.D.

Working from government documents and corporate records, Sauder has compiled an impressive book that digs below the surface of the military's super-secret underground! Go behind the scenes into little-known corners of the public record and discover how corporate America has worked hand-in-glove with the Pentagon for decades, dreaming about, planning, and actually constructing, secret underground bases. This book includes chapters on the locations of the bases, the tunneling technology, various military designs for underground bases, nuclear testing & underground bases, abductions, needles & implants, military involvement in "alien" cattle mutilations, more. 50 page photo & map insert.
201 PAGES. 6x9 PAPERBACK. ILLUSTRATED. $15.95. CODE: UGB

UNDERWATER & UNDERGROUND BASES
Surprising Facts the Government Does Not Want You to Know
by Richard Sauder

Dr. Richard Sauder's brand new book *Underwater and Underground Bases* is an explosive, eye-opening sequel to his best-selling, *Underground Bases and Tunnels: What is the Government Trying to Hide?* Dr. Sauder lays out the amazing evidence and government paper trail for the construction of huge, manned bases offshore, in mid-ocean, and deep beneath the sea floor! Bases big enough to secretly dock submarines! Official United States Navy documents, and other hard evidence, raise many questions about what really lies 20,000 leagues beneath the sea. Many UFOs have been seen coming and going from the world's oceans, seas and lakes, implying the existence of secret underwater bases. Hold on to your hats: Jules Verne may not have been so far from the truth, after all! Dr. Sauder also adds to his incredible database of underground bases onshore. New, breakthrough material reveals the existence of additional clandestine underground facilities as well as the surprising location of one of the CIA's own underground bases. Plus, new information on tunneling and cutting-edge, high speed rail magnetic-levitation (MagLev) technology. There are many rumors of secret, underground tunnels with MagLev trains hurtling through them. Is there truth behind the rumors? *Underwater and Underground Bases* carefully examines the evidence and comes to a thought provoking conclusion!
264 PAGES. 6x9 PAPERBACK. ILLUSTRATED. BIBLIOGRAPHY. INDEX. $16.95. CODE: UUB

KUNDALINI TALES
by Richard Sauder, Ph.D.

Underground Bases and Tunnels author Richard Sauder's second book on his personal experiences and provocative research into spontaneous spiritual awakening, out-of-body journeys, encounters with secretive governmental powers, daylight sightings of UFOs, and more. Sauder continues his studies of underground bases with new information on the occult underpinnings of the U.S. space program. The book also contains a breakthrough section that examines actual U.S. patents for devices that manipulate minds and thoughts from a remote distance. Included are chapters on the secret space program and a 130-page appendix of patents and schematic diagrams of secret technology and mind control devices.
296 PAGES. 7x10 PAPERBACK. ILLUSTRATED. BIBLIOGRAPHY. $14.95. CODE: KTAL

QUEST FOR ZERO-POINT ENERGY
Engineering Principles for "Free Energy"
by Moray B. King

King expands, with diagrams, on how free energy and anti-gravity are possible. The theories of zero point energy maintain there are tremendous fluctuations of electrical field energy embedded within the fabric of space. King explains the following topics: Tapping the Zero-Point Energy as an Energy Source; Fundamentals of a Zero-Point Energy Technology; Vacuum Energy Vortices; The Super Tube; Charge Clusters: The Basis of Zero-Point Energy Inventions; Vortex Filaments, Torsion Fields and the Zero-Point Energy; Transforming the Planet with a Zero-Point Energy Experiment; Dual Vortex Forms: The Key to a Large Zero-Point Energy Coherence. Packed with diagrams, patents and photos. With power shortages now a daily reality in many parts of the world, this book offers a fresh approach very rarely mentioned in the mainstream media.
224 PAGES. 6x9 PAPERBACK. ILLUSTRATED. $14.95. CODE: QZPE

HITLER'S FLYING SAUCERS
A Guide to German Flying Discs of the Second World War
by Henry Stevens

Learn why the Schriever-Habermohl project was actually two projects and read the written statement of a German test pilot who actually flew one of these saucers; about the Leduc engine, the key to Dr. Miethe's saucer designs; how U.S. government officials kept the truth about foo fighters hidden for almost sixty years and how they were finally forced to "come clean" about the foo fighter's German origin. Learn of the Peenemuende saucer project and how it was slated to "go atomic." Read the testimony of a German eyewitness who saw "magnetic discs." Read the U.S. government's own reports on German field propulsion saucers. Read how the post-war German KM-2 field propulsion "rocket" worked. Learn details of the work of Karl Schappeller and Viktor Schauberger. Learn how their ideas figure in the quest to build field propulsion flying discs. Find out what happened to this technology after the war. Find out how the Canadians got saucer technology directly from the SS. Find out about the surviving "Third Power" of former Nazis. Learn of the U.S. government's methods of UFO deception and how they used the German "Sonderbueroll" as the model for Project Blue Book.
388 PAGES. 6x9 PAPERBACK. ILLUSTRATED. INDEX. $18.95. CODE: HFS

THE TIME TRAVEL HANDBOOK
A Manual of Practical Teleportation & Time Travel
edited by David Hatcher Childress

In the tradition of *The Anti-Gravity Handbook* and *The Free-Energy Device Handbook*, science and UFO author David Hatcher Childress takes us into the weird world of time travel and teleportation. Not just a whacked-out look at science fiction, this book is an authoritative chronicling of real-life time travel experiments, teleportation devices and more. *The Time Travel Handbook* takes the reader beyond the government experiments and deep into the uncharted territory of early time travellers such as Nikola Tesla and Guglielmo Marconi and their alleged time travel experiments, as well as the Wilson Brothers of EMI and their connection to the Philadelphia Experiment—the U.S. Navy's forays into invisibility, time travel, and teleportation. Childress looks into the claims of time travelling individuals, and investigates the unusual claim that the pyramids on Mars were built in the future and sent back in time. A highly visual, large format book, with patents, photos and schematics. Be the first on your block to build your own time travel device!
316 PAGES. 7x10 PAPERBACK. ILLUSTRATED. $16.95. CODE: TTH

ANCIENT SCIENCE

THE GIZA DEATH STAR
The Paleophysics of the Great Pyramid & the Military Complex at Giza
by Joseph P. Farrell

Physicist Joseph Farrell's amazing book on the secrets of Great Pyramid of Giza. *The Giza Death Star* starts where British engineer Christopher Dunn leaves off in his 1998 book, *The Giza Power Plant*. Was the Giza complex part of a military installation over 10,000 years ago? Chapters include: An Archaeology of Mass Destruction, Thoth and Theories; The Machine Hypothesis; Pythagoras, Plato, Planck, and the Pyramid; The Weapon Hypothesis; Encoded Harmonics of the Planck Units in the Great Pyramid; High Fregquency Direct Current "Impulse" Technology; The Grand Gallery and its Crystals: Gravito-acoustic Resonators; The Other Two Large Pyramids; the "Causeways," and the "Temples"; A Phase Conjugate Howitzer; Evidence of the Use of Weapons of Mass Destruction in Ancient Times; more.
290 PAGES. 6x9 PAPERBACK. ILLUSTRATED. $16.95. CODE: GDS

THE GIZA DEATH STAR DEPLOYED
The Physics & Engineering of the Great Pyramid
by Joseph P. Farrell

Physicist Joseph Farrell's amazing sequel to *The Giza Death Star* which takes us from the Great Pyramid to the asteroid belt and the so-called Pyramids of Mars. Farrell expands on his thesis that the Great Pyramid was a chemical maser, designed as a weapon and eventually deployed—with disastrous results to the solar system. Includes: Exploding Planets: The Movie, the Mirror, and the Model; Dating the Catastrophe and the Compound; A Brief History of the Exoteric and Esoteric Investigations of the Great Pyramid; No Machines, Please!; The Stargate Conspiracy; The Scalar Weapons; Message or Machine?; A Tesla Analysis of the Putative Physics and Engineering of the Giza Death Star; Cohering the Zero Point, Vacuum Energy, Flux: Synopsis of Scalar Physics and Paleophysics; Configuring the Scalar Pulse Wave; Inferred Applications in the Great Pyramid; Quantum Numerology, Feedback Loops and Tetrahedral Physics; and more.
290 PAGES. 6x9 PAPERBACK. ILLUSTRATED. BIBLIOGRAPHY. INDEX. $16.95. CODE: GDSD

TECHNOLOGY OF THE GODS
The Incredible Sciences of the Ancients
by David Hatcher Childress

Popular *Lost Cities* author David Hatcher Childress takes us into the amazing world of ancient technology, from computers in antiquity to the "flying machines of the gods." Childress looks at the technology that was allegedly used in Atlantis and the theory that the Great Pyramid of Egypt was originally a gigantic power station. He examines tales of ancient flight and the technology that it involved; how the ancients used electricity; megalithic building techniques; the use of crystal lenses and the fire from the gods; evidence of various high tech weapons in the past, including atomic weapons; ancient metallurgy and heavy machinery; the role of modern inventors such as Nikola Tesla in bringing ancient technology back into modern use; impossible artifacts; and more.
356 PAGES. 6x9 PAPERBACK. ILLUSTRATED. BIBLIOGRAPHY. $16.95. CODE: TGOD.

MAPS OF THE ANCIENT SEA KINGS
Evidence of Advanced Civilization in the Ice Age
by Charles H. Hapgood

Charles Hapgood's classic 1966 book on ancient maps produces concrete evidence of an advanced world-wide civilization existing many thousands of years before ancient Egypt. He has found the evidence in the Piri Reis Map that shows Antarctica, the Hadji Ahmed map, the Oronteus Finaeus and other amazing maps. Hapgood concluded that these maps were made from more ancient maps from the various ancient archives around the world, now lost. Not only were these unknown people more advanced in mapmaking than any people prior to the 18th century, it appears they mapped all the continents. The Americas were mapped thousands of years before Columbus. Antarctica was mapped when its coasts were free of ice.
316 PAGES. 7X10 PAPERBACK. ILLUSTRATED. BIBLIOGRAPHY & INDEX. $19.95.
CODE: MASK

ATLANTIS & THE POWER SYSTEM OF THE GODS
Mercury Vortex Generators & the Power System of Atlantis
by David Hatcher Childress and Bill Clendenon

Atlantis and the Power System of the Gods starts with a reprinting of the rare 1990 book *Mercury: UFO Messenger of the Gods* by Bill Clendenon. Clendenon takes on an unusual voyage into the world of ancient flying vehicles, strange personal UFO sightings, a meeting with a "Man In Black" and then to a centuries-old library in India where he got his ideas for the diagrams of mercury vortex engines. The second part of the book is Childress' fascinating analysis of Nikola Tesla's broadcast system in light of Edgar Cayce's "Terrible Crystal" and the obelisks of ancient Egypt and Ethiopia. Includes: Atlantis and its crystal power towers that broadcast energy; how these incredible power stations may still exist today; inventor Nikola Tesla's nearly identical system of power transmission; Mercury Proton Gyros and mercury vortex propulsion; more. Richly illustrated, and packed with evidence that Atlantis not only existed—it had a world-wide energy system more sophisticated than ours today.
246 PAGES. 6x9 PAPERBACK. ILLUSTRATED. $15.95. CODE: APSG

PATH OF THE POLE
Cataclysmic Pole Shift Geology
by Charles Hapgood

Maps of the Ancient Sea Kings author Hapgood's classic book *Path of the Pole* is back in print! Hapgood researched Antarctica, ancient maps and the geological record to conclude that the Earth's crust has slipped in the inner core many times in the past, changing the position of the pole. *Path of the Pole* discusses the various "pole shifts" in Earth's past, giving evidence for each one, and moves on to possible future pole shifts. Packed with illustrations, this is the sourcebook for many other books on cataclysms and pole shifts.
356 PAGES. 6x9 PAPERBACK. ILLUSTRATED. $16.95. CODE: POP.

CONSPIRACY & HISTORY

SAUCERS OF THE ILLUMINATI
by Jim Keith, Foreword by Kenn Thomas

Seeking the truth behind stories of alien invasion, secret underground bases, and the secret plans of the New World Order, *Saucers of the Illuminati* offers ground breaking research, uncovering clues to the nature of UFOs and to forces even more sinister: the secret cabal behind planetary control! Includes mind control, saucer abductions, the MJ-12 documents, cattle mutilations, government anti-gravity testing, the Sirius Connection, science fiction author Philip K. Dick and his efforts to expose the Illuminati, plus more from veteran conspiracy and UFO author Keith. Conspiracy expert Keith's final book on UFOs and the highly secret group that manufactures them and uses them for their own purposes: the control and manipulation of the population of planet Earth.
148 PAGES. 6x9 PAPERBACK. ILLUSTRATED. $12.95. CODE: SOIL

THE SHADOW GOVERNMENT
9-11 and State Terror
by Len Bracken, introduction by Kenn Thomas

Bracken presents the alarming yet convincing theory that nation-states engage in or allow terror to be visited upon their citizens. It is not just liberation movements and radical groups that deploy terroristic tactics for offensive ends. States use terror defensively to directly intimidate their citizens and to indirectly attack themselves or harm their citizens under a false flag. Their motives? To provide pretexts for war or for increased police powers or both. This stratagem of indirectly using terrorism has been executed by statesmen in various ways but tends to involve the pretense of blind eyes, misdirection, and cover-ups that give statesmen plausible deniability. Lusitania, Pearl Harbor, October Surprise, the first World Trade Center bombing, the Oklahoma City bombing and other well-known incidents suggest that terrorism is often and successfully used by states in an indirectly defensive way to take the offensive against enemies at home and abroad. Was 9-11 such an indirect defensive attack?
288 PAGES. 6x9 PAPERBACK. ILLUSTRATED. $16.00. CODE: SGOV

ARKTOS
The Myth of the Pole in Science, Symbolism, and Nazi Survival
by Joscelyn Godwin

A scholarly treatment of catastrophes, ancient myths and the Nazi Occult beliefs. Explored are the many tales of an ancient race said to have lived in the Arctic regions, such as Thule and Hyperborea. Progressing onward, the book looks at modern polar legends including the survival of Hitler, German bases in Antarctica, UFOs, the hollow earth, Agartha and Shambala, more.
220 PAGES. 6x9 PAPERBACK. ILLUSTRATED. $16.95. CODE: ARK

THE LUCID VIEW
Investigations in Occultism, Ufology & Paranoid Awareness
by Aeolus Kephas

An unorthodox analysis of conspiracy theory, ufology, extraterrestrialism and occultism. *The Lucid View* takes us on an impartial journey through secret history, including the Gnostics and Templars; Crowley and Hitler's occult alliance; the sorcery wars of Freemasonry and the Illuminati; "Alternative Three" covert space colonization; the JFK assassination; the Manson murders; Jonestown and 9/11. Also delves into UFOs and alien abductions, their relations to mind control technology and sorcery practices, with reference to inorganic beings and Kundalini energy. The book offers a balanced overview on religious, magical and paranoid beliefs pertaining to the 21st century, and their social, psychological, and spiritual implications for humanity, the leading game player in the grand mythic drama of Armageddon.
298 PAGES. 6x9 PAPERBACK. ILLUSTRATED. $16.95. CODE: LVEW

POPULAR PARANOIA
The Best of Steamshovel Press
edited by Kenn Thomas

The anthology exposes the biologocal warfare origins of AIDS; the Nazi/Nation of Islam link; the cult of Elizabeth Clare Prophet; the Oklahoma City bombing writings of the late Jim Keith, as well as an article on Keith's own strange death; the conspiratorial mind of John Judge; Marion Pettie and the shadowy Finders group in Washington, DC; demonic iconography; the death of Princess Diana, its connection to the Octopus and the Saudi aerospace contracts; spies among the Rajneeshis; scholarship on the historic Illuminati; and many other parapolitical topics. The book also includes the Steamshovel's last-ever interviews with the great Beat writers Allen Ginsberg and William S. Burroughs, and neuronaut Timothy Leary, and new views of the master Beat, Neal Cassady and Jack Kerouac's science fiction.
308 PAGES. 8x10 PAPERBACK. ILLUSTRATED. $19.95. CODE: POPA

DARK MOON
Apollo and the Whistleblowers
by Mary Bennett and David Percy

•Did you know a second craft was going to the Moon at the same time as Apollo 11?
•Do you know there are serious discrepancies in the account of the Apollo 13 'accident'?
•Did you know that 'live' color TV from the Moon was not actually live at all?
•Did you know that the Lunar Surface Camera had no viewfinder?
•Do you know that lighting was used in the Apollo photographs—yet no lighting equipment was taken to the Moon? All these questions, and more, are discussed in great detail by British researchers Bennett and Percy in *Dark Moon*, the definitive book (nearly 600 pages) on the possible faking of the Apollo Moon missions. Bennett and Percy delve into every possible aspect of this beguiling theory, one that rocks the very foundation of our beliefs concerning NASA and the space program. Tons of NASA photos analyzed for possible deceptions.
568 PAGES. 6x9 PAPERBACK. ILLUSTRATED. BIBLIOGRAPHY. INDEX. $25.00. CODE: DMO

24 hour credit card orders—call: 815-253-6390 fax: 815-253-6300

email: auphq@frontiernet.net www.adventuresunlimitedpress.com www.wexclub.com

ANCIENT SCIENCE

THE LAND OF OSIRIS
An Introduction to Khemitology
by Stephen S. Mehler

Was there an advanced prehistoric civilization in ancient Egypt? Were they the people who built the great pyramids and carved the Great Sphinx? Did the pyramids serve as energy devices and not as tombs for kings? Independent Egyptologist Stephen S. Mehler has spent over 30 years researching the answers to these questions and believes the answers are yes! Mehler has uncovered an indigenous oral tradition that still exists in Egypt, and has been fortunate to have studied with a living master of this tradition, Abd'El Hakim Awyan. Mehler has also been given permission to present these teachings to the Western world, teachings that unfold a whole new understanding of ancient Egypt and have only been presented heretofore in fragments by other researchers. Chapters include: Egyptology and Its Paradigms; Khemitology—New Paradigms; Asgat Nefer—The Harmony of Water; Khemit and the Myth of Atlantis; The Extraterrestrial Question; 17 chapters in all.
272 PAGES. 6x9 PAPERBACK. ILLUSTRATED. COLOR SECTION. BIBLIOGRAPHY. $18.95. CODE: LOOS

A HITCHHIKER'S GUIDE TO ARMAGEDDON
by David Hatcher Childress

With wit and humor, popular Lost Cities author David Hatcher Childress takes us around the world and back in his trippy finalé to the Lost Cities series. He's off on an adventure in search of the apocalypse and end times. Childress hits the road from the fortress of Megiddo, the legendary citadel in northern Israel where Armageddon is prophesied to start. Hitchhiking around the world, Childress takes us from one adventure to another, to ancient cities in the deserts and the legends of worlds before our own. Childress muses on the rise and fall of civilizations, and the forces that shaped mankind over the millennia, including wars, invasions and cataclysms. He discusses the ancient Armageddons of the past, and chronicles recent Middle East developments and their ominous undertones. In the meantime, he becomes a cargo cult god on a remote island off New Guinea, gets dragged into the Kennedy Assassination by one of the "conspirators," investigates a strange power operating out of the Altai Mountains of Mongolia, and discovers how the Knights Templar and their off-shoots have driven the world toward an epic battle centered around Jerusalem and the Middle East.
320 PAGES. 6x9 PAPERBACK. ILLUSTRATED. BIBLIOGRAPHY. INDEX. $16.95. CODE: HGA

CLOAK OF THE ILLUMINATI
Secrets, Transformations, Crossing the Star Gate
by William Henry

Thousands of years ago the stargate technology of the gods was lost. Mayan Prophecy says it will return by 2012, along with our alignment with the center of our galaxy. In this book: Find examples of stargates and wormholes in the ancient world; Examine myths and scripture with hidden references to a stargate cloak worn by the Illuminati, including Mari, Nimrod, Elijah, and Jesus; See rare images of gods and goddesses wearing the Cloak of the illuminati; Learn about Saddam Hussein and the secret missing library of Jesus; Uncover the secret Roman-era eugenics experiments at the Temple of Hathor in Denderah, Egypt; Explore the duplicate of the Stargate Pillar of the Gods in the Illuminists' secret garden in Nashville, TN; Discover the secrets of manna, the food of the angels; Share the lost Peace Prayer posture of Osiris, Jesus and the Illuminati; more. Chapters include: Seven Stars Under Three Stars; The Long Walk; Squaring the Circle; The Mill of the Host; The Miracle Garment; The Fig; Nimrod: The Mighty Man; Nebuchadnezzar's Gate; The New Mighty Man; more.
238 PAGES. 6x9 PAPERBACK. ILLUSTRATED. BIBLIOGRAPHY. INDEX. $16.95. CODE: COIL

LEY LINE & EARTH ENERGIES
An Extraordinary Journey into the Earth's Natural Energy System
by David Cowan & Anne Silk

The mysterious standing stones, burial grounds and stone circles that lace Europe, the British Isles and other areas have intrigued scientists, writers, artists and travellers through the centuries. They pose so many questions: Why do some places feel special? How do ley lines work? How did our ancestors use Earth energy to map their sacred sites and burial grounds? How do ghosts and poltergeists interact with Earth energy? How can Earth spirals and black spots affect our health? This exploration shows how natural forces affect our behavior, how they can be used to enhance our health and well being, and ultimately, how they bring us closer to penetrating one of the deepest mysteries being explored. A fascinating and visual book about subtle Earth energies and how they affect us and the world around them.
368 PAGES. 6x9 PAPERBACK. ILLUSTRATED. BIBLIOGRAPHY. INDEX. $18.95. CODE: LLEE

THE ORION PROPHECY
Egyptian & Mayan Prophecies on the Cataclysm of 2012
by Patrick Geryl and Gino Ratinckx

In the year 2012 the Earth awaits a super catastrophe: its magnetic field reverse in one go. Phenomenal earthquakes and tidal waves will completely destroy our civilization. Europe and North America will shift thousands of kilometers northwards into polar climes. Nearly everyone will perish in the apocalyptic happenings. These dire predictions stem from the Mayans and Egyptians—descendants of the legendary Atlantis. The Atlanteans had highly evolved astronomical knowledge and were able to exactly predict the previous world-wide flood in 9792 BC. They built tens of thousands of boats and escaped to South America and Egypt. In the year 2012 Venus, Orion and several others stars will take the same 'code-positions' as in 9792 BC! For thousands of years historical sources have told of a forgotten time capsule of ancient wisdom located in a mythical labyrinth of secret chambers filled with artifacts and documents from the previous flood. We desperately need this information now—and this book gives one possible location.
324 PAGES. 6x9 PAPERBACK. ILLUSTRATED. BIBLIOGRAPHY. $16.95. CODE: ORP

ALTAI-HIMALAYA
A Travel Diary
by Nicholas Roerich

Nicholas Roerich's classic 1929 mystic travel book is back in print in this deluxe paperback edition. The famous Russian-American explorer's expedition through Sinkiang, Altai-Mongolia and Tibet from 1924 to 1928 is chronicled in 12 chapters and reproductions of Roerich's inspiring paintings. Roerich's "Travel Diary" style incorporates various mysteries and mystical arts of Central Asia including such arcane topics as the hidden city of Shambala, Agartha, more. Roerich is recognized as one of the great artists of this century and the book is richly illustrated with his original drawings.
407 PAGES. 6x9 PAPERBACK. ILLUSTRATED. $18.95. CODE: AHIM

24 hour credit card orders—call: 815-253-6390 fax: 815-253-6300
email: auphq@frontiernet.net www.adventuresunlimitedpress.com www.wexclub.com

One Adventure Place
P.O. Box 74
Kempton, Illinois 60946
United States of America
•Tel.: 1-800-718-4514 or 815-253-6390
•Fax: 815-253-6300
Email: auphq@frontiernet.net
http://www.adventuresunlimitedpress.com
or www.adventuresunlimited.nl

10% Discount when you order 3 or more items!

ORDERING INSTRUCTIONS

➤➤ Remit by USD$ Check, Money Order or Credit Card
➤➤ Visa, Master Card, Discover & AmEx Accepted
➤➤ Prices May Change Without Notice
➤➤ 10% Discount for 3 or more Items

SHIPPING CHARGES

United States

➤➤ Postal Book Rate { $3.00 First Item
50¢ Each Additional Item

➤➤ Priority Mail { $4.50 First Item
$2.00 Each Additional Item

➤➤ UPS { $5.00 First Item
$1.50 Each Additional Item

NOTE: UPS Delivery Available to Mainland USA Only

Canada

➤➤ Postal Book Rate { $6.00 First Item
$2.00 Each Additional Item

➤➤ Postal Air Mail { $8.00 First Item
$2.50 Each Additional Item

➤➤ Personal Checks or Bank Drafts MUST BE
USD$ and Drawn on a US Bank
➤➤ Canadian Postal Money Orders in US$ OK

➤➤ Payment MUST BE US$

All Other Countries

➤➤ Surface Delivery { $10.00 First Item
$4.00 Each Additional Item

➤➤ Postal Air Mail { $14.00 First Item
$5.00 Each Additional Item

➤➤ Checks and Money Orders MUST BE US $
and Drawn on a US Bank or branch.

➤➤ Payment by credit card preferred!

SPECIAL NOTES

➤➤ RETAILERS: Standard Discounts Available
➤➤ BACKORDERS: We Backorder all Out-of-
Stock Items Unless Otherwise Requested
➤➤ PRO FORMA INVOICES: Available on Request
➤➤ VIDEOS: NTSC Mode Only. Replacement only.
➤➤ For PAL mode videos contact our other offices:

European Office:
Adventures Unlimited, Pannewal 22,
Enkhuizen, 1602 KS, The Netherlands
http: www.adventuresunlimited.nl
Check Us Out Online at:
www.adventuresunlimitedpress.com

Please check: ☑

☐ This is my first order ☐ I have ordered before ☐ This is a new address

Name	
Address	
City	
State/Province	Postal Code
Country	
Phone day	Evening
Fax	Email

Item Code	Item Description	Price	Qty	Total

Please check: ☐

☐ Postal-Surface
☐ Postal-Air Mail
(Priority in USA)
☐ UPS
(Mainland USA only)

Subtotal ➡	
Less Discount-10% for 3 or more items ➡	
Balance ➡	
Illinois Residents 6.25% Sales Tax ➡	
Previous Credit ➡	
Shipping ➡	
Total (check/MO in USD$ only)➡	

☐ Visa/MasterCard/Discover/Amex

Card Number

Expiration Date

10% Discount When You Order 3 or More Items!

Comments & Suggestions	Share Our Catalog with a Friend